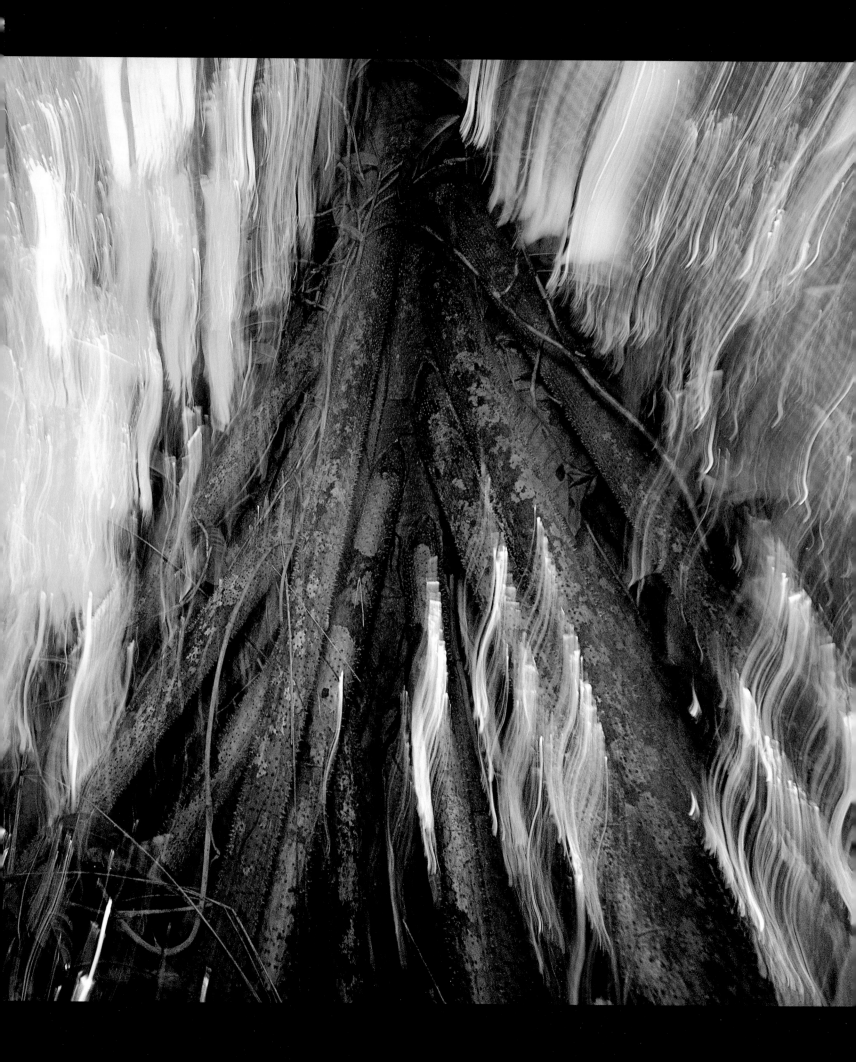

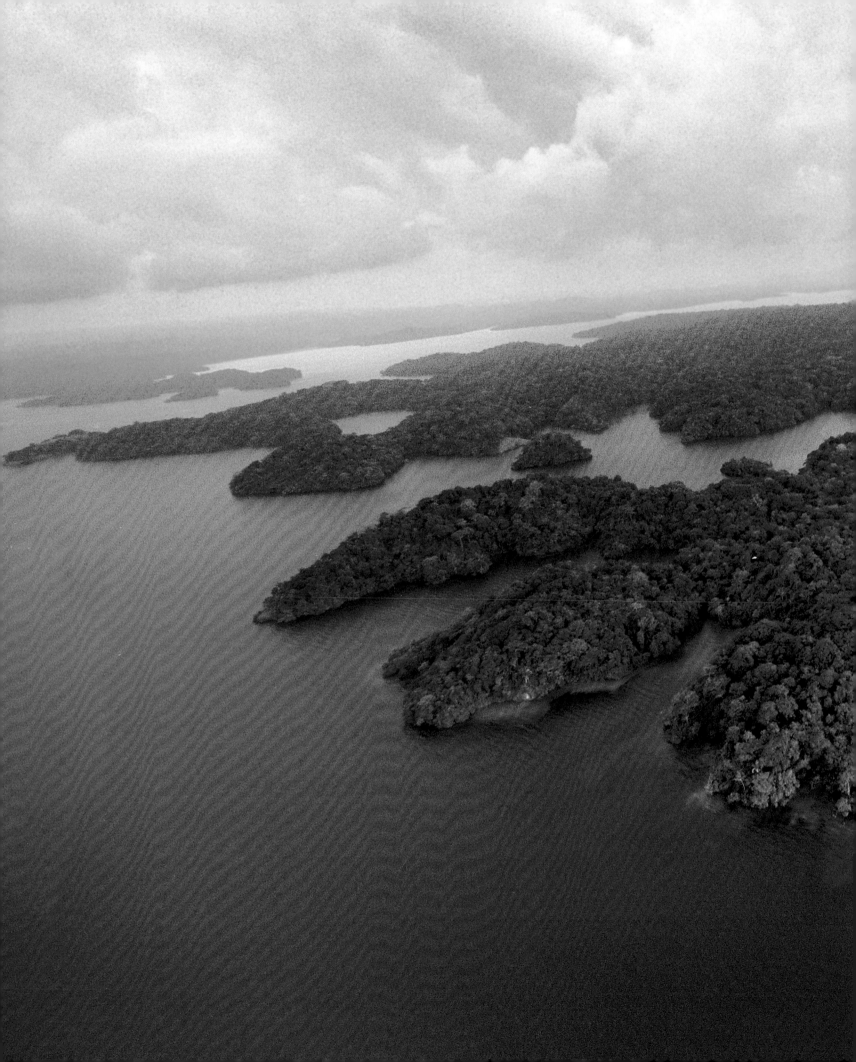

UN TEJIDO MÁGICO

EL BOSQUE TROPICAL DE ISLA BARRO COLORADO

FOTOGRAFÍAS DE
CHRISTIAN ZIEGLER

TEXTO DE
EGBERT GILES LEIGH, JR.

TRADUCIDO POR
MARÍA MARTA KANDLER

 Smithsonian Tropical Research Institute

 Smithsonian Institution
Scholarly Press

FRONTISPICIO, FIG. 1

Como salida de un sueño, esta imagen asalta
los sentidos durante una caminata matinal
en la estación seca: ribetes de azul y verde
danzan fantasmagóricamente sobre las raíces
expuestas de esta palma zancona (*Socratea
exorrhiza*).

PORTADA, FIG. 2

Fotografiada una tarde en las postrimerías
de la estación lluviosa, Isla Barro Colorado
descansa en las plácidas aguas del Lago Gatún
envuelta en un espeso manto de bosque.

CONTENIDOS

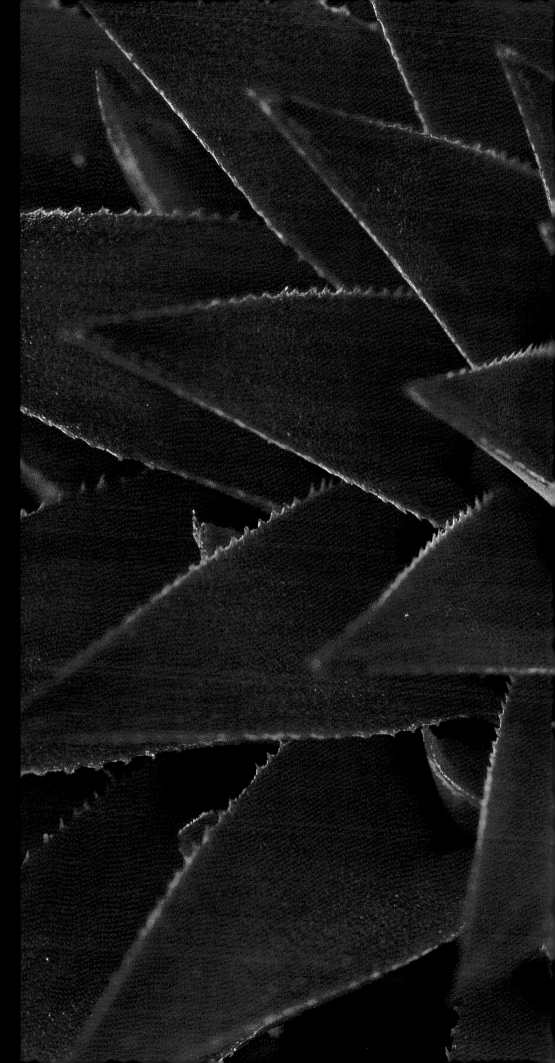

A nuestros padres

Que este libro cumpla con sus idea
de un discurso claro y agradable

3

Esta gigantesca flor es una *Aechmea
magdalenae,* de la familia de las bromelias,
a la que pertenece la piña.

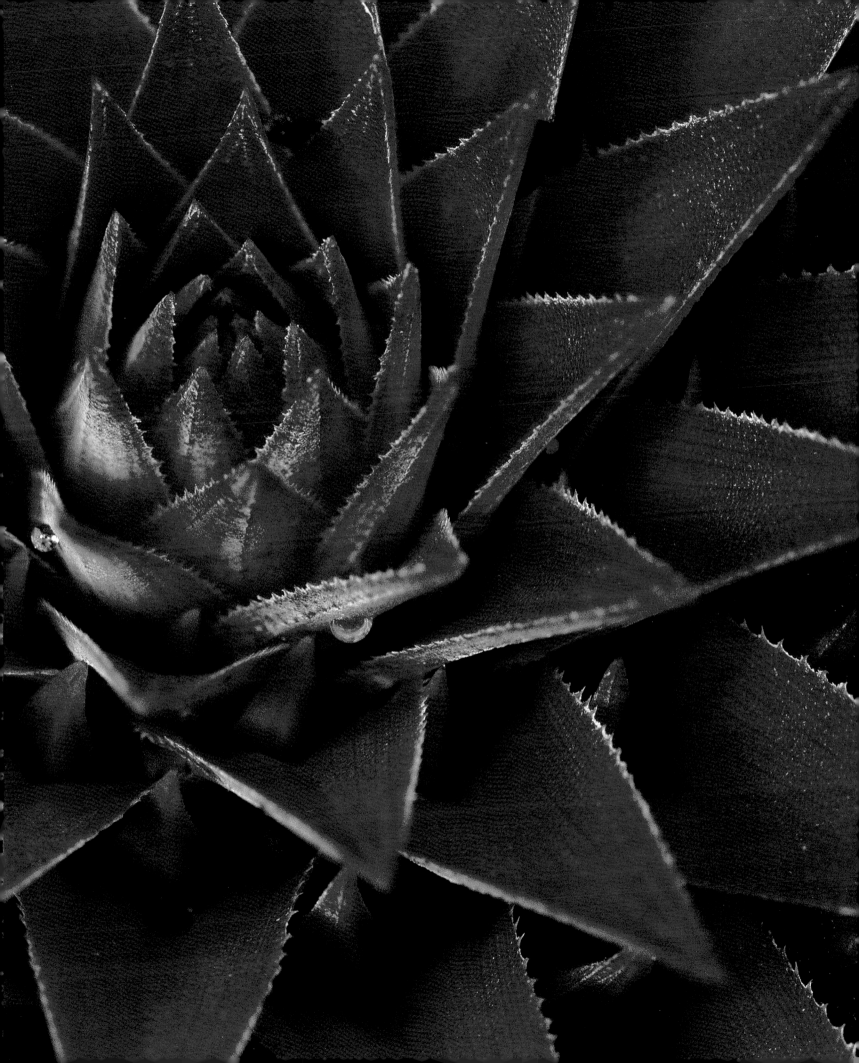

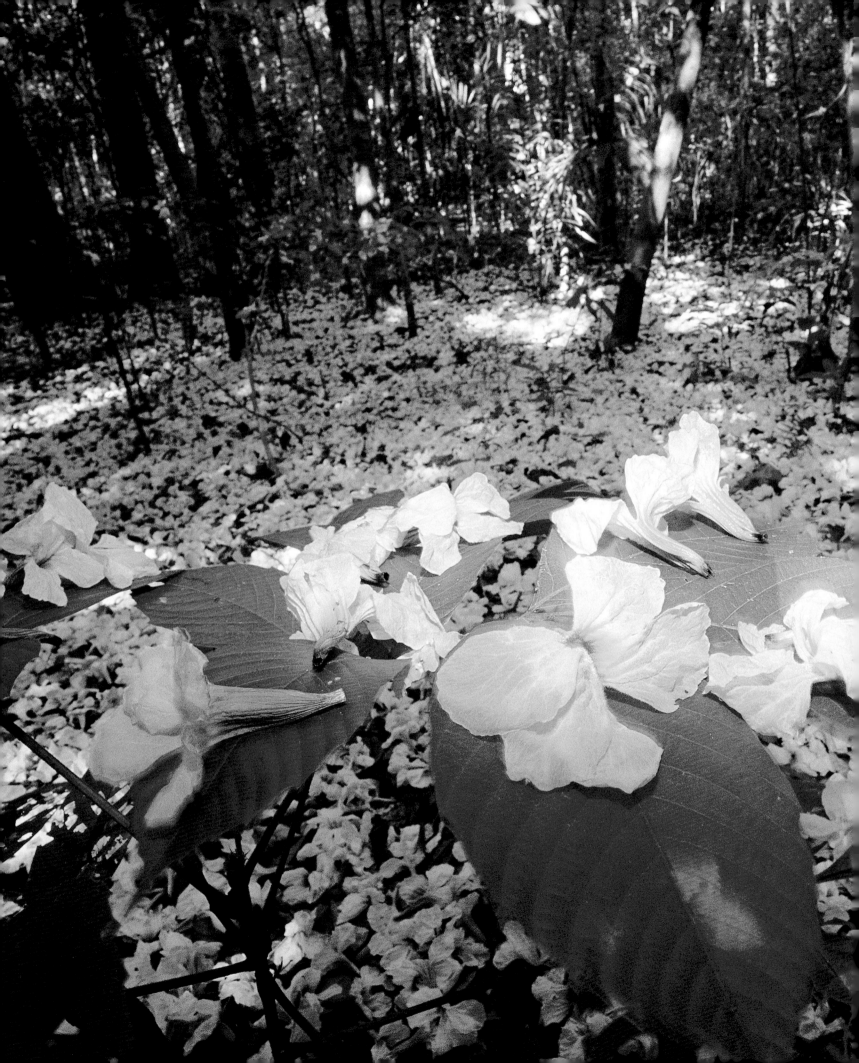

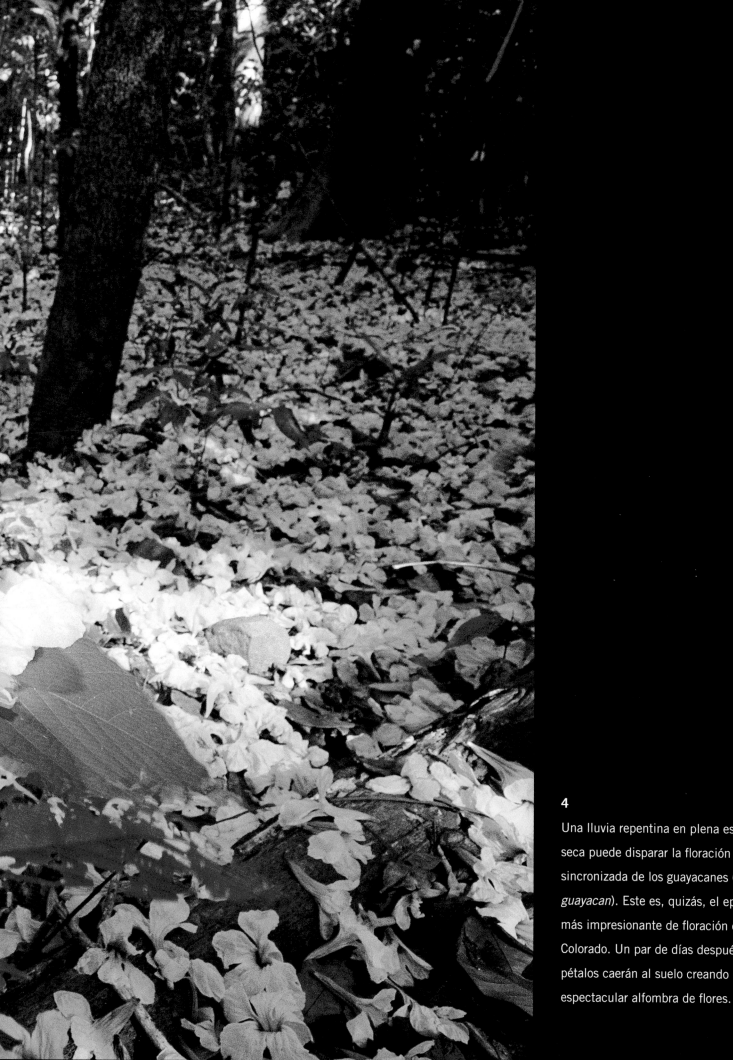

4

Una lluvia repentina en plena estación seca puede disparar la floración sincronizada de los guayacanes (*Tabebuia guayacan*). Este es, quizás, el episodio más impresionante de floración en Barro Colorado. Un par de días después, los pétalos caerán al suelo creando una espectacular alfombra de flores.

5

Colonias compuestas por millones de hormigas arrieras (*Atta colombica)* cultivan y protegen un hongo que les sirve de alimento.

PRÓLOGO

Egbert Leigh describió una vez al Instituto Smithsonian de Investigaciones Tropicales (STRI, por sus siglas en inglés) como un "reino de elfos". Con esto deseaba describir el aura mágica de un centro de ciencias donde los científicos pueden explorar un gran número de temas de investigación, junto a talentosos colegas y con el apoyo de una institución sólida que les permite mejorar su comprensión de la naturaleza y las culturas humanas de los trópicos. En este "reino", Panamá posee una de las "joyas de la corona". Esta joya es la isla Barro Colorado (BCI, por sus siglas en inglés) localizada en el Lago Gatún, hogar del bosque tropical más estudiado del planeta. Cada año, cerca de 1400 científicos y estudiantes —alrededor de la mitad de ellos y ellas panameños y latinoamericanos— visitan a BCI y a otras instalaciones para colaborar con científicos de STRI y estudiar la rica biodiversidad de Panamá. No ha sido coincidencia que el Dr. Leigh y Christian Ziegler hayan escogido *Un tejido mágico* como título de su libro para iluminar esta joya en todo su esplendor.

El surgimiento del Istmo de Panamá, hace varios millones de años, cambió el mundo al unir dos continentes y separar dos océanos. El siglo XX vio esos océanos unidos por medio de un trabajo espectacular de ingeniería y gran sacrificio humano: la construcción del Canal de Panamá, la cual a su vez dio forma al Lago Gatún y dio lugar a Isla Barro Colorado a partir de una montaña en el valle del Chagres. No dudamos que el siglo XXI será el "Siglo del Medioambiente". Hoy, la buena voluntad por parte del pueblo panameño y su Nación, que permiten estudios científicos intensivos en BCI y en otras partes del país, garantizan que Panamá continúe jugando un papel central en la comprensión de la vida en los trópicos, y en abordar mejor y racionalmente los retos ambientales que encara nuestro planeta.

Estamos encantados de tener una traducción al castellano de *Un tejido mágico*, y esta es una muestra de agradecimiento al pueblo de Panamá que por más de 100 años han sido anfitriones nuestros. Esperamos en especial que este libro llegue a manos de tantos jóvenes estudiantes como sea posible. Tal vez aliente a algunos a convertirse en científicos para ayudarnos a aprender más de los hilos que conforman el complejo tejido de la vida en los trópicos, ayudando así a otros a apreciar la belleza mágica de éste tejido. Este extraordinario libro ilustra por qué debemos esforzarnos mucho en preservar el mundo natural y por qué este esfuerzo nos debe importar. La prosa de Egbert Leigh también nos

enseña que para conservar algo debemos comprenderlo, y para eso necesitamos de las ciencias. En este libro la ciencia se hace accesible también gracias a la perspectiva artística de la belleza, en el lente de Christian Ziegler.

Estamos muy agradecidos con el Programa de Subvenciones Arthur Seidell y la Smithsonian Institution Scholarly Press por el apoyo en la publicación de este libro en castellano, y por la publicación como libro electrónico para que se su disponibilidad sea aún mayor.

DR. MATTHEW LARSEN
Director, Instituto Smithsonian de Investigaciones Tropicales

DR. WILLIAM WCISLO
Subdirector de investigacion, Instituto Smithsonian de Investigaciones Tropicales

PREFACIO DEL FOTÓGRAFO

A la segunda edición

Hace ya casi diez años que se publicó por primera vez la edición en inglés de *Un tejido mágico*, y estoy muy ilusionado con esta edición, nueva y actualizada. El bosque de Barro Colorado ha cambiado poco desde su primera edición. Decenas de miles de especies aún tejen una intrincada tela de vida, tal como lo han hecho durante miles de años y como esperamos que lo sigan haciendo por mucho más tiempo. Sin embargo, nuestro entendimiento de la ecología del lugar ha cambiado en los últimos diez años, así como diez años de mi propio trabajo me han hecho ver de manera diferente algunas de las especies y procesos que se ilustran en el libro. Por eso cambié algunas imágenes en los casos en que sentía que contaba con una mejor representación de lo que había intentado mostrar originalmente. Espero que este libro se disfrute y que sea educativo e inspirador para cualquiera que tenga interés en los bosques tropicales. Puede que hasta motive al lector a visitar uno de estos bosques, si es que aún no lo ha hecho. Yo, después de 15 años de trabajar en la Isla, sigo sorprendiéndome cada vez que recorro sus senderos. No tengo razones para pensar que esto podría dejar de suceder algún día. ¡Si es un tejido mágico y glorioso!

Gamboa, 8 de junio de 2011

A la primera edición

Desde la primera vez que visité un bosque tropical quedé fascinado con estos asombrosos ecosistemas. Gracias a mis estudios universitarios en Biología Tropical tuve el privilegio de visitar bosques lluviosos en Asia, África y Centroamérica, y la oportunidad de entrar en contacto con su biología, su encanto y su belleza. Ahondé en el campo de la fotografía porque me pareció una buena herramienta para compartir mi aprecio por la naturaleza tropical, y comencé a pensar en hacer un libro ilustrado sobre bosques lluviosos que le permitiera al lector adquirir conocimientos básicos sobre la ecología de los bosques tropicales. Cuando visité Isla Barro Colorado por primera vez, supe que sería el escenario perfecto para un libro como el que tenía en mente.

Egbert Leigh y yo nos propusimos revelar, a través de la ciencia y la fotografía, las diferentes capas que componen un bosque tropical, desde su complejidad hasta su estética impactante. Esperamos alcanzar un público amplio: científicos, naturalistas y gente que simplemente desee obtener un conocimiento general sobre los bosques tropicales.

El bosque de Barro Colorado alberga decenas de miles de organismos diferentes, cada uno con características individuales que definen su papel en el sistema. Este bosque es una red vívida, tejida con miles de actividades

curiosas, una variedad impresionante de modos de vida, que, en conjunto, hacen que el bosque funcione como un todo. La mayoría de estas actividades se realizan callada y secretamente al amparo de una gruesa cortina verde o a una escala en miniatura. Sacando provecho del conocimiento de generaciones de investigadores, usando las técnicas de las cámaras modernas y con mucha paciencia (y a veces mucha suerte), procuré descorrer la cortina verde por un instante para mirar fugazmente los procesos que dan forma al bosque de Barro Colorado.

Para mí, los 15 meses de trabajo de campo fueron un viaje emocionante, un viaje que me permitió en muchos casos ir más allá de la superficie, rastreando animales individuales y observando los acontecimientos y los cambios que experimentaba el bosque conforme se iban desarrollando.

Por cada fotografía que se muestra en el libro hay una docena que deseché. Horas y días de espera por el animal correcto o la luz correcta, lluvias torrenciales que resultaban en fallos del equipo o del fotógrafo, el rollo incorrecto, el flash que no se cargó a tiempo: había mil maneras de perderse el momento crucial. Aun así, valía la pena el esfuerzo. Muchas de las imágenes son el resultado de momentos conmovedores, encuentros cercanos con el bosque y sus criaturas, que me siento privilegiado de haber presenciado. Fácilmente compensaban por las decepciones que son inevitables cuando se trata de fotografiar la naturaleza. Algunos momentos memorables me vienen a la mente: la intimidad de los tucanes y los momotos alimentando a sus crías, un millón de hormigas guerreras pululando por el bosque, una línea infinita de hormigas arrieras cosechando hojas, encuentros con criaturas que difícilmente se ven, como el osito hormiguero sedoso y los puercoespines arborícolas; los murciélagos pescadores barriendo la superficie del lago en las noches en busca de comida; la emoción de encontrar las huellas de un ocelote cerca de mi sistema de cámara remota.

Esperamos haber transmitido nuestra fascinación por los bosques tropicales y la complejidad del sistema tanto como su belleza. Pero más que todo, esperamos que este libro sea entretenido y se disfrute. También esperamos que ayude a crear conciencia sobre el estado de estos ecosistemas a inicios del siglo veintiuno. Los bosques tropicales están desapareciendo a un ritmo cada vez más rápido en todo el mundo. Algunos de los animales que se muestran en este libro se ven amenazados por la pérdida de su hábitat y por la caza furtiva. Sería una verdadera tragedia que lo único que quedara de estos bosques fueran imágenes en libros como este. Esperamos que nuestros lectores se identifiquen con estas preocupaciones y que busquen maneras propias de ayudar a los esfuerzos de conservación de los bosques tropicales.

CHRISTIAN ZIEGLER
Isla Barro Colorado, diciembre de 2001

PREFACIO AUTOR

A la segunda edición

El Instituto Smithsonian de Investigaciones Tropicales está celebrando con una gran variedad de actividades cien años desde que el Smithsonian realizó su primer estudio científico en Panamá. Uno de los celebrantes exclamó "¡Qué mejor manera de compartir la alegría de este aniversario que haciendo una nueva edición de *Un tejido mágico*!". La sugerencia dio frutos: he aquí el libro.

Diez años han transcurrido desde la primera edición. El bosque ha cambiado poco, aunque las lianas se han vuelto más comunes. Mientras tanto, el fotógrafo, en aquel entonces un principiante que prometía y que aún debía darse a conocer, se convirtió en un profesional de gran demanda, a quien regularmente se le asigna fotografiar escenas en lugares como las zonas rurales de Guatemala o los bosques de bonobos del sur de la República Democrática del Congo. Como un diamante bien tallado o una pintura renacentista bien lograda, el bosque siempre tiene algo nuevo que revelar bajo la luz cambiante de las nuevas técnicas y perspectivas de la biología.

Cambié el texto solo para corregir errores o anacronismos, reemplazar información desactualizada o retomar algunas discusiones desde una perspectiva más amplia. También agregué algunas referencias nuevas.

Estoy infinitamente agradecido con las plantas y los animales de la Isla por ofrecernos alimento abundante para la mente y belleza abundante para alegrar el corazón. Agradezco también a los estudiantes de la Isla por encontrarle sentido a esa belleza. Finalmente, agradezco a Gregory Retallack, Scott Wing, Jennifer Powers y Joseph Wright por su ayuda oportuna.

Isla Barro Colorado, Fiesta de San Columbano, 2011

A la primera edición

A inicios de 1999, un estudiante vino a consultarme sobre la posibilidad de hacer un "ensayo fotográfico" sobre la Isla Barro Colorado. Estaba claro que él sabía fotografiar. También estaba claro que él sólo podría conseguir el apoyo del Instituto Smithsonian de Investigaciones Tropicales (STRI) si yo escribía el texto.

La oportunidad de trabajar con un fotógrafo de primera clase para transmitir la belleza del bosque tropical y el conocimiento de cómo funciona no se presenta todos los días. ¿Qué es lo que este trabajo conjunto debería lograr?

Robert Paine, de la Universidad de Washington, me introdujo a la vida marina de las costas rocosas y golpeadas por las tormentas de la Isla Tatoosh, hacia el extremo noroeste de la Península Olímpica de Washington en el Pacífico noreste. Me mostró cómo la distribución y la zonación de los mejillones, las estrellas de mar, los erizos de mar, las algas coralinas y las algas marinas revelaban (al ojo entrenado por los experimentos adecuados) los factores que daban forma a esa zonación —cómo las estrellas de mar evitaban que la cama de mejillones se extendiera como un glaciar bajo las algas marinas y las desplazara, cómo las olas

que golpeaban la orilla mantenían a los erizos cerca de sus refugios, evitando que se comieran todas las algas marinas, entre otros—. Estaba seguro de que un ensayo fotográfico podría hacer lo mismo por el bosque tropical de otra isla. Es fácil ilustrar la intensidad de la lucha de las plantas por conseguir un poco de luz, el impacto de los herbívoros, el peligro omnipresente de los depredadores y cómo los animales sortean, cada uno a su manera, este peligro. Sin embargo, es un trabajo mucho más sutil mostrar que las diferentes plantas se ven afectadas de diferentes maneras por diferentes agentes, pero esta demostración indica por qué las plantas que se mantienen escasas debido a sus pestes deben utilizar a los animales para transmitir su polen y, a menudo, a otros animales para dispersar sus semillas. ¿Podríamos también mostrar cómo la lucha por la vida dio lugar, sin premeditación o esfuerzo consciente, a una comunidad exuberante y diversa de plantas, animales y hongos mutuamente dependientes?

Cualquier libro es un homenaje, consciente o inconsciente, a aquellos que forjaron la educación del autor. Este libro debe mucho al interés que Robert Paine y Robert MacArthur mostraron en cómo leer el libro de la naturaleza, al interés de Elisabeth Kalko por los murciélagos, al interés de Alfred Fisher por cómo usar los registros fósiles para interpretar el presente, al interés de Robert Stallard por la escorrentía, la tierra, la erosión y el cambio climático, y finalmente, a los escritos de Michael Robinson, un verdadero modelo de cómo comunicar las maravillas de la naturaleza tropical de una manera simple y alegre.

Quiero agradecer al Instituto Smithsonian de Investigaciones Tropicales, especialmente a su director, Ira Rubinoff, a su Secretario Interino, Cristián Samper, y a Kirk Jensen de Oxfort University Press, New York, por apostarle a este proyecto.

También deseo agradecer a Jacalyn Giacalone, Elisabeth King, Fernando Santos-Granero, John Murray Leigh y a Ira Rubinoff por hacer comentarios a los borradores del texto, y a Elisabeth Kalko, Ricardo Moreno, Robert Stallard y Janeene Touchton por leer partes importantes del texto y brindarme información inédita.

Agradezco a Laura Flores por su ayuda en este proyecto. Su experiencia es en administración de negocios y este proyecto no se apegaba exactamente a las reglas ordinarias de las iniciativas de negocios. Enfrentándose a un fotógrafo que consumía cinta fotográfica del modo en que una ballena antártica come krill y a un autor que de ninguna manera iba a restringir este consumo, ella se las arregló, y este proyecto es testigo de que se puede sobrevivir a pesar el determinismo económico, un peligro nada desdeñable para un bosque lluvioso tropical.

Finalmente, quiero agradecer a David Barclay y Sonia Tejada por su apoyo con la redaccion y a Sharon Ryan paro todo su apoyo con la produccion de *Un tejido mágico* en español.

EGBERT GILES LEIGH, JR.
Isla Barro Colorado, Fiesta de San Aidano, 2001

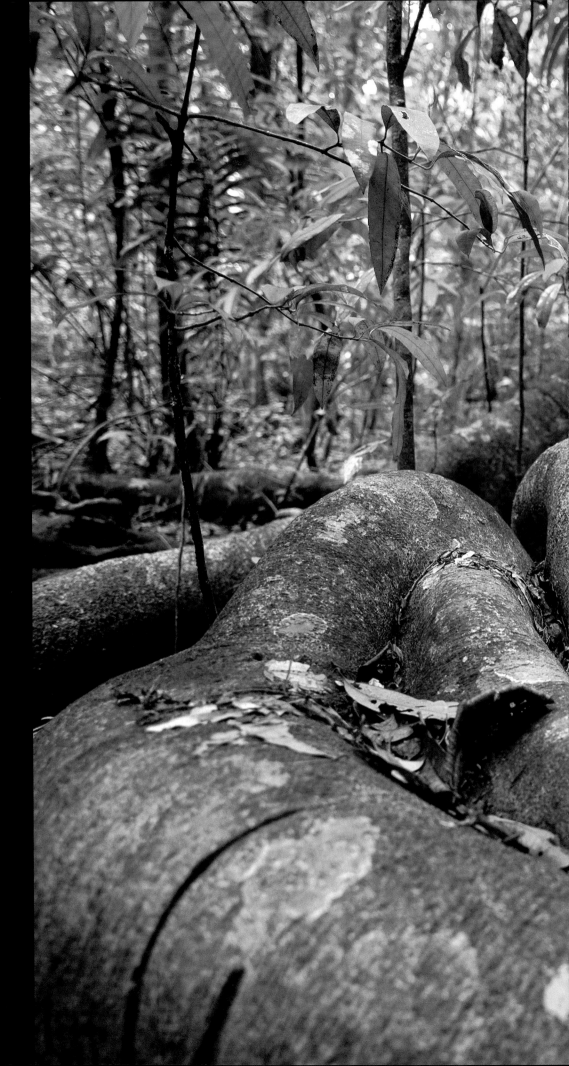

6

Este imponente higuerón, *Ficus insipida*, se levanta en el "bosque viejo" que crece al sur de la Isla. Muchos árboles del bosque lluvioso pueden vivir cientos de años, aunque no comienzan a reproducirse hasta que han cumplido unas cuantas décadas.

LA PRIMERA IMPRESIÓN

LA PRIMERA IMPRESIÓN

Para muchos, la frase "bosque tropical" evoca un escenario exótico, lleno de plantas extravagantes, salpicado de flores vistosas y rodeado de un aura de peligro, como en los cuadros de Henri Rousseau. En efecto, Rousseau, como tantos otros, imaginó el bosque tropical como un mundo misterioso y exuberante, cuya atmósfera, seductoramente amenazadora, no distaba mucho de la que experimentaban algunos de los personajes ingleses de E. M. Forster que viajaban a Italia.

El bosque tropical es, sin duda, un mundo diferente; caliente y a menudo sofocante (aunque Washington D. C. puede ser más caliente y pegajosa en el verano). Barro Colorado, una isla en el Lago Gatún, Panamá, destinada exclusivamente a la investigación tropical es, además, un mundo aislado, al que solo se puede llegar en bote

(fig. 2). Un mundo difícil de entender, porque la primera impresión del visitante puede resultar abrumadora ante la profusa confusión de verdes que dominan el paisaje (figs. 5, 6, 7). Tal es la exuberancia y la variedad de plantas que muchas veces hay que hacer un esfuerzo y ajustar la mirada para poder desentrañar cada uno de los elementos que componen esta asombrosa mancha vegetal. Un árbol solitario con un tronco de casi dos metros de ancho, apuntalado en vigorosas gambas se dispara limpiamente hacia el cielo cortando la techumbre vegetal a veinticinco metros de altura (fig. 6). Una palma de tallo esbelta danza en raíces zancudas (fig. 1). Una enredadera pega con esmero ordenadas hileras de hojas a la superficie de una roca; otra se adhiere con fuerza al tronco que la llevará a lo alto. Una liana, gruesa como el brazo de un gladiador, se descuelga desde unos treinta metros de altura. Un tronco sucumbe al abrazo mortal de un higuerón estrangulador. Todos y cada uno de ellos forman parte de la extraordinaria variedad de este bosque tropical.

Trechos de sombra flanqueados de árboles altos y frondosos alternan con claros de luz recién abiertos por la caída de un árbol y casi de inmediato asfixiados por la multitud de retoños que compiten por ocupar su lugar. Guirnaldas de helechos, orquídeas, bromelias y hasta cactus decoran las ramas de los árboles grandes. Colocar las hojas al sol debe ser uno de los temas centrales en la vida de las plantas tropicales, y su ingenio para lograrlo no parece tener limites.

7

Los monos aulladores (*Alouatta palliata*) son los monos más comunes en Barro Colorado, donde habrá unos 1300 individuos. Sus rugidos están entre los sonidos más característicos y memorables de este bosque.

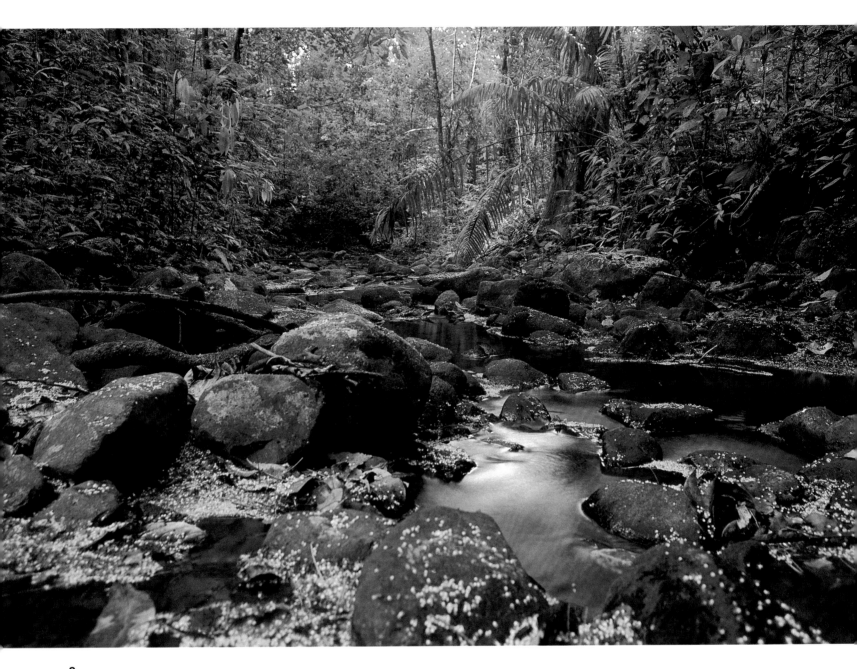

8

Un pequeño riachuelo discurre por la Isla.

Los colores brillantes no abundan en los bosques tropicales. Puede que uno vea un fruto de colores brillantes, de esos que invitan a un animal a comérselo y a dispersar sus semillas. Pero los colores brillantes normalmente son señal de sexo o de peligro. Sexo, como cuando un ave macho de deslumbrantes colores busca pareja (fig. 30) o una encendida llamarada de flores quiere ser polinizada (fig. 3). Peligro, como el que anida en el negro, rojo y amarillo de la temible serpiente de coral o el que se oculta en las hermosas alas de una mariposa de sabor desagradable. En Barro Colorado las hojas de unos cuantos árboles se tornan escarlata antes de caer, pero la gloria del otoño está en Vermont, en Virginia o en los bosques de arce japoneses, no en Panamá.

En la estación correcta, los visitantes podrán ver desde la lancha que los trae a la Isla, árboles y enredaderas en flor, pero en el bosque solo encuentra alfombras de flores (fig. 4) caídas de una copa que la vista no alcanza a descubrir. Habrá, eso sí, ráfagas de color: el destello radiante de un ave (aunque las más llamativas se encuentran en los jardines u orillas del bosque); el aleteo blanco-azulado de una libélula de casi diez centímetros de largo suspendida en medio de un claro, como un faro luminoso que atrae a las hembras y mantiene alejados a los rivales.

El bosque tropical alberga otras escenas y sonidos inesperados. El rugido distante, como de leones africanos, de los monos aulladores (fig. 7), el canto agudo y persistente de las cigarras llamando a una pareja. Los monos se pueden escuchar, pero también se pueden ver, arriba, desplazándose entre el follaje. Uno se puede topar con un insecto magistralmente disfrazado de hoja o de palito. O con un ejército de hormigas legionarios que cruza el sendero ahuyentando a oreos insectos y que irrumpa voraen los nidos de otras hormigas para arrebatarles sus larvas, mientras un grupo de aves sobrevuela la escena capturando a aquellos que en vano intentaron escapar de esa incursión arolladora. No muy lejos, un desfile de hormigas diferente podría estar transportando hojas o flores al vasto nido en el que habitan (fig. 5). La noche vendrá con su propio espectáculo; otros sonidos, otras imágenes, ambos igualmente sorprendentes.

Muchas de estas escenas no tienen paralelo en las zonas templadas. Cada una cuenta una historia sobre los problemas de vivir en un bosque tropical: plantas que luchan por ganar un espacio bajo el sol, flores que atraen polinizadores, animales que buscan comida o que se esfuerzan por no convertirse en comida, a veces en solitario, a veces en grupos cooperativos asombrosamente organizados. Los animales y plantas de Barro Colorado han sido objeto de estudio desde la Primera Guerra Mundial. Gracias a estas investigaciones ahora entendemos cómo el bosque tropical logra mantenerse verde a pesar de la inmensa variedad de "comedores de hojas" que lo habitan (perezosos, puercoespines, iguanas, monos, por no mencionar las incontables legiones de insectos); por qué alberga tal variedad de plantas y animales; y qué clase de comunidad han construido, de manera colectiva, esas plantas y esos animales. Porque en efecto han construido una comunidad, una economía natural. Y como cualquier economía, esta comunidad es un campo de batalla donde hay que competir para sobrevivir y reproducirse, pero es también una red donde se tejen las más intrincadas relaciones de interdependencia. ¿Cuánto se extienden estas relaciones más allá de la Isla? Esto es algo que apenas ahora estamos comenzando a descubrir.

Christian Ziegler pasó 15 meses en el bosque de Barro Colorado capturando algunas de las imágenes —tanto cotidianas como extraordinarias— para la primera edición

de este libro. Diez años más tarde, continúa tomando
fotos del lugar para otros proyectos que se llevan a cabo
en la Isla. El biólogo que les narra echó mano a más de
cuarenta años de experiencia en Barro Colorado y en
otros lugares del trópico, y a más de cuarenta años de
conversaciones con estudiosos de más de un bosque
tropical para tejer, con los mensajes de las fotos, una
historia sobre la vida del bosque. Juntos, Christian y
yo, hemos tratado de mostrar cómo se deben "leer" las
fotografías para entender los problemas básicos que
enfrentan los animales y plantas de Barro Colorado, y
cómo su manera de responder a esos problemas ha dado
forma al balance natural de este lugar.

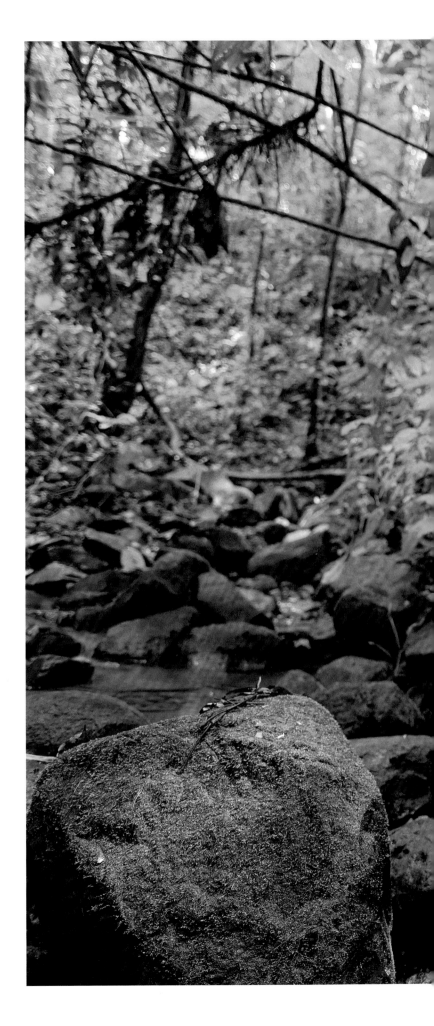

9

Plantas de sombra adornan la orilla de
una pequeña quebrada en el bosque.

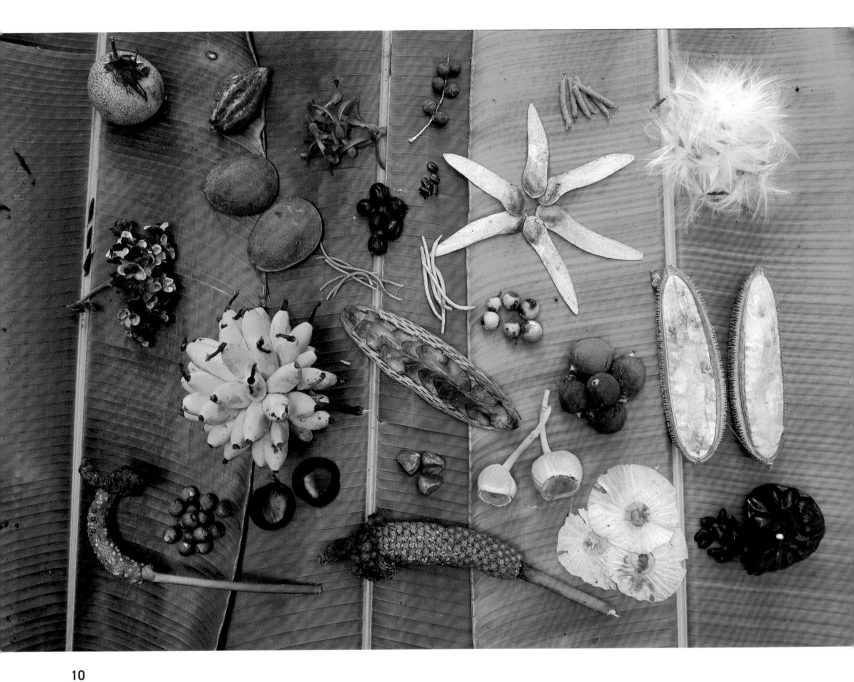

10

Colección de semillas y frutos de casi treinta especies
diferentes recogidos en la Isla a finales de abril, cuando
la estación seca está por terminar.

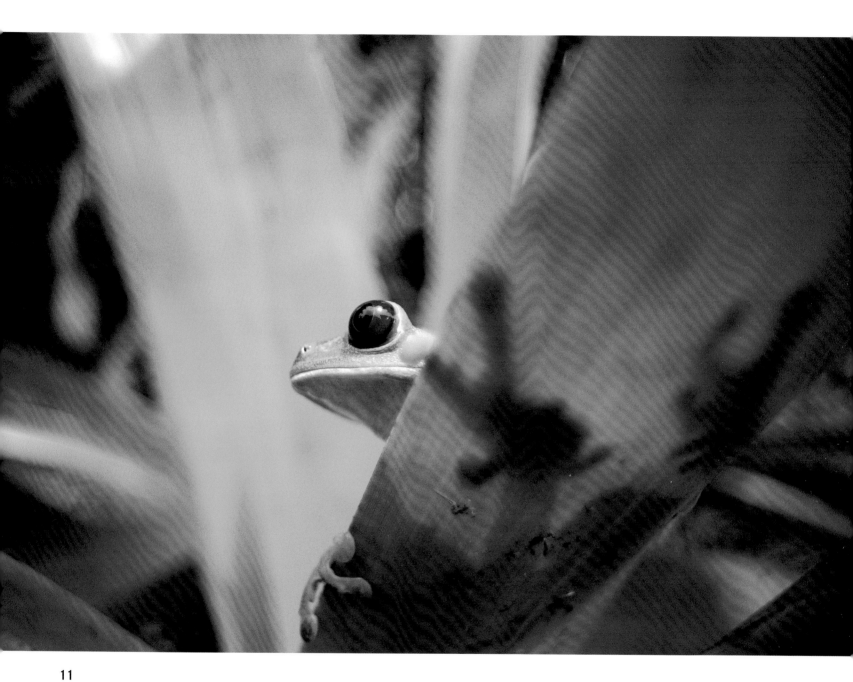

11

Una ranita de ojos rojos (*Agalychnis callidryas*) descansa
sobre las hoja de una bromelia. Este hermoso animalito
se ha convertido en símbolo de la biodiversidad y
en emblema de un hábitat amenazado: los bosques
lluviosos de Centroamérica.

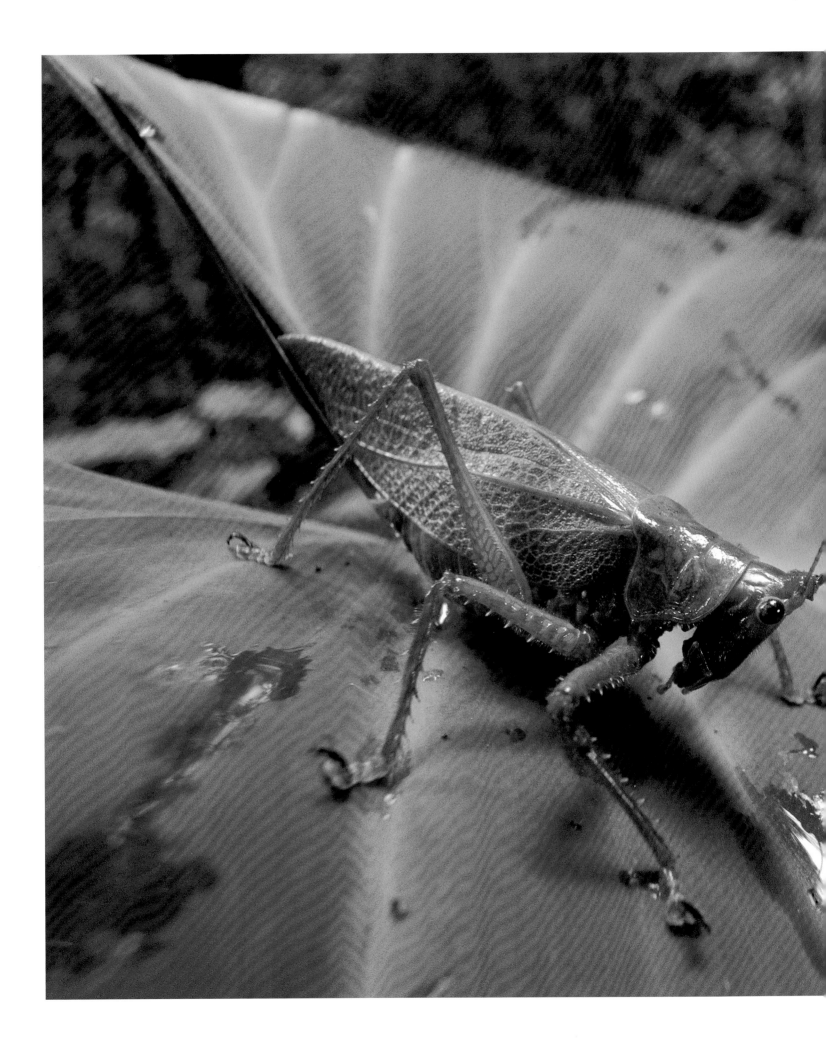

12

Este esperanza (*Copiphora* sp.), traviesamente vestido de naranja, es carnívoro, a diferencia de la mayoría de sus parientes. Pertenece a una de las decenas de miles de especies de insectos que encuentran su hogar en Barro Colorado.

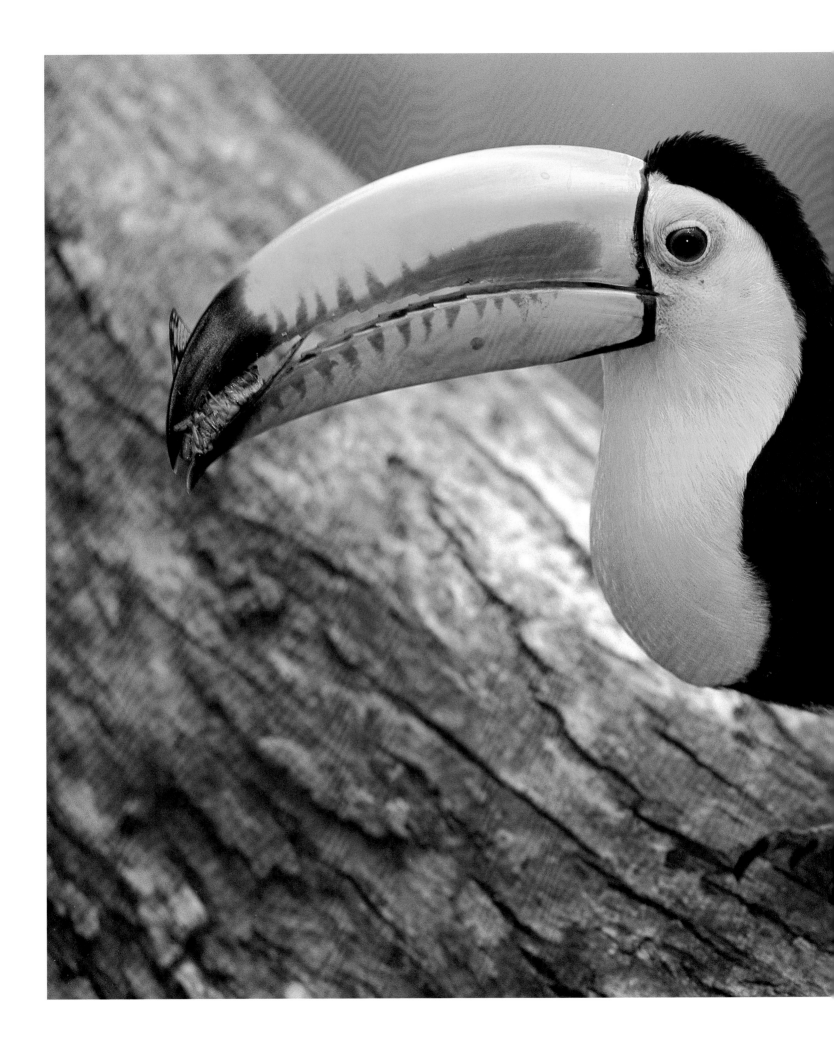

13

Los tucanes de pico irisado, *Ramphastos sulfuratus* suelen reunirse en árboles cargados de frutos. Son importantes diseminadores de semillas, tanto que algunas especies de árboles, como el ucuuba, parecen depender enteramente de ellos. También cumplen otra función relevante: aunque su dieta está compuesta básicamente de frutas, alimentan a los pichones con insectos, con lo cual ayudan a regular el herbivorismo en el bosque. Este adulto regresa al nido cargando una cigarra en el pico.

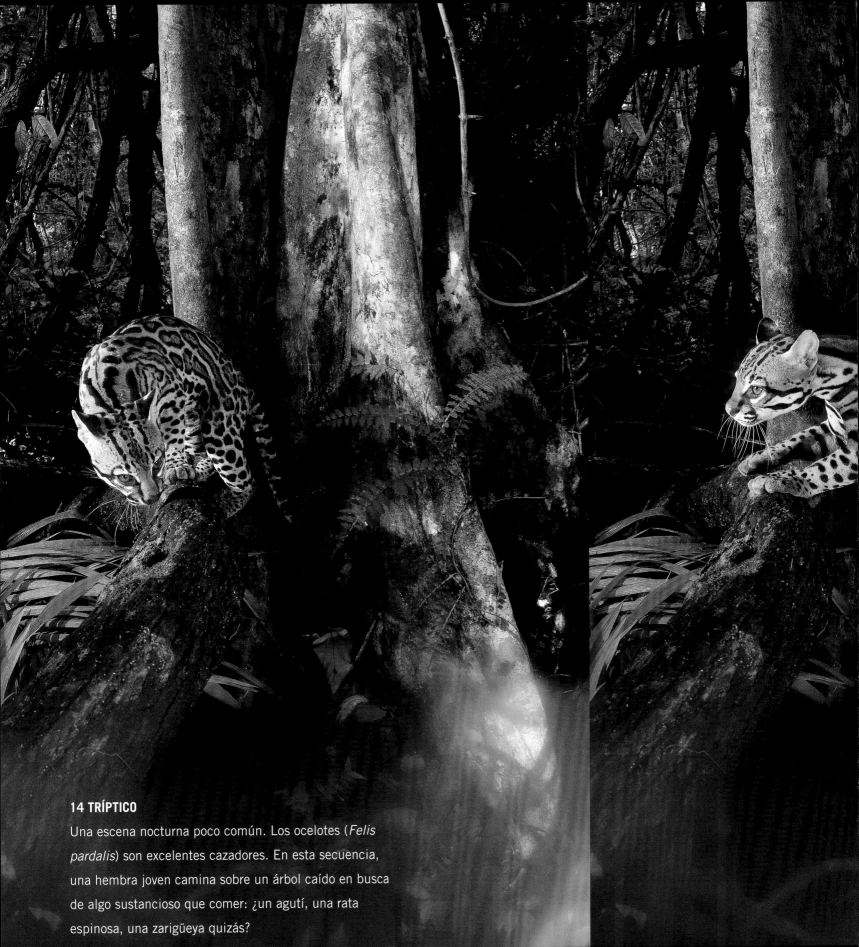

14 TRÍPTICO

Una escena nocturna poco común. Los ocelotes (*Felis pardalis*) son excelentes cazadores. En esta secuencia, una hembra joven camina sobre un árbol caído en busca de algo sustancioso que comer: ¿un agutí, una rata espinosa, una zarigüeya quizás?

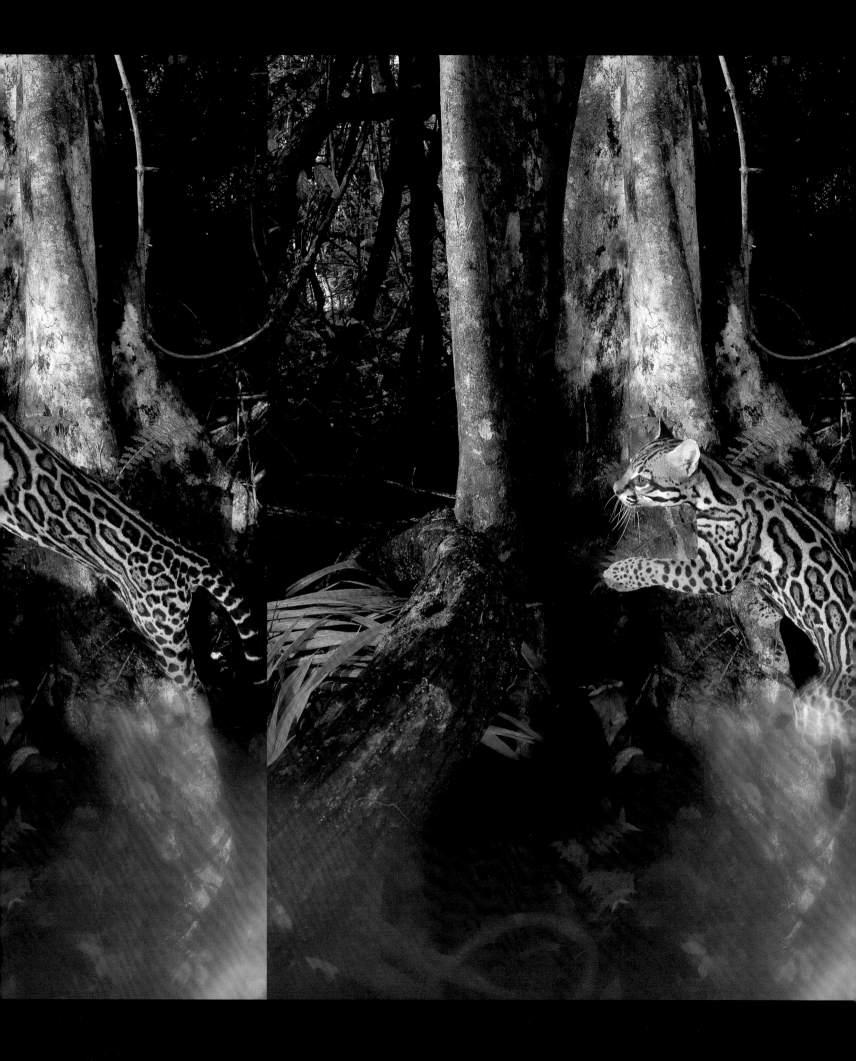

15

Los hongos juegan un papel clave al descomponer madera y hojas muertas. Desde la perspectiva de una hormiga, estos *Xeromphalina* sp. deben parecer unas enormes sombrillas de color naranja adornando una calzada.

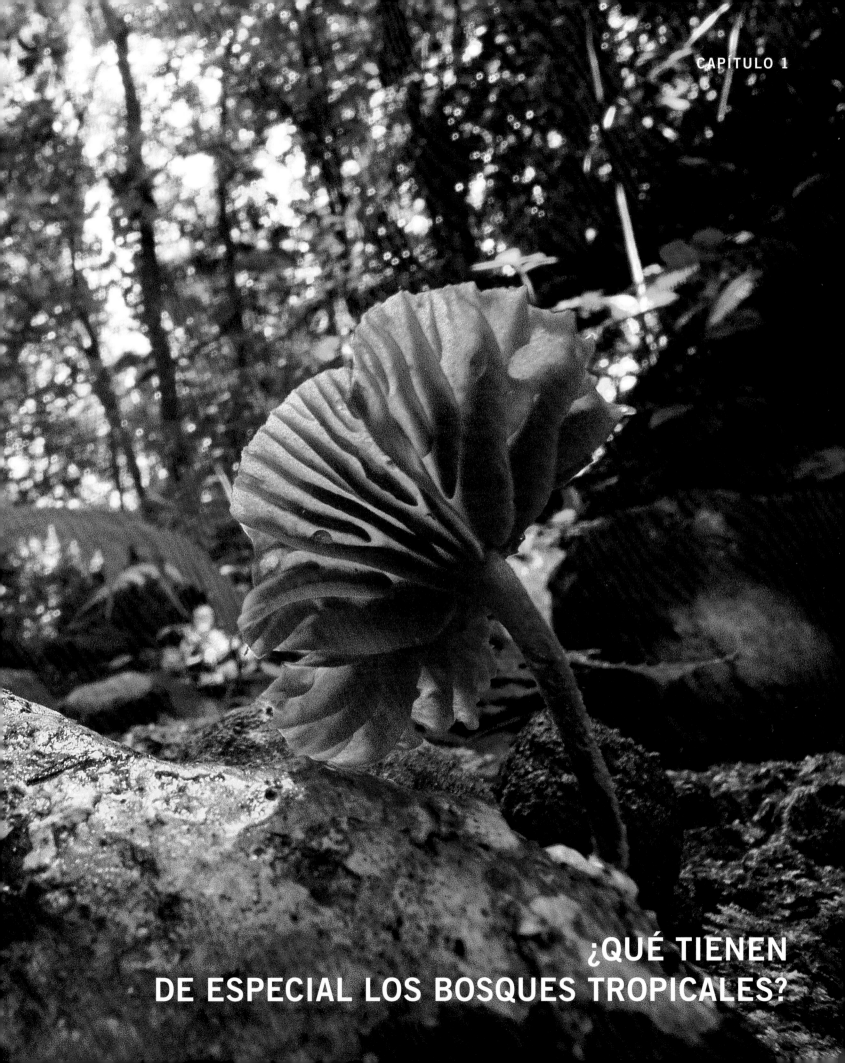

¿QUÉ TIENEN DE ESPECIAL LOS BOSQUES TROPICALES?

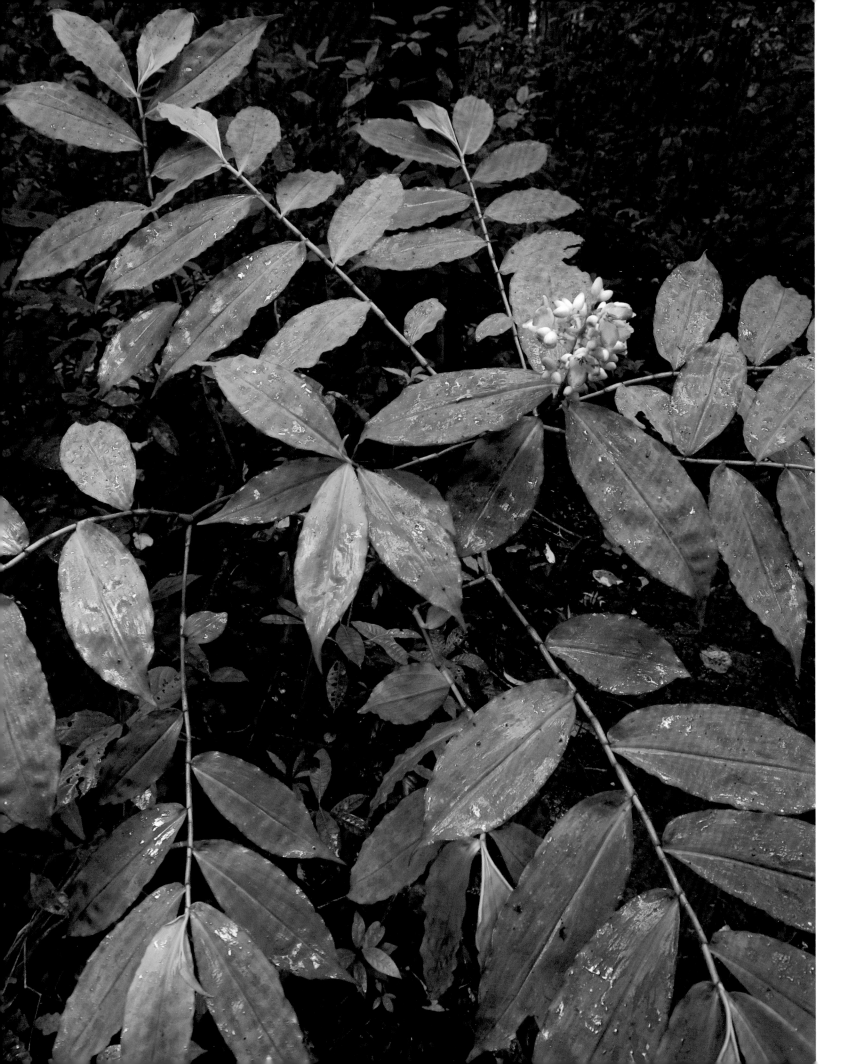

¿QUÉ TIENEN DE ESPECIAL LOS BOSQUES TROPICALES?

Los bosques tropicales ejercen una atracción poderosa. Han cautivado a artistas tan diferentes como Frederick Church y Henri Rousseau, y reclamado la atención de biólogos de la estatura de Charles Darwin y Alfred Russel Wallace. Hoy, infinidad de estudiantes, siguiendo las huellas de sus predecesores, sacrifican ingresos y comodidades con tal de trabajar en estos hermosos parajes. A la vez, el insaciable y devastador comercio de especies en peligro de extinción, sea en el Nuevo Mundo o en Madagascar, es atizado por maravillas que solo se encuentran en los trópicos: lapas, felinos, orquídeas, camaleones, peces, lémures, monos, todos igualmente fascinantes, todos igualmente susceptibles de perderse para siempre.

16

Las hojas de *Dichorisandra sp*, una planta de sotobosque común en Barro Colorado, muestran la disposición típica de las plantas que reciben poca luz: al alinear todas las hojas en un solo plano, la planta evita que se hagan sombra unas a otras.

LA INMENSA VARIEDAD DE ORGANISMOS TROPICALES

La característica del bosque tropical que más sorprende a los biólogos es la variedad de animales y plantas, muy superior a la de los bosques templados. En una hectárea de bosque maduro de árboles caducifolios de 120 años de edad cerca de Anápolis (Maryland) se contabilizaron 16 especies entre 351 árboles de más 10 centímetros de diámetro; en una hectárea de bosque maduro en Barro Colorado, 91 especies entre 425 árboles de ese diámetro. No obstante, para los estándares tropicales la diversidad de Barro Colorado es mediocre. En Borneo, un área de 120m x 80m de bosque lluvioso se contabilizaron 256 especies entre 596 árboles de más de 10 centímetros de diámetro, más del doble que en la mitad norte de Europa. En el oriente de Ecuador, una hectárea de bosque presentó 307 especies entre 693 árboles de más 10 centímetros de diámetro. Esta diferencia en cuanto al número de especies de árboles entre las zonas tropicales y las zonas templadas se mantiene cuando se comparan parcelas más grandes o regiones geográficas (tabla 1.1).

Con todo, quienes visitan un bosque tropical por primera vez suelen sentirse demasiado abrumados por la omnipresencia del verde como para percatarse de la diversidad de plantas que los rodea. Más fácil es notar la diversidad de animales. En las 50000 hectáreas que conforman el Bosque Experimental H. J. Andrews, al

oeste de Oregón, se han identificado unas 60 especies de mariposas (excluyendo los hespéridos o "saltarines"); en las 1500 hectáreas de Barro Colorado, 270. De nuevo, una diversidad mediocre para los estándares tropicales: las 4000 hectáreas de bosque tropical que conforman la Reserva Biológica de Pakitza, cerca de la desembocadura del Río Manú, al sureste de Perú, cobijan 850 especies de mariposas. La diversidad de aves también es mayor en el trópico que más al norte (o más al sur). Mientras el Parque Nacional Congaree, en Carolina del Sur, una de las muestras más impresionantes de bosque primario templado, es hogar permanente de 40 especies de aves terrestres, Barro Colorado resguarda 135, y los bosques que rodean la Estación Biológica de Cocha Cashu, en

el Valle del Manú, en Perú, más de 200. La diversidad de organismos tropicales no se limita a los habitantes del bosque. De hecho, el incremento en diversidad que se observa conforme nos acercamos al trópico se documentó por primera vez para las conchas y los caracoles de la costa pacífica de Norteamérica y Centroamérica.

¿POR QUÉ EN EL MUNDO HAY TANTAS CLASES DE ANIMALES Y PLANTAS?

¿Por qué en los bosques tropicales hay tantas clases de animales y plantas? Para responder a esta pregunta tenemos que conocer primero cuáles son los factores

TABLA 1.1

DIVERSIDAD DE ÁRBOLES EN EL TRÓPICO Y EN LAS ZONAS TEMPLADAS

Diversidad de árboles en parcelas seleccionadas

Localidad	Cantidad de árboles*	Cantidad de especies
Indiana, EE. UU.	2722	32
Barro Colorado, Panamá	2682	161
Yasuni, Ecuador	2839	490
Lambir Hills, Malasia	2482	497

Cantidad de especies de árboles en diferentes regiones

Región	Área (km²)	Cantidad de especies de árboles
Norte, Centro y Este de Europa	6 000 000	124
Este de EE. UU.	2 324 000	253
Panamá	78 500	2870
Península de Malasia	131 600	3197

*Árboles con un mínimo de 10 cm de diámetro. Las parcelas se seleccionaron para que tuvieran cantidades similares de árboles (entre 4 y 8 ha).

17

Los frutos presentan infinidad de formas, colores y
tamaños; todo depende de la estrategia de dispersión.
Puede que inusual combinación de verde y púrpura resulte
atractiva para los aves.

que permiten que varias especies vivan juntas en una comunidad ecológica determinada.

Las comunidades ecológicas son mundos competitivos. Para apreciar hasta qué punto la competencia moldea una comunidad, imaginemos que varias especies viven en el mismo lugar y que sus poblaciones se encuentran limitadas por la disponibilidad del mismo tipo de alimento. Mientras haya reservas suficientes, las especies van a continuar multiplicándose, pero la comida se va a ir agotando y llegará el momento en que la única especie que sobreviva es la que necesite la menor abundancia de ese alimento para seguir manteniendo a su población. Al llevar las existencias al punto en que solo ella puede sobrevivir, esta especie habrá expulsado de su nicho a los competidores que no lograron hacerlo tan bien. Este ejemplo ilustra el principio de exclusión competitiva: no hay dos especies que puedan ganarse la vida del mismo modo y en el mismo lugar porque la que lo haga mejor reemplazará a la otra. De manera similar, si dos aerolíneas ofrecen las mismas rutas de vuelo y compiten por el mismo mercado, la más eficiente se va a expandir hasta sacar a la otra del mercado. En resumen, la competencia reduce la diversidad, salvo que las especies en conflicto encuentren formas distintas de sobrevivir.

Los organismos, sin embargo, tienen a su disposición muchas formas de "ganarse la vida". Eso sí, ninguna especie puede ser la mejor en todo: como dice el refrán, "el que mucho abarca poco aprieta". Volviendo al mundo de los negocios y al ejemplo de las aerolíneas, la incompatibilidad, el *trade-off*, que surge cuando se pretende mantener las tarifas bajas y ofrecer un servicio de lujo significa que dos compañías que vuelan las mismas rutas podrán coexistir siempre y cuando una atraiga pasajeros que quieran "volar barato", y la otra, pasajeros que estén dispuestos a pagar por la comodidad y la puntualidad. En el mundo vegetal, la abundante maquinaria fotosintética que necesita una planta para aprovechar al máximo la luz brillante es incompatible con la necesidad de las plantas de sombra de reducir al mínimo los costos de mantenimiento, conservando apenas lo imprescindible de esa maquinaria para usar la poca luz disponible. Por esta razón, siempre que la muerte de los grandes árboles del bosque siga abriendo claros amplios y soleados, las especies de sol y las especies de sombra podrán coexistir en la misma comunidad. El compromiso que enfrentan las plantas entre crecer apresuradamente a plena luz o asegurarse una mayor sobrevivencia a la sombra es lo que evita que las especies que crecen pronto a pleno sol desplacen a las que se han adaptado a vivir en el sotobosque, y viceversa. De igual forma, algunos insectos, como los escarabajos y las orugas, tienen la boca diseñada para masticar hojas, mientras que otros, como los áfidos, las cigarras y los grillos, la tienen en forma de estilete, para perforar hojas y tallos y chupar. Ninguna de las dos bocas puede hacer bien los dos trabajos.

Es más, así como un negocio le brinda a otro la oportunidad de fabricarle una herramienta o prestarle algún servicio y, aunque no lo quiera, hasta de ser objeto de robo, los organismos también les proporcionan a otros organismos una forma de ganarse la vida. Los árboles del dosel conforman el hábitat donde prosperan los arbustos y las hierbas del sotobosque. También proporcionan las estructuras en que se apoyan las lianas (trepadoras leñosas) para escalar y las epífitas (plantas que crecen sobre otras plantas) para acercar sus hojas al sol. Cuando un árbol muere, su madera y sus hojas alimentan a una inmensa cantidad de hongos (fig. 15), bacterias y hasta animales: los descomponedores, que viven de la materia muerta y liberan los nutrientes que esta contiene para que otras plantas los puedan utilizar. La materia muerta generalmente se encuentra en la sombra profunda o en el suelo mismo, donde el aire escasea y reina la oscuridad.

De este modo, los organismos que descomponen materia muerta rara vez obtienen suficiente luz como para sintetizar azúcar a partir de agua y dióxido de carbono. Pero incluso si lo hacen, pocas veces les resulta económico equiparse además para la fotosíntesis.

Las plantas también sirven de alimento a los hongos patógenos y a los animales herbívoros, que se comen los tejidos fabricados por las plantas en vez de fabricarlos ellos mismos con la luz del sol. Son, también, el medio de vida de otro tipo de hongos, las micorrizas, que forman una relación mutualista con las raíces y ayudan a captar minerales del suelo a cambio de que la planta hospedera les entregue algunos azúcares.

La movilidad que permite a algunos animales ir tras la parte de la planta que más les apetece resulta beneficiosa para las plantas; razón por la cual los atraen: para que polinicen sus flores (fig.18) y dispersen sus semillas (fig. 10). De esta forma, se crea un mundo donde, en palabras de E. J. H. Corner, los animales se sirven de las plantas pero también son sus servidores. Los polinizadores, sin embargo, abren una nueva vía para la transmisión de enfermedades entre plantas. Finalmente, los animales herbívoros sirven de sustento a los carnívoros, que se han adaptado a perseguir, sorprender y dominar una presa en movimiento. Para resumir, todo organismo normalmente representa una oportunidad para otro organismo: la diversidad biótica posibilita más diversidad biótica.

¿POR QUÉ LOS BOSQUES TROPICALES TIENEN MÁS ABUNDANCIA DE ESPECIES QUE LOS BOSQUES TEMPLADOS?

En los bosques tropicales hay más tipos de plantas y animales que en los bosques templados porque el clima, cálido y húmedo, y la falta de invierno, posibilitan una producción voluminosa y continua de materia vegetal.

El Bosque de Harvard, en Massachussets, es productivo menos de la mitad del año. Mientras dura el invierno no se encuentra ni néctar, ni fruta fresca, ni tampoco hojas tiernas y, aunque hubiera comida, hace demasiado frío como para que los murciélagos o los colibríes puedan volar. Por causa del invierno, las hojas del Bosque de Harvard solo producen el equivalente a 28 toneladas de azúcar por hectárea por año, mientras que las hojas de los bosques de la Amazonía, que funcionan todo el año, producen 75 toneladas. Es probable que el bosque de Barro Colorado sea tan productivo como la Amazonia. Aunque la estación seca se establece cuatro o cinco meses al año en Barro Colorado, y el bosque recibe apenas una cuarta parte de la lluvia que necesita y el suelo se seca y se resquebraja, la mayor parte de los árboles grandes tiene acceso a aguas subterráneas todo el año. En los bosques tropicales húmedos y muy húmedos los animales pueden estar afuera siempre, porque la temperatura así lo permite. Además, prácticamente todos los árboles tienen hojas todo el año, algunos tienen frutos y otros más, hojas nuevas, tiernas y nutritivas. De esa forma, los bosques tropicales les proporcionan un medio de subsistencia más que suficiente, y a tiempo completo, a muchos animales que solo podrían funcionar como trabajadores migrantes en el Bosque de Harvard, si pudieran darse el lujo de emigrar a esas tierras.

El clima y la oferta de alimento, considerablemente más estables en los hábitat tropicales, son los factores que más contribuyen a enriquecer la diversidad de estos bosques. La disponibilidad permanente de al menos algo de frutas y flores garantiza el sustento de animales que jamás se verían en el Bosque de Harvard, como los monos y los kinkajús, que se comen la fruta en los árboles, o los coatíes, los agutíes, las pacas y las ratas espinosas que la buscan en el suelo; o de una inmensa variedad de murciélagos (tabla 1.2) y aves que comen fruta, y de colibríes (fig. 22)

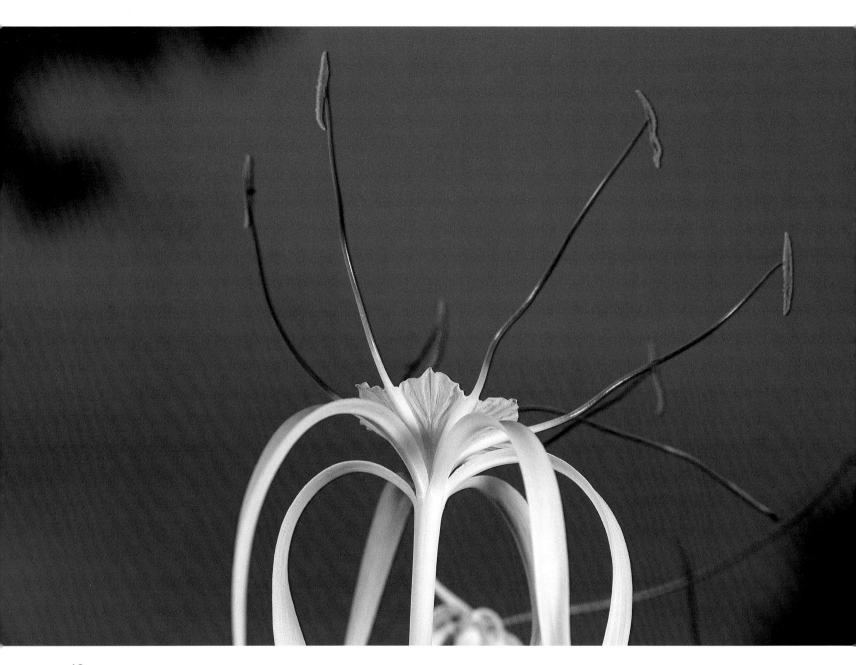

18

Las plantas exhiben flores que han sido diseñadas para atraer a un polinizador específico. Este lirio del bosque, *Hymenocallis pedalis*, es polinizado por una mariposa nocturna, la polilla halcón. Sus flores se abren al atardecer y, una vez que el sol se ha puesto, desprenden un aroma dulzón que no tarda en atraer a las sus polinizadoras.

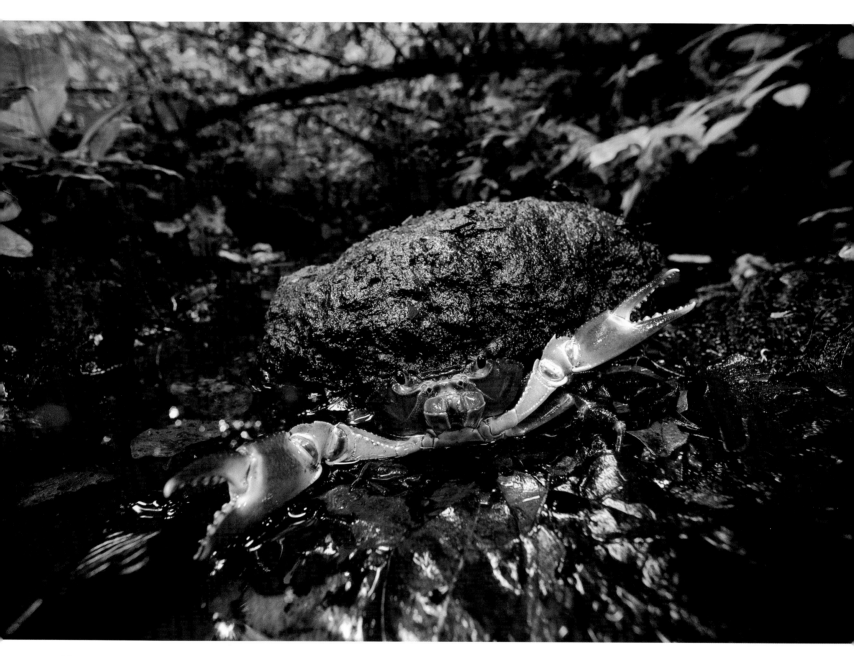

19

Además de insectos, Barro Colorado alberga otros grupos de artrópodos, entre ellos, algunos crustáceos, como este cangrejo de agua dulce, *Potamocarcinus richmondi*. Sus tenazas le permiten abrir las vainas más duras y causar dolorosas mordeduras a todo el que se atreva a molestarlo.

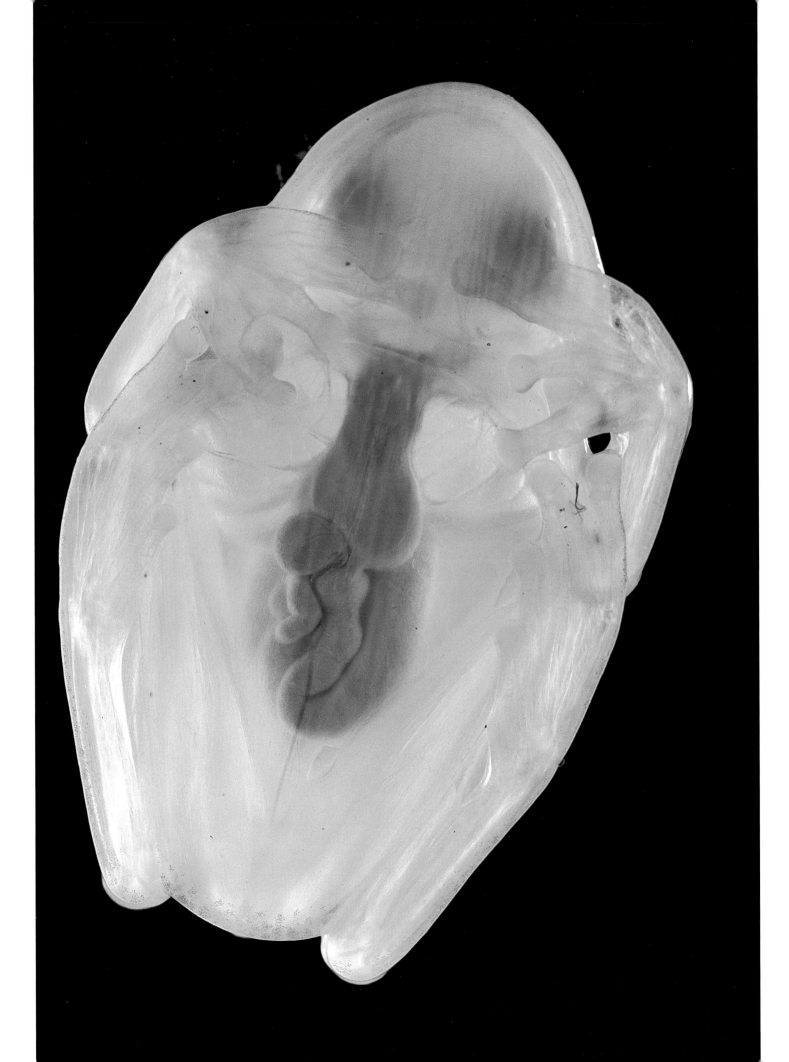

y murciélagos que se alimentan de néctar. Además, la disponibilidad permanente de hojas garantiza el sustento de los perezosos en los árboles (fig. 23) y de los tapires en el suelo, de legiones de insectos herbívoros —larvas y adultos de escarabajos [fig. 25], orugas de mariposas y polillas (que en su mayoría se alimentan del néctar de las flores al alcanzar la fase adulta), de áfidos, chicharras, cigarras y otros "chupadores de savia" [fig. 24]—, así como de una infinidad de murciélagos, aves, arañas, avispas, moscas depredadoras, chinches asesinos, y otros, que se alimentan de los insectos que se alimentan de las hojas. Pocos podrían sobrevivir un invierno en Massachussetts, y pocos, también, podrían reinventarse para conseguirlo sin tener que cambiar radicalmente su modo de vida.

Puesto que "el que mucho abarca, poco aprieta", la especialización permite a los miembros de una especie explotar o defender más efectivamente su alimento o su hábitat predilectos y reducir las probabilidades de ser desplazados por un competidor superior. La especialización es ventajosa si la especie enfrenta una competencia dura y si puede confiar en la disponibilidad del alimento y del hábitat en los que se ha especializado. La especialización es el motor que impulsa la diversidad en los trópicos. Donde la cantidad y la composición de la oferta alimentaria son más estables, una especie puede especializarse aún más, sin correr el riesgo de extinguirse por la desaparición del alimento del que depende. Así, un grupo dado de alimentos puede servir de sustento a una mayor cantidad de especies.

LA PRESIÓN DE LAS PLAGAS Y LA DIVERSIDAD DE ÁRBOLES

¿Por qué en el trópico hay tantas clases de árboles diferentes? Todas las plantas verdes usan la luz para

20

De las 57 especies de anfibios que habitan en la Isla, la ranita de cristal, *Centrolenella colymbiphyllum* es una de las más asombrosas. Estas ranitas pasan el día en el envés de las hojas. El animal completo, incluidos los huesos, es prácticamente transparente, lo que le permite camuflarse a la perfección.

TABLA 1.2
Especies de murciélagos de diferentes gremios alimentarios en diferentes localidades

Gremio alimentario	Barro Colorado	Indiana	Alemania del Este
Murciélagos que capturan presas en el aire	32	10	11
Murciélagos que capturan presas en el suelo, en su mayoría insectos	11	2	6
Carnívoros	2	0	0
Vampiros	2	0	0
Nectarívoros y frugívoros	25	0	0
TOTAL (TODAS LAS ESPECIES COMBINADAS)	**72**	**12**	**17**

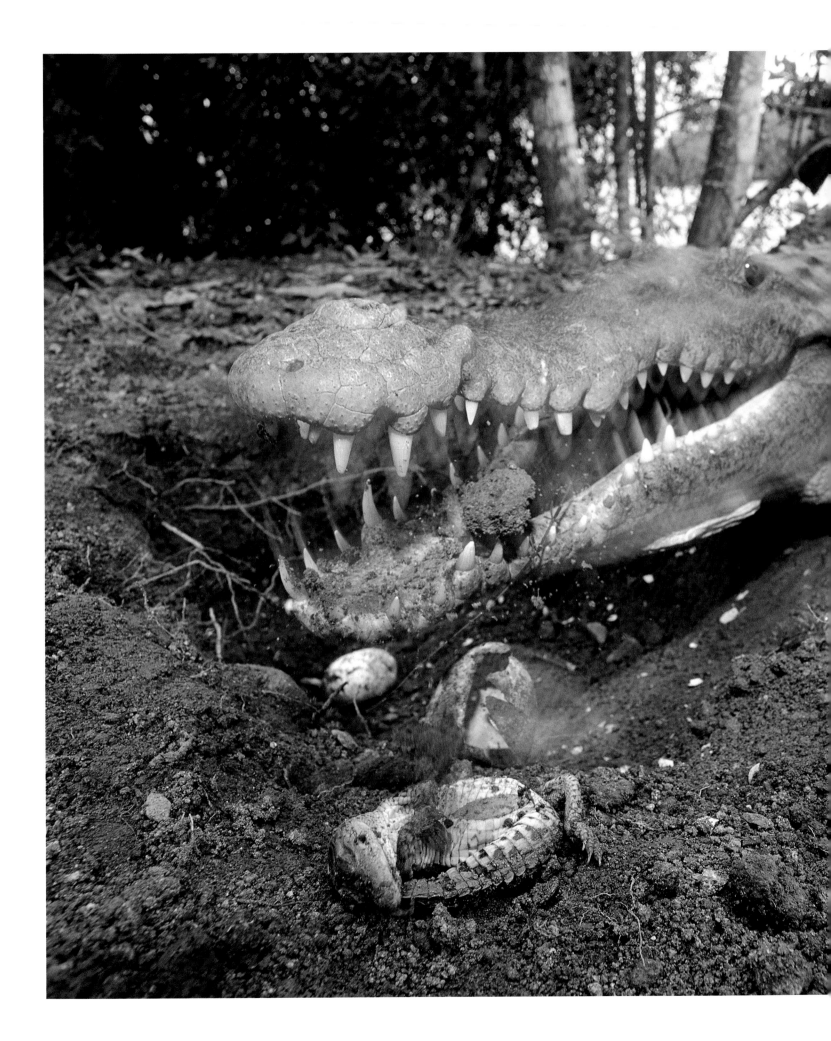

21

Las mamás cocodrilo (*Crocodilus acutus*) cuidan a sus crías.
Las hembras entierran los huevos y los vigilan durante casi
dos meses hasta que los pequeños rompen la cáscara y las
llaman para que vengan a desenterrarlos y los lleven al agua.

transformar dióxido de carbono y agua en azúcar y oxígeno, y los árboles no son la excepción. Los árboles pueden especializarse —y de hecho lo hacen— en diferentes niveles del bosque. Ahora bien, en una hectárea de bosque, todos los árboles del dosel tienen prácticamente el mismo acceso a la luz y al suelo, con su reserva de nutrientes y agua. ¿Cómo es posible que en esa hectárea haya más de una manera de ser el mejor árbol del dosel?

¿Puede ser que el distinto grado de vulnerabilidad a las plagas y enfermedades favorezca la coexistencia de diferentes especies de árboles? En la zona templada, los árboles son presa fácil de hongos como el de la "pudrición de la raíz" y de plagas como el "gusano del abeto" y la "polilla gitana". Pero, aunque la "polilla gitana" tiene un gusto universal, las plagas más virulentas, como el "chancro del castaño", que acabó con el castaño americano, o el "pulgón lanígero", que está acabando con el abeto oriental, son plagas especializadas. Las plagas especializadas son menos dañinas cuando los árboles a los que asocian se encuentran distanciados, de modo que una especie de árbol sufre menos cuando crece en un bosque mixto que cuando crece rodeado únicamente de los de su clase.

¿Es posible que la presión que ejercen las plagas y enfermedades en los bosques tropicales sea tan intensa que las plagas especializadas mantienen cada especie de árbol lo suficientemente escasa como para dar cabida a una mayor cantidad de especies? En Barro Colorado se capturan insectos fitófagos en trampas de luz ultravioleta todo el año (fig. 26); en Maryland están ausentes durante el invierno. Debido a la presencia continua de plagas, las hojas tropicales tienen tal variedad de venenos que los insectos no especializados (los que comen todo tipo de hojas) no pueden arrasar con el bosque. De hecho, las hojas tropicales sufren los peores daños cuando son atacadas por insectos que se han especializado en comer hojas de una especie o tal vez de unas pocas especies estrechamente emparentadas.

¿Cómo se comporta la presión de las plagas en los inviernos cálidos? Hace 56 millones de años, en el sureste de Wyoming la temperatura se elevó unos cinco grados Celsius por encima del promedio anual durante un período de cien mil años. El resultado: inviernos sin heladas. Al comparar las hojas fósiles de ese periodo con los periodos inmediatamente anterior y posterior, Peter Wilf, Ellen Currano y Conrad Labandeira, de la Universidad Estatal de Pensilvania y del Instituto Smithsonian de Investigaciones Tropical, encontraron que, durante el periodo de calentamiento, un mayor número de hojas presentaba daños por insectos, había más tipos de daño por hoja y los daños eran ocasionados, en su mayoría, por especialistas. En este caso, el calentamiento incrementó la presión de las plagas y favoreció a los especialistas.

En Barro Colorado, donde los árboles de distintas especies se hallan entremezclados, las hojas maduras no son atacadas porque son demasiado duras como para que se las coman, pero las hojas jóvenes, son consumidas más vorazmente, a pesar de que contienen más venenos, que las hojas jóvenes de los árboles caducifolios de las zonas templadas. En plantaciones tropicales de árboles de una sola especie, las plagas con frecuencia se propagan velozmente de un árbol a otro, defoliándolos o comiéndose las semillas y los retoños, al igual que una enfermedad se propaga en un campamento de refugiados hacinado. En Barro Colorado, un retoño sobrevive mejor cuando en las cercanías hay menos retoños y menos adultos de la misma especie. Es más, la mortalidad de plántulas mediada por la vecindad influye en la densidad de individuos adultos: los retoños de las especies más escasas sufren más por cada vecino adicional de su

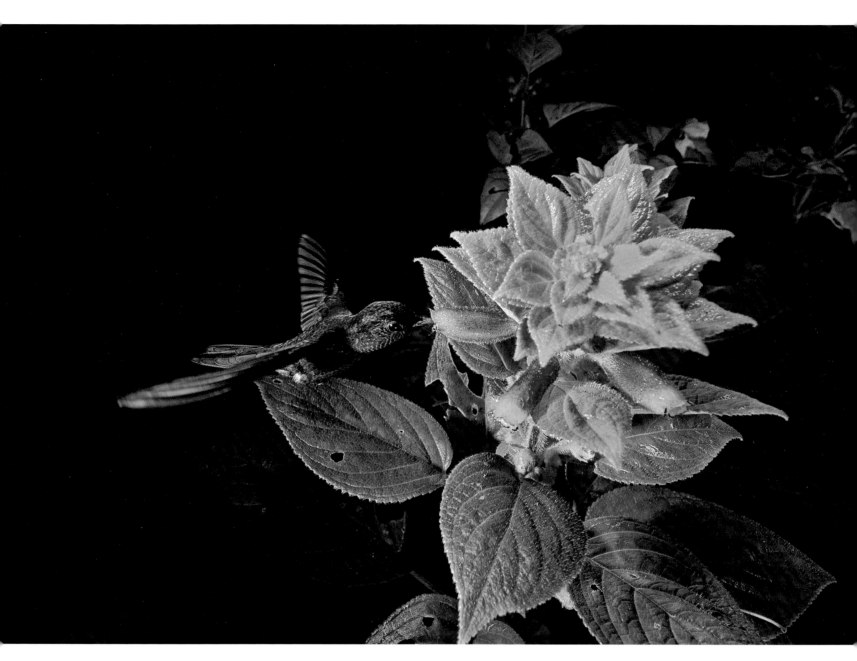

22

Un colibrí ventrivioleta, *Damophila julie panamensis*, bebe el néctar de una *Kohleria tubiflora*, de la familia Gesneriácea. Las aves nectarívoras viven principalmente en las regiones tropicales y subtropicales donde hay flores todo el año. Este es uno de varios gremios —grupos de animales que tienen un modo de vida similar— que contribuyen a que la diversidad en los trópicos sea más alta que en las zonas templadas. Los bosques tropicales tienen muchos tipos de aves nectarívoras, cuya presencia resulta esencial para la polinización de numerosas especies de plantas.

23

Un consumidor totalmente especializado solo puede
vivir en un hábitat de probada estabilidad. Este perezoso
de tres dedos, *Bradypus infuscatus*, se alimenta
exclusivamente de hojas. Las hojas son difíciles de
digerir; de ahí el metabolismo reptil de los perezosos y
su bajo nivel de actividad.

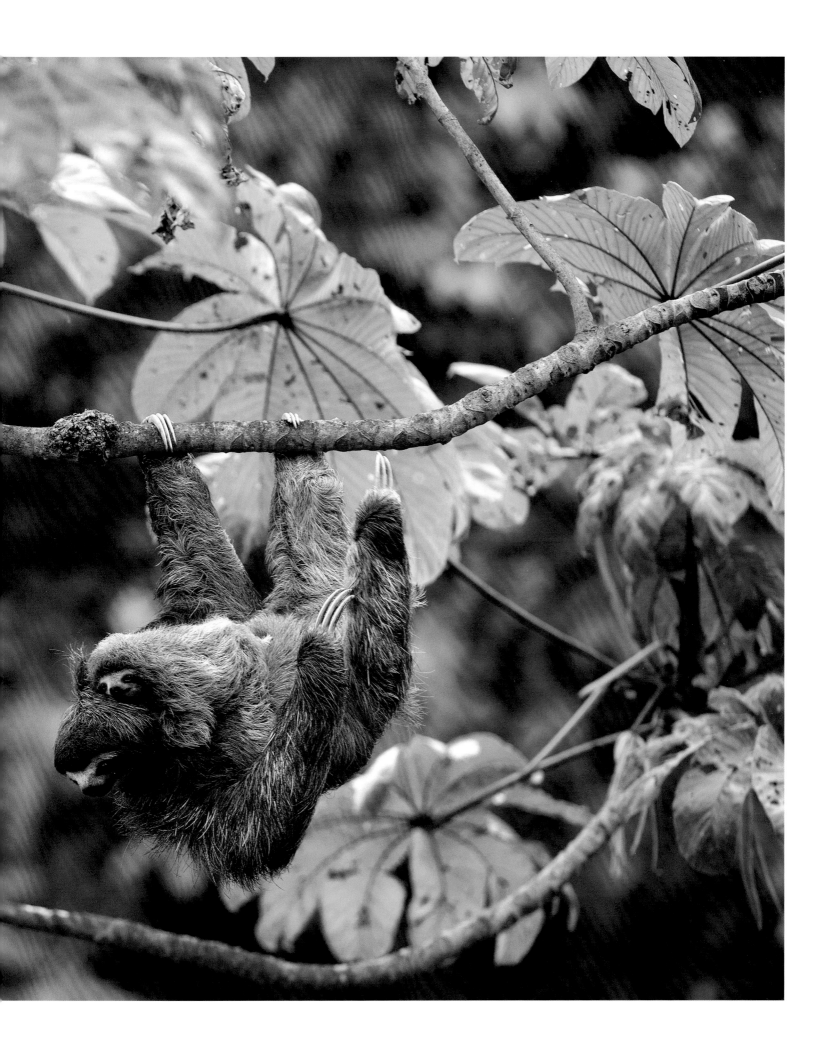

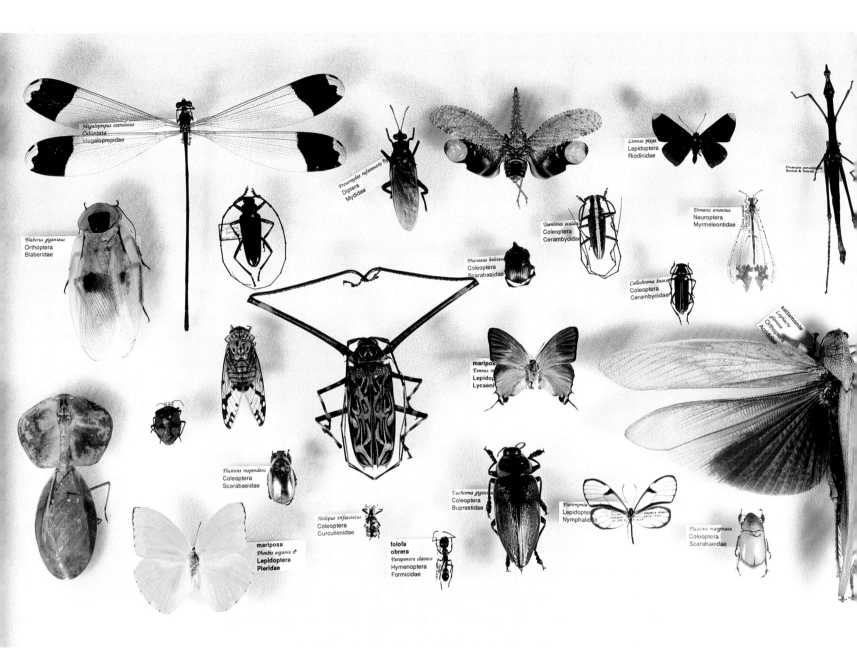

24

Los insectos superan en diversidad al resto de los animales. En Barro Colorado se cuentan por decenas de miles. Es más, tras ochenta años de investigación en la Isla, aún no se puede dar un número más preciso. Esta fotografía, de la colección científica del Instituto Smithsonian de Investigaciones Tropicales, muestra algunas especies representativas de los grupos de insectos más importantes de la Isla. Arriba a la izquierda, libélula, *Megaloprepus coerulatus*; más abajo y un poco a la derecha, el escarabajo grande con los antebrazos largos y colocados en forma de rombo es un *Acrocinus longimanus*, mejor conocido como escarabajo arlequín.

misma especie. Esta mortalidad parece reflejar, al menos en parte, el impacto de las enfermedades causadas por hongos. En efecto, parece que la diversidad de árboles en los bosques tropicales es tan alta porque cada especie se mantiene escasa debido a su plagas (fig. 25) y enfermedades.

La estación seca también reduce las poblaciones de plagas, aunque no tan marcadamente como el invierno. En los lugares donde la estación seca se siente con particular dureza, como en los bosques caducifolios del sur de la India, los árboles del dosel amortiguan el daño de los insectos brotando hojas nuevas justo antes de las lluvias. Unos cuantos árboles hacen lo mismo en Barro Colorado. En un bosque montano en Panamá, donde no se presenta una estación seca, las capturas de insectos herbívoros en trampas de luz varían menos a lo largo del año que lo que varían en Barro Colorado. Supuestamente por estar sometida una presión de plagas más intensa y sostenida, una hectárea del bosque siempre húmedo de la Reserva Natural de Nusagandi (100 km al este de Barro Colorado), comprende mucho más especies de árboles que una hectárea de bosque en la misma Barro Colorado. De igual modo, la diversidad de árboles es más baja donde la estación seca es más rigurosa (cuadro 1.3).

A diferencia de los desiertos, donde las plantas se defienden cubriéndose de espinas y donde los aromas de sus defensas impregnan el aire vespertino, las defensas de la mayoría de las hojas tropicales ni son visibles ni se pueden oler fácilmente. Después de todo, las hojas conspicuas son un blanco fácil para las plagas especializadas. Los signos más claros de la presión de las plagas son las adaptaciones por medio de las cuales las plantas atraen polen de plantas de su misma especie de lugares distantes, y se las ingenian para dispersar las semillas. Las flores recuerdan la importancia de atraer exactamente a los animales que tienen más

25

Las plagas especializadas parecen jugar un papel importante en el mantenimiento de la diversidad de las plantas, pues impiden que ninguna especie se vuelva tan común que desplace a las otras. Los escarabajos de la familia Bruchidae son depredadores de semillas especializados y destruyen casi todas las semillas de sus especies favoritas, a no ser que los agutíes las hayan enterrado. Aquí, un *Speciomerus giganteus* emerge de la semilla de una *Attalea buyracea*, un tipo de palmera.

probabilidades de transportar el polen entre plantas de una misma especie. Los frutos diseñados para viajar con el viento o para seducir a un animal a que se los coma y disperse sus semillas son prueba irrefutable de lo urgente que resulta alejar esas semillas de la planta madre y sus plagas. Cuanto más lluvioso sea un bosque tropical, y cuanto más constante sea la presión de las plagas a lo largo del año, mayor será la proporción de especies de árboles que emplearán animales para dispersar sus semillas (tabla 1.4, figs. 28, 29). Tal vez los animales dejan más fruta sin comer debajo del árbol, pero se llevan más semillas, y más lejos, que el viento.

Quizá las enfermedades contribuyan más que los insectos a aumentar la diversidad de los árboles tropicales, pero sabemos más sobre los insectos del bosque. Los insectos son el medio de subsistencia de una gran cantidad de animales insectívoros: aves, murciélagos, monos capuchinos, monos tití, lagartijas, arañas, hormigas y avispas depredadoras, insectos parasitoides

(insectos que ponen sus huevos encima de otro insecto y cuyas larvas se desarrollan dentro de ese insecto) y muchos otros más. Cuanto más diversas las plagas, más diversos sus depredadores. Pero así como las plagas aumentan la diversidad de las plantas, los depredadores de las plagas aumentan la diversidad de las plagas. Una plaga puede especializarse en las hojas de un tipo de árbol por muchas razones. En ausencia de depredadores una plaga puede elegir un árbol ya sea porque solo puede comer las hojas de ese árbol o porque ese es el único tipo de hojas que la "mamá plaga" reconoce como comestible entre todas las hojas del bosque. En presencia de depredadores, las plagas pueden optar por atacar hojas que contienen venenos que pueden incorporar a su cuerpo para adquirir un sabor desagradable o volverse tóxicas, con lo cual evitarían ser comidas. También pueden elegir hojas que están muy escondidas, donde un depredador difícilmente las va a encontrar o se las va a poder comer. El impacto de la depredación puede

TABLA 1.3: Diversidad de árboles en parcelas de una hectárea con regímenes de precipitación diferentes

LOCALIDAD	Santa Rosa, Costa Rica	Barro Colorado Panamá	Nusagandi, Panamá
Vegetación	Bosque seco	Bosque húmedo	Bosque lluvioso
Precipitación anual, mm	1614	2600	3324
Precipitación durante los dos meses más secos, mm	0	60	123
Número de árboles ≥ 10 cm DAP*	354	429	559
Número de especies≥ 10 cm DAP*	56	91	191

*Diámetro a la altura del pecho (1,3 metros sobre el suelo)

TABLA 1.4: Porcentaje de especies de árboles grandes cuyas semillas son dispersadas por animales en diferentes tipos de bosque

LOCALIDAD	Tipo de bosque	Porcentaje dispersado por animales
Santa Rosa, Costa Rica	Bosque seco	64%
Barro Colorado, Panamá	Bosque húmedo	78%
Río Palenque, Ecuador	Bosque lluvioso	94%

26

Las "trampas" de luz ultravioleta atraen toda clase de
insectos. La trampa consiste en un haz de luz que se coloca
frente a una manta blanca. Aquí vemos la cantidad de
insectos que se acercó a esta manta.

27

En los tropicos, las hojas jóvenes son devoradas mucho
más aceleradamente que las hojas jóvenes de las zonas
templadas. El herbivorismo ayuda a mantener la diversidad
de las plantas tropicales. El patrón de daño que presenta
esta hoja de *Protium* refleja el trabajo de una especie de
insecto en particular.

calibrarse viendo los esfuerzos que hacen los insectos por disfrazarse, por resultar difíciles de comer, por adquirir un sabor desagradable o por volverse venenosos. También viendo los colores con que los insectos de mal sabor y sus imitadores, perfectamente comestibles, advierten a sus depredadores de su supuesto mal sabor. En conclusión, la diversidad de plantas aumenta la diversidad de plagas; lo cual aumenta la diversidad de animales que se alimentan de plagas; lo cual aumenta aún más la diversidad de plagas; lo cual aumenta aún más la diversidad de plantas: un ejemplo maravilloso de un proceso ecológico causal y circular.

EL ORIGEN DE LAS ESPECIES Y LA SELECCIÓN EN RELACIÓN CON EL SEXO

Entender la diversidad significa entender cómo coexisten las especies y cómo una especie llega a convertirse en dos. Una especie animal se ha convertido en dos cuando se ha dividido en dos poblaciones cuyos miembros ya no se aparean con los miembros de la otra población. De este modo, el origen de las especies animales se encuentra estrechamente ligado a cambios en la forma en que los animales eligen pareja.

¿Cómo hacen los animales para atraer a una pareja y cómo la eligen? Los machos de muchas especies atraen a las hembras emitiendo llamados propios de su especie. El zumbido de las cigarras, el canto de las aves, los llamados nocturnos de ranas, grillos y las esperanzas, todos, tienen como finalidad conservar o atraer a una pareja. Los cantos de las aves también sirven para alejar a los rivales, pero aquí nos interesa el papel del llamado en el ritual de apareamiento. Los llamados no solo sirven para identificar a la especie; también anuncian el atractivo relativo del cantor como reproductor. Una hembra de rana túngara mostrará predilección por un macho que

lance llamados graves y profundos, porque es probable que machos como esos sean más grandes y tengan más posibilidades de fertilizar todos los huevos que ella deposite.

Otros machos atraen a las hembras mediante despliegues visuales. El pavo real exhibe su legendaria cola, el ave del paraíso, sorprendente su plumaje, el pájaro de emparrado, sus impresionantes "nidos de amor", y el quetzal, su larga e inconfundible cola. En Barro Colorado, una caminata matinal en la estación lluviosa puede conducir al visitante a un caballito del diablo, un macho de *Megaloprepus* (fig. 24) suspendido en un claro abierto por la caída de un árbol, fácilmente visible por el revoloteo azul y blanco de sus alas. Estará anunciando que en un tronco cercano hay un agujero lleno de agua, un buen lugar para que las hembras depositen sus huevos, pero, cuidado, también está avisando que si las hembras quieren poner los huevos en "su" agujero tendrán que dejar que sea él el que los fertilice. En la estación seca, el visitante podría escuchar los curiosos chasquidos y zumbidos de una pequeña ave negra coronada de rojo: un saltarín cabecirrojo (fig. 30), de un grupo donde los machos hacen despliegues conjuntos para atraer a las hembras, pero cuando una hembra se acerca todos compiten por ganarse sus favores.

En algunas especies, los llamados y despliegues visuales de los machos permiten a las hembras escoger a los machos de "mejor calidad": los más grandes y saludables, o los que tienen la resistencia suficiente para prolongar el despliegue hasta resultar convincentes. ¿Se cumplirá esto siempre? ¿O a veces las hembras se dejan seducir por estímulos que tienen tanto que ver con la calidad del macho como la que tiene que ver un traje que se exhibe en un desfile de modas en París?

Los estudios de cortejo y apareamiento entre insectos, muchos de ellos realizados por William

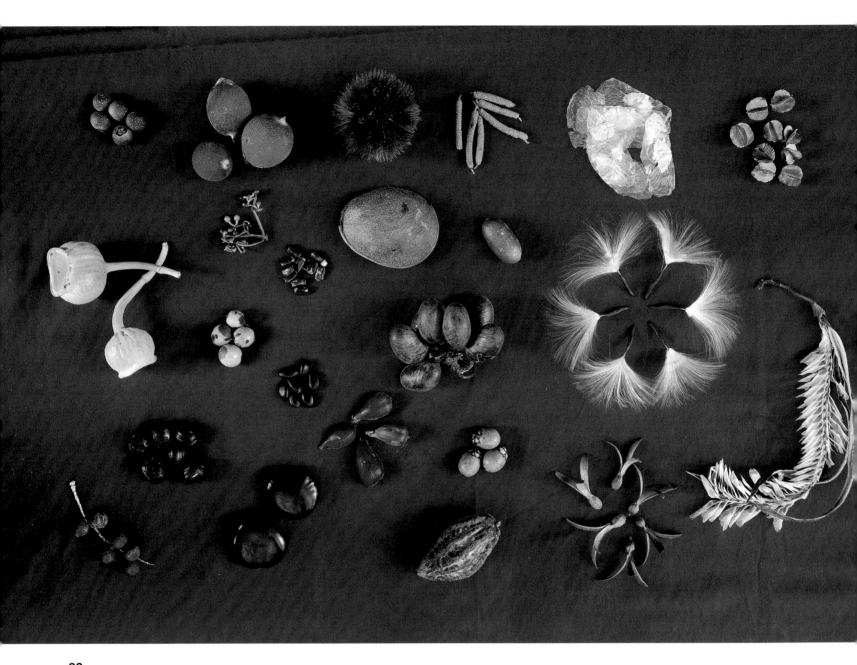

28

Como muchas plagas (insectos que se comen las hojas o las semillas de las plantas, microbios patógenos y hongos) se asocian a una especie de planta en particular, las semillas que caen más cerca de la planta madre corren un mayor riesgo de ser abatidas por las plagas que afectan a la madre. Por esta razón, las plantas buscan la forma de alejar a las semillas de sus progenitores. Muchas lo hacen por medio de animales. Cuatro de cada cinco semillas que se aprecian en la foto, todas recogidas en abril, pertenecen a especies que son dispersadas por animales, lo que refleja fielmente la proporción de especies de árboles grandes en Barro Colorado cuyas semillas son dispersadas por animales.

29

Los agutíes (*Dasyprocta punctata*) juegan un papel fundamental en la conservación de la diversidad de árboles de los bosque donde habitan. Son depredadores de semillas, pero también las protegen: al enterrar las semillas de muchas especies de plantas, las protegen del ataque de los insectos. Si un agutí termina convirtiéndose en comida de ocelote, las semillas que dejó enterradas aún tienen posibilidad de germinar.

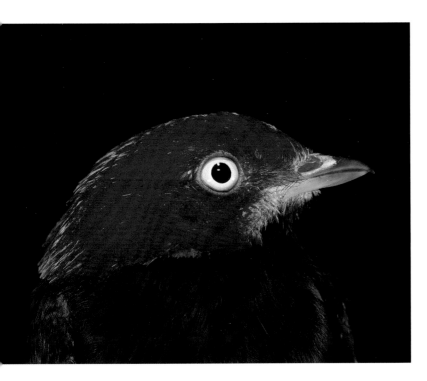

30

Saltarín cabecirrojo macho, *Pipra mentalis ignífera*. Los machos de esta especie se reúnen en grupos llamados "leks" para atraer hembras y competir por sus favores.

Eberhard, del Instituto Smithsonian de Investigaciones Tropicales (STRI), muestran que en poblaciones aisladas las elecciones de las hembras motivan cambios inexorables en los rasgos de los machos y en los despliegues que hacen para atraer a las hembras, y viceversa. Martin Moynihan, fundador de STRI, describió una situación análoga en ciertas señales humanas: "Una frase o una palabra especialmente fuerte, como una obscenidad o un término técnico llamativo, causarán gran impresión y tendrán gran efecto las primeras veces que se usen. Solo porque son efectivas habrá una tendencia a emplearlas más y más frecuentemente. Pero, a no ser que se las refuerce constantemente, añadiéndoles alguna variación o reelaborándolas de algún modo, terminarán vaciándose de contenido". Esos cambios son tan impredecibles como los cambios en la moda. Si una población resulta escindida en dos fragmentos aislados, los criterios que emplea cada una para elegir a su pareja podrían llegar a divergir tanto que llegará el momento en que ninguna de las dos poblaciones reconozca a los miembros de la otra como parejas adecuadas. En ese momento se habrán convertido en dos especies distintas.

Mientras hacía investigación posdoctoral en el STRI, Christopher Jiggins encontró que hace menos de un millón de años las mariposas de las especies *Heliconius melpomene* y *H. cydno* se separaron de un ancestro común para imitar a las mariposas de las especies *Heliconius erato* y *H. Sappho*, respectivamente. La especiación se aceleró porque las mariposas del género *Heliconius* prefieren aparearse con mariposas que tienen las alas de su mismo color y porque hay más probabilidades de que los depredadores se coman a las híbridas, que no se parecen a las mariposas que ellos reconocen como de sabor desagradable. En general, la especiación es más rápida cuando la selección sexual se centra en los "rasgos mágicos", de manera que las diferencias en estos rasgos (como la imitación de

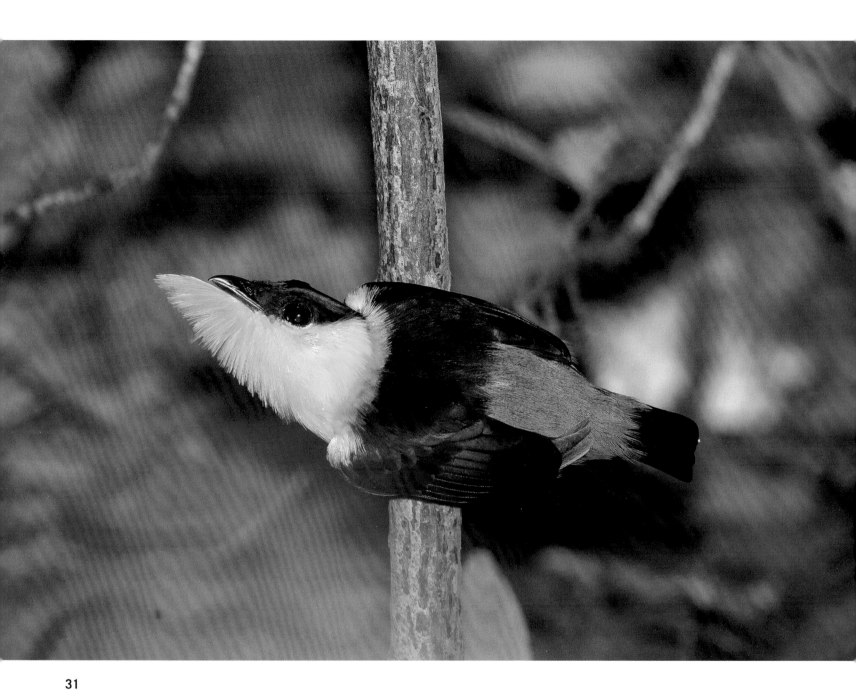

31

Se piensa que la selección sexual es uno de los motores que impulsa la especiación. Los "adornos" de los machos suelen ser importantes, pues les permiten a las hembras reconocer si se trata de un compañero apropiado y juzgar su calidad como reproductor. Un ejemplo interesante es el saltarín cuellidorado (*Manacus vitellinus*), especie en que los machos presentan un elaborado conjunto de plumas modificadas bajo el pico. Esta "barba" forma parte del despliegue visual que acompaña una complicada danza de cortejo.

32

33

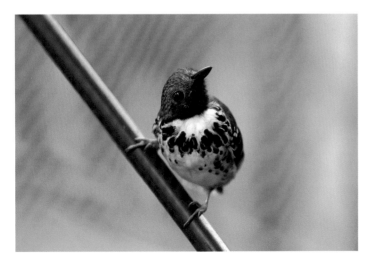

34

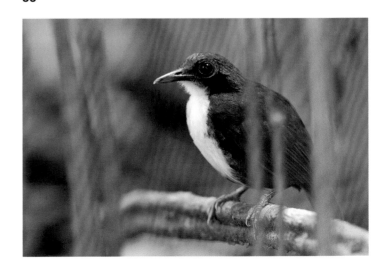

35

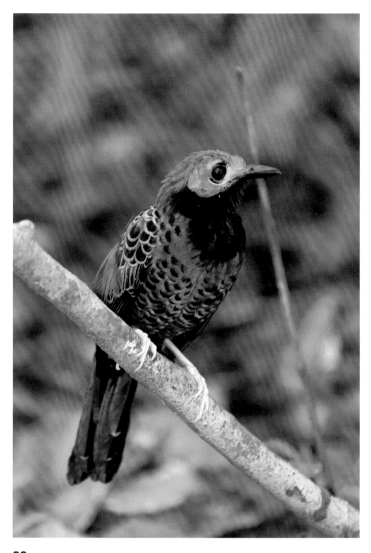

36

37

32-37

Un fenómeno bien conocido del bosque tropical son las bandadas de aves mixtas, donde hasta diez especies de aves se unen para forrajear. En la región neotropical, distintas especies de aves hormigueras se unen para seguir a las hormigas legionarias y comerse los insectos que saltan al paso de la marabunta. Las figuras 32-77 muestran seis especies que frecuentemente se unen a estas bandadas. SEGÚN LA NUMERACIÓN: El buco barbón (*Malacoptila m. panamensis*), seguidor habitual de las columnas de hormigas legionarias (32). El cuco hormiguero (*Neomorphus geoffroyi*), la especie más grande y dominante entre las aves que siguen a las legionarias (33). El hormiguero moteado macho, Hylophylax naevioides, infaltable en estas bandadas (34). El hormiguero bicolor (*Gymnopiths leucaspis*), una de las especies denominadas "profesionales" u obligatorias, por su grado de especialización (35). El hormiguero ocelado (*Phaenostictus mcleanani*), aquí fotografiado en tierra continental, cerca de Barro Colorado (36); este seguidor "profesional" se extinguió de Barro Colorado. Finalmente, un trepatroncos pardo (*Dendrocincla fuliginosa*) (37). Ver discusión en página 211.

modelos distintos), permiten que las especies que se han separado sigan coexistiendo.

LA INTERDEPENDENCIA: LAS MÚLTIPLES FORMAS EN QUE LAS ESPECIES DEPENDEN UNAS DE OTRAS

Los bosques, al igual que otras comunidades ecológicas, son redes de interdependencias. Los animales dependen de las plantas verdes por el alimento y el oxígeno que se crean mediante la fotosíntesis. Las plantas dependen de una gran variedad de animales, desde las termitas y las lombrices hasta los ácaros, los insectos, los hongos y las bacterias para que consuman la materia vegetal muerta y la descompongan, etapa por etapa —un gremio de organismos consumiendo lo que ha sido fragmentado o pasado por el tracto digestivo de otro— hasta que los minerales allí contenidos sean liberados fertilizar otras plantas. En su último libro, Charles Darwin demostró lo mucho que dependen las plantas de Gran Bretaña de las lombrices para airear el suelo e incrementar la penetrabilidad por parte de las raíces, su fertilidad y su capacidad de retener agua. En efecto, tanto en el trópico como en Gran Bretaña, innumerables microorganismos ayudan a las lombrices a conservar la estructura y la fertilidad del suelo. Además, las plantas dependen de una gran cantidad de aves, murciélagos, arañas, avispas y otros animales que contribuyen a controlar las plagas de insectos que las asedian.

La estabilidad de los ambientes tropicales promueve interdependencias más complejas. Debido a que las hormigas legionarias siempre están marchando por el bosque haciendo saltar insectos a su paso, un gremio de aves sobrevive alimentándose de estos insectos. Los agutís entierran semillas de tamaño adecuado a lo largo del territorio donde habitan, como reserva para los tiempos de escasez. Donde hay agutís, varios árboles de semilla grande

dependen de ellos para que entierren sus semillas y las protejan así de los depredadores. Como los depredadores son una amenaza constante en los bosques tropicales, muchas aves del sotobosque se unen a aves de otras especies, que comen cosas diferentes o se alimentan de modo diferente, para formar "bandadas o grupos mixtos". Estas aves casi nunca se ayudan entre sí a encontrar alimento; es más, las diferentes especies nunca están representadas en la bandada por más de una pareja y sus pichones, como si los miembros de la bandada se eligieran para minimizar la competencia por alimento entre ellos. Estas aves se unen porque cuanto más aves haya para detectar depredadores, más tiempo tendrá cada ave para alimentarse. Dichas bandadas son un rasgo característico de los bosques tropicales de tierras bajas, ya sea en Borneo o en Nueva Guinea como también en Panamá.

En muchos casos, esta interdependencia surge cuando los organismos aúnan habilidades complementarias. Las plantas son buenas para fabricar alimento, otros organismos son buenos para descomponer plantas muertas, otros, para transportar y enterrar semillas vivas, y así sucesivamente. De hecho, todas las especies que están vivas hoy día dependen de servicios que parecen ser una consecuencia automática o un subproducto de los modos de vida de otras especies. Los animales dependen de las plantas por su oxígeno; las plantas dependen, en gran medida, de los organismos que las comen o las descomponen por su dióxido de carbono, y así sucesivamente. Aunque los descomponedores en última instancia dependen de las plantas cuya materia muerta degradan, un descomponedor no beneficia más a otros descomponedores siendo más útil a las plantas, que el beneficio que prestaría a su vecinos alguien que se pusiera a limpiar el aire que lo rodea en Times Square. En ambos casos, los beneficios de estas actividades se diluyen demasiado como para que al agente pueda sacar un provecho significativo.

LOS MUTUALISMOS

A veces, sin embargo, la complementariedad de funciones lleva a que dos especies o grupos de especies se asocien en una relación mutualista. En el mutualismo, los miembros de cada especie explotan las actividades de la otra para beneficiarse recíprocamente. Los mutualismos son relaciones en las que se trabaja por el bien común de los socios. Por tanto, no es raro que una especie evolucione de cierta manera para acomodar a su socio en mutualismo, con el fin de sacar mayor provecho de la relación.

Muchas plantas tienen nectarios, glándulas situadas en el peciolo o en las hojas que, al menos cuando las hojas son jóvenes, segregan un fluido que atrae hormigas depredadoras que matan a orugas comedoras de hojas o que asustan o persiguen a otros insectos también comedores de hojas. Estas hormigas ni anidan en la planta ni la defienden con gran fervor. Las plantas pagan un pequeño precio en carbohidratos, cuya fabricación es su especialidad para obtener cierto grado de protección de la movilidad y agresividad de las hormigas que atraen. Una de esas plantas es el *Croton billbergianus:* cada hoja tiene un nectario, una pequeña área circular en el peciolo, justo donde este se une a la base de la hoja, que tiene forma de corazón. Por lo general, sólo se observan hormigas en las hojas más jóvenes.

En este tipo de relaciones en las que todo vale, los animales pueden tomar "la paga" y no proteger a la planta, que no tiene forma de desquitarse. Algunos herbívoros pueden incluso "pujar" más alto que la planta para obtener la protección de las hormigas. Las orugas de la mariposa *Thisbe irenea* solo comen hojas de *Croton*. En 1985, Philip DeVries, un estudiante graduado de la Universidad de Texas, llegó a Barro Colorado con una beca de investigación predoctoral del Smithsonian a estudiar cómo las orugas de *Thisbe* subvertían el comportamiento de las hormigas de los *Croton* (fig. 38). Estas orugas se toman el fluido de los nectarios de los *Croton* y lo transforman en algo mucho más nutritivo, que las hormigas prefieren con creces. Las orugas dispensan este fluido en nectarios situados en su propio cuerpo. Pero eso no es todo. Las orugas usan otros mecanismos para transformar a las hormigas de indolentes protectoras de hojas en aguerridas guardaespaldas de orugas, las cuales, sin la protección de las hormigas, enfrentan una muerte segura. Las orugas pueden convocar la protección de las hormigas liberando una sustancia química que las hormigas confunden con una señal de alarma de sus compañeras así como usando unas estructuras que tienen en el cuerpo para llamar a las hormigas "ultrasónicamente". La relación entre las *Thisbe* y las hormigas que las protegen constituye un ejemplo excepcionalmente complejo de los muchos mutualismos donde hormigas agresivas protegen insectos herbívoros vulnerables y lentos, como los áfidos o las orugas, a cambio de una provisión copiosa y segura de almíbar (ligamaza) (fig. 40).

Algunas plantas ofrecen albergue y alimento diseñados para atraer a un tipo específico de hormigas, las cuales, a cambio del favor, defienden sus plantas "a capa y espada". En estos casos, la complementariedad de funciones se ha pulido a tal grado que ambas partes salen beneficiadas. En Barro Colorado, *Acacia hayesii* presenta nectarios extraflorales que atraen hormigas que apenas si defienden a sus hojas jóvenes. En cambio, Acacia melanoceros presenta ambos, nectarios en las hojas y sitios de anidamiento —unas espinas grandes, bulbosas y huecas— que atraen hormigas que con toda razón reciben el nombre de Pseudomyrmex satanica, por el aguijón que portan y la celeridad con que están dispuestas a utilizarlo. Estas hormigas muerden las puntas de cualquier enredadera que toque su planta, repelen el ataque de los herbívoros y mantienen limpia un

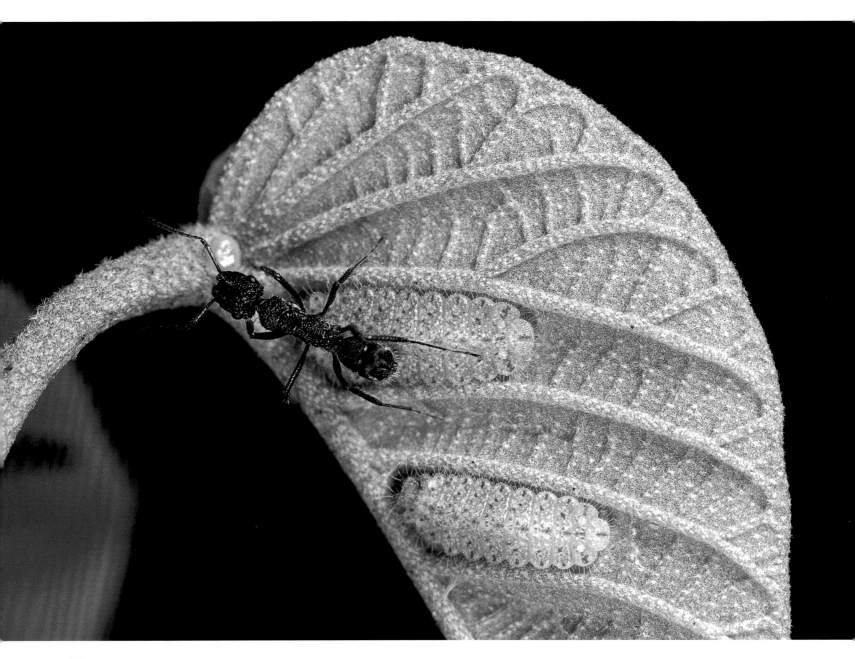

38

Muchas plantas entre ellas *Croton billbergianus*, presentan unas estructuras llamadas nectarios en las hojas jóvenes, los cuales atraen hormigas. Se espera que a cambio del néctar que ofrece la planta, las hormigas ahuyenten a los herbívoros. Sin embargo, en el caso de este *Croton*, la oruga de la mariposa *Thisbe irenea* bebe el néctar de la planta y lo transforma en un líquido que a las hormigas les resulta mucho más atractivo. Las hormigas, entonces, permiten que las orugas coman hojas a su antojo y hasta las defienden de algunos enemigos.

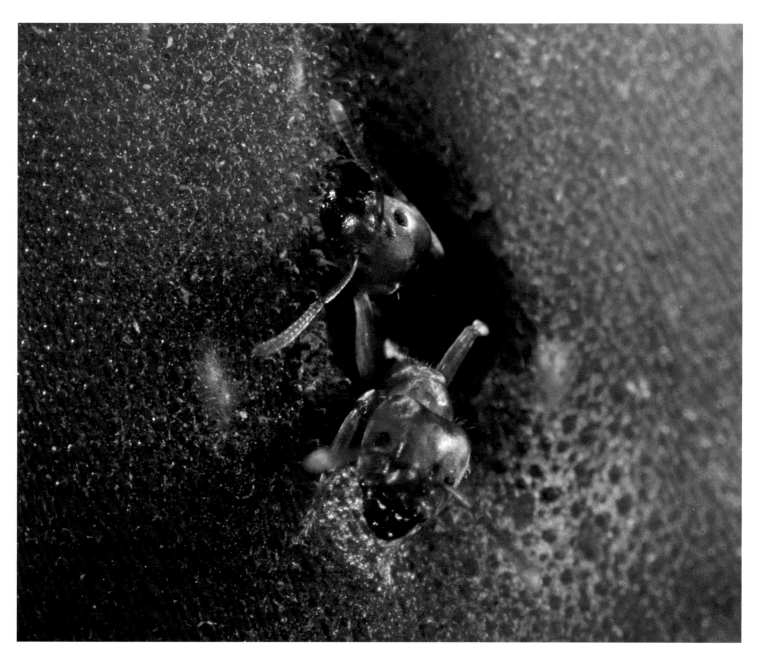

39

Las plantas del género *Cecropia* han desarrollado una relación estrecha con las hormigas. Por tratarse de especies pioneras, las *Cecropia* tienen que crecer aceleradamente y no pueden darse el lujo de invertir mucha energía en repeler a los herbívoros. Es por esto que ofrecen a las hormigas "alojamiento y comida" a cambio de protección. El tronco de las *Cecropia* es hueco y se encuentra dividido en "recámaras": un alojamiento ideal para muchas especies de hormigas pequeñas. Como alimento, la planta ofrece unas estructuras muy nutritivas que están situadas en la base de sus hojas jóvenes. La planta se beneficia porque las hormigas defienden su fuente de alimento atacando a cualquier animal que intente comerse las hojas de "su" planta. Aquí vemos a unas hormigas *Azteca* sp. emergiendo de un agujero en el tallo de una *Cecropia*.

área de terreno circular en la base de la planta. Una planta mirmecófita (asociada a una colonia de hormigas) más conocida, el típico árbol de vegetación pionera, *Cecropia*, también se observa en Barro Colorado. Los árboles tienen tallos huecos para alojar hormigas *Azteca* y corpúsculos ricos en glucógeno, sobre unas estructuras lanosas en la parte basal de cada peciolo, para alimentar a las hormigas y a sus larvas. Las hormigas de la *Cecropia* se aseguran de que ninguna enredadera se enrosque en su árbol y rechazan asimismo los ataques de los herbívoros (fig. 39).

Un grupo distinto de hormigas recoge insectos muertos, estiércol o vegetación muerta donde cultivan un hongo con el alimentan a sus larvas. La movilidad de las hormigas les permite acumular recursos apropiados para el hongo, el cual los digiere en beneficio propio y en beneficio de las hormigas. Estas colonias suelen ser pequeñas, compuestas por unos cuantos cientos o unos cuantos miles de obreras. No obstante, algunas hormigas cultivadoras de hongos, las cortadoras de hojas o arrieras, cultivan un "superhongo" que digiere fragmentos recién cortados de hojas de una extraordinaria variedad de especies de plantas (figs. 41-45). Cada nido es un sistema de galerías subterráneas que aloja a millones de hormigas, más su huerto de hongos. En Barro Colorado, la mayoría de estos hormigueros se reconocen por los movimientos de tierra roja, de varios metros de ancho, que se observan en la superficie y que suelen estar acompañados de un "botadero" donde constantemente, de día o de noche, se depositan fragmentos de hojas usados. Las "autopistas" de las hormigas se extienden del centro del hormiguero por treinta metros o más en todas direcciones, muchas repletas de hileras de hormigas cargando trocitos de hojas que a veces vienen de la copa de árboles muy altos, al huerto de hongos que mantienen en el nido. Un hormiguero consume más de media tonelada de hojas frescas al año. Estas populosas colonias

de hormigas y lo mismo que los hongos que cultivan son, como las grandes ciudades medievales, un blanco facil para las enfermedades epidémicas; de ahí que las obreras tomen medidas rigurosas para prevenir cualquier enfermedad y vigilen celosamente la pureza del hongo.

Cada nueva reina arriera se lleva consigo un trozo de hongo del nido de su madre para comenzar su propio huerto. Este trozo contiene bacterias de *Streptomyces*, cuyas secreciones antibióticas impiden que el cultivo sea contaminado por las especies más peligrosas de hongos parásitos. Las hormigas se comen lo que llegarían a ser las partes reproductivas del hongo. Así, el hongo solo puede reproducirse cuando las hormigas lo transportan a un nuevo hormiguero. Las perspectivas reproductoras del hongo, entonces, dependen de lo bien que sirva a las hormigas.

40

Los insectos que chupan savia frecuentemente consumen más azúcar de la que pueden usar, así que la ofrecen a las hormigas en forma de almíbar. Las hormigas, a su vez, cuidan a sus proveedores de alimentos asustando a cualquier posible depredador. En la imagen, unas hormigas del género *Ectatomma* atienden a unos de estos "chupadores de savia", unas chinches membrácidas, parientes de las cigarras.

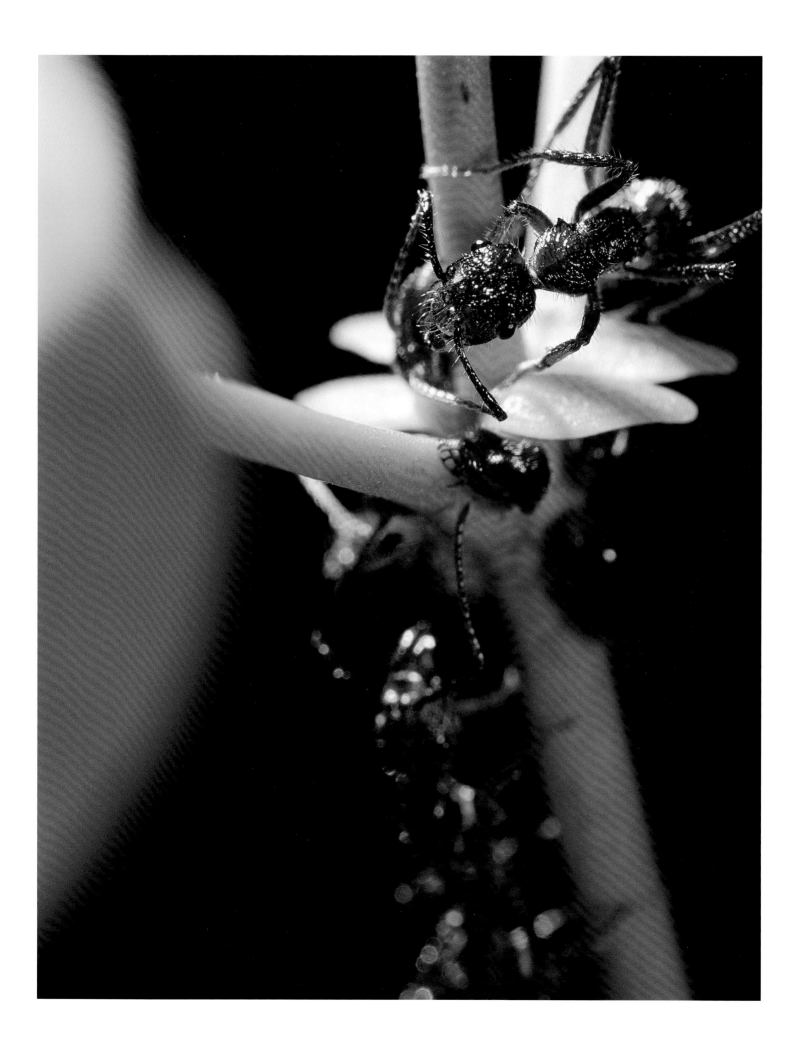

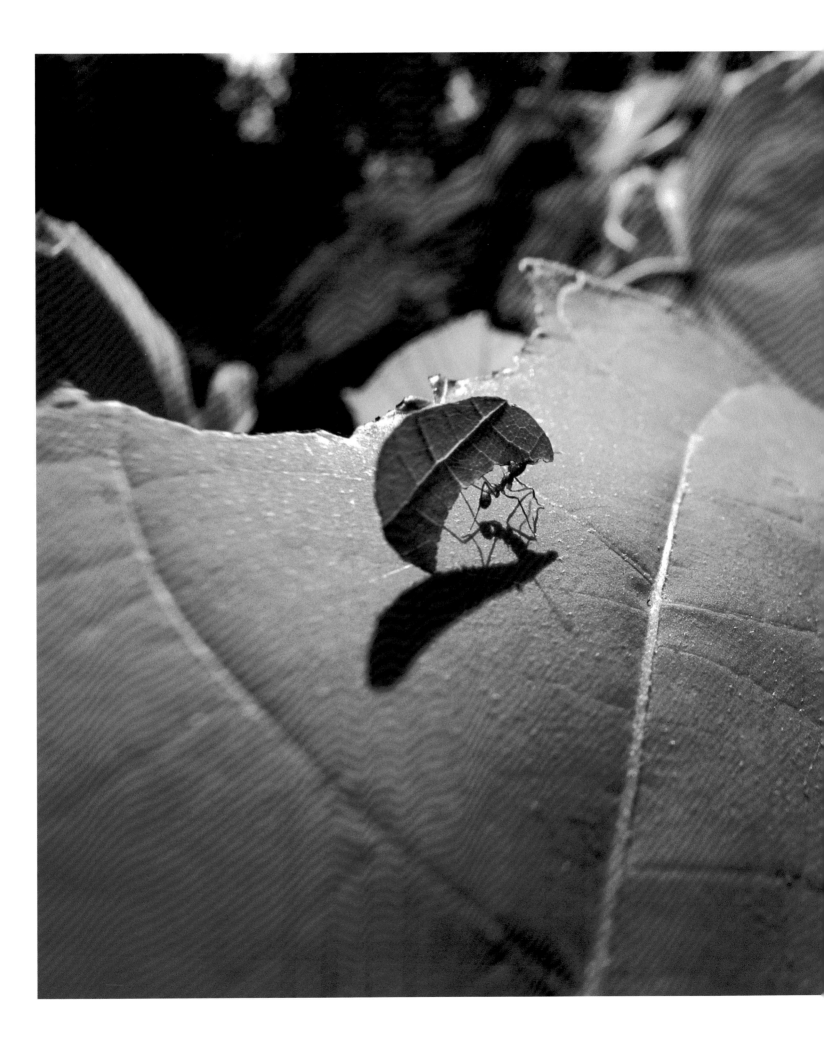

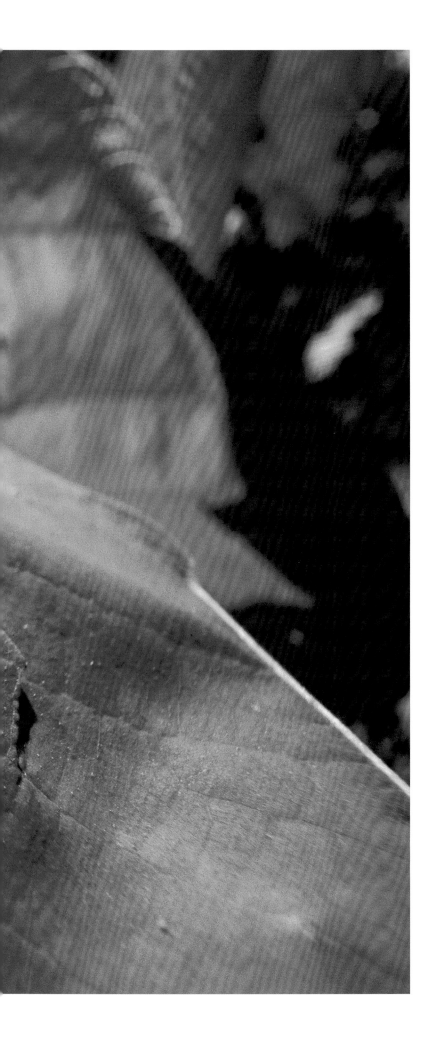

41

Una obrera transporta un trozo de hoja recién cortado. Las sociedades de hormigas "arrieras" o "cortadoras de hojas" (*Atta colombica*) están entre las más complejas del mundo de los insectos. Las colonias, que agrupan hasta millones de individuos, cultivan un hongo que se encarga de digerir los trocitos de hojas acarreados por las obreras. Las hormigas comenzaron a usar a los hongos como órganos digestores externos hace unos 50 millones de años. La domesticación de hongos ha transformado a algunas especies de hormigas arrieras en herbívoros prolíficos y versátiles que son una verdadera plaga para la agricultura humana.

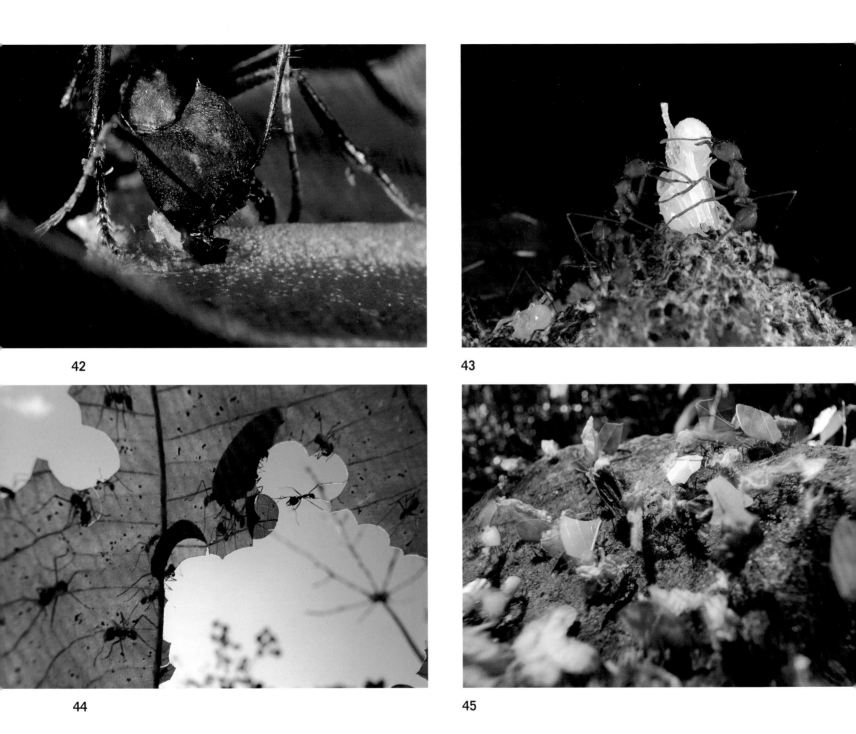

42

43

44

45

42-45: Dotadas de mandíbulas especiales (fig. 42), las obreras de las hormigas arrieras (*Atta colombica*) recortan trocitos de hojas de balso, *Ochroma* (fig. 44) y los trasladan (fig. 45) al nido por trechos de hasta 200 metros. También acostumbran cosechar flores y frutos, además de hojas. Las "jardineras", las hormigas que están a cargo del huerto, cortan las hojas en trocitos aún más pequeños y los mascan junto con trocitos de hongo. El hongo, que parece una esponja de baño (fig. 43), "digiere" el material vegetal y procesa los venenos que protegen a la hoja de los herbívoros. Las larvas de las hormigas se alimentan con los cuerpos nutricios del hongo. Aquí, dos obreras atienden a una larva en el huerto de hongos.

LA POLINIZACIÓN Y LA DISPERSIÓN DE LAS SEMILLAS

Los mutualismos más conocidos son aquellos en que las plantas atraen animales para que polinicen sus flores o dispersen sus semillas. Las plantas aportan carbohidratos o fingen tener ese o algún otro atractivo y usan como "señuelo" flores de colores brillantes o de construcción curiosa para despertar el interés del animal que habrá de transportar su polen o sus semillas. A veces los animales toman el señuelo, e incluso lo roban de manera destructiva, sin prestar el servicio esperado. Un colibrí que de buena gana poliniza un tipo de flor roja y tubular podría encontrar que es más fácil alcanzar el néctar de otra atravesándola por la base, en vez de insertar el pico en la flor de la manera natural que lo deja bañado de polen. De igual forma, una abeja podría morder la base de la flor para sacarle el néctar. Los loros, una vez sí y otra también, despedazan y digieren las semillas de las frutas que comen.

Para atraer a los polinizadores más competentes y confiables, las plantas esgrimen una variedad asombrosa de mecanismos. Es más, parece que hubiera un premio en juego para la que encuentre la forma más novedosa de polinización. Las flores amarillas del guayacán están diseñadas para atraer abejas grandes de varios tipos, mientras que la flor de una orquídea podría estar diseñada para atraer solo a un tipo de abeja (fig. 46). Las flores rojas, largas y tubulares, fueron hechas para los colibríes. Las flores de algunas *Aristolochia* recuerdan las cavidades de los esqueletos y a veces hasta desprenden un olor semejante, para atraer moscas carroñeras (fig. 48). Ciertas aráceas elevan su temperatura al atardecer y desprenden un aroma que atrae a un tipo de escarabajo, que, una vez dentro la flor, es tomado cautivo toda la noche para asegurar la efectividad de la polinización.

De igual modo, los frutos de algunos higuerones atraen a una variedad indiscriminada de monos, murciélagos, kinkajús y otros similares, mientras que los frutos de la nuez moscada, cuyas semillas deben ser transportadas lejos del árbol progenitor para escapar de sus plagas, son del gusto casi exclusivo de los tucanes y los monos araña. Las plantas usan diferentes medios para atraer animales diseminadores: bayas de colores brillantes para las aves pequeñas; semillas grandes y duras para los agutís; frutos verdosos para los murciélagos; frutas azucaradas o aceitosas para otros mamíferos y aves más grandes. La interdependencia va mucho más allá de la planta y los animales que la polinizan o dispersan sus semillas. Una planta que depende de ciertas aves para que dispersen sus semillas depende de otras plantas para que alimenten a esas aves cuando esta no tiene frutos, y a veces hasta de otros bosques para que las alimenten cuando su propio bosque no tiene fruta. Muchos árboles también dependen de los depredadores que se agazapan en sus copas cuando están cargadas de frutos, para que asusten a los diseminadores y los obliguen a marcharse lejos con la fruta, antes de comerla y dejar caer las semillas.

Si el néctar de una planta atrae suficientemente a un animal, este lo va a buscar y va a polinizar a otras plantas de la misma especie aunque se encuentren ampliamente diseminadas. Si una plaga especializada diezma esa población de plantas, sus flores todavía van a ser polinizadas. Es así como la polinización por animales permite que una especie de planta sea muy poco común y esté muy diseminada, sin que corra por ello el riesgo de extinguirse. Una especie de planta que puede sobrevivir porque es lo bastante escasa como para escapar de sus plagas necesita invertir menos en defensas contra herbívoros que otra cuyos miembros

46

Las plantas ofrecen néctar a los animales para persuadirlos de que les sirvan de polinizadores. Aquí, la característica inflorescencia carnosa de una arácea atrajo a dos abejas euglosinas: la pequeñita es una *Euglossa*, la grande, una *Exaerete*. Esta última es una abeja parásíta; es decir, pone sus huevos en los nidos de otras euglosinas. Las euglosinas pueden transportar el polen a grandes distancias. La polinización de muchas plantas, como las orquídeas y las aráceas, depende exclusivamente de las euglosinas. Estas plantas desprenden aromas dulces y muy florales que atraen abejas desde lugares remotos.

crecen tan juntos que las plagas fácilmente pasan de uno a otro. La planta polinizada por animales puede, en cambio, invertir en crecer más rápido y en reproducirse más pronto.

Hace unos 200 millones de años, varios grupos de plantas, incluidos algunos parientes de las cicas empleaban insectos como polinizados. Algunas incluso atraían polinizadores que eran fieles a sus especies. Pero solo las plantas con flor fueron capaces de transformar la necesidad de escapar de las plagas en un crecimiento verdaderamente acelerado: desarrollaron la manera de transportar agua del suelo a las hojas a una velocidad tal que podían llevar a cabo la fotosíntesis, y crecer, más rápidamente que sus competidoras. Cuando esto ocurrió, hace cien millones de años, las plantas con flor se diversificaron vertiginosamente colonizando los claros del bosque, las riberas de los ríos y otras áreas alteradas. Más adelante, las plantas con flor comenzaron a usar a los mamíferos como vehículo de dispersión de semillas grandes (fig. 47) que podían germinar y crecer en la penumbra de los bosques maduros, lejos de otros miembros de su misma especie. Los árboles cuyas semillas eran dispersadas por animales se diversificaron para construir el bosque tropical que hoy conocemos. La diversidad y la exuberancia de los bosques tropicales son, entonces, un regalo de los animales polinizadores y diseminadores. Flores hermosas y frutos apetitosos atraen polinizadores y diseminadores que permiten que los distintos tipos de plantas tropicales escapen de sus plagas al dejarlas escondidas entre una multitud de otras plantas que no podrán ser atacadas por sus propias plagas, en vez de defenderse cargándose de pesadas toxinas contra herbívoros que las obligarían a bajar la velocidad de crecimiento.

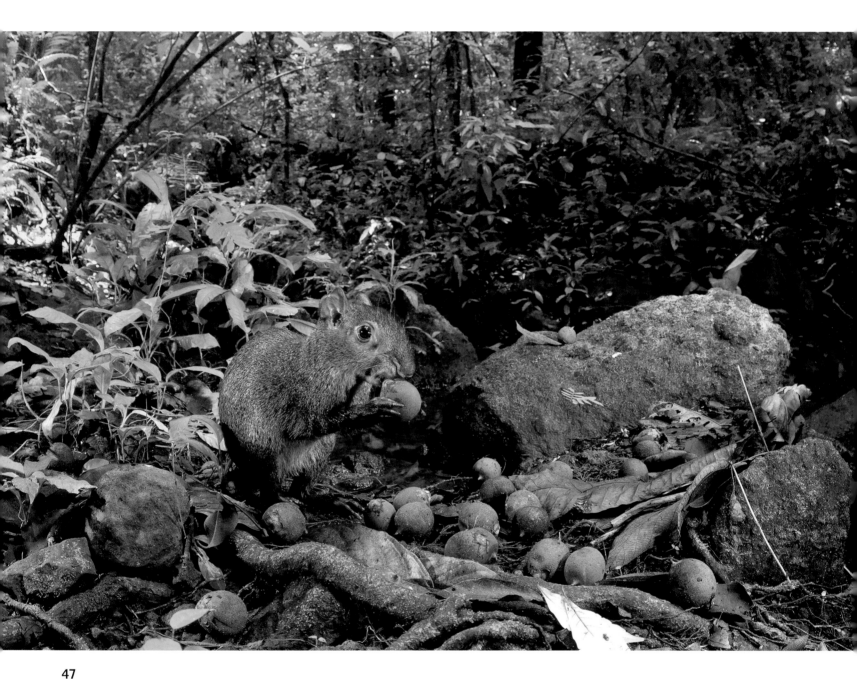

47

Los agutíes (*Dasyprocta punctata*), como el que vemos en la imagen, están entre los pocos animales que pueden abrir semillas de cáscara dura, como estas, del pejibaye de montaña, *Astrocaryum standleyanum*, para comerse la parte nutritiva. Aunque los agutíes están entre los principales consumidores de semillas de *Astrocaryum* y otras semillas de cáscara dura, también las entierran, para comerlas más adelante, con que las ponen a salvo de otros depredadores de semillas. Lo mismo hace el arrendajo azul en Norteamérica con las bellotas. Las semillas olvidadas germinan y así se asegura la continuidad de la especie.

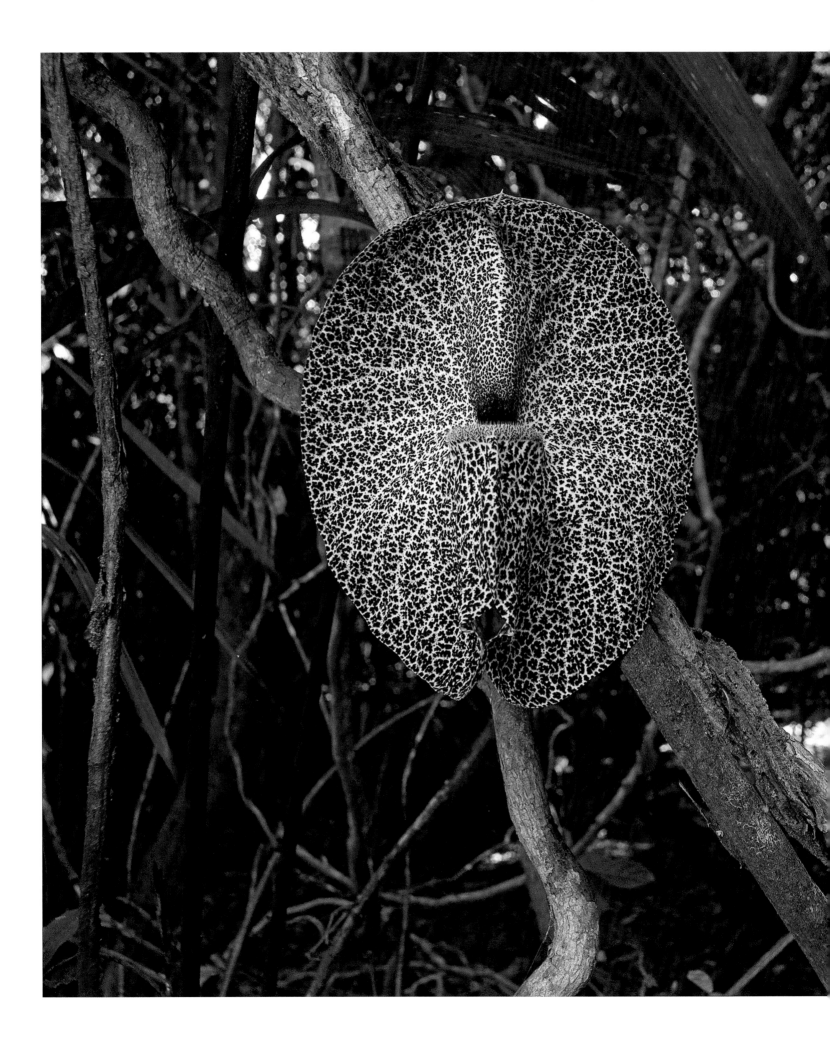

48

Algunas plantas usan mecanismos engañosos para atraer polinizadores. Las flores de esta *Aristolochia gigantea* desprenden un olor putrefacto que despierta el interés de moscas y escarabajos coprófagos.

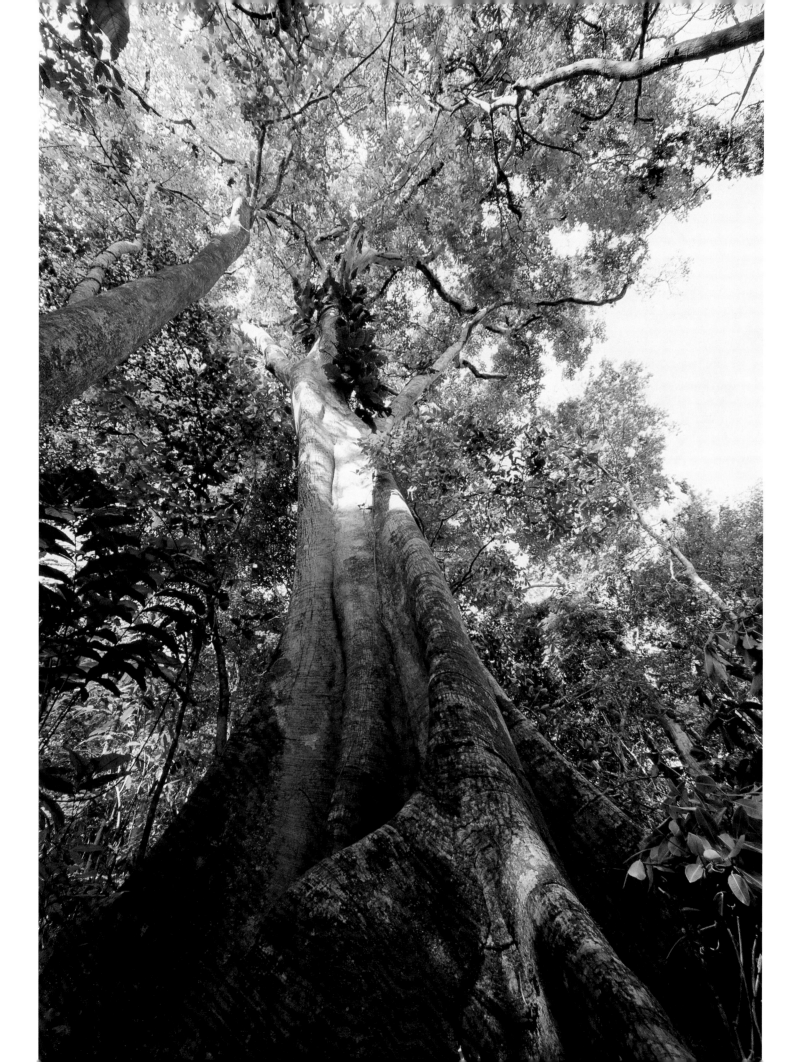

LA AVISPA DE HIGUERÓN: UNA POLINIZADORA SIN PAR

Casi todos los polinizadores dependen de varias especies de plantas para sobrevivir. Las avispas que polinizan a los higuerones constituyen una excepción espectacular. En Barro Colorado se encuentran 18 de las 700 especies de higuerón que se observan en todo el mundo. Cada una de esas 700 especies tiene su propia especie de avispa polinizadora. Los "frutos" son en realidad la corola de la flor vuelta al revés (la parte de afuera hacia adentro), de modo que se forma una bola o sicono, que tiene un orificio en un extremo y cuyo interior está recubierto de pequeñas flores. Cuando las flores de un árbol están listas para ser polinizadas, un olor especial atrae a las avispas cargadas de polen. Una o más avispas entran en cada sicono, depositan polen en todas las flores y un huevecillo en aproximadamente la mitad de ellas. Cada larva de avispa madura en los confines de una sola semilla: ninguna semilla recibe más de una avispa. Al emerger de las semillas, las avispas adultas se aparean, y los machos abren un agujero en la pared del sicono por el que saldrán las hembras. Las hembras fertilizadas se bañan en el polen que las flores recién han comenzado a producir y emprenden el vuelo en busca de nuevos árboles que polinizar (figs. 49-55).

Los higuerones están diseñados para asegurar la fertilización cruzada. Cuando las flores de un sicono finalmente producen polen, ya no pueden ser fertilizadas por ese polen. En la mayoría de las especies de higuerón, los siconos se desarrollan tan sincrónicamente que cuando las primeras avispas bañadas en polen son liberadas, el árbol ya no le quedan siconos que polinizar. Estas avispas tienen que ir a buscar otro árbol. Aunque la avispas adultas viven solo unos poco días, éstas pueden polinizar árboles que se encuentran a kilómetros de distancia. De hecho, los higuerones atraen avispas que

49 PÁGINA OPUESTA

Vista de un higuerón no estrangulador. Los adultos de muchas especies de higuerón son impresionantes, con el tronco artísticamente contorsionado. Aproximadamente la mitad de las especies de higuerón que hay en el mundo son especies estranguladoras, "matapalos", que comienzan su vida como epífitas sobre otros árboles pero que luego envían sus raíces al suelo. Muchas de estas especies tienden un cerco tan apretado alrededor del árbol hospedero que tarde o temprano terminan matándolo: lo único que queda de él es un espacio vacío dentro del tronco del higuerón (fig. 55).

50 ARRIBA

Avispa parásíta del higuerón (*Idarnes* sp.). Obsérvese el tamaño del ovipositor.

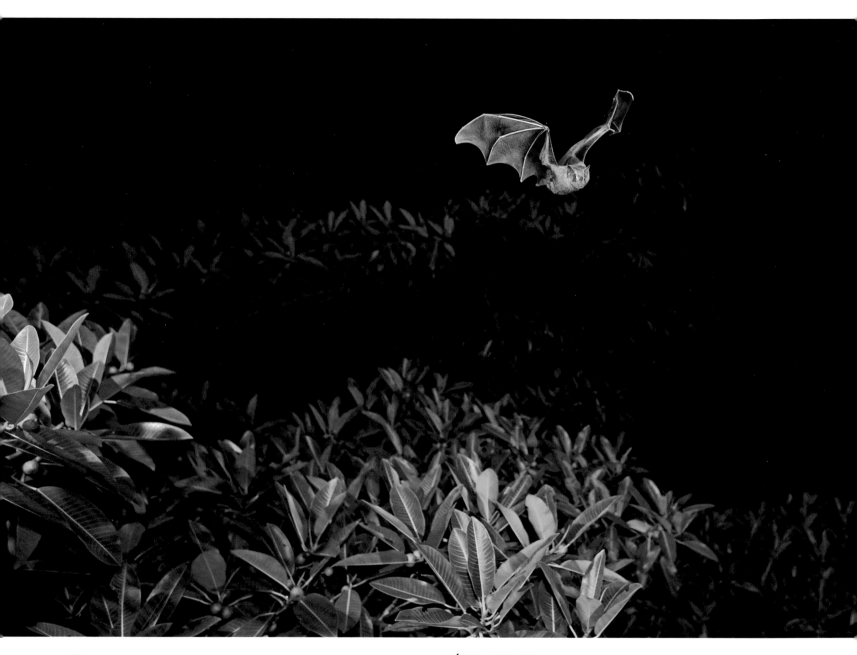

51

Un murciélago frugívoro, probablemente un Artibeus
lituratus, vuela sobre la copa de un higuerón, *Ficus insipida*,
cargado de frutos.

PÁGINA OPUESTA, DE ARRIBA HACIA ABAJO:

52 Frutos rojos de un *Ficus* sp. fotografiado en tierra firme.
Sus semillas son dispersadas las aves.

53 La imagen captura a un grupo de avispas *Pegoscapus* sp.
emergiendo del interior de un fruto de higuerón.

54 Los frutos verdes del *Ficus obtusifolia* producen semillas
que son dispersadas por murciélagos.

La relación entre los higuerones y las avispas que los polinizan representan una de las relaciones mutualistas más especializadas que existen entre plantas y animales. Ni los higos ni las avispas pueden sobrevivir sin su socio. Esta asociación tan compleja se desarrolló en la época de los dinosaurios. En el mundo hay más de 700 especies de higuerones; al menos 19 crecen en Barro Colorado o en los alrededores. Cada una es polinizada por una o unas pocas especies de avispa. En cada semilla madura una larva. Cuando los adultos eclosionan (fig. 53) se aparean dentro del fruto. Las hembras fertilizadas recogen algo de polen, salen del fruto y alzan vuelo en busca de otro higuerón en flor de la misma especie. A veces recorren más de diez kilómetros hasta encontrar a su árbol. Una vez allí, una o más hembras se introducen a un higo en desarrollo (que en ese momento es una bolita con el interior recubierto de flores), polinizan las flores y ponen un huevecillo en algunas de las semillas. En general, aproximadamente la mitad de las semillas producirán avispas; el resto podrían convertirse en un nuevos árboles de higuerón. Otras avispas parasitan esta relación mutualista: son avispas equipadas con un ovipositor que les permite poner sus huevecillos en el fruto desde afuera, sin polinizar ninguna flor (fig. 50). Los higuerones dependen de que otros animales se coman sus frutos maduros (figs. 52, 54) y dispersen sus semillas. Los higuerones que dan frutos de color rojo (fig. 52) son dispersados sobre todo por aves. Las especies que dan frutos de color verde (fig. 54) convocan sobre todo murciélagos frugívoros que llegan de noche atraídos por una fragancia especial.

52

53

54

55 Detalle del interior del tronco completamente hueco de un higuerón estrangulador (matapalo).

pueden estar a cien o más kilómetros de distancia (tabla 1.5).

John Nason, en ese momento estudiante de posgrado de la Universidad de Iowa fue el primero en determinar las distancias que recorrían las avispas de los higuerones. Trabajando con plántulas que provenían de frutos que habían sido polinizados por una sola avispa, y luego de establecer su genotipo, Nason aplicó una metodología análoga a la que se emplea en los análisis de paternidad en humanos para inferir los genotipos, tanto de la semilla como del polen que habían dado origen a estas plántulas. Así, dado un grupo de frutos polinizados por una única avispa y provenientes de la cosecha de un único árbol, Nason podía determinar cuántos árboles habían contribuido avispas para polinizar estos frutos. Como máximo, 1 de cada 14 árboles pudo haber aportado avispas al mismo tiempo para polinizar esa cosecha de frutos. El número de hectáreas que estarían suministrando avispas para polinizar la cosecha de frutos de ese árbol es por lo menos 14 veces el número de hectáreas por árbol adulto de esa especie multiplicado por el número de árboles que estarían suministrando polen al fruto polinizado del que habían germinado las plántulas cuyo genotipo Nason había determinado.

Las avispas polinizadoras de higuerones son costosas de mantener. Para poder alimentar a sus polinizadoras, una especie de higuerón debe tener siempre algunos árboles con frutos listos para ser polinizados, independientemente de que la estación sea la propicia o no para las plántulas del parásita del higuerón. Además, las avispas pueden morir por sobrecalentamiento. Por tanto, las especies con frutos más grandes, que tienden a calentarse más cuando les pega el sol, tienen que evaporar constantemente una corriente de agua durante el día para mantener los frutos frescos. De ahí que los higuerones con frutos grandes tienen que tener acceso

TABLA 1.5
Características de las áreas de atracción de avispas polinizadoras de dos especies de higuerón

	obtusifolia	*dugandii*
Cantidad de frutos recolectados que provienen de una sola avispa	28	15
Cantidad de árboles que suministra polen a ese grupo de frutas	22	11
Área por árbol adulto de esta especie	14 ha	250 ha
Área por árbol que se encuentra liberando avispas en el momento preciso para polinizar estos frutos	196 (14×14) ha	3500 (250×14) ha
Área de bosque que suministra polinizadores para estos frutos	4300 (196×22) ha	38 500 (3500×11) ha

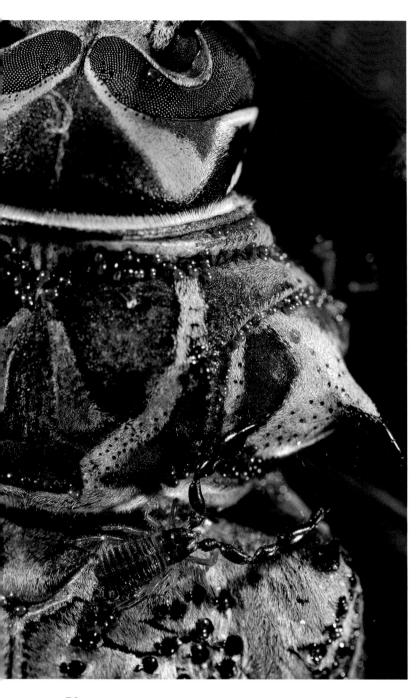

56

Muchos artrópodos pequeños se suben a animales más grandes para viajar de un lugar a otro en busca de comida o de pareja. Aquí, un pseudoescorpión camina sobre la grupa de un escarabajo arlequín, *Acrocinus longimanus*, plagado de ácaros rojos. Los pseudoescorpiones acostumbran esconderse debajo de las alas de los arlequines con la esperanza de que el aventón los lleve hasta un higuerón en descomposición donde puedan quedarse a vivir.

seguro al agua del suelo. También, los higuerones favorecen el trabajo de las avispas dejando caer los frutos que no fueron polinizados o marchitando las flores que no fueron polinizadas.

Con todo, estas fantásticas polinizadoras permiten que hasta las especies más escasas de higuerón mantengan una diversidad genética alta. Es más, los higuerones no necesitan cargarse de defensas contra herbívoros, pues son árboles que crecen rápido, viven poco, se pudren pronto y producen una cantidad sorprendente de hojas y frutos ricos en nutrientes. Un metro cuadrado de hojas de hojas higuerón expuestas al sol produce más azúcar por día que un metro cuadrado de hojas expuestas al sol de cualquier otro árbol conocido: 20 gramos en comparación con los 8 gramos que produce un árbol promedio del dosel. Algunos higuerones colonizan los campos abandonados y las riberas recién formadas, otros comienzan su vida sobre la rama de un árbol para ir dejando caer raíces que acaban envolviendo y estrangulando al hospedero: son los "matapalos".

Gracias a su oferta constante y confiable de frutos, así como al valor nutritivo de sus hojas, los higuerones son "especies clave" —especies inmensamente importantes para la supervivencia de otras especies— en muchos bosques tropicales, tanto en el Nuevo Mundo como en Asia. Un gremio especial de varias especies de murciélagos se alimenta de sus frutos y dispersa sus semillas. Muchos otros animales dependen de sus frutos durante al estación de escasez de fruta en el bosque. Más aún, una cantidad copiosa y vibrante de insectos se especializa en consumir la madera muerta de los higuerones.

LOS ECOSISTEMAS: ¿COMUNIDADES AL SERVICIO DEL BIEN COMÚN?

La exuberancia y la diversidad del bosque tropical de Barro Colorado, así como la de las áreas cercanas

protegidas contrasta brutalmente con los estériles campos de *Saccharum spontaneum* ("paja canalera") un pasto del sudeste asiático que se introdujo en Panamá en la década de 1970 y que ahora ocupa grandes extensiones abandonadas en las inmediaciones del Canal de Panamá. Los pastizales de paja blanca pueden ser muy productivos, pero también desplazan a las demás plantas. En la estación seca este pasto se seca, con lo cual sirve de combustible para desatar quemas que destruyen a sus competidores (fig. 57). Pocos mamíferos y aves encuentran un medio de subsistencia en este pasto y para los humanos es considerablemente menos útil que el bosque que antes crecía en su lugar.

Mucho antes de que llegara la "civilización", los seres humanos causaron desastres ecológicos peores que los que este pasto ha causado hasta ahora. En la Edad del Hielo, una extensa pradera que servía de sustento a mamuts y otros animales de gran porte cubría el este de Siberia. Su pisoteo constante impedía que los musgos de la tundra reemplazaran el pasto del que se alimentaban. Las praderas son mucho más productivas que la tundra y transfieren muchísimo más agua del suelo al aire, con lo que el suelo se mantiene lo bastante seco como para que el pasto continúe creciendo. Cuando los cazadores exterminaron a los mamuts, hace unos 12 000 años, los musgos de la tundra reemplazaron a los pastos, los suelos se anegaron y la producción de biomasa vegetal cayó catastróficamente.

La "paja canalera" y el musgo de la tundra son ejemplos extremos de la regla de que las alteraciones que los seres humanos provocan en comunidades naturales que entienden poco y les importan menos terminan reduciendo la productividad de estas comunidades y la variedad de organismos que mantienen. Los organismos se han organizado para sobrevivir y multiplicarse. Uno de los argumentos que ofrecía Aristóteles en apoyo de esta proposición era que los organismos mutantes,

organismos cuyo diseño ha sufrido un cambio azaroso, tenían más problemas para lograr ese cometido que sus contrapartes normales. ¿Es posible que la sensibilidad que presentan las comunidades ecológicas, los ecosistemas, a alteraciones que no tienen paralelos naturales significa que se han organizado en modos que tienden a incrementar su productividad y el número de especies que mantienen? Si es así, ¿qué procesos gobiernan esta organización? ¿Para qué se organizan? ¿Por qué habrían de incrementar su productividad y su diversidad?

Los ecosistemas, lo mismo que las economías, son redes de interdependencia. Cada especie depende de múltiples maneras del contexto ecológico en el que ha evolucionado, lo mismo que las empresas dependen del contexto económico o social en que se desenvuelven. Alteramos el contexto y la mayoría sale perdiendo. ¿Pero se trata de una interdependencia caprichosa o responde a un orden interno que busca incrementar el bien común de las especies participantes?

De hecho, los ecosistemas se parecen más a las economías que a los organismos. Los ecosistemas, como las economías, son campos de competición y conflicto, pero también son sistemas funcionales con una división de labores entre sus participantes que los beneficia a todos por igual. No solo hay división de labores entre productores, consumidores y descomponedores: hay división de labores entre productores adaptados a diferentes puestos en el bosque —árbol del dosel, árbol del sotobosque, hierba terrestre y así sucesivamente—. De igual modo, hay división de labores entre los organismos que descomponen materia vegetal de distintos tipos —de hecho, entre aquellos que intervienen en las diferentes etapas de la descomposición de cada tipo—. Los polinizadores y los diseminadores de semillas ayudan a mantener la productividad del bosque tropical al permitir que sus árboles evadan el herbivorismo

excesivo sin tener que recargarse de toxinas contra herbívoros que reducirían su velocidad de crecimiento. Tal diversidad de funciones, incrementa, sin duda, la productividad del bosque.

La competencia es la fuerza que impulsa esta división de labores. Una especie que explota una fuente de energía disponible en una comunidad mejor que cualquiera de las especies presentes podrá establecerse ahí, si llega a esa comunidad. La competencia, sin embargo, a veces es destructiva. La paja canalera se propaga sirviendo de combustible para alimentar los fuegos que queman a sus competidores. Por otra parte, el éxito de la competencia destructiva puede ser efímero. Si la competencia destructiva deja los recursos infrautilizados en extremo, algo evolucionará con el fin de explotarlos. En términos generales, una especie cuya forma de vida beneficia al mayor número posible de especies y perjudica al menor número posible estará menos propensa a experimentar la revancha evolutiva de las especies perjudicadas. ¿Bastarán estos procesos para hacer de los ecosistemas comunidades productivas que le aseguran un medio de subsistencia a una gran cantidad de especies?

ENTENDER LA NATURALEZA TROPICAL PARA TRABAJAR DE SU LADO, NO EN SU CONTRA

Los bosques tropicales tienen un gran valor práctico para muchas personas —mucho más que cualquier cosa con que la que se les termine sustituyendo—. Por eso debemos entender cómo funcionan: cómo logran mantener esa productividad y esa diversidad tan altas. Aunque la naturaleza tropical es degradada diariamente por personas que no entienden este hábitat, o que carecen del interés o los incentivos para cuidarlo, los bosques tropicales se pueden usar sosteniblemente para extraer madera y otros productos, si se trabaja del lado de la naturaleza, no en su contra. Muchos silvicultores visionarios, tanto en el trópico como en las zonas templadas, están tratando de que la extracción de madera se asemeje lo más posible a perturbaciones naturales de las que los bosques pueden recuperarse, porque están adaptados para ello. Los agricultores también se benefician cuando aprenden a trabajar con la naturaleza. Hay más probabilidades de que la gente cuide la tierra si esto le genera ganancias; de ahí que una tenencia de la tierra segura y que les permita a los agricultores sacar provecho de las mejoras que hagan es esencial para lograr un uso cuidadoso y sostenible de la tierra. Además, trabajar del lado de la naturaleza supone entender la tierra y amarla de verdad. Solo podemos trabajar del lado de la naturaleza tropical si entendemos cómo trabaja la naturaleza tropical.

57

El fuego se propaga rápidamente por la paja canalera. Actualmente, este agresivo pasto, *Saccharum spontaneum*, originario del sureste asiático, coloniza potreros abandonados y sitios en barbecho en la cuenca del Canal de Panamá. Las quemas constantes impiden que los árboles reemplacen el pasto.

58

Las plantas verdes son los productores primarios del bosque. Durante el proceso llamado fotosíntesis, las hojas de estas plantas usan la radiación solar para fabricar azúcar a partir del agua que toman del suelo y del dióxido de carbono que toman del aire. Este proceso suple de alimento a toda la comunidad forestal.

LA VIDA DE
LAS PLANTAS

LA VIDA DE LAS PLANTAS

Nosotros, y prácticamente todos los organismos de este planeta, somos huéspedes de las plantas verdes. La fotosíntesis, el proceso mediante el cual las plantas combinan dióxido de carbono y agua para fabricar carbohidratos y oxígeno suministra la energía que hace posible la vida en el planeta (fig. 8). Hasta los carnívoros que desdeñan alimentos vegetales comen herbívoros, o animales que se alimentan de herbívoros, o animales que se alimentan de animales que se alimentan de herbívoros. Estas cadenas alimentarias tienen relativamente pocos eslabones porque en cada nivel se necesitan 10 kilos de alimento para construir 1 kilo de animal. Por eso, en lo más alto de la cadena hay muy pocos animales como para constituir una fuente confiable de alimento. Para

59

Las plantas no solo dan de comer a la comunidad forestal, también construyen hábitats, "autopistas" y "caminos vecinales". Al conectar las copas de los árboles, las lianas les proporcionan senderos a muchos habitantes de los árboles, como los monos y las ardillas, así como a otras criaturas más pequeñas, como las hormigas y las termitas.

"construir" un *Micronycteris hirsuta*, un murciélago de 14 gramos que de noche sale a cazar libélulas, que, a su vez, se alimentan de arañas, que, a su vez, se alimentan de avispas, que, a su vez, se alimentan de orugas, que, a su vez, se alimentan de hojas, se necesitan 142 gramos de libélulas, que, a su vez, debieron haber comido 1,4 kilos de arañas, que debieron haber comido 14 kilos de avispas, que debieron haber comido 136 kilos de orugas, que debieron haber comido tonelada y media de hojas. A decir verdad, solo una pequeña parte de las calorías de este murciélago experimenta tantas transformaciones a partir de la materia vegetal. El *Micronycteris hirsuta* también se alimenta de orugas y esperanzas vegetarianos, como más abajo en la cadena alimentaria, las arañas que cayeron presa de las libélulas atraparon insectos vegetarianos y avispas depredadoras.

Una hectárea de bosque tropical carga entre seis y ocho hectáreas de hojas. En otras palabras, tiene un índice de área foliar de entre seis y ocho (fig. 60). ¿Cómo sabemos esto? Quien les escribe lo determinó en Barro Colorado midiendo la cantidad de hojas que caían semanalmente en un área determinada de trampas de hojarasca durante un periodo de dos años. El resultado: el bosque dejaba caer aproximadamente siete hectáreas de hojas por hectárea de terreno por año. Si la vida media de una hoja en Barro Colorado es de un año, el índice de área foliar en este lugar debe ser de aproximadamente siete. En Malasia, en la Reserva

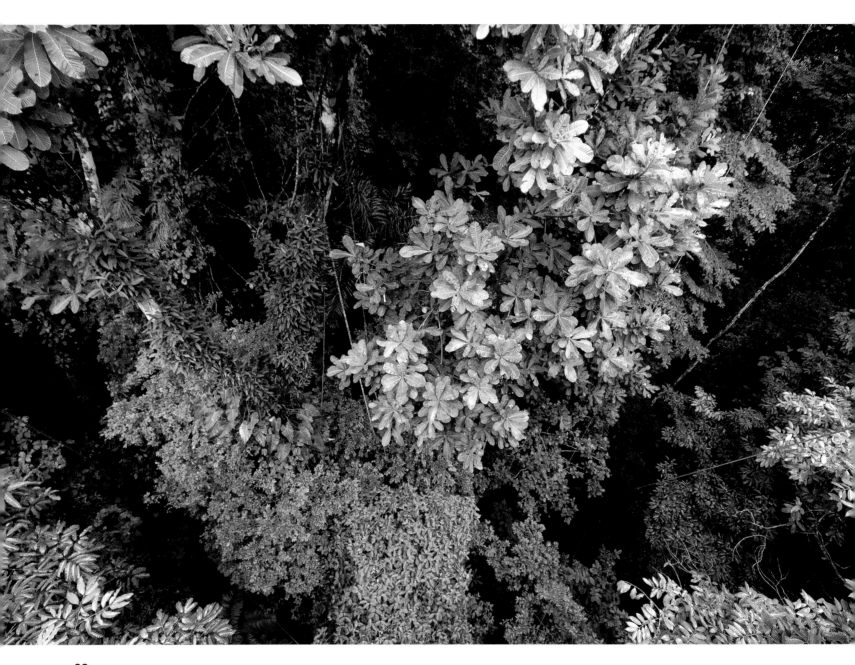

60

La densidad de las hojas de un bosque se mide calculando los metros cuadrados de hojas verdes por metro cuadrado de terreno, relación que se conoce como "índice de área foliar". En Barro Colorado, el índice de área foliar es de alrededor de siete, lo que significa que hay siete metros cuadrados de hojas por metro cuadrado de terreno. Una vista desde lo alto de una torre de observación permite apreciar las distintas capas foliares que componen el dosel de la Isla.

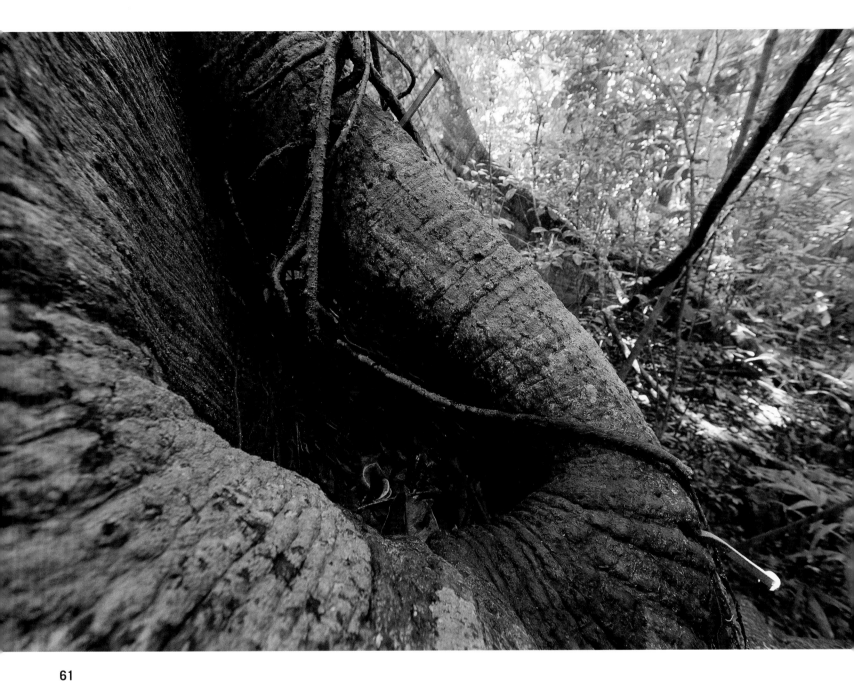

61

Un agujero lleno de agua en las gambas de una ceiba sirve de hogar a un grupo específico de animales. Allí puede alojarse una comunidad entera, un microcosmos de organismos unicelulares que degradan hojarasca y descomponen cuerpos muertos y larvas de diferentes insectos, así como renacuajos y ranitas que, además de comer descomponedores, también se comen entre sí.

62

Además de las legiones de insectos que comen plantas, también hay vertebrados que comen hojas. Uno de estos "vegetarianos" es la iguana verde, *Iguana iguana*, un reptil de tamaño considerable y hábitos mayormente arborícolas. Cuando son jóvenes, el color verde brillante que las cubre les permite confundirse con la vegetación.

Forestal de Pasoh, un equipo japonés que investigaba la productividad del bosque lluvioso bajo la dirección de Ryosuke Kato, cortó los árboles de una parcela de 2000 metros cuadrados y midió el área que ocupaban las hojas. Los árboles cargaban 16 000 metros cuadrados de hojas, ocho veces el área de la parcela: el área foliar de la parcela era de ocho.

Un bosque tropical no gana nada agregando más hojas. Kyoji Yoda, otro integrante del equipo japonés, observó que dada una hectárea bosque, cada hectárea de hojas intercepta aproximadamente la mitad de la luz que recibe. La mitad de la luz atraviesa la hectárea superior de hojas, una cuarta parte, las dos hectáreas superiores y así sucesivamente, de modo que solo un 1/256, o un 0.4%, atraviesa las ocho hectáreas de hojas y llega al suelo. Muy poca luz para impulsar un mayor crecimiento vegetal ahí. A la vez, si el índice de área foliar se redujera de ocho a seis, la cantidad de luz que llegaría al suelo se multiplicaría por cuatro, suficiente para dar a las plántulas y a las hierbas terrestres un buen comienzo en la vida. En la mayoría de los bosques tropicales maduros, sin embargo, solo un 1% de la luz incidente llega al suelo: demasiado poca para dar soporte a más hojas.

¿Cuánta energía generan las hojas de un bosque? En el Instituto Smithsonian de Investigaciones Tropicales, Gerhard Zotz, estudiante de posgrado, y su profesor Klaus Winter, encontraron que la fotosíntesis total diaria de una hoja expuesta al sol en e dosel equivale a unas seis horas de fotosíntesis a la tasa máxima de la hoja. A máxima potencia, la fotosíntesis en un metro cuadrado de hojas de sol de un bosque maduro típico produce 1.3 gramos de azúcar por hora. En promedio, ese metro cuadrado de hojas produce ocho gramos de azúcar por día, suficiente para generar 129 600 julios por día, o 1.5 vatios (1.5 julios por segundo), un cuarentavo de la potencia que se necesita para mantener encendido un bombillo de 60 vatios.

La fotosíntesis de una hectárea de bosque puede estimarse partiendo del supuesto de que cada hectárea de hojas recibe la mitad de la luz que recibe la capa superior y así sucesivamente, y calculando la fotosíntesis de cada hectárea de hojas durante cada media hora del día a partir de la cantidad de luz recibida en ese lapso. Estos cálculos hacen pensar que un metro cuadrado de bosque en Barro Colorado, lo mismo que un metro cuadrado de bosque en la Reserva Forestal de Pasoh, produce 24 gramos de azúcar por día, suficiente para mantener un suministro promedio de 4.5 vatios. Otros investigadores han estimado la fotosíntesis total de un bosque de manera empírica midiendo la velocidad a la que el bosque consume dióxido de carbono, en relación con su tasa de respiración basal nocturna, a diferentes niveles de luz y sumando la fotosíntesis que corresponde al promedio de luz recibido cada media hora del día. Este método indica que un metro cuadrado de bosque en la Amazonía, en los alrededores de Manaos, produce 21 gramos de azúcar por día; luego, una hectárea de bosque produce 75 toneladas de azúcar por año. El mismo método muestra que en el Bosque de Harvard en Massachusetts una hectárea de bosque produce un 37% de esa cantidad de azúcar al año. Los hábitats tropicales son, en efecto, más productivos que los de las zonas templadas.

Las plantas no solo alimentan al mundo; también aportan el oxígeno que hace posible una vida animal eficiente. Y dan forma a una gran cantidad de hábitats. En el bosque tropical crean el escenario que los visitantes admiran, mientras que los animales aparecen como adornos relativamente escasos. Los árboles y las lianas construyen senderos, escalerillas y pasadizos por donde los mamíferos no voladores pueden desplazarse sin tocar el suelo (fig. 59). Las plantas ofrecen sitios de anidación y descanso a animales de toda clase y de todo tamaño. Albergues, cavidades diminutas de un milímetro de ancho

a lo largo de la vena central en el envés de las hojas de *Psychotria marginata*, sirven de refugio a ácaros que mantienen las hojas bien cuidadas. Los monos duermen en las ramas de los árboles, relativamente a salvo de los jaguares. Los agujeros y las oquedades de los árboles son sitios de anidación y descanso de aves y murciélagos. Algunos árboles recogen agua en estos espacios huecos permitiendo que se formen acuarios arbóreos que son verdaderos ecosistemas en miniatura (fig. 61).

Cuando las plantas abren los estomas —unos pequeños orificios situados en las hojas— para permitir la entrada de dióxido de carbono, también dejan salir agua por evaporación. Este proceso, llamado transpiración, refresca el bosque como el sudor nos refresca a nosotros. Antes de que fuera común instalar neveras en los cuartos de los hoteles, en Egipto se acostumbraba colocar agua en jarrones de cerámica: parte del agua se evaporaba por los poros de la cerámica y el resto se mantenía agradablemente fresca. Estas jarras ilustran cómo nosotros, al sudar, nos mantenemos frescos. De igual forma, la transpiración enfría el bosque. La temperatura del bosque es más húmeda y calurosa que lo que la mayoría de las personas, excepto quienes tienen un invernadero, elegiría, pero los bosques tropicales evitan los calores y los fríos extremos, típicos de los climas desérticos. Mientras haya suficiente agua en el suelo, cuanto más caliente y soleado el clima, más va a transpirar el bosque, mientras que cuando el vapor transpirado comienza a formar nubes, la transpiración se hace más lenta. Cuanto más caliente el clima, más dióxido de carbono van a usar las plantas, lo que ocasiona un descenso en las existencias de este gas de invernadero en la atmósfera y un enfriamiento de la atmósfera. Una atmósfera más fría reduce la fotosíntesis, lo cual permite que los niveles de dióxido de carbono suban hasta recuperar el balance. Hace más de 300 millones de años, sin embargo, cuando los primeros

bosques evolucionaron, no había termitas en el mundo que degradaran la madera muerta, así que los bosques fijaron tanto carbono que se generó un enfriamiento global significativo.

¿Cuánta agua usa un bosque tropical lluvioso? En una cuenca hidrográfica o de captación verdaderamente hermética, el agua que ingresa como precipitación se evapora, sale como agua de escorrentía en la corriente que drena la cuenca o queda almacenada en el suelo. La cantidad de agua que se almacena en el suelo es prácticamente la misma al final de cada estación seca, cuando las plantas han extraído todo lo que pueden sacar sin mayor esfuerzo. La cantidad de agua que un bosque utiliza durante un año hidrológico (periodo que va del final de una estación seca al final de la siguiente) es el volumen de agua que entra a la cuenca como lluvia menos el volumen que sale como agua de escorrentía. Los bosques tropicales que reciben más de 1.7 metros de lluvia al año usan alrededor de 1.4 metros de estos 1.7 metros básicamente para transpirar (tabla 2.1). En la microcuenca de Conrad, en Barro Colorado, la diferencia entre la precipitación y la escorrentía es sorprendentemente alta, de unos dos metros, como si parte del agua se estuviera escapando por el suelo. Robert Stallard, geólogo del Departamento de Recursos Hídricos del Servicio Geológico de los Estados Unidos, considera que, incluso en la microcuenca de Lutz, que se pensaba que no perdía agua, un 10% de la precipitación podría estarse filtrando por el suelo.

Buena parte del agua que se evapora de este modo regresa al bosque forma de tormenta convectivas. Como señaló el especialista en Botánica Tropical E. J. H. Corner, la evapotranspiración "se convierte en la tarea primordial del bosque, que, a través de su copiosa transpiración, termina engendrando sus propias tormentas".

Una evapotranspiración anual de 1.4 metros equivale a una evaporación anual de 1.4 toneladas de agua por

63-64

Las raíces deben captar y transportar agua y nutrientes. También tienen que estabilizar al árbol, tarea nada fácil cuando se trata de un árbol de 45 metros de altura, con una copa voluminosa, cargada de lluvia y azotada por vientos inclementes. Para afianzarse mejor, los árboles del trópico desarrollan raíces que pocas veces, o quizá nunca, se ven en las zonas templadas, como las raíces zancudas de la "palma que camina", *Socratea exorrhiza* (fig. 63, arriba), los "arbotantes" de las *Cecropia* sp. (fig. 64, a la derecha) y los aletones de la *Tachigalia versicolor* (fig. 65).

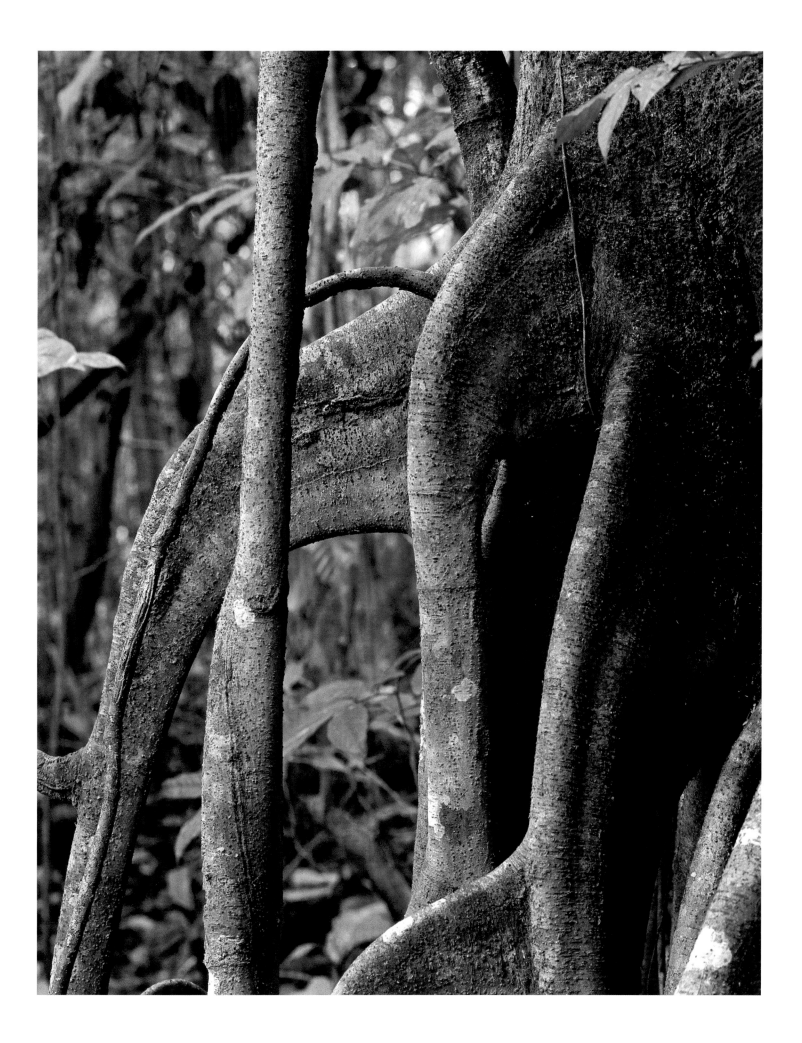

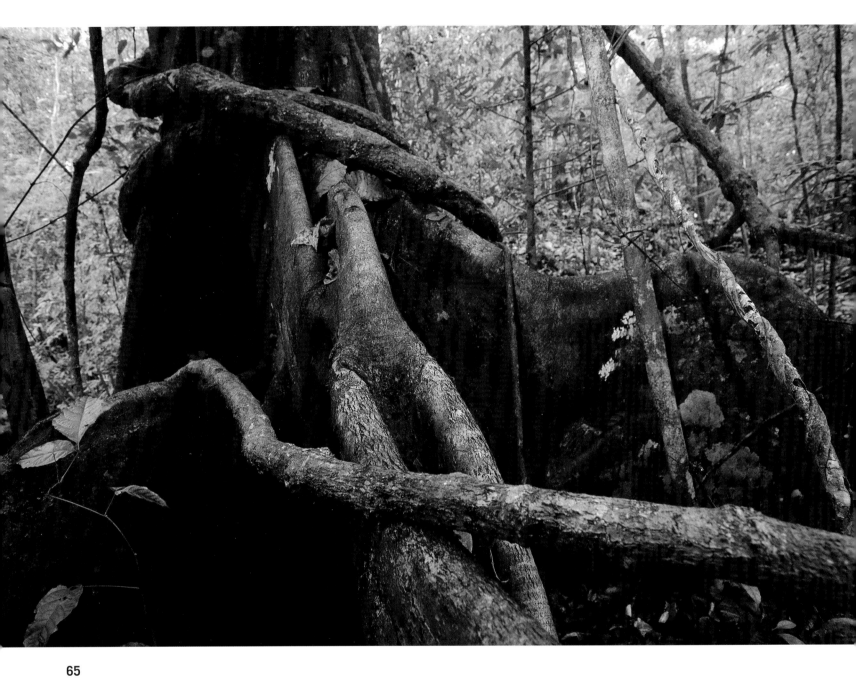

65

Los aletones que se muestran en la imagen sirven de soporte
a una *Tachigalia versicolor*.

metro cuadrado de bosque. Un metro cuadrado de bosque "suda" 4 kilos de agua por día, o un 1 gramo de agua cada 11 segundos de luz diurna. Una tasa de evaporación como esta consume más de 100 de los 200 (+-50) vatios de energía solar que recibe un metro cuadrado de bosque como promedio anual. La evapotranspiración, entonces, consume más de veinte veces la energía que se genera con la fotosíntesis. En otra época, cuando la atmósfera era mucho más rica en dióxido de carbono, una proporción más pequeña de las células superficiales de las hojas de las plantas eran estomas. Pareciera que la función principal de los estomas es permitir la entrada de dióxido de carbono, no extraer nutrientes del agua del subsuelo y llevarlos hasta las hojas, o enfriar el bosque.

Las plantas tienen que crecer hacia arriba para obtener la luz que necesitan para la fotosíntesis. Tienen que desarrollar raíces para captar agua y nutrientes del suelo. Tienen que sobrevivir para reproducirse y no morir antes de tiempo por causa de una tormenta, una plaga o una enfermedad. Todas estas demandas compiten por los beneficios de la fotosíntesis. ¿Cómo distribuir los recursos disponibles entre todas estas necesidades: reproducirse, defenderse de los herbívoros, desarrollar madera para impedir que las hojas queden a la sombra de las plantas vecinas, y desarrollar raíces que aseguren un suministro adecuado de agua y la captura de nutrientes antes de que las plantas vecinas se los lleven? Veamos cada una de esas opciones en detalle.

TABLA 2.1

Evapotranspiración y escorrentía anual en bosques tropicales seleccionados (en mm)

Sitio	Evapotranspiración	Escorrentía
Barro Branco (cerca de Manaos, Brasil), 1982	1463	909
Barro Branco (cerca de Manaos, Brasil), 1983	1424	482
Río Caura, Venezuela, 1982-1984	1425	2425
Barro Colorado, Quebrada Lutz, 1981	1811	2354
Barro Colorado, Quebrada Lutz, 1982	1464	360
Sungei Tekam, Malasia	1498	229
Guma, Sierra Leona	1217	4578
Coweeta, Carolina del Norte, EE. UU. (cuenca 18)	858	955
Noroeste de Baltimore, Maryland, EE. UU.	807	159

Nota: La evapotranspiración se define como precipitación menos escorrentía. Los bosques tropicales de tierras bajas presentan una evapotranspiración anual muy similar, cercana a los 1400 mm, casi independientemente de la precipitación, siempre que la precipitación anual supere los 1700 mm. En los bosques templados, la evapotranspiración es más baja.

66-67

La mayoría de los árboles del dosel elevan su tronco para
llevar su corona de hojas a la luz. En los bosques tropicales,
sin embargo, la lucha por la luz es tan intensa que algunas
plantas —trepadoras, epífitas y hemiepífitas— aprovechan
la madera de otros árboles para colocar sus propias hojas
al sol. Al usar la madera de árboles autónomos, estas
plantas reducen su inversión en estructuras de soporte no
fotosintéticas. Por consiguiente, presentan mucho menos
madera por metro cuadrado de hojas que los árboles.

Las lluvias frecuentes y la ausencia de heladas favorecen
la abundancia y la diversidad de epífitas vasculares,
incluyendo muchos tipos de orquídeas, aráceas,
bromeliáceas y helechos. Las epífitas, sin embargo, tienen
que hacer sacrificios significativos para poder ocupar un
puesto bajo el sol. Como no tienen acceso al suelo y, por
tanto, a un suministro relativamente estable de agua y
nutrientes, tienen que satisfacer estas necesidades en otra
parte. Algunas bromeliáceas (miembros de la familia de la
piña), como esta *Vriesia gladioliflora* (fig. 66), distribuyen
sus hojas de manera que se forma un tanque central donde
se acumula agua, basura y hojas muertas. Este humus libera
nutrientes que son absorbidos por la planta a través de unas
estructuras especiales en la base de las hojas.

66

Algunas hemiepífitas, incluidas muchas aráceas, comienzan
su vida como trepadoras, pero con el tiempo cortan su
conexión con el suelo. Al igual que las epífitas normales,
esas aráceas no le hacen daño al árbol hospedero, salvo
añadirle un poco de peso. Otras hemiepífitas, como la
que se observa en la figura 67, comienzan su vida como
epífitas, pero terminan anclando las raíces al suelo para
asegurarse un suministro más estable de agua y nutrientes.

Los higuerones estranguladores ("matapalos") han
perfeccionado esta segunda estrategia. Las raíces de un
estrangulador terminan encerrando el tronco del hospedero,
dejándolo sin espacio para crecer o desarrollar nuevos vasos
conductores que lleven agua y nutrientes a las hojas. Una
vez que el hospedero muere, el estrangulador, cuyo tronco
ahora sí puede sostener el peso de su propio follaje, hereda
el lugar del hospedero en el dosel.

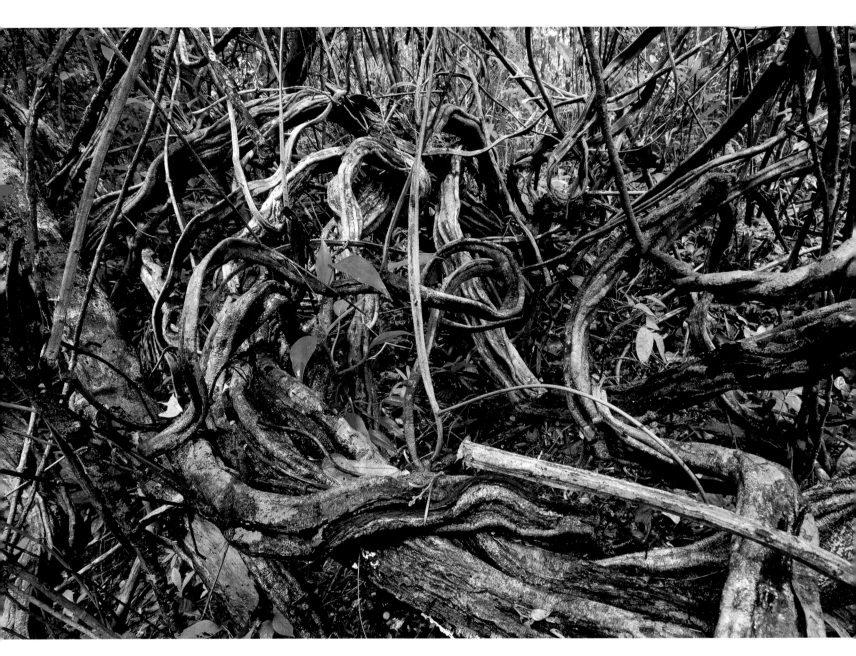

68

Las lianas —trepadoras leñosas— pueden alcanzar dimensiones considerables. En Barro Colorado, una liana se extendió sobre 49 árboles para cubrir media hectárea de bosque. Las lianas pertenecen a muchas familias de plantas diferentes. La parcela de monitoreo de 50 hectáreas de Barro Colorado alberga 21 000 árboles de más de 10 centímetros de diámetro de 229 especies diferentes, pero también 43 000 lianas de más de 1 centímetro de diámetro de 163 especies diferentes. Las lianas aportan aproximadamente el 15% de los 100 kilómetros cuadrados de hojas que hay en Barro Colorado. Cada tipo de liana tiene su propio método de ascenso.

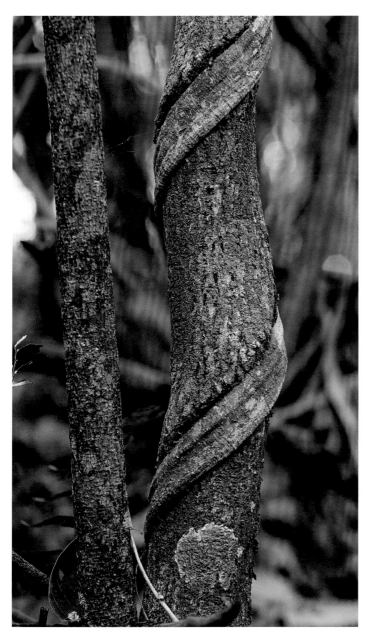

69

Las trepadoras de tallo voluble se enroscan alrededor de su soporte. Pocas pueden escalar tallos de más de diez centímetros de ancho. Frecuentemente se observan árboles jóvenes que, al crecer, quiebran la enredadera que ceñía su tallo. La trepadora muere, pero la huella de su presencia —un canal en forma de espiral— permanece.

70

Las trepadoras no adhesivas enroscan "zarcillos" —hojas, foliolos y otras estructuras semejantes modificadas— alrededor de la planta de soporte para mantenerse erguidas. Esta es la forma más económica de trepar. No obstante, como los zarcillos rara vez miden más de diez centímetros, la trepadora tiene que encontrar soportes delgados (pocas veces de más de cinco centímetros de diámetro) para poder enroscarse a ellos.

EN BUSCA DE LA LUZ

La lucha por la luz es lo que le confiere al bosque su estructura, así como la belleza y el porte grandioso de los troncos de los árboles del dosel. El tronco y las ramas son los medios de que dispone un árbol para elevar sus hojas por encima de las de sus "vecinos". Así, la belleza de un bosque es un claro ejemplo de una "tragedia de los bienes comunes", donde el deseo de cada uno de los miembros de la sociedad de satisfacer su propio interés cortoplacista, explotando un recurso que pertenece a todos, lesiona el acceso de todos a ese recurso. La tragedia de los árboles comenzó en una pradera primigenia hace 400 millones de años, cuando un nuevo tipo de planta reemplazó a sus competidoras, al emplear troncos leñosos para elevar las hojas por encima de las de sus rivales. Para sobrevivir, las especies en competencia tuvieron que hacer lo mismo, o, en su defecto, adaptarse a vivir en la sombra. Ahora bien, una hectárea de bosque tropical necesita 200 toneladas o más de madera en peso seco para sostener las seis u ocho hectáreas, seis u ocho toneladas en peso seco de hojas, que carga encima. De hecho, como veremos más adelante, el bosque de Barro Colorado destina más energía a

71

Las trepadoras adhesivas, como esta *Monstera*, se pegan o adosan de alguna forma al tronco del hospedero. Aunque pueden escalar troncos de cualquier tamaño, la suya es la forma más costosa de trepar.

fabricar madera para colocar sus hojas al sol que a fabricar las hojas mismas.

A esto hay que sumarle que en un bosque maduro, la luz se reparte de manera muy desigual entre las hojas. Las hojas del dosel reciben más luz de la que pueden usar, mientras que las hojas de las plantas que crecen en el suelo profundamente sombreado del bosque apenas si reciben la luz necesaria para sobrevivir. Los silvicultores siempre han sabido que cuando el dosel de un bosque se cierra y las copas de los árboles vecinos comienzan a tocarse, la productividad baja, porque el cierre del dosel agrava la desigualdad en la distribución de la luz entre las hojas.

LA RUTA HACIA EL SOL SE CONSTRUYE CON MADERA

¿Cómo se compara la producción de hojas con la producción de madera? En Barro Colorado caen cerca de siete toneladas de hojas en peso seco por hectárea por año, lo que representa una producción anual de ocho toneladas de hojas por hectárea. Para medir la producción de madera directamente habría que medir el incremento en altura y en diámetro de cada uno de los árboles de una parcela, tarea difícil e incierta. Sin embargo, la producción de madera se puede medir indirectamente. En Barro Colorado se estableció una parcela de monitoreo de 50 hectáreas, donde se marcó e identificó todo tallo de más de un centímetro de diámetro que no fuera una liana. El diámetro de cada uno se midió en 1982 y cada cinco años a partir de 1985. La tasa de mortalidad de árboles con tallos de 5 a 80 centímetros fue de 2% por año de 1985 a 2005, mientras que la composición de tamaños del bosque prácticamente no varió. Esta parcela tiene unas 275 toneladas de madera en peso seco por hectárea. Por tanto, la producción de madera debe ser de alrededor de un 2% de esa cifra:

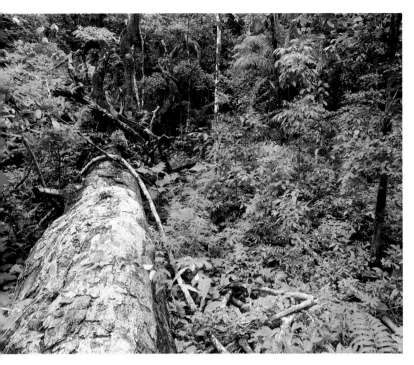

72

Los claros que se abren en los bosques tropicales al caer un árbol marcan el ritmo de crecimiento de los árboles. Las especies pioneras o heliófitas colonizan estos espacios tan pronto como se abren.

ANTES Y DESPUÉS DE LA CAÍDA DE UN ÁRBOL: CÓMO CAMBIAN LAS CONDICIONES DE LUZ

73

En un tiempo sorprendentemente corto ya se observa una gruesa capa de vegetación.

74

Tras varias décadas, en un proceso llamado sucesión, comenzarán a llegar más especies de árboles tolerantes a la sombra del "bosque viejo", las cuales, con el tiempo, acabarán reemplazando a las especies pioneras, que viven relativamente poco. Este claro se abrió al caer un árbol de grandes dimensiones en abril del 2000. La primera foto (fig. 72) se tomó en junio del 2000, la segunda (fig. 73) en octubre del 2000 y la última (fig. 74) en abril del 2001. Buena parte de la diversidad de árboles que se observa en los bosques tropicales se debe a que el bosque es un mosaico de diferentes estados de sucesión, cada uno de los cuales le ofrece condiciones óptimas a un grupo determinado de especies de árboles.

75-76

La disponibilidad de luz en el bosque cambia radicalmente cuando un árbol se desploma, como ocurrió con este higuerón estrangulador (fig. 75), que se vino al suelo poco después de que se tomara esta foto, desatando una carrera entre los miles de plántulas y árboles jóvenes (fig. 76) que se encontraban a la sombra esperando a que llegara luz suficiente para iniciar su ascenso hacia el dosel. Al final, solo un árbol reemplazará al higuerón, con lo cual, dentro de muchas décadas, la bóveda forestal volverá a cerrarse.

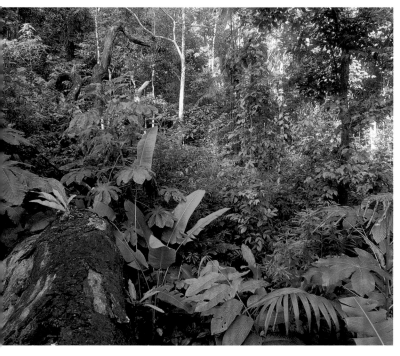

73

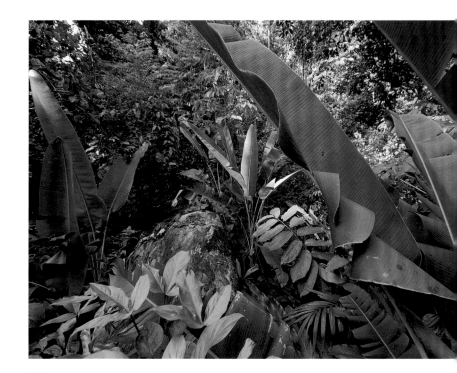

74

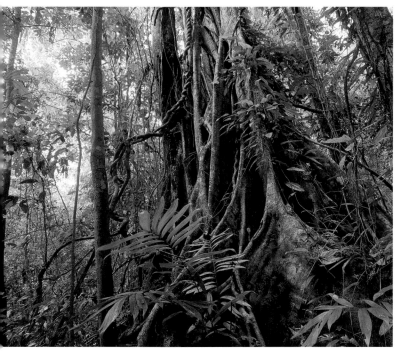

75

76

5.5 toneladas de peso seco por hectárea, sin incluir las ramitas pequeñas. En Barro Colorado, los colectores de hojarasca recogen anualmente cerca de 1.75 toneladas en peso seco de ramitas por hectárea. Estas ramitas están medio descompuestas, así que representan una producción de ramitas de 3.5 toneladas de peso seco por hectárea. Entonces, si se incluyen ambas, la producción de ramitas y la producción de "madera en grande", se tiene que este bosque invierte más en colocar las hojas al sol que en fabricarlas.

A veces los troncos altos necesitan apoyarse en estructuras especiales para mantenerse erguidos. Palmas como la *Socratea exorrhiza* se apoyan en raíces zancudas (fig. 63). Por lo general cuando una palma de estas se cae es porque se quebró justo encima de donde estos "zancos" (raíces fúlcreas) se unen para formar el tronco: los "zancos" mismos son un soporte muy fuerte. Árboles como el *Protium panamensis,* y las distintas especies de *Cecropia* que brotan en los claros que se abren al caer un árbol apoyan su tronco en raíces que salen del tronco a manera de arbotantes (fig. 64). Muchos árboles apuntalan su tronco con grandes aletones basales, a veces rectos, a veces ondulados. Estos aletones son lo que los biólogos tropicales llaman "gambas" o "contrafuertes" (fig. 65). Los contrafuertes de las *Ceiba pentandra* son realmente espectaculares. Por lo general, los contrafuertes de los árboles presentan un mayor desarrollo de cara al viento, puesto que funcionan como cables de amarre para impedir que el árbol se desplome ante el paso de un vendaval.

CRECIENDO EN MADERA AJENA: LAS LIANAS Y LAS EPÍFITAS

La lucha por la luz es tan intensa que algunas plantas aprovechan la madera de otras para colocar sus hojas al sol. Las epífitas o "plantas aéreas" se acercan al sol asentándose en las ramas de los árboles (fig. 66), pero usan a su anfitrión solo como apoyo. Para una epífita no es fácil sobrevivir, sobre todo en las tierras bajas, donde las lluvias suelen ser esporádicas, y ellas no extraen ni agua ni nutrientes de su anfitrión.

Entonces, ¿cómo hacen las epífitas para obtener agua y nutrientes? Muchas bromelias acumulan agua y detrito en la base de las apretadas rosetas que forman con sus hojas inclinadas (fig. 66). El agua atrae insectos acuáticos y renacuajos, cuyas heces y cuerpos muertos fertilizan ese detrito. Las bromelias envían raíces en dirección al humus que se va formando a extraer agua y nutrientes. José Luis Andrade, quien hizo investigación de posgrado en Barro Colorado, se preguntó cómo hacían otros tipos de epífitas para obtener agua y nutrientes. Observó que un helecho epífito soluciona el problema atrapando polvo y detrito en un canasto de raíces, para formar un suelo fértil y con buena capacidad de retención de agua. Los cactus epífitos, en cambio, no hacen canastos de raíces, así que tienen que enraizar en cavidades provistas de suelo fértil. Tales sitios son más bien escasos y se encuentran muy distanciados entre sí, pero si un cactus logra asentarse en uno de ellos, puede crecer más rápido que un helecho epífito que invierte en construir un canasto de raíces.

Pocas veces se han hecho recuentos de epífitas. Sin embargo, cuando los miembros de un equipo de investigación liderado por T. Yamakura talaron la octava parte de una hectárea de bosque lluvioso en Sebulu, Borneo, para determinar el área foliar y el peso de la madera de los árboles y lianas que habían cortado, aprovecharon para medir el área foliar de las epífitas, y secar y pesar el tejido de apoyo. Fue un trabajo arduo, tedioso y costoso. A juzgar por la muestra, una hectárea de bosque tenía 680 metros cuadrados de hojas de epífitas apoyadas en 236 kilos de raíces y tallos en peso seco. Las epífitas emplearon 350 gramos de materia

vegetal en peso seco para sostener un metro cuadrado de hojas. En esa misma hectárea, los árboles emplearon más de 800 toneladas de madera en peso seco para sostener aproximadamente 7 hectáreas de hojas, más de 12 kilos de madera en peso seco por metro cuadrado de hojas. Los árboles usaron 35 veces más materia seca para sostener un metro cuadrado de hojas que las epífitas. A pesar de esta extraordinaria ventaja, las epífitas aportaron menos de un 1% del área foliar de este bosque lluvioso.

Los higuerones estranguladores (matapalos) y algunas otras plantas comienzan su vida como epífitas, pero luego dejan caer las raíces al suelo. A estas plantas se les denomina hemiepífitas. Los matapalos construyen su tronco alrededor del tronco de un árbol hospedero (más rápido así que tener construir un tronco sin ayuda) y cuando ya han rodeado el tronco del hospedero, lo matan, pues le impiden seguir creciendo. Así, el estrangulador hereda el lugar del hospedero en el dosel del bosque (fig. 67). No obstante, para poder tomar posesión de ese sitio soleado, las plántulas de los matapalos tienen que tener acceso a una abundante cantidad de tierra atrapada. Lo ideal es que alcancen un agujero medio descompuesto y lleno de tierra en el hospedero mismo, pero, por lo general, esos sitios son más escasos que las cavidades donde puede prosperar un cactus epífito. Con todo, los matapalos se instalan sin problema en las hojas de algunas palmeras, porque el humus que acumulan en la base de las hojas les ofrece a sus plántulas un buen comienzo en la vida.

Las lianas son trepadoras leñosas que pueden llegar a tener más de 10 centímetros de diámetro y que viajan a la luz trepándose al tronco o a las ramas de otros árboles (fig. 68). Los experimentos que llevó a cabo Francis Putz como estudiante de posgrado en Barro Colorado mostraron que las lianas podían crecer en la parte más oscura del bosque, si tenían el soporte adecuado.

Las lianas jóvenes sortean el problema de falta de luz subiéndose a otras plantas. Putz observó que el sitio donde puede crecer una liana y qué tan rápido puede hacerlo depende de cómo se adhiera al hospedero. En efecto, parece que hay un compromiso (*trade-off*) entre qué tan rápido puede ascender una liana cuando tiene a su disposición una gran cantidad de soportes adecuados y la variedad de soportes que siquiera le van a permitir crecer. Algunas lianas enroscan zarcillos (hojas modificadas) alrededor de su soporte (fig. 70). Como los zarcillos rara vez miden más de 10 centímetros, el soporte no puede tener más que unos pocos centímetros de circunferencia. A la vez, los zarcillos son la forma más económica de colgarse a un hospedero; donde hay soportes de tamaño adecuado disponibles, las trepadoras de zarcillos pueden dejar atrás a otro tipo de lianas. Las enredaderas que se enroscan alrededor del hospedero pueden asirse a soportes más gruesos (fig. 69). Las que tienen ramas laterales, semejantes a ganchos, no tienen problema en adosarse a soportes de más de 10 centímetros, algo imposible para una enredadera corriente. Las trepadoras adherentes, por su parte, pueden subirse a troncos de cualquier tamaño, si tienen suficiente luz para hacerlo (fig. 71). Las trepadoras adherentes cambiaron la limitación por escasez de soportes apropiados por la limitación por escasez de luz.

Cuando una liana llega al final de su soporte, ya no puede ir más lejos, a menos que logre asirse a un soporte que esté a uno o dos metros de su predecesor. Por eso, aunque las lianas no están limitadas por la escasez de luz, se desarrollan mejor en los bordes de los claros que se abren al caer un árbol, porque ahí hay más soportes disponibles y a distancias convenientes.

Se necesita menos madera para sostener un metro cuadrado de hojas de lianas que para sostener un metro cuadrado de hojas de árbol. En Barro Colorado no se han

LA ARQUITECTURA FOLIAR DEL SOTOBOSQUE

Solo un 1% de la luz que incide en el dosel logra filtrarse al suelo. Por esta razón, las plantas del sotobosque, incluidas las plántulas y los árboles jóvenes de especies tolerantes a la sombra disponen las hojas de modo que puedan captar la mayor cantidad de luz por centímetro cuadrado. Las hojas se colocan en posición horizontal, perpendiculares a la luz, para no hacerse sombra unas a otras. Las plantas de sombra logran este objetivo de muchas maneras:

Xanthosoma helleboricum presenta hojas compuestas con foliolos dispuestos en espiral doble (fig. 77).

Geophila repens extiende sus estolones por el suelo, los cuales se van ramificando de tanto en tanto, formando apretados tapetes de hojas (fig. 78).

Los estolones de esta *Serjania* presentan hojas compuestas que se alternan ordenadamente a uno y otro lado del tallo para evitar traslapes (fig. 79).

Chrysothemis friedrichsthaliana organiza sus pocas hojas en forma de roseta, pegadas al suelo. El par superior se observa rotado 90° con respecto al par inferior para evitar traslapes (fig. 80).

Este árbol joven de *Virola sebifera* presenta una sola capa de hojas dispuestas en un solo plano y organizadas en una espiral compuesta por cinco ramitas (fig. 81).

Esta plántula de *Alseis blackiana* sostiene una roseta formada por muchas hojas, largas, angostas y planas. Cada par de hojas opuestas se encuentra rotado unos 70° con respecto al par inferior, lo que distribuye las hojas de manera notablemente pareja alrededor del tallo (fig. 82).

Aquí, la escalera de caracol que forma el *Costus pulverulentus* (fig. 83) vista desde arriba.

77

78

Las flores de *Psychotria acuminata* brotan en la punta de las ramitas y luego las ramitas se bifurcan. El resultado es una sombrilla de rosetas de hojas (fig. 84) que se construyen al estilo de las rosetas de *Chrysothemis friedrichsthaliana*.

Las ramas de *Psychotria chagrensis* se bifurcan asimétricamente formando ramilletes horizontales de rosetas de hojas (fig. 85). Cada roseta es como una versión en pequeño de las rosetas de *Chrysothemis*.

Los arbolitos jóvenes de *Terminalia amazonica* extienden las hojas en capas. Cada rama horizontal brota de una ramita corta que se dispara en vertical con una roseta de hojas en espiral. Debajo de cada roseta brotan una o más ramitas cortas que forman racimos horizontales de rosetas de hojas (fig. 86).

87

88

89

90

Mientras que las hojas de sombra del ucuuba, *Virola surinamensis* (fig. 87), son planas y horizontales, las hojas expuestas al sol se organizan a ambos lados de las ramitas doblándose en la nervadura central para que la luz se distribuya sobre la mayor área posible de hoja (fig. 88). Las hojas expuestas al sol del caracolí o espavé, *Anacardium excelsum,* crecen en forma inclinada con respecto a sus ramitas, formando espirales cerradas cerca de la punta (fig. 89). La escalera de caracol que construyen las hojas de *Costus pulverulentus* (fig. 90) vista de lado.

recogido datos que permitan corroborar esta afirmación, porque esto supone cortar árboles. No obstante, los pocos datos disponibles de otros bosques señalan que, en promedio, un árbol emplea de 6 a 13 kilos de madera en peso seco para sostener un metro cuadrado de hojas, mientras que las lianas emplean, en promedio, de 1.3 a 1.4 kilos. Las lianas son cuatro veces menos económicas en cuanto a tejido de sostén que las epífitas, pero mucho más económicas que los árboles.

Las lianas son consideradas el sello distintivo de los bosques tropicales. Sin embargo, Francis Putz, el estudioso de lianas de mayor renombre en la actualidad, se enteró por la revista *Northern Logger* de que la producción de madera de algunos bosques de los Apalaches estaba siendo seriamente afectada por la superabundancia de vides leñosas. ¿Qué tan comunes son, entonces, las lianas en los bosques tropicales?

Como parte de su investigación doctoral, Putz evaluó la abundancia de lianas en Barro Colorado. Encontró que el 22% de las plantas de 10 a 200 centímetros de alto que crecían en sus parcelas de monitoreo eran lianas y que el 43% de los árboles con troncos de más de 20 centímetros de diámetro cargaban lianas en sus copas. Más adelante, siendo profesor universitario, y trabajando junto a Paul Chai, un experto en gestión de bosques de Sarawak, observó que, en el fondo de los valles del Parque Nacional Lambir Hills, el 31% de las plántulas de menos de 1 metro de alto eran lianas y el 54% de los árboles con troncos de más de 20 centímetros de diámetro presentaban lianas en sus copas.

Para determinar qué porcentaje de las hojas que caen en un bosque corresponde a hojas de lianas, se necesita un botánico que identifique a qué especie pertenece cada hoja que cae en un colector de hojarasca. En Barro Colorado, el botánico Oswaldo Calderón examinó las hojas que caían en colectores de hojarasca

distribuidos en cuatro hectáreas de bosque maduro. De las 7.37 toneladas de hojas en peso seco que cayeron por hectárea en 1991, el 14% correspondió a hojas de lianas, y otro 2% no se identificó. En Sabah, Malasia, el 13% de las 6.53 toneladas de hojas que cayeron anualmente por hectárea en un bosque lluvioso maduro no perturbado correspondió a hojas de lianas, mientras que, en un bosque cercano sometido a explotación maderera, el 27% de las 6.16 toneladas de peso seco de hojas que cayeron anualmente por hectárea eran hojas de lianas.

Aunque las lianas son muy pintorescas, son un problema para el bosque. Son parásitas de la comunidad ecológica y dan poco a cambio. En Barro Colorado, y dondequiera que estén, obstaculizan el crecimiento de los árboles, aumentan su tasa de mortalidad y en algunos claros se propagan tan desmedidamente que sofocan el crecimiento del bosque por décadas.

LOS EFECTOS RESTRICTIVOS DE LA FALTA DE LUZ: LA DIFERENCIA ENTRE VIVIR A LA LUZ Y SOBREVIVIR A LA SOMBRA

Para comprender hasta qué punto la limitación de luz afecta el crecimiento de las plantas basta observar el contraste entre el sotobosque relativamente despejado que predomina bajo un dosel intacto y la afluencia de vegetación nueva allí donde la caída de un árbol ha permitido que la luz bañe profusamente el suelo (figs. 72-76).

Los efectos restrictivos de la falta de luz también se aprecian al comparar la disposición de las hojas del sotobosque con la de las hojas de los árboles del dosel. Las plantas del sotobosque extienden una o más capas horizontales de hojas planas que no se traslapan para concentrar la mayor cantidad de luz posible por centímetro cuadrado de hoja. Cuando era estudiante de

91

Los árboles pioneros, como esta *Cecropia peltata,* usan
la energía para crecer más rápido que sus rivales. Como
invierten poco en defensas contra herbívoros, las hojas
sólo viven unos meses, y necesitan estar expuestas a luz
abundante para poder costear ambos, su propio reemplazo
y el crecimiento de su planta.

posgrado en la Université Pierre et Marie Curie (Paris VI), Patrick Blanc mostró que las hierbas que crecían en la penumbra del bosque tropical presentaban el mismo repertorio de disposición de hojas en Suramérica, África y Asia. También quien les escribe, al comparar bosques de tierras bajas de distintas partes del mundo, observó que los árboles jóvenes y los arbustos del sotobosque presentaban prácticamente la misma variedad en la disposición de las hojas. Muchos, como las plántulas de *Virola sebifera* (fig. 81), extienden las hojas a lo largo de ramas horizontales que se desprenden de un tallo central erecto. Otros, como las plántulas de *Alseis blackiana* (fig. 82), forman una roseta de hojas en lo alto de un tallo que no se ramifica. Unos pocos, como los árboles jóvenes de *Terminalia* (fig. 86) y *Psychotria chagrensis* (fig. 85), forman racimos horizontales de rosetas de hojas, cada uno sobre una ramita corta que asciende de un sistema horizontal de ramas. También hay algunos cuyos tallos se bifurcan tras florecer en la punta, cada bifurcación repitiendo el proceso, para formar una sombrilla de rosetas de hojas sobre las ramitas terminales, como en *Psychotria acuminata* (fig. 84). Los árboles del dosel, por el contrario, distribuyen la superabundante luz que reciben sobre la mayor cantidad posible de superficie de hoja. Las hojas de sol de *Virola surinamensis* (fig. 88) se agrupan a ambos lados de sus ramitas, pendiendo en doblez de la nervadura central, mientras que las hojas de sombra son planas y horizontales. Otros, como *Anacardium excelsum* (fig. 89) agrupan sus inclinadas hojas alrededor de la punta de ramitas erectas, lo más cerca posible unas de otras para que se hagan sombra intermitentemente.

Algunos árboles cambian su forma de crecimiento conforme pasan del sotobosque a la luz. Las ramas de *Faramea occidentalis* crecen en pares, unidas a lados opuestos del tallo principal y rotadas 90 grados con respecto al par inferior (un orden denominado "decusado"). En el sotobosque, estas ramas se extienden horizontalmente y los peciolos de las hojas, que, al sol se ordenan en decusado alrededor de un tallo empinado, a la sombra se tuercen para que las hojas descansen horizontalmente, cada hoja del par en lados opuestos de la ramita horizontal que las sostiene. En un claro, las ramas de los *Faramea* se tuercen hacia arriba y las hojas se acomodan alrededor de las ramas, como se acomodan las ramas alrededor del tallo. En Barro Colorado, otros árboles, como los *Garcinia*, hacen lo mismo cuando están expuestos a luz abundante. Las hojas de sol son totalmente diferentes de las hojas de sombra, tanto en su fisiología como en la forma de colocarse. Las hojas de sol contienen más clorofila y más de las enzimas que se necesitan para llevar a cabo la fotosíntesis, elementos, ambos, que confieren mayor capacidad fotosintética. Pero, mantener todo este equipo fotosintético supone una serie de costos que las hojas de sombra no pueden pagar: si se estima que las ganancias van a ser pocas, hay que restringir los gastos.

Plantas que hoy ocupan un mismo puesto en el bosque también difieren de acuerdo a la altura que alcancen al madurar. Sean Thomas, estudiante de posgrado de Harvard que hizo investigación en la Reserva de Pasoh, en Malasia, observó que, incluso en condiciones de luz idénticas, un árbol joven de una especie del dosel presenta hojas con mayor capacidad fotosintética que un árbol joven de una especie del sotobosque. Después de todo, un metro cuadrado de hojas de un árbol del dosel completamente desarrollado tiene que sostener mucha más madera y raíces que un metro cuadrado de hojas de un árbol del sotobosque: para poder mantener a su árbol, las hojas del dosel tienen que tener buena luz. David King, por su parte, mientras hacía trabajo posdoctoral en el bosque lluvioso de La

Selva, en Costa Rica, observó que los árboles jóvenes de las especies del dosel tenían el tallo más delgado y la copa más angosta que otras plantas de la misma altura de especies del sotobosque.

Es más, existen al menos dos tipos básicos de plantas tolerantes a la sombra. Thomas Kursar, profesor de la Universidad de Utah que hizo investigación en Barro Colorado, encontró que algunas plantas del sotobosque presentaban hojas duras y longevas. (La hoja que tiene que el récord de longevidad en Barro Colorado vivió 14 años, cuando este tipo de hojas normalmente vive alrededor de 4 años.) Hojas tan preciadas como esta hay que protegerlas: el árbol que las porta tiene que hundir las raíces más hondo en la tierra para garantizarles un suministro de agua estable. Estas hojas pueden soportar el aumento en luminosidad que se produce cuando cae un árbol y se abre una brecha en el dosel, pero su capacidad fotosintética tiene un límite. Otras plantas del sotobosque tienen hojas menos costosas, más delgadas y más desechables, que habitualmente duran uno o dos años. Esas plantas pueden darse el lujo de perder muchas hojas, si llegaran a experimentar una sequía anormalmente fuerte, así que no necesitan hundir sus raíces tan hondo. Si llegara a abrirse una brecha de grandes dimensiones, estas plantas pueden darse el lujo

de reemplazar sus hojas por hojas nuevas con mayor capacidad fotosintética. En otras palabras, las plantas tolerantes a la sombra enfrentan un compromiso entre adaptación y adaptabilidad, entre adecuación al medio y flexibilidad para adaptarse a sus cambios. En la respuesta de una especie vegetal a este compromiso entran en juego la fisiología de las hojas y la naturaleza de las defensas contra los herbívoros, así como la estructura del sistema radicular.

EL DILEMA DE LAS PLANTAS: CRECER PRONTO A PLENA LUZ O SOBREVIVIR DISCRETAMENTE A LA SOMBRA

Todas las plantas enfrentan un compromiso fundamental: crecer aceleradamente a plena luz o ser capaces de sobrevivir a la sombra. Mientras era estudiante de posgrado de Robin Foster, la persona que más ha influido en la ruta de investigación de Barro Colorado, Nicholas Brokaw comparó la respuesta de diferentes tipos de planta a condiciones de luz y a condiciones de sombra en la Isla. Brokaw buscaba una posible relación entre el crecimiento que alcanzaban las especies pioneras y el tamaño del claro que debían tener a su disposición.

TABLA 2.2

Compromisos (*trade-offs*) entre disponibilidad de luz y tamaño del claro en tres especies pioneras

Especie	Altura alcanzada en los dos primeros años, con mucha luminosidad	Tamaño del claro necesario para sobrevivir nueve años
Trema micrantha	14 m	376 m^2
Cecropia insignis	10 m	215 m^2
Miconia argentea	5 m	105 m^2

Encontró que mientras más rápido crecía una especie pionera en un claro de grandes dimensiones, más amplio sería el claro que iba a necesitar para poder alcanzar la edad reproductiva (tabla 2.2). Este compromiso entre crecer rápido en un claro de grandes dimensiones o vivir más tiempo a la sombra significa que las tres especies citadas en la tabla tienen cierto rango de tamaños de claro donde pueden o crecer más alto o vivir más tiempo, que sus competidores.

David King, por su parte, llegó a Barro Colorado con una beca de post doctorado a estudiar qué características distinguían a los árboles de luz jóvenes de los árboles de sombra jóvenes. Para ello, analizó el crecimiento de diez especies, tres demandantes de luz y siete tolerantes a la sombra. Una *Cecropia* era su especie menos tolerante a la sombra (fig. 91). En condiciones de poca luminosidad, otras plantas responden invirtiendo menos en tejido de sostén que en hojas nuevas, pero las *Cecropia* están estrictamente programadas para invertir igualmente en ambos, independientemente del nivel de luz. Es más, las hojas de las *Cecropia*, que prácticamente no tienen defensas, viven menos de cinco meses. Por eso tienen que recibir toda la luz que puedan: para sostener el crecimiento de su árbol y para costear su propio reemplazo en unos pocos meses. Entonces, para evitar que su área foliar se reduzca, las *Cecropia* tienen que producir más materia seca por metro cuadrado de hoja por semana que cualquier otra especie. Por otro lado, con un peso seco de 0.15 gramos por centímetro cúbico, la madera de las *Cecropia* tenía la mitad de la densidad que el resto de las especies que King estaba estudiando. En consecuencia, las *Cecropia* necesitan menos materia seca para levantar un metro cuadrado de hojas un metro más alto que cualquier otra especie; así, con solo recibir un 6% de luz solar plena, la *Cecropia* creció 71 centímetros al año, casi el doble que el resto de las especies. Los otros

"amantes del sol" también tenían el tallo más liviano que sus contrapartes tolerantes a la sombra y necesitaban producir más materia seca por metro cuadrado de hoja para mantener su área foliar. De este modo, las especies demandantes de luz necesitaban un 4% o más de luz solar plena para salir adelante, mientras que las tolerantes a la sombra lo conseguían con un 3% o menos.

Casi al mismo tiempo, Kaoru Kitajima, en aquel entonces estudiante de posgrado de la Universidad de Illinois, cuya profesora, Carol Augspurger, también había hecho investigación doctoral en Barro Colorado, se encontraba en la Isla analizando las bases de este compromiso entre crecer rápido a plena luz o sobrevivir a la sombra. Kitajima estudió 13 especies de plantas con semillas dispersadas por el viento, que incluían desde un balso, *Ochroma pyramidale*, cuyas semillas solo germinan en los suelos recalentados de los grandes claros del bosque, hasta una especie de bosque maduro, *Aspidosperma cruenta*, que tiene el récord de la hoja más longeva de Barro Colorado (14 años). En su experimento, las especies que crecieron más rápido a pleno sol mostraron una tendencia a morirse más rápido a la sombra, pero fue casi una constante que las especies que crecían más rápido a plena luz también crecían más rápido que las otras a la sombra. Luego, lo que impulsa el compromiso es la alta tasa de mortalidad en condiciones de sombra, no el crecimiento lento. Las plántulas de las especies que crecían más rápido tendían presentar el área foliar más alta por unidad de peso seco de plántula. Las que sobrevivían mejor a la sombra tendían a presentar los tallos más pesados (los tallos con la mayor cantidad de materia seca por milímetro cúbico). Finalmente, a excepción de *Bombacopsis sessilis*, que presentó la mortalidad de plántulas más baja de todas, a pesar de invertir poco en raíces, las especies que sobrevivieron mejor a la sombra presentaban la proporción más alta de peso radicular en

92

93

95

96

94

92 La mayoría de los nutrientes que hay en el suelo del bosque se localizan en una delgada capa superficial. Muchas raíces, más que hundirse en la tierra, serpentean sobre el suelo para escarbar los nutrientes que se liberan de la hojarasca en descomposición.

93 Para asegurarse una fuente confiable de nutrientes y agua en un hábitat desprovisto de suelo, los helechos de *Anthurium*, como muchas otras epífitas, ordenan sus hojas de manera que en su base se acumulan residuos que luego se pudren y liberan nutrientes. Estos "canastos vegetales" absorben el agua a manera de esponjas. Este espécimen en particular está siendo utilizado como nido por un ave.

94 Esta plántula germinó en un puñado de humus que se acumuló en la base de una hoja enorme. Aunque lo más probable es que muera, la plántula continuará creciendo, apostándole a la vida.

95 En los bosques tropicales las hojas se descomponen rápidamente cuando están mojadas. Aquí se observa un parche de suelo a finales de mayo, tras una larga estación seca. Las hojas secas se han ido acumulando desde que dejó de llover . . .

96 . . . aquí está el mismo parche seis meses después, a finales de la estación lluviosa, con la mayoría de las hojas ya descompuestas.

97

Toda materia muerta libera nutrientes al descomponerse y estos nutrientes son aprovechados por otros organismos. Aquí, la deslumbrante ala de una mariposa morfo muerta yace en el suelo, descomponiéndose.

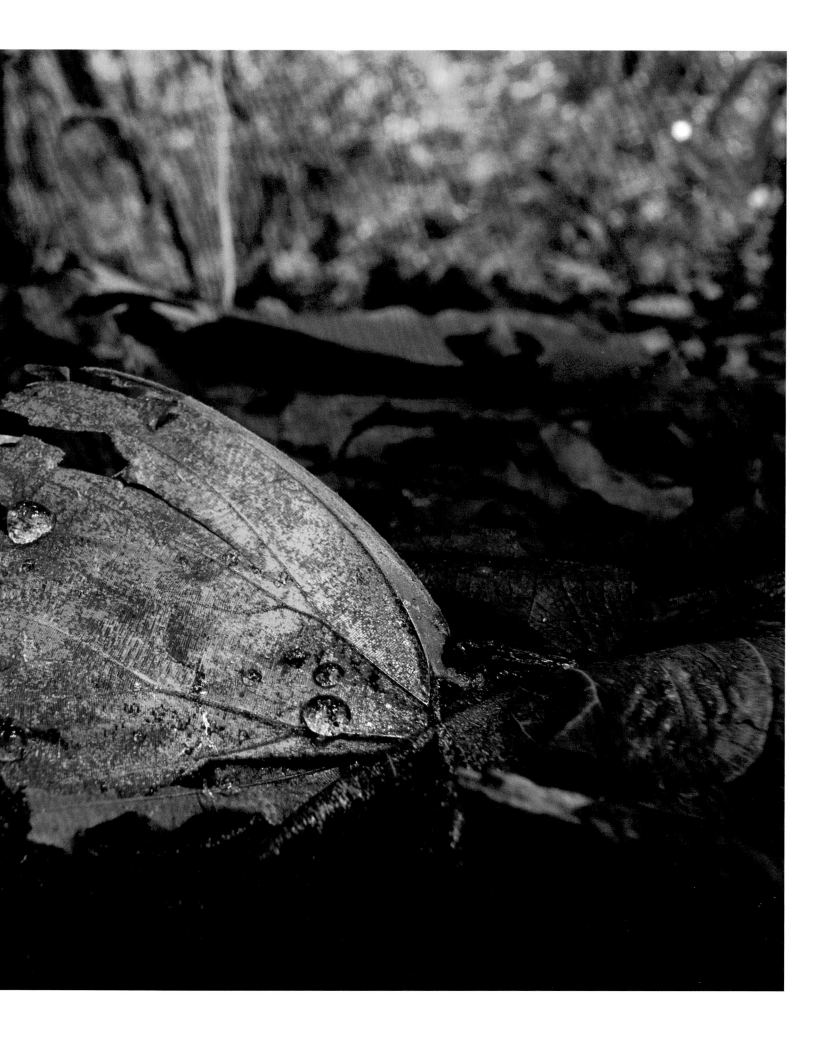

relación con el peso del brote por encima de la superficie. Por lo general, invertir en raíces mejora la tolerancia a la sombra. ¿Pero cómo compiten las plantas bajo tierra?

LA BÚSQUEDA DE NUTRIENTES Y AGUA

Las plantas necesitan nutrientes y agua para poder usar la luz del sol para construir materia vegetal y almacenar energía. Y tienen que extraer la mayor parte de los nutrientes y (sobre todo en los bosques de tierras bajas) prácticamente toda el agua que necesitan del suelo. Las epífitas, aunque no tienen que construir material leñoso para colocar sus hojas al sol, se encuentran atadas por su imposibilidad de acceder al suelo. Como hemos visto, muchas solucionan el problema construyendo un humus de detrito que les permite obtener los nutrientes y el agua que no pueden tomar del aire. Cierto, el aire está lleno de nitrógeno, pero la mayor parte de este nitrógeno es nitrógeno molecular, N_2, que las plantas no pueden procesar. Algunas plantas, al menos, absorben nitrógeno a través de las hojas, ya sea dióxido de nitrógeno, NO_2, del aire, o amoníaco, el cual es fabricado a partir de nitrógeno atmosférico por los líquenes que tienen en sus hojas. Las leguminosas, por su parte, encuentran provechoso subsidiar la presencia de bacterias del género *Rhizobium* en sus raíces, porque estas bacterias convierten el N_2 en amoniaco que la planta puede aprovechar y lo hacen en el suelo mismo para conveniencia de las plantas. Los agricultores también consideran beneficioso intercalar leguminosas en sus cultivos o usarlas como cultivos de rotación para enriquecer los suelos con nitrógeno.

LA COMPETENCIA BAJO TIERRA

Las plantas compiten tan despiadadamente —y tan dispendiosamente— por los nutrientes del suelo como compiten por la luz del cielo. Como la mayoría de las raíces crece bajo tierra es difícil ver qué están haciendo. En Barro Colorado, las señales de la competencia bajo tierra que un visitante podrá observar a simple vista son las raíces que reptan por el suelo, a menudo en mayor abundancia y alejándose a mayores distancias del árbol parental que sus contrapartes de las zonas templadas (fig. 92). Puede ser, también, que el visitante observe raíces que crecen de arriba hacia abajo, del dosel al suelo: son raíces de plantas que, al igual que los higuerones estranguladores, comienzan su vida como epífitas en la copa de los árboles. Menos comúnmente, el visitante podría toparse con una epífita que se ha caído sosteniendo firmemente en su "cesto de basura" el humus que acumuló con las hojas y el polvo que logró arrebatarle al viento, mudo testigo de la importancia de la lucha por nutrientes (fig. 93).

Barro Colorado, sin embargo, tiene suelos relativamente fértiles. En los bosques tropicales que crecen en suelos más pobres, gran parte del suelo se observa cubierta de finos tapetes de raíces que tienen por objeto atrapar cuanto antes los nutrientes de la hojarasca. Es más, estos bosques presentan "canastos vegetales" en el sotobosque. Cada una de estas plantas tiene una roseta de hojas que crecen firmemente inclinadas alrededor de un tallo que no se ramifica para formar un canasto que atrapa las hojas y ramitas que caen del dosel. De la punta del tallo brotan raíces adventicias que se introducen en esa masa de hojarasca medio descompuesta para absorber los nutrientes que esta libera. A veces, las raíces de los árboles vecinos trepan por el tallo de estos "canastos" para extraer los nutrientes como si fueran sifones. De igual modo, muchos árboles desarrollan raíces adventicias para robar nutrientes del humus que con tanta paciencia fabricaron sus epífitas.

Los biólogos tienen otras maneras de medir la intensidad de la competencia entre raíces. Un

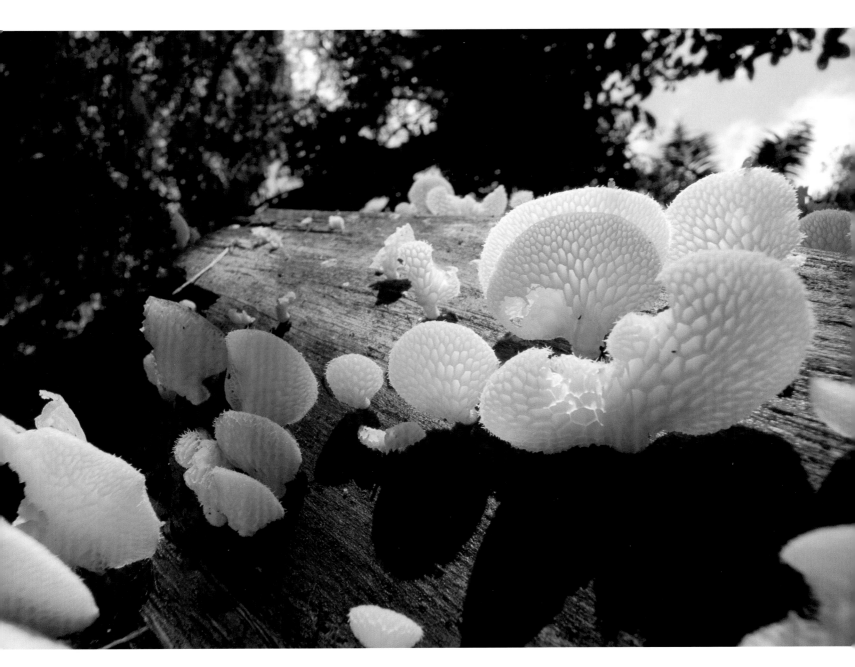

98

Los hongos, como estos *Favolus brasiliensis*, son un grupo
importante de organismos que descomponen o degradan
materia orgánica. Pueden degradar lignina, el componente de
la madera más resistente y más reacio a la descomposición.

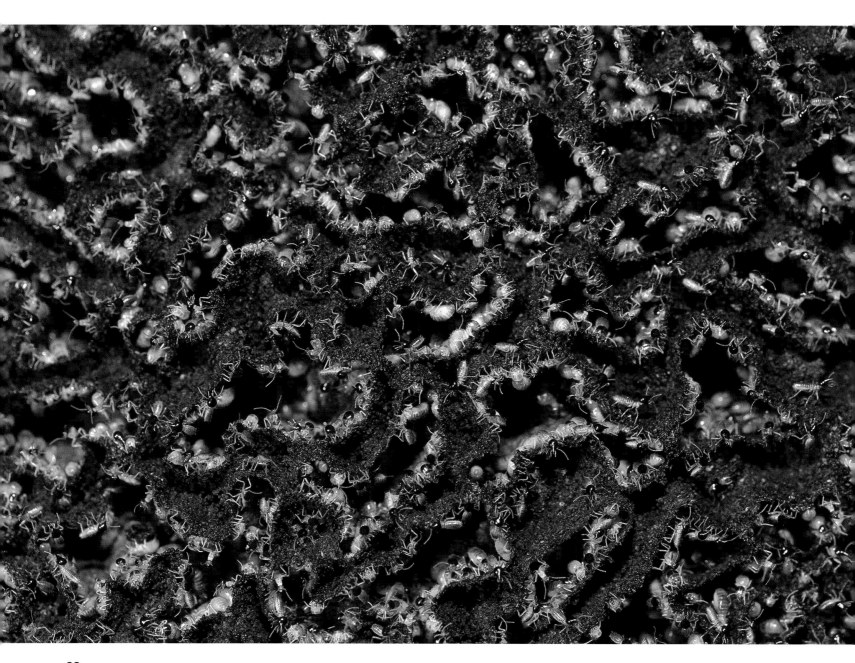

99

Las termitas cumplen un papel clave en la descomposición
de la materia vegetal muerta, la cual digieren con la ayuda
de microorganismos simbiontes —bacterias y protozoos—
que se alojan en su intestino. Muchas especies de termitas
se especializan en descomponer madera muerta y hojas
caídas.

procedimiento invasivo, y de hecho con frecuencia destructivo, es comparar el peso seco de raíces por hectárea de terreno con el peso seco de vegetación sobresaliente por hectárea de terreno. En San Carlos de Río Negro, en Venezuela, la relación más baja entre peso seco de raíces por unidad de superficie y peso seco de vegetación sobresaliente por unidad de superficie la presentan los "bosques de tierra firme", que crecen en el suelo más fértil de los suelos extremadamente pobres del área (tabla 2.3). Cuanto más depauperado el suelo, mayor será esta relación, que alcanza su máximo en el "bana abierto", una comunidad de matorrales esclerófilos (de hojas duras) que crece sobre suelos de arenas blancas, tan pobres en nutrientes que las plantas apenas si logran aprovechar la luz que reciben. De igual modo, los bosques secos, que reciben de 700 a 1000 milímetros de lluvia al año en comparación con los más de 2000 milímetros al año que regularmente recibe un bosque lluvioso, invierten la mitad de su biomasa vegetal en desarrollar raíces que les permitan "escarbar" de la manera más eficiente posible la poca agua disponible, cuando los bosques lluviosos que crecen en suelos normales invierten solo un 15%.

Una manera menos invasiva de medir la intensidad de la competencia radicular es midiendo la "respiración del suelo", la cantidad de dióxido de carbono que se libera del suelo por metro cuadrado por día en diferentes momentos del año. En la naturaleza, lo mismo que en los seres humanos, la tasa a la que se libera dióxido de carbono mide la tasa de uso de combustible; es decir, el gasto energético. Así, la respiración del suelo mide la tasa a la que se está consumiendo energía bajo tierra. Una parte de la respiración del suelo refleja la descomposición (el metabolismo) de la hojarasca. Todo el metabolismo que aparece representado en la respiración del suelo, sin embargo, tiene que provenir ya sea de la descomposición de la hojarasca, de la producción de raíces nuevas, de la descomposición de raíces viejas, o del mantenimiento y funcionamiento de las raíces y los hongos o microbios simbiontes, ya que las hojas verdes son la última fuente de energía utilizable del bosque. Si se mide la caída de hojarasca

TABLA 2.3

Biomasa (ton/ha) sobre tierra y bajo tierra, según grado de depauperación del suelo.
 San Carlos de Río Negro, Amazonas, Venezuela

Tipo de bosque	Biomasa sobre tierra	Biomasa bajo tierra
Tierra firme (IAF = ~7)	248	56
Caatinga alta (IAF = ~5)	252	105
Bana alta (IAF = ~5)	182	128
Bana baja (IAF = 3.3)	40	69
Bana abierta (IAF = 1.4)	6	42

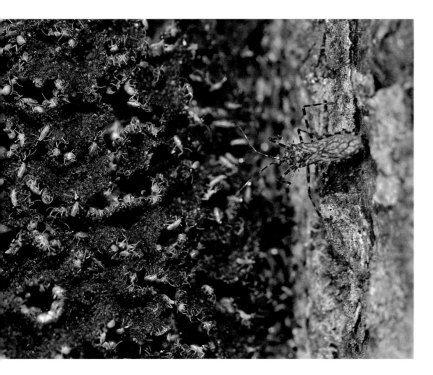

100 ARRIBA

Esta especie de chinche asesino es otro depredador de termitas. Aquí vemos a uno de estos insectos en las proximidades de un termitero, esperando a su presa.

101 DERECHA

Tamandua mexicana. Los tamandúas son animales especializados que "destapan" los nidos de las termitas y las hormigas para comerse sus larvas.

y se determina el peso total de átomos de carbono en la hojarasca, se puede determinar cuánto CO_2 producirá la metabolización de esta hojarasca, porque la metabolización completa de la hojarasca produce una molécula de dióxido de carbono por cada átomo de carbono presente en la hojarasca, o sea, 44 gramos de dióxido de carbono por cada 12 gramos de carbono en la hojarasca. El exceso de dióxido de carbono que se libera del suelo sobre aquél que se explica por la tasa de caída de hojarasca debería reflejar el gasto metabólico asociado al desarrollo de raíces grandes, que ayudan a sostener el árbol, así como la competencia que tiene lugar bajo tierra por agua y nutrientes. En Barro Colorado, Thomas Kursar, investigador de la Universidad de Utah, midió la respiración del suelo en distintos lugares y en distintos momentos del año. También en la Amazonía central, donde los suelos son más pobres, se midió la respiración del suelo, como parte de un estudio a gran escala de la productividad de los ecosistemas. La caída de hojarasca se midió en ambos sitios. Se puede, por tanto, comparar el metabolismo de la hojarasca con el metabolismo radicular en cada uno de estos sitios. El metabolismo radicular es dos veces más alto y el metabolismo de la hojarasca significativamente más bajo en la Amazonía que en Barro Colorado (tabla 2.4). Cuando hay nutrientes disponibles, a los árboles les conviene más tratar de sobrepasar a sus rivales en altura que tratar de arrebatarles los nutrientes.

Aún así, la respiración del suelo no puede revelar qué está haciendo la raíz de cada árbol. Lo que sí se puede determinar es de dónde obtienen agua los árboles. El agua contiene unos pocos átomos de hidrógeno que pesan el doble que los demás: son átomos de deuterio. Cuando el agua se evapora, los átomos de deuterio tienden a quedarse atrás. Así, durante la estación seca la concentración de átomos de deuterio en el agua es más baja a mayor profundidad, donde hay poca evaporación.

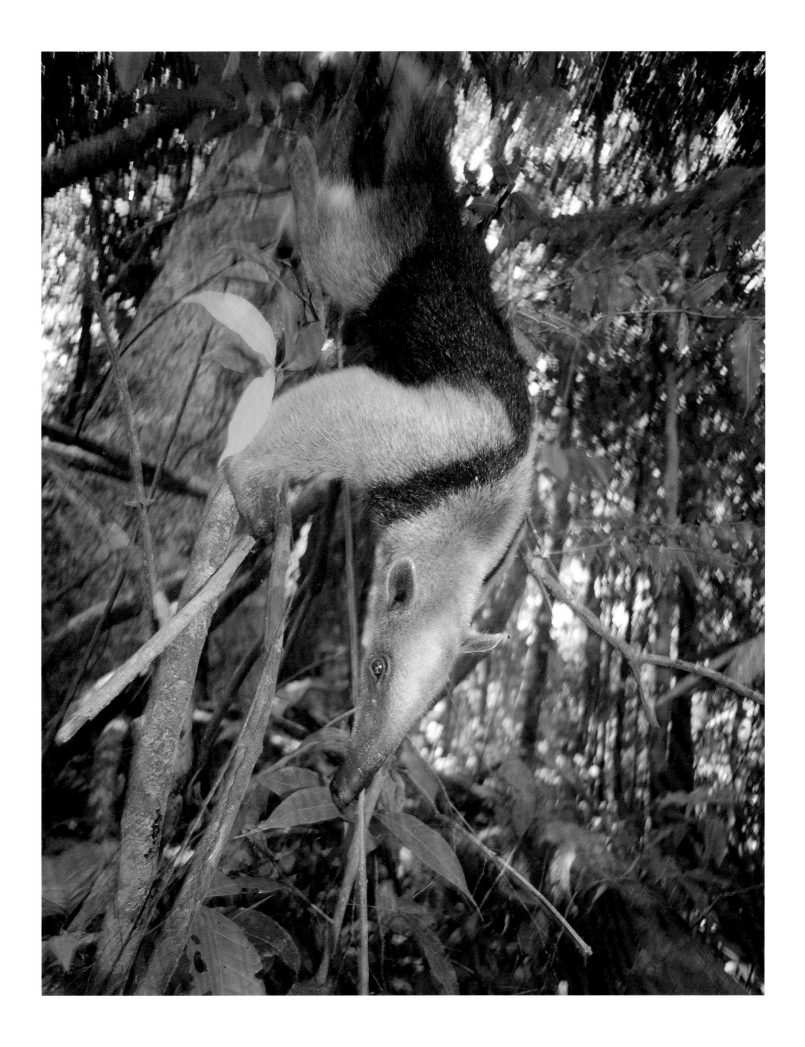

Si se analiza el contenido de deuterio en la savia que sube por el árbol, se puede determinar de qué parte del suelo proviene. Estudios llevados a cabo en Barro Colorado señalan que en la estación seca los árboles de 20 a 40 centímetros de diámetro tienden a extraer el agua de mayor profundidad, donde es más abundante, que los árboles de más de 60 centímetros de diámetro. Los árboles verdaderamente grandes, por su parte, obtienen la mayor parte del agua de la capa superficial de suelo, seca, pero relativamente fértil, donde extienden ampliamente sus raíces. Al parecer, incluso en la estación seca los árboles de Barro Colorado compiten más intensamente por nutrientes que por agua.

LA COMUNIDAD DE ORGANISMOS DESCOMPONEDORES

La mayor parte de la materia vegetal muere antes de que los herbívoros se la coman. Es frecuente ver grandes tramos del piso del bosque cubiertos de hojas, lo mismo que troncos caídos. Menos común es ver árboles o arbustos que han perdido la mayor parte de las hojas por causa de los insectos. Eso sí, por lo general las plantas que son defoliadas son las que tienen hojas nuevas, que son excepcionalmente tiernas y nutritivas. De hecho, la mayor parte de la materia vegetal se salva de ser comida porque tiene sabor desagradable, es difícil de digerir o

tiene poco valor nutritivo. En los bosques (a diferencia de lo que ocurre en los grandes pastizales del África oriental), la mayor parte de los nutrientes de las hojas son reciclados por organismos descomponedores, no comidos por herbívoros (figs. 95, 96).

Ahora bien, descomponer la materia vegetal que los herbívoros no se comen es asunto de especialistas. Actualmente, la comunidad de organismos descomponedores comprende hongos (fig. 98), termitas (fig. 99), larvas de escarabajos y otros insectos barrenadores, lombrices de tierra y un sinfín de artrópodos de hojarasca. Este gremio de especialistas no evolucionó al mismo tiempo que los bosques. Los enormes yacimientos de carbón del periodo Carbonífero se depositaron antes de que los organismos descomponedores pudieran hacerse cargo del suministro de madera muerta de bosques que no hacía mucho habían evolucionado.

Los protozoos simbiontes que descomponen la celulosa en los intestinos de las termitas, permitiéndoles con ello consumir leños y hojas caídos, no se pueden ver. Lo que sí se puede ver son los nidos de las termitas aposentados en los árboles —en Barro Colorado habrá unos 50 termiteros por hectárea—. Estos nidos son un signo de la compleja organización social y la elaborada división del trabajo que debían tener los insectos que terminarían ganando la carrera contra múltiples hongos

TABLA 2.4

Metabolismo de las raíces y metabolismo de la hojarasca. Bosques con suelos fértiles y bosques con suelos depauperados (toneladas de carbono/hectárea/año)

Lugar	Metabolismo radicular	Metabolismo de los residuos vegetales
Barro Colorado (suelo fértil)	8	6.5 (total = 14.4)
Amazonía central (suelo depauperado)	15.7	3.9 (total = 19.6)

saprófitos por el consumo de troncos caídos. La división del trabajo en una colonia de termitas es tan compleja como la que le permite a una colmena de abejas localizar y explotar diferentes plantas cuando sea y donde sea que estén floreciendo, antes de que otros insectos se lleven el néctar y el polen de esas flores.

A diferencia de las termitas, la mayor parte de los organismos descomponedores son básicamente invisibles. La parte activa de un hongo es un embrollo de filamentos, generalmente invisibles que invade el objeto en descomposición. Muchos hongos solo se revelan por las estructuras reproductoras (las setas o champiñones) o por otras estructuras que usan para dispersar las esporas, y que brotan de un tronco en pudrición tan repentinamente como desaparecen. No obstante, los descomponedores sirven de sustento a una comunidad animal cuantiosa y visible: los consumidores de detrito, materia vegetal parcialmente descompuesta, los depredadores de los descomponedores (figs. 100, 101), los depredadores de esos depredadores y así sucesivamente. Muchas hormigas anidan en la hojarasca, o a escasa profundidad, y algunas ranas y sapos se especializan en alimentarse de esas hormigas o de termitas. Algunas lagartijas sobreviven de insectos de hojarasca, y los coatíes pasan la mayor parte del tiempo inspeccionando la hojarasca en busca de lagartijas o invertebrados de tamaño aceptable. Un visitante nocturno podría observar un armadillo olisqueando la hojarasca o escarbando el suelo en busca de descomponedores o de los depredadores de los descomponedores. De día, el visitante más bien podría observar un tamandúa destapando un termitero. Pero tal vez el consumidor más impresionante de la comunidad que depende de los descomponedores son los ejércitos de hormigas guerreras, que barren el suelo comiéndose las larvas de las hormigas de hojarasca, así como cualquier otro insecto que salte a su paso, o llevándose las presas a casa para entregárselas

a sus propias larvas. Entretanto, una bandada de aves planea sobre el tropel capturando aquellos insectos que en vano intentan escapar de esa incursión arrolladora.

El último estadio de descomposición de la materia vegetal es cuando esta se convierte en materia orgánica del suelo. E. F. Bruenig observó que esta materia sirve "como fuente de nutrientes para los árboles, y como alimento y nutrientes para los organismos del suelo; como sustancia estabilizadora de los agregados, lo que le da estabilidad al suelo, cohesión, porosidad y aireación y, por tanto, una mayor penetrabilidad a las raíces; y como complejo facilitador de la absorción y el intercambio de agua, sales minerales y micronutrientes". De este modo, la manera en que se descompone la materia vegetal y los organismos que participan en esta tarea determinan aspectos cruciales del suelo: su capacidad de retener agua y nutrientes antes de que las plantas los absorban, la prontitud con que entra el oxígeno atmosférico y sale el dióxido de carbono, la facilidad con que las raíces penetran el suelo, y otros aspectos similares.

EL INTERÉS COLECTIVO DE LAS PLANTAS EN LA CALIDAD DEL SUELO

En la mayoría de los bosques tropicales, las plantas ayudan a proteger y a mejorar el suelo en el que crecen. Los árboles trabajan en conjunto para mejorar el campo de batalla donde se celebrará la dura competencia entre raíces, como los caballeros de antaño preparaban el terreno para una justa singular. El suelo, sin embargo, es un logro mucho más extraordinario que crear condiciones iguales para todos los competidores. El suelo tiene que satisfacer una gran cantidad de requisitos contrarios. Debe ser lo bastante suave para favorecer el enraizamiento, lo bastante poroso para favorecer la circulación del oxígeno y el dióxido de carbono, pero también lo bastante cohesionado para no desmoronarse.

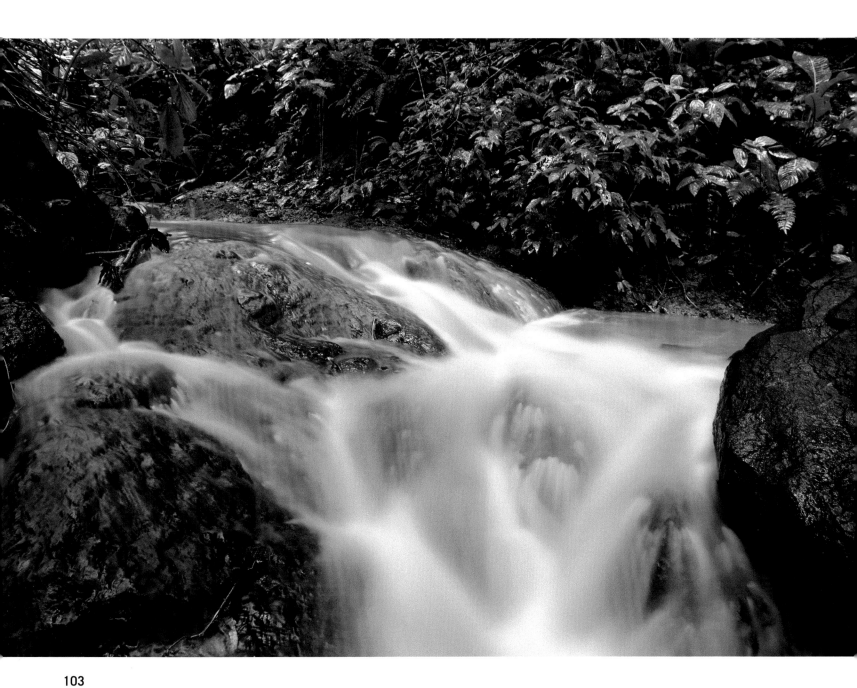

103

Las lluvias intensas van erosionando la Quebrada de Lutz.
Lo que es un arroyuelo apenas visible (fig. 102) se convierte
en un torrente lodoso tras un fuerte aguacero (fig. 103).

Debe tener una estructura que le permita retener firmemente el agua y los nutrientes para que estos no se laven o se filtren, pero la soltura necesaria para que las raíces puedan succionarlos.

Por lo general, en los terrenos accidentados, una lluvia torrencial puede transformar una quebrada tropical, limpia y apacible, en un torrente turbio y violento en cuestión de minutos (figs. 102, 103). Por eso hay que proteger el suelo. Las plantas tienen un interés colectivo en impedir que su suelo, y ellas mismas, sean arrasados.

Los bosques tropicales claramente protegen su suelo. La cuenca arbolada del Amazonas recibe más de veinte veces más lluvia por año que la cuenca deforestada del Huang Ho, en China y, aún así, el Huang Ho transporta más sedimentos al mar. Cierto, la deforestación no tiene por qué ser tan destructiva. Una tierra de labranza bien cuidada puede sortear muchos de los efectos adversos que se derivan de la "limpieza" del terreno. El tema es que hay que tener el cuidado de reemplazar los servicios que antes prestaba el bosque. Una agricultura así de prudente supone entender la tierra, que quien la cultiva y sus descendientes tengan seguridad sobre su tenencia, que se les garantice que van a recibir una cuota razonable de los beneficios de esa labranza cuidadosa y que quienes se dediquen a esta tarea lo hagan por vocación. Esta combinación de elementos se ve poco en esta era de movilidad laboral y hasta de dominio despiadado del mercado, tan poco, que en la mayoría de los escenarios tropicales nos enteramos de lo que hacen los bosques por sus suelos al ponderar los efectos de la deforestación.

El sedimento que transportan los ríos no siempre refleja adecuadamente el impacto de la deforestación. En Puerto Rico, por ejemplo, un estudio geológico comparó la erosión de dos cuencas aledañas con idéntico lecho rocoso, la cuenca arbolada del Icacos y la cuenca deforestada del Cayaguas. Aunque la escorrentía en la cuenca del Icacos es tres veces más alta, la cuenca del Cayaguas pierde más sedimentos por hectárea (tabla 2.5). Esta comparación, sin embargo, subestima grandemente el aumento en la erosión que ocasionan la deforestación y el uso irreflexivo de la tierra. Los deslizamientos son el motor principal de la erosión en estas empinadas cuencas y el volumen total de surcos de deslizamiento por hectárea es 200 veces más alto en la deforestada cuenca del Cayaguas (tabla 2.5).

El flujo de salida de sedimentos mide la tasa de erosión razonablemente solo donde la vegetación ha permanecido relativamente intacta por mucho tiempo.

TABLA 2.5

Efectos de la deforestación en la tasa de erosión y en el volumen de deslizamientos

Cuenca	Pérdida de sedimentos por año	Densidad de surcos de deslizamientos	Volumen por surco	Volumen de surcos por hectárea
Icacos (arbolada)	9.5 ton por ha	1 por 16 ha	300 m³	18 m³ por ha
Cayaguas (deforestada)	11.6 ton por ha	0.8 por ha	4714 m³	3771 m³ por ha

El contraste en cuanto al volumen de deslizamientos por hectárea entre estas dos cuencas es muchísimo más pronunciado que el contraste en cuanto a la salida de sedimentos, porque los escombros de un derrumbe no salen de la cuenca inmediatamente, sino que quedan apilados al fondo de la pendiente donde se produjo el deslizamiento, y solo se van moviendo corriente abajo por etapas, con cada nuevo aguacero. Cuando una cuenca ha sido deforestada, pasarán cientos de años hasta que el flujo de sedimentos y la tasa de erosión recuperen su equilibrio.

Para calcular cuánta agua usa el bosque de Barro Colorado y lo bien que retiene agua y nutrientes el suelo, en 1971, Benjamin Morgan instaló un vertedero en forma de "V" en la quebrada de Lutz, cerca del claro del laboratorio (fig. 105). El agua que fluye a través del vertedero proviene de un área de captación de 9.7 hectáreas con topografía accidentada y una pendiente media de 15 grados. Si se conoce la altura del nivel de agua en la poza de sedimentación ("trampa") que está detrás del vertedero, con respecto a la base de la "V" del vertedero, se puede calcular la velocidad a la que fluye el agua. Un registro automático del nivel del agua en la trampa permite conocer la cantidad de agua que sale de la cuenca. Por otra parte, si se toman muestras de agua del arroyo que corre justo antes de la poza de sedimentación se puede determinar cómo varían su composición química y su contenido de sedimentos, según la época del año y el caudal. Un vertedero, entonces, permite estimar tanto la escorrentía como la salida de nutrientes, sólidos disueltos y sólidos en suspensión, del área de captación.

El relieve del terreno influye en la capacidad de retención de agua y nutrientes del suelo. Para determinar esta influencia, Robert Stallard, instaló un segundo vertedero en "V" en la quebrada de Conrad, que tiene un área de captación de 40.6 hectáreas en la meseta que corona la Isla. Su objetivo era comparar la composición química y el contenido de sedimentos del agua, así como el patrón de flujo de la quebrada de Conrad, que es relativamente plana, con los de la quebrada de Lutz, que corre por terreno empinado. Como era de esperar, el proceso de erosión resultó ser 25 veces más rápido en Lutz que en Conrad (tabla 2.6). La erosión en Lutz equivale a la pérdida de una capa de lecho rocoso de 0.188 milímetros al año, mientras que en Conrad equivale a 0.008 milímetros al año.

La topografía de una cuenca gobierna el espesor del suelo y afecta la velocidad a la que crecen los cuerpos de agua cuando cae una lluvia intensa. En la

TABLA 2.6: Erosión de material disuelto, total de material erosionado y escorrentía en dos áreas de captación en Barro Colorado (gr por m^2 de área de captación por año)

Sitio	Área de captación	Salida de solutos	Salida de sólidos	Escorrentía
Meseta (Conrad)	40.6 ha	11	22	722 000
Barranco (Lutz)	9.7 ha	103	407	1 075 000

microcuenca de Lutz la erosión marcha al paso del desgaste del lecho rocoso, de modo que el suelo es delgado y no puede retener mucha agua. Al final de la estación lluviosa, cuando los suelos están saturados, el caudal de la quebrada de Lutz se incrementa a los pocos minutos de iniciado un aguacero: la escorrentía que ocasiona esta crecida fluye, a través de agujeros abiertos en el suelo por raíces, así como de grietas y fisuras subterráneas, directo a la quebrada (figs. 102, 103). El área de captación de Conrad, por el contrario, es demasiado plana para que la erosión vaya al paso del desgaste del lecho rocoso, así que los suelos son más profundos que los de Lutz. Aunque un litro de suelo de la microcuenca de Conrad retiene menos agua que un litro de suelo de la microcuenca de Lutz, que es más poroso, los suelos profundos de Conrad retienen mucha más agua por hectárea. Así, la quebrada de Conrad crece mucho más lentamente que la de Lutz durante un aguacero. Es más, las crecidas en Conrad son proporcionalmente menos significativas. Los desbordamientos de la quebrada de Lutz han llegado a sobrepasar los dos metros cúbicos de agua por segundo; los de Conrad nunca han llegado a un metro cúbico de agua por segundo, a pesar de que el área de captación de Conrad es cuatro veces más amplia que la de Lutz. Por último, a juzgar por la tasa anual de escorrentía, que es menor en Conrad que en Lutz, buena parte del agua del área de captación de Conrad debe estar abandonando la cuenca por el subsuelo.

Los suelos en ambas cuencas son admirablemente eficaces impidiendo que los nutrientes se laven. Cuando la quebrada de Lutz está en su nivel máximo, la composición química del agua (sin tomar en cuenta los sedimentos) es similar a la de la lluvia que cae al suelo del bosque. Esta corriente fluye tan rápido de la superficie del bosque a la quebrada que no hay tiempo de que los nutrientes se laven. Por otro lado, aunque el agua permanece más tiempo en los suelos profundos de la microcuenca de Conrad antes de sumarse a la quebrada, los suelos de Conrad tampoco dejan que sus nutrientes se laven. Si bien la meseta de Barro Colorado puede considerarse fértil en comparación con la media tropical, y la hojarasca es sorprendentemente rica en nitrógeno y fósforo, el agua de la quebrada de Conrad está tan desprovista de nitrógeno y fósforo como las corrientes que drenan los suelos poco fértiles de la Amazonía central y oriental. Quizá la prueba más clara del poder que tienen los suelos de Barro Colorado para retener nutrientes decisivos es que el agua que corre, tanto por Lutz como por Conrad, contiene menos nitrógeno y fósforo que el agua de lluvia que cae en estas áreas de captación.

Mucha gente piensa que la deforestación provoca inundaciones repentinas y hace que en la estación seca los ríos pierdan su caudal. Para verificar si este supuesto aplicaba en Panamá, y hasta qué punto era cierto, Stallard comparó dos cuencas aledañas, igualmente escarpadas y con el mismo tipo de lecho rocoso, en tierra firme, al otro lado del Canal de Panamá, desde Barro Colorado. Una de las cuencas tenía un área de captación de 127 hectáreas y estaba completamente arbolada; la otra, de 169 hectáreas, mostraba un 44% de su territorio cubierto de pastizales y vegetación secundaria degradada. En las áreas deforestadas el suelo era bastante menos fértil, más delgado y mucho menos permeable al agua. Cuando llovía intensamente, el curso de agua crecía más rápida y significativamente en la cuenca deforestada que en su contraparte arbolada (tabla 2.7). La deforestación también reducía la cantidad de agua que usaban las plantas. Como resultado, la cuenca deforestada experimentaba una mayor escorrentía por hectárea durante la estación

104

Las lluvias torrenciales arrasan con los suelos descubiertos.
Aquí podemos observar ese fenómeno a escala
microcósmica: donde el suelo se encuentra cubierto por
trocitos de hojas, se forman pequeñas pirámides de suelo
protegido.

lluviosa (tabla 2.8). La cuenca boscosa, por el contrario, almacenaba más agua en la estación lluviosa, así que en la estación seca siguiente había más agua de salida, lo que, de paso, beneficiaba a los usuarios que vivían corriente abajo.

Las plantas también afectan la calidad del suelo, por la composición química de la hojarasca y de las raíces, que suministran la materia prima para los organismos descomponedores, y que son, en última instancia, la fuente de la materia orgánica del suelo. En la mayoría de los ambientes tropicales, al igual que en Barro Colorado, la mayoría de las plantas obtienen más beneficios ganando altura que destinando energía a envenenar herbívoros y rivales. No obstante, en algunos sitios depauperados, las plantas se propagan destruyendo a sus competidoras. En los yermos de Pine Barrens, en Nueva Jersey, los pinos acumulan hojarasca inflamable que desencadena fuegos que queman a algunos de sus rivales y les arruina el suelo a otros, al dejarlo reducido a una arena calcinada. Algunos árboles adaptados a crecer en suelos pantanosos poco fértiles dejan caer hojas que forman un humus bruto (mor) que prácticamente no se descompone. Este humus blanquea los primeros centímetros de suelo: si un árbol de estos es plantado en un suelo de mejor calidad, este humus lo degrada. En virtud de estos elementos, merece la pena

preguntarse qué circunstancias convienen más al interés colectivo de las plantas en relación con la fertilidad del suelo

RITMOS ESTACIONALES, ESTACIÓN SECA Y ESTACIÓN LLUVIOSA

Como en muchas áreas de Centroamérica y Suramérica, Barro Colorado experimenta una estación seca rigurosa. En Barro Colorado, la estación seca normalmente comienza en algún momento en diciembre y termina en algún momento entre mediados de abril y mediados de mayo. En el hemisferio sur, la estación seca comienza y termina unos seis meses después. Al igual que el invierno en la zona templada, la estación seca refleja cambios estacionales en la duración del día y en la posición del sol al mediodía. En Barro Colorado, a medida que la estación seca avanza, el suelo se seca y se resquebraja, los arroyos dejan de correr y el suelo se cubre de hojas. Algunos árboles pierden sus hojas.

Aunque la precipitación anual en Barro Colorado es de 2614 milímetros, la media para el primer trimestre del año, cuando la estación seca está en su apogeo, es de 126 milímetros. De hecho, en la mitad de los años entre 1925 y 1986 cayeron menos de 100 milímetros de lluvia en el primer trimestre. En Madagascar, las regiones tropicales

TABLA 2.7

Precipitación y escorrentía, en mm, en dos cuencas adyacentes, tras un aguacero torrencial en la estación lluviosa

Cuenca	Precipitación	Escorrentía 2-4:30 pm	Escorrentía, 4:30 pm a 5:00 am el día siguiente
Arbolada	54	2	4
44% talada	38	6	6

que reciben 125 mm de lluvia en promedio por trimestre (500 mm al año) presentan una vegetación muy parecida a la del desierto de Sonora, con plantas que recuerdan a los cactus y al ocotillo. La estación seca en Barro Colorado también es más soleada el primer trimestre del año, con una radiación solar media de 229 vatios por metro cuadrado de bosque, muy por encima de los 158 vatios que se reciben entre junio y noviembre.

El regreso de las lluvias suele ser fascinante. Los suelos se ablandan, los arroyos vuelven a correr y la hojarasca comienza a descomponerse. La lluvia revitaliza la tierra y trae consigo una explosión de actividad. Las plantas de algunas especies florecen en rápida sucesión; otras dejan caer fruta madura; los retoños se multiplican. La primera gran lluvia de la estación convoca nubes de termitas que abandonan sus nidos para emprender su vuelo nupcial, vuelos que se convierten en un festín para las aves insectívoras que comen desaforadamente sin hacer mella visible en tanta prodigalidad. A principios de mayo, apenas retoñan las hojas que necesitan, las crías de las iguanas salen del cascarón y nadan hasta el bosque, dejando atrás las isletas donde habían sido puestos los huevos y donde se encontraban relativamente a salvo de los depredadores. Los coatíes y otros mamíferos también paren sus crías cuando empiezan las lluvias, pues es época generosa en frutos para las madres lactantes.

SOBRELLEVANDO LA ESTACIÓN SECA

Las plantas sortean los rigores de la estación seca de muchas maneras. Muchas son de hoja perenne. Los árboles de hoja perenne sobreviven extrayendo agua de profundidades cada vez mayores, donde hay más abundancia. Otros árboles se quedan sin hojas parte del año. El ceibo barrigón, *Pseudobombax septenatum* (fig. 106), árbol pionero de gran hermosura, bota las hojas con el cambio de año y las repone a principios de mayo, casi sin importar cuándo empieza o cuándo termina la estación seca. El jobo, *Spondias mombin*, sin embargo, espera hasta que las capas superiores del suelo estén totalmente resecas para dejarlas caer. La *Ceiba pentandra* las pierde en octubre, cuando el cielo está nublado y la estación lluviosa está llegando a su punto más alto. Las ceibas vuelven a brotar hojas nuevas en febrero con lo cual reducen el daño que les causan los insectos, que están menos activos en la estación seca. Bajo la luz brillante de la estación seca, estas hojas nuevas estarán realizando fotosíntesis a su máxima potencia, como si hubiera cantidades de agua disponible.

Otras plantas producen un tipo de hoja diferente para cada estación. En Barro Colorado, el arbusto del sotobosque *Psychotria marginata* produce "hojas de estación lluviosa" en mayo, cuando llegan las lluvias, y

TABLA 2.8
Precipitación y escorrentía, en mm, a lo largo de tres meses lluviosos y tres meses secos, en dos cuencas adyacentes

	Últimos 3 meses de estación lluviosa, 1997 (precipitación = 710 mm)	Primeros 3 meses de estación seca, 1997-98 (precipitación = 28 mm)
Cuenca arbolada	Escorrentía = 218 mm	Escorrentía = 102 mm
Cuenca desprovista en un 44% de vegetación	Escorrentía = 281 mm	Escorrentía = 62 mm

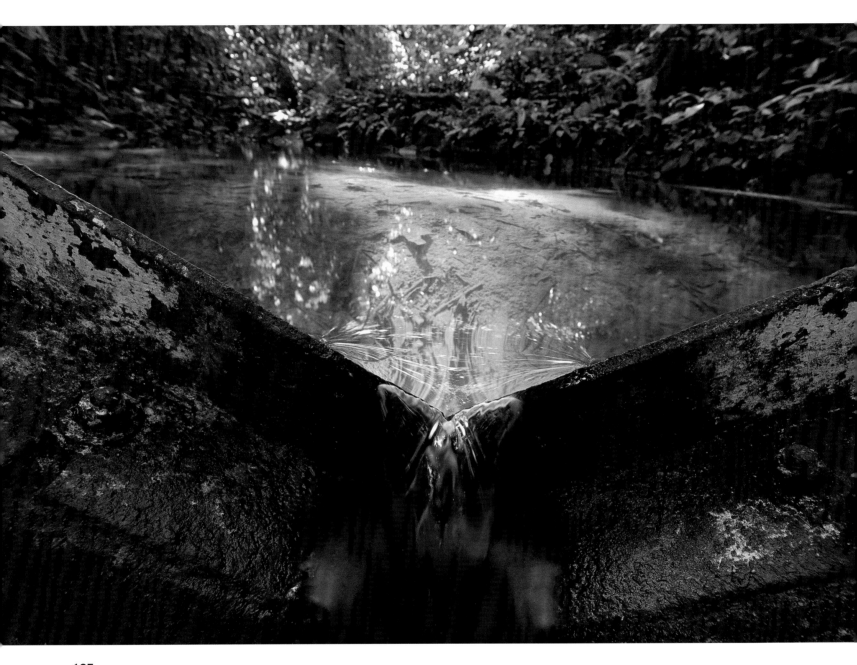

105

Con las lluvias, las quebradas crecen y se llenan de lodo. Esta represa en forma de "V" se construyó para medir el flujo de agua en la Quebrada de Lutz. El nivel de agua en la laguna que está detrás gobierna la velocidad a la que el agua cruza la represa. El registro de datos que maintiene STRI sobre el nivel de agua de la laguna y sobre el contenido de barro en el agua, así como el registro sincronizado de la precipitación que cae cerca de la represa, nos indican qué tan rápido crece la quebrada después de que ha comenzado a llover y cuánta erosión ocasionan las tormentas de diferentes magnitudes.

"hojas de estación seca" en diciembre, cuando éstas se han marchado. Ambos tipos de hojas viven dos años, pero las más jóvenes son las que tienen que estar a la altura de las necesidades de la estación, pues son las más productivas y las que ocupan los mejores puestos bajo el sol. Los dos tipos de hojas tienen igual capacidad fotosintética: ambas fabrican la misma cantidad de azúcar por unidad de área de hoja, si tienen suficiente luz y suficiente. Sin embargo, las hojas de estación seca transpiran la mitad del agua que transpiran las hojas de estación lluviosa al fabricar un gramo de azúcar, un ahorro muy útil cuando el suelo está seco. No obstante, las propiedades que permiten a las hojas de estación seca ahorrar agua, reducen a la mitad su capacidad de producir azúcar por unidad de luz recibida cuando se encuentran bajo la abundante sombra que suele traer consigo la estación lluviosa.

¿Qué hay de los árboles del dosel? ¿También producen hojas diseñadas para atender las exigencias de cada estación? Alan Smith, del Instituto Smithsonian de Investigaciones Tropicales, instaló una grúa en el Parque Metropolitano en la Ciudad de Panamá para que los biólogos interesados pudieran acceder a distintos punto del dosel. Resultó que varias de las especies del dosel del parque efectivamente producían hojas para cada estación. La estación seca que experimenta Ciudad de Panamá es mucho más rigurosa que la de Barro Colorado. Pero las hojas de estación seca de esas especies tienen mayor capacidad. Es más, a una misma humedad relativa, transpiran más agua que las hojas de estación lluviosa. Es evidente que las hojas de estación seca de estas especies han sido diseñadas para aprovechar la copiosa luz de la estación. A diferencia de la *Psychotria marginata*, estos árboles se aseguran un suministro abundante de agua durante la estación seca.

Las plantas extraen agua del suelo; la tiran hacia arriba. La transpiración libera vapor a través de los estomas. El agua se evapora por los extremos abiertos de los vasos xilemáticos. Los vasos son unos conductos de entre 1/10 y 1/3 de milímetro de diámetro que transportan el agua por tramos desde la raíz hasta las hojas. La evaporación desde los extremos de los vasos sube el agua que viene detrás a través los vasos, conduciendo agua del suelo a las raíces para reemplazarla. No obstante, si el tirón es demasiado fuerte, las columnas de agua empiezan a romperse en los conductos, como cables sobrecargados. ¿Qué tan fuerte puede ser este tirón?

Muchas veces, al transpirar, las hojas transportan el agua por el tallo más rápido que una bomba de vacío, lo que hace pensar que el agua que está dentro de los vasos xilemáticos a menudo se halla sometida a una presión negativa. Si uno coloca una rama de hojas en una cámara de presión y deja el extremo de la rama fuera, la presión negativa, el tirón, que se va a ejercer sobre el agua que está en el xilema equivale a la presión positiva que se necesita para obligar el agua a salir por el extremo de la rama. El agua contenida en un conducto de 1/10 de milímetro de diámetro puede resistir tirones muy fuertes, siempre que no contenga burbujas. Las membranas de las raíces y los vasos xilemáticos están diseñados para impedir la entrada de burbujas. Un tirón fuerte en el agua de un vaso xilemático crea una succión poderosa. Si llegara a entrar aire al vaso, el agua se evaporaría (hasta el agua fría hierve si se le somete al vacío) provocando la ruptura de la columna de agua e interrumpiendo el flujo en el vaso. Los poros en las membranas que unen los vasos conductores son tan pequeños que no permiten que las burbujas de vapor pasen de uno a otro.

Psychotria horizontalis, un arbusto común en el sotobosque de Barro Colorado, puede resistir un tirón

equivalente al empuje vertical, a la presión, que sentiría un buzo a 400 metros de profundidad, suponiendo que pudiera sobrevivir a esa profundidad. Las raíces de este arbusto están a tan solo 30 centímetros de profundidad, por lo que en la estación seca tienen que tirar duro para poder extraer agua de la reseca capa superior de suelo. El caso de *Ochroma pyramidalis*, árbol pionero de hoja perenne es distinto: un tirón inferior a la cuarta parte del tirón mencionado comenzaría a romper las columnas de agua y pondría en riesgo el suministro de agua a las hojas. Al final de la estación seca, el tirón que se necesita para sacar agua de la capa superficial de suelo suele ser más fuerte de lo que los vasos de *Ochroma* pueden resistir; este árbol tiene que hundir sus raíces más profundamente para poder extraer agua con facilidad, aunque la estación seca esté en su apogeo.

LAS CONSECUENCIAS DE UNA ESTACIÓN SECA ANÓMALA

Cuando era estudiante de posgrado en la Universidad de Duke, en 1969, Robin Foster comenzó a llevar un registro de la cantidad y el tipo de flores y frutos que caían en los cientos de recipientes que se hallan distribuidos en Barro Colorado. Dos años de estudio le dejaron grandes enseñanzas. La caída de frutos alcanzó un pico entre septiembre y octubre de 1969, y estuvo seguida de unos cuantos meses de escasez. Sus compañeros de clase notaron que cuando la fruta escaseaba, los animales frugívoros andaban hambrientos y algunos, especialmente los más jóvenes, morían sin remedio (fig. 107). La caída de frutos alcanzó un nuevo pico entre abril y mayo de 1970, y lo mismo ocurrió un año después. Sin embargo, no hubo pico de fructificación entre septiembre y octubre de 1970. A medida que avanzaba la estación lluviosa, la hambruna comenzó a desatarse entre los

mamíferos frugívoros y murieron en tales cantidades que el bosque entero apestaba.

¿Qué había ocurrido? Dos años completos de datos revelaron que muchas de las especies que fructificaron en septiembre y octubre de 1969 florecieron tras la llegada de las lluvias en 1971, pero no florecieron en 1970. La estación seca de 1970 fue débil, con uno de los eneros más lluviosos jamás vistos. ¿Es posible que la estación seca haya sido tan débil que algunos árboles no reconocieron que la estación lluviosa había llegado? Ya estudios anteriores habían informado de años en los que una estación seca lluviosa había estado sucedida de una escasez de frutos en septiembre y octubre, y de la consiguiente hambruna entre los mamíferos.

A partir de los resultados de su estudio, Foster dedujo que (1) las poblaciones de mamíferos frugívoros se encuentran limitadas por la escasez estacional de fruta, (2) que algunas plantas necesitan una estación seca fuerte para saber cuándo florecer y (3) que se necesita la alternancia normal entre estación seca y estación lluviosa para garantizar una provisión adecuada de frutos a lo largo del año. Aunque estas conclusiones tardaron diez años en publicarse, Foster enseñó a toda una generación de estudiantes en Barro Colorado a identificar plantas e inspiró sus investigaciones con consejos brillantes. En consecuencia, su trabajo encaminó buena parte de la investigación de Barro Colorado a plantearse preguntas como: (1) ¿qué desencadena una escasez de frutos tan extrema que todo un bosque se ve afectado? (2) ¿qué factores limitan la abundancia de las poblaciones de vertebrados herbívoros? y (3) ¿en qué momento florecen, fructifican y renuevan hojas los distintos tipos de plantas? Estas preguntas ocuparán el resto de este capítulo.

¿Puede ser que el bosque de Barro Colorado tenga que experimentar una estación seca rigurosa

106

Algunos árboles de Barro Colorado, como este
Pseudobombax, dejan caer las hojas en la estación seca
para reducir la pérdida de agua por transpiración.

107

En Barro Colorado, la provisión de fruta y hojas nuevas disminuye conforme la estación lluviosa se acerca a su fin (de octubre a mediados de diciembre). Consiguientemente, en esta época aumenta la mortalidad entre los herbívoros vertebrados de la isla. Esta calavera de mono aullador, *Alouatta palliata*, se encontró en noviembre, momento en que la escasez de fruta y hojas nuevas llega a su máximo.

para asegurar una fructificación normal en los meses venideros de septiembre y octubre? Mientras hacía investigación para obtener su grado doctoral en la Universidad de Michigan, Carol Augspurger demostró que una lluvia podía hacer que una especie floreciera, pero solo si había estado precedida de un período de sequía bien marcado. Esta investigadora buscaba entender qué desencadenaba la floración de *Hybanthus prunifolius*. Estos arbustos florecen en sincronía, luego de una lluvia en la estación seca. En la estación seca de 1975, cuando no se presentaron las lluvias, Augspurger logró que los pequeños *Hybanthus* florecieran regando agua alrededor de las raíces cuando el suelo se veía realmente seco. También pudo prevenir la floración regando las plantas continuamente una vez finalizadas las lluvias. Otras especies también florecieron después de una lluvia en la estación seca (fig. 108). Con todo, una estación seca rigurosa no es una condición necesaria para que se produzca una buena fructificación de agosto a octubre. La estación seca muy lluviosa que se vivió en 1981 no trajo la esperada escasez de fruta en los meses de septiembre y octubre siguientes, ni hubo, tampoco, signos de hambruna ese año entre los frugívoros del bosque.

S. J. Wright, miembro del equipo permanente del STRI, logró descifrar las causas de los años de hambruna examinado un amplio periodo de registros climáticos. Al parecer la ausencia de fructificación que desencadenaba las hambrunas se producía luego de una estación seca lluviosa, sólo si el año anterior se había presentado una estación seca excepcionalmente rigurosa. El clima de Barro Colorado se ve afectado por el fenómeno de El Niño, una perturbación de nivel planetario. Un Niño particularmente severo trae inundaciones a las costas desérticas del Perú, disminuye la zona de inundación del Nilo, desata tormentas en la costa californiana y lleva sequías a distintas partes de Indonesia. Los Niños severos también traen estaciones secas más largas o más

duras (o ambas cosas) a Barro Colorado y una menor precipitación en los meses precedentes (fig. 109). Una estación seca de El Niño, sin embargo, estimula una producción extraordinaria de frutos. Muchas especies de árboles que florecen con la llegada de las lluvias gastan sus reservas cargándose generosamente de frutos y al año siguiente simplemente no pueden producir. El año que sigue a un año de El Niño suele presentar una estación seca húmeda: así sucedió en todos los años de hambruna examinados por Foster. Es más, una estación seca especialmente lluviosa hace que algunos árboles no florezcan cuando regresan las lluvias. Sin embargo, la ausencia total de frutos en septiembre y octubre se presenta únicamente cuando la estación seca precedente es lluviosa y la estación seca que la antecede es lo bastante rigurosa como para generar una fructificación inusualmente vigorosa.

LA ESCASEZ ESTACIONAL DE ALIMENTOS Y LAS POBLACIONES DE HERBÍVOROS

Muchos de los mamíferos terrestres de Barro Colorado —pecaríes, venados, pacas, agutíes, coatíes y ratas espinosas— viven de fruta en la estación en que esta abunda. ¿Por qué no se multiplican estas poblaciones? En 1966, N. Smythe, un estudiante de posgrado de la Universidad de Maryland que más adelante se unió al STRI, llegó a Barro Colorado a estudiar a los agutíes y sus competidores. Determinó cuánta fruta caía al suelo, y encontró que en diciembre y enero era mínima. Además, cuando el alimento escaseaba, estos mamíferos fácilmente entraban a las trampas, las crías de las pacas y los agutíes crecían más lentamente, si es que crecían, y todos dedicaban más tiempo forrajear, ampliaban su ámbito de exploración y se arriesgaban más para encontrar alimento. En Barro Colorado tenemos una idea aproximada de cuántos frugívoros de cada especie hay

en la Isla. Usando una fórmula fisiológica para calcular cuánto come un animal por día, según su peso, se puede calcular cuánto comen en conjunto todos los frugívoros terrestres por día. En diciembre y enero la fruta no alcanza para alimentarlos a todos. ¿Se podría pensar que estas poblaciones están limitadas por la escasez estacional de alimentos?

Más fácil es pensar que la escasez estacional de frutas y hojas nuevas beneficia a los árboles, si también controla a las poblaciones de herbívoros vertebrados que viven en sus copas. De hecho, la historia es prácticamente la misma para los habitantes de las copas que para los habitantes del suelo. Tanto los murciélagos frugívoros como las iguanas herbívoras se programan para tener cría cuando hay abundancia de frutas y hojas tiernas. Los estudiantes encuentran más perezosos y monos aulladores muertos (fig. 107) en los senderos de la Isla cuando las frutas y las hojas tiernas escasean. Katharine Milton, profesora de la Universidad de California que visitó Barro Colorado por primera vez en 1974, observó que en la época de escasez los monos aulladores disputaban la posesión de árboles con fruta intercambiando aullidos más seguido. También encontró que la mayoría de los aulladores que morían en esta época no morían de hambre, sino que estaban tan malnutridos que las heridas abiertas por los tórsalos se les infectaban de gusanos barrenadores (fig. 148) y esta infección siempre resultaba mortal.

Desde comienzos de 2010, Stephanie Ramírez, estudiante de posgrado de la Universidad de Texas en San Antonio, ha estado aplicando nuevas técnicas para evaluar el impacto de la escasez de alimentos en la reproducción de las hembras de los monos araña. Experimentalmente se ha determinado que cuando una hembra come poco, quema grasa, con lo que se altera la química de la orina. También se sabe que la presencia de ciertas hormonas en las heces indica si la hembra puede

o no concebir. Ramírez encontró que cuando la fruta escaseaba, las hembras, efectivamente, quemaban grasa. El análisis hormonal, que está por publicarse, revelará si la falta de alimentos incide en la capacidad reproductora de estas hembras.

Las poblaciones de herbívoros vertebrados ciertamente parecen estar limitadas por la escasez de fruta y hojas tiernas. Por consiguiente, si hay fruta en abundancia es menos probable que las semillas que han sido dispersadas sean recuperadas y comidas. La escasez estacional claramente controla la defoliación por parte de los vertebrados. Los perezosos, los monos aulladores y las iguanas son los herbívoros vertebrados que más hojas comen en Barro Colorado; sin embargo, entre todos, le arrebatan menos hojas al bosque que los insectos.

LOS RITMOS ESTACIONALES: LA RENOVACIÓN DEL FOLLAJE, LA FLORACIÓN Y LA FRUCTIFICACIÓN

Las plantas del bosque florecen, fructifican y renuevan el follaje en distintos momentos del año, poniendo de manifiesto el ritmo estacional del bosque. ¿Por qué estas diferencias?

La mayoría de los árboles de hoja perenne y muchas plantas del sotobosque reverdecen con el cambio de año anticipando la abundante luz que traerá la estación seca. Otra oleada de brotes verdes, mucho más generalizada, vendrá antes de la estación lluviosa y con el comienzo de las lluvias. Un pico más pequeño podría presentarse en septiembre. Algunas plantas renuevan las hojas de manera oportunista. En la estación lluviosa, los árboles jóvenes del sotobosque tienden a llenarse de brotes después de una semana inusitadamente soleada, mientras que en la estación seca algunos tienden a reverdecer después de una semana más lluviosa que de costumbre.

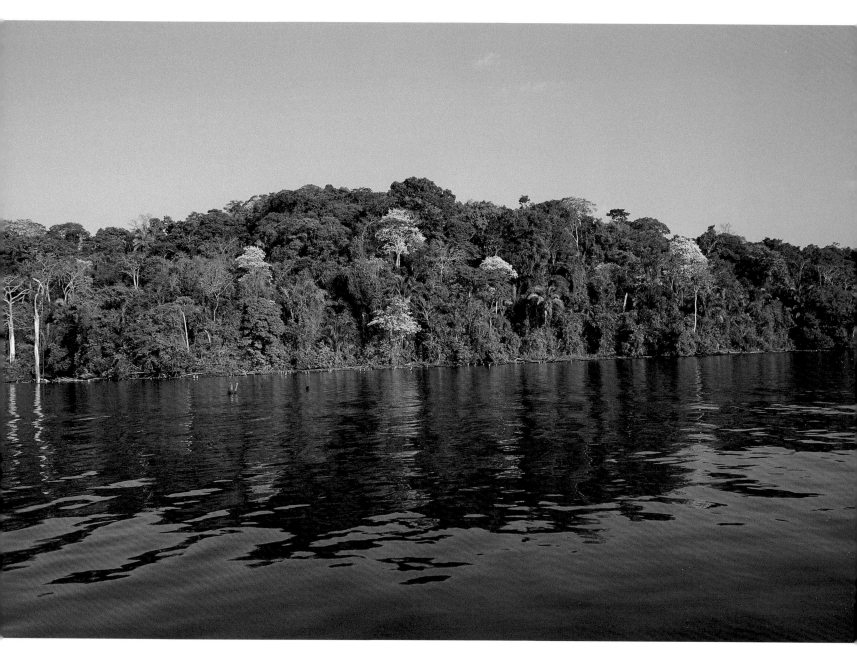

108

Una lluvia torrencial en plena estación seca puede disparar
la floración sincronizada de muchos de los *Tabebuia
guayacan* que hay en la isla, lo que facilita la polinización
cruzada entre estos árboles.

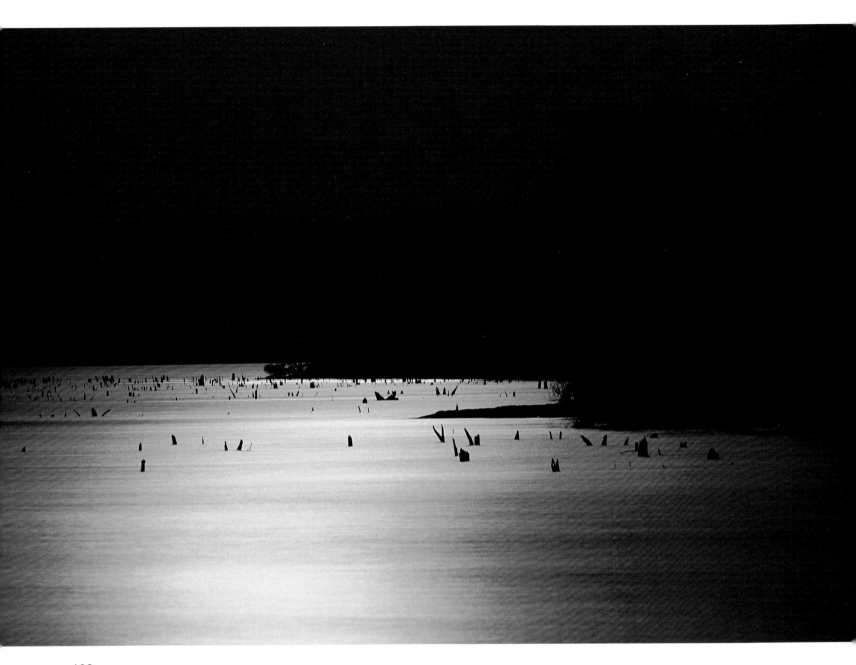

109

Aquí, la luz de la luna baña las aguas del Lago Gatún en abril de 1998, sacando a relucir una cantidad impresionante de troncos muertos son los restos del bosque que se inundó cuando se creó el Lago Gatún para formar la parte central del Canal de Panamá. La mayoría de ellos solo quedan expuestos cuando baja el nivel del lago. El Niño, un fenómeno climático que ocurre irregularmente cada varios años, provoca sequías en Centroamérica. El Niño de 1997-98, uno de los más fuertes registrados en Panamá, hizo que el Lago Gatún bajara a niveles nunca vistos, dando lugar a la escena que se muestra aquí.

La luz y el agua, sin embargo, no son los únicos factores que influyen en el momento de aparición de hojas nuevas. Los herbívoros encuentran las hojas jóvenes particularmente apetecibles. Las plantas pueden reducir este "impuesto al herbivorismo" renovando sus brotes en sincronía con muchas otras plantas para que los herbívoros no den abasto comiéndoselos (fig. 110), o bien en la estación seca, cuando la presencia de insectos herbívoros es menor.

Muchas plantas florecen en respuesta al advenimiento de la estación lluviosa, cuando hay más abundancia de insectos polinizadores. La floración del almendro de montaña *Dipteryx panamensis*, cuya copa se corona de violeta en junio y julio, marca el final de esta ola de floración. Las flores amarillas del árbol pionero *Cochlospermum vitifolium* son heraldos de la estación seca, aunque las lluvias estén en pleno apogeo cuando aparecen las primeras flores. ¿Florecerán acaso en respuesta al acortamiento de los días de diciembre, como, entre las aves, los hormigueros moteados (*Hylophylax naevioides*) se preparan para reproducirse en respuesta a los días más largos de febrero y marzo? Algunas especies, como el guayacán, *Tabebuia guayacan*, usan las lluvias que caen en la estación seca como la señal que las plantas de su clase están esperando para entrar en floración sincrónica, facilitando, así, la polinización (fig. 108).

Muchas frutas maduran con la llegada de las lluvias o poco antes. Las semillas germinan con las primeras lluvias, lo que les da la más tiempo para prepararse para la estación seca venidera. Una buena cantidad de lianas libera semillas voladoras avanzada la estación seca cuando todavía soplan los vientos alisios que las van a dispersar. Otras plantas, incluidas muchas de las que florecen con las lluvias, maduran la fruta en septiembre o en octubre, pero las semillas permanecen durmientes hasta la próxima estación lluviosa. Las aves migratorias de Norteamérica regresan a sus lugares de hibernación en el trópico en esta época del año y de camino van dispersando las semillas de algunos árboles que se cargan de frutos en septiembre y octubre. Los arbustos, que no dan frutos apetitosos, tienden a fructificar mejor una vez comenzadas las lluvias, cuando los árboles del dosel tienen ocupados a un menor número de diseminadores.

¿CÓMO SE AJUSTAN LOS RITMOS ESTACIONALES DEL BOSQUE? UN EXPERIMENTO A GRAN ESCALA

Para entender cómo la estación seca ajusta los ritmos estacionales de las diferentes plantas, S. J. Wright instaló un complejo sistema de aspersores de agua en dos parcelas de 2.25 hectáreas en Barro Colorado y prolongó el experimento por cinco estaciones secas consecutivas. Los aspersores suministraban el equivalente a 6 milímetros de lluvia al día, cinco días a la semana, durante toda la estación seca, suficiente para asegurar que cualquier planta pudiera extraer agua del suelo sin mayor esfuerzo. Wright comparó el momento de florecimiento, fructificación, caída de hojas y brote de hojas nuevas de las plantas irrigadas con el de plantas de la misma especie en parcelas cercanas desprovistas de riego.

Su primera sorpresa fue que la gran mayoría de las especies del dosel se comportaba exactamente igual, se les regara o no, durante la estación seca. Hubo unas pocas excepciones, como la del *Tabebuia guayacan*, que claramente respondió a los cambios en el contenido de humedad en el suelo. No hay duda de que la alternancia entre estación seca y estación lluviosa regula los ritmos de estas plantas. La mayoría de los árboles del dosel, sin embargo, actúan en respuesta a cambios estacionales en la atmósfera, no a cambios en el contenido de humedad en el suelo. De hecho, estos árboles tienen acceso constante y

confiable al agua del suelo todo el año, porque a un metro de profundidad siempre hay agua disponible. Como el riego aumenta la humedad en el sotobosque pero no en el dosel, es más difícil afirmar si las plantas del sotobosque actúan en respuesta a cambios en la humedad atmosférica o a cambios en el contenido de humedad en el suelo.

La segunda sorpresa se la dio, *Psychotria furcata*. Estos arbustos normalmente renuevan sus hojas sincrónicamente con la llegada de las lluvias. En las parcelas irrigadas, los brotes nuevos aparecieron un poco más temprano y la renovación se fue haciendo un poco menos sincrónica cada año. Era como si la aparición de hojas nuevas estuviera programada por relojes internos que marcaban un lapso ligeramente menor a un año —como si los relojes se ajustaran y sincronizaran con la llegada de las lluvias—. Eliminemos la señal que ordena ajustar los relojes, y el reloj interno de cada planta se irá desfasando más y más con el paso del tiempo.

110

Las hojas jóvenes son tiernas y nutritivas, y los herbívoros las prefieren con creces a las hojas viejas, que son más duras. Si las hojas de suficientes plantas brotan en sincronía, se produce tal abundancia de hojas nuevas que los herbívoros solo pueden comerse una pequeña fracción antes de que éstas maduren. Aquí vemos las hojas nuevas, de color rojizo, de dos especies de árboles, brotando en sincronía a comienzos de la estación lluviosa.

111

Casi un 40% de la dieta de
los monos aulladores, *Alouatta
palliata*, consiste de hojas,
especialmente hojas jóvenes.
Los 1300 aulladores que habitan
en Barro Colorado se comen una
doscientasava parte (1/200) de
la producción de hojas de la Isla.
Estos monos usan sus grandes
dientes caninos básicamente para
defenderse de los aulladores de
otras tropas.

COMER Y SER COMIDO

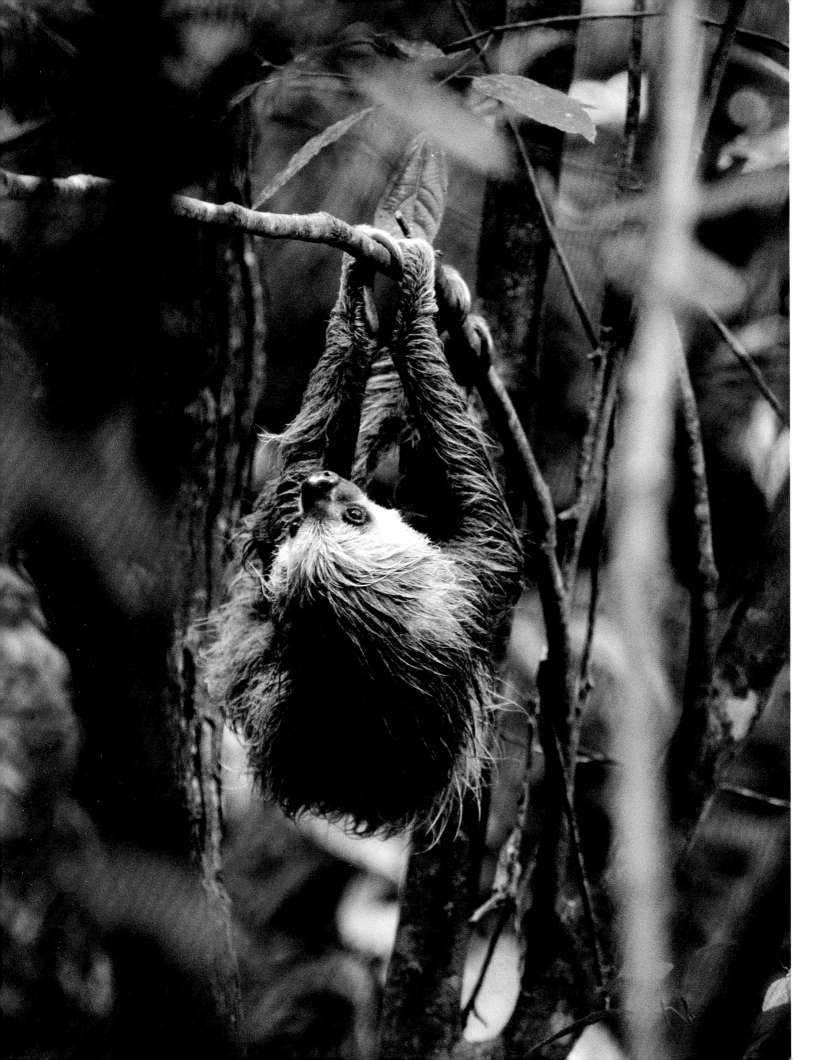

COMER Y SER COMIDO

EL HERBIVORISMO

Los animales tienen que comer para vivir, y como tienen que comer para vivir, tanto ellos como las plantas, tienen que tomar medidas para no ser comidos.

El alimento fresco que más abunda en los bosques son las plantas. Aún así, puede ser que alguien que visite la Isla nunca vea nada comiéndose a una planta. Con suerte verá a un grupo de monos aulladores llevándose un puñado de hojas tiernas a la boca (fig. 111) o a una oruga mordisqueando lentamente una hoja (fig. 114). Puede ser que al colocarse bajo un árbol sienta caer una llovizna de algo más sólido que el agua y que al mirar hacia arriba descubra que ese árbol se ha quedado prácticamente sin hojas: la lluvia no es otra cosa que los desechos —las excreciones— de las orugas que se las están comiendo. Muy probablemente verá hileras de hormigas arrieras bajando por el tronco de un árbol o serpenteando por el suelo, cargando trocitos de hojas recién cortadas (figs. 11, 41-45). Más difícil será ver el momento en que las cortan porque estarán demasiado alto.

Un examen cuidadoso de las hojas de los arbustos que colindan con el laboratorio o de los árboles jóvenes y arbustos que crecen a ambos lados de los senderos ofrece abundante evidencia de que algo se está comiendo las hojas. Algunas hojas tienen agujeros, otras, los bordes raídos, donde los insectos las han estado comiendo. Un grupo de escarabajos hambrientos podría reducir una hoja a un delicado entramado de venas (fig. 113); un tipo de orugas podría cavar largos y sinuosos túneles en los tejidos suaves de otras (fig. 116); una plaga o una enfermedad podría dejar su marca en forma de feas manchas de color marrón. Cuánto del follaje se comen y qué tipo de daño ocasionan los "comedores de hojas" varía según el tipo de planta (fig. 115). Otro daño es invisible. Insectos como las cigarras (fig. 117), los grillos y los áfidos, que se chupan la savia de las plantas, aparentemente retrasan el crecimiento de la planta tanto como los que muerden las hojas, con la diferencia de que no dejan un rastro visible de su acción destructiva.

Phyllis Coley, en ese entonces estudiante de posgrado de Robin Foster en la Universidad de Chicago, llegó a Barro Colorado con una beca predoctoral del Smithsonian a estudiar el herbivorismo. Como parte de su investigación de tesis, midió la velocidad a la que los insectos se comían las hojas de diferentes plantas. Midió

112

Los perezosos, como este perezoso de dos dedos, *Choleopus hoffmanni,* se han adaptado a comer hojas. Las hojas son difíciles de digerir, lo que trae como resultado una tasa metabólica baja y explica el comportamiento lento y aletargado de estos animales.

qué porcentaje de la hoja que era comido o dañado en dos momentos distintos y luego calculó qué porcentaje de la hoja era comido por día. En los claros, las hojas maduras de las plantas tolerantes a la sombra perdían en promedio un 1.3% del área al mes: ¡con razón casi nunca se ve a un herbívoro en acción! Ahora, el ritmo de pérdida varía según la especie. Las hojas maduras de ciertos árboles, como *Calophyllum longifolium*, son devoradas a una velocidad imperceptible, mientras que las hojas maduras de *Alseis blackiana* pierden un 6.4% del área al mes. Está claro que los herbívoros se comen una parte del follaje. ¿Pero por qué no comen más? ¿Qué se los impide? ¿Y por qué unas plantas son más apetecidas que otras?

¿POR QUÉ LOS HERBÍVOROS NO COMEN MÁS?

El daño es más evidente en las hojas jóvenes, tiernas y blandas. Así como nosotros preferimos una hoja de repollo tierna antes que una madura, también la mayoría de los mamíferos e insectos prefieren las hojas tiernas. Casi nunca se ve a un mono aullador comiendo hojas maduras. En las épocas en que las hojas tiernas escasean, los monos se ven visiblemente malnutridos, aunque viven en un mar de hojas maduras. Las hormigas arrieras también tienden a atacar los árboles con hojas tiernas.

Coley encontró que las hojas tiernas de las plantas tolerantes a la sombra son devoradas veinte veces más rápido que las hojas maduras (fig. 118). En Barro Colorado, la hoja tierna promedio pierde aproximadamente un 1% de su área al día, o un 25% al mes. ¿Qué hacen las hojas maduras para protegerse?

Las defensas de las plantas del desierto se pueden ver e incluso oler. Los cactus y las especies asociadas se cubren de espinas. Al amanecer y al anochecer, el aroma de las defensas químicas de las plantas perfuma el aire del desierto. En Barro Colorado, por el contrario,

113 ARRIBA

Diferentes herbívoros dejan intactas diferentes partes de la hoja. Algunos las dejan reducidas a un delicado entramado de venas, que no se comen porque son duras y poco nutritivas.

114 DERECHA

Las orugas pertenecen a un grupo diverso y abundante de insectos fitófagos. Muchas se alimentan de un solo género o de una sola especie de planta. Plagas tan especializadas como estas contribuyen a aumentar la diversidad de árboles al impedir que ninguna especie desplace a las demás. Esta oruga, de la familia de las mariposas nocturnas de Limacodidae, tiene el cuerpo recubierto de espinas venenosas para disuadir el ataque de posible depredadores, como las aves.

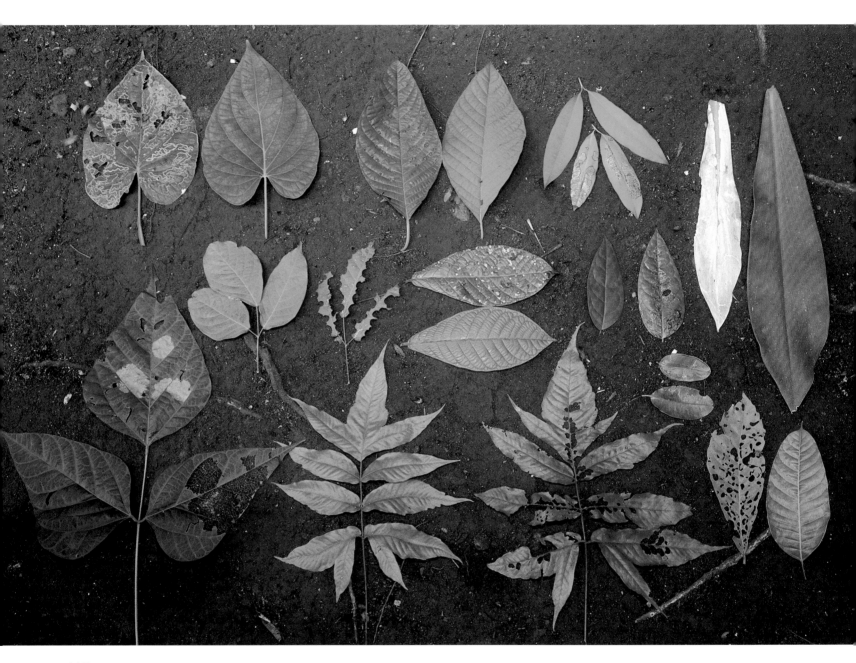

115

Los herbívoros dejan distintos tipos de huella en las hojas. La variedad de marcas refleja la variedad de consumidores. Las hojas dañadas, que se muestran a la par de su contraparte no dañada, se recolectaron en marzo.

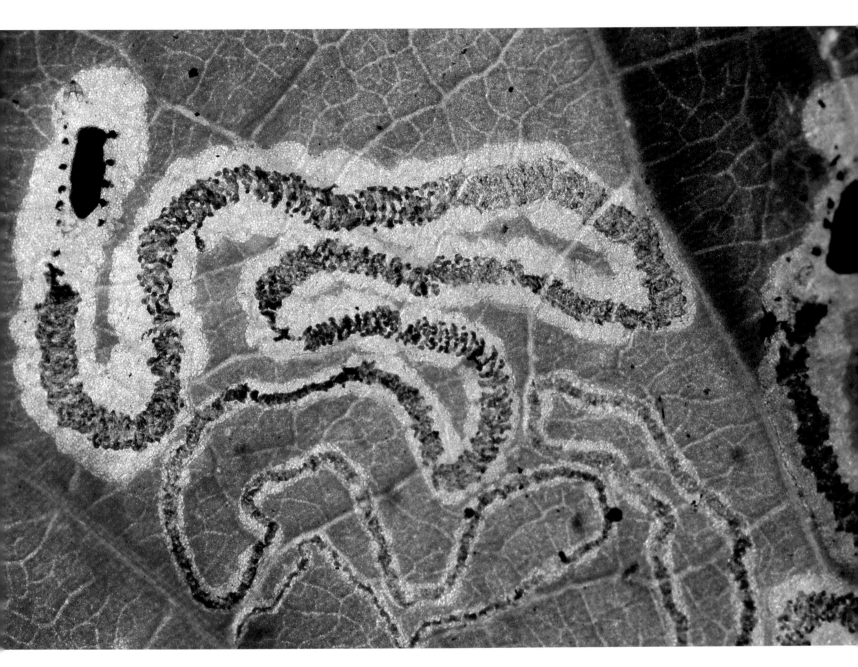

116

Un grupo de larvas de insectos que tiene una forma distintiva de alimentarse de las plantas son los minadores. En general, se trata de larvas de mariposas, escarabajos o moscas. Son larvas, pequeñas y planas, que pasan su estadio larval entre las dos superficies de la hoja. Muchas se especializan en un género o en una especie de planta. Hace cien millones de años, los ancestros de algunos minadores ya cavaban túneles en hojas de plantas emparentadas con los hospederos actuales.

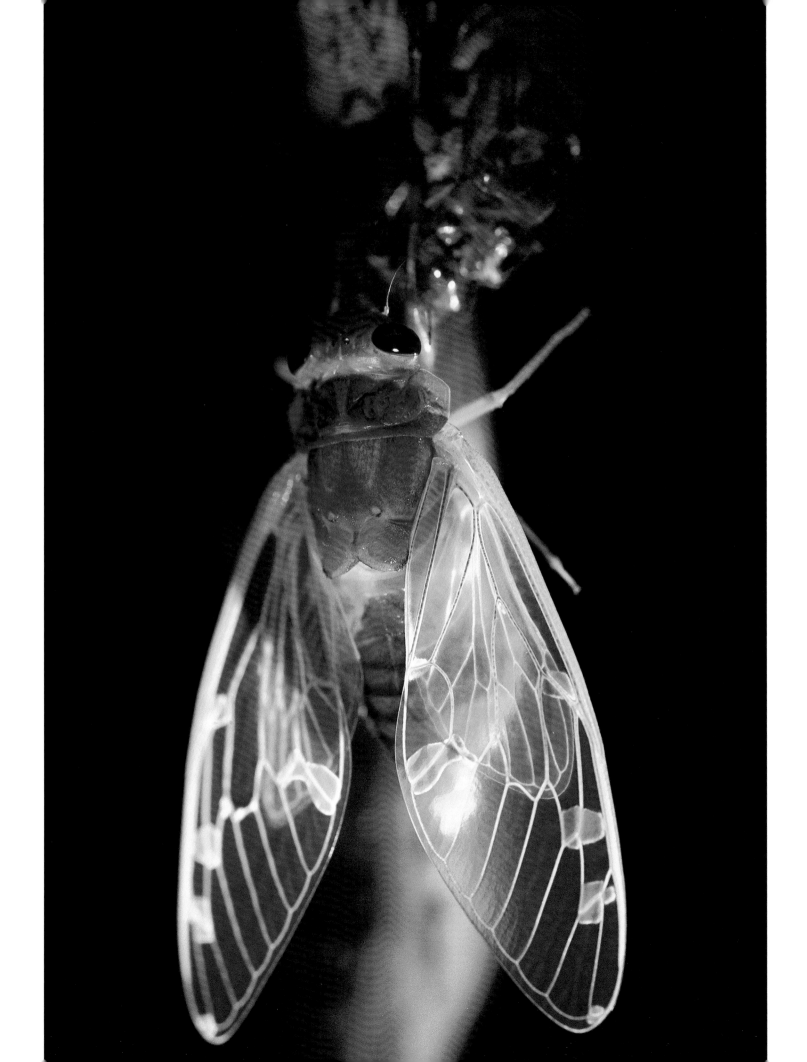

los tallos espinosos son poco comunes y las hojas con espinas, más todavía. Un bosque tropical puede estar repleto de olores, pero estos generalmente provienen de la vegetación en descomposición o de la fragancia de las flores. Algunas plantas tropicales tienen hojas vellosas, porque los vellos supuestamente disuaden a algunos herbívoros. Sin embargo, las hojas vellosas, como norma, son comidas a mayor velocidad que las hojas lisas de otras especies que supuestamente tienen mejores defensas. ¿Qué defensas son esas?

En Barro Colorado, Coley encontró que las hojas tiernas son más venenosas que sus contrapartes maduras. Más específicamente, las hojas tiernas contienen una mayor cantidad de taninos y otros fenoles que disuaden o retrasan la acción de los herbívoros. En vista de que los herbívoros prefieren las hojas tiernas, no puede ser que los venenos sean la mejor defensa de una hoja. Por el contrario, las hojas más duras, las que son más difíciles de morder, esas son devoradas más lentamente y viven más tiempo.

117

Las cigarras se chupan savia. Están equipadas con un aparato bucal largo y tubular, que insertan en la hoja o el tallo para succionar savia, que es una sustancia rica en azúcares y aminoácidos. La cigarra que vemos en la foto acaba de despojarse de su cascarón de ninfa, tras pasar años bajo tierra succionando savia de las raíces. Como la savia es un alimento muy diluido, la larva crece lentamente. Esta larva emergió de noche, trepó por la planta, buscó un lugar adecuado para colgarse y completó su metamorfosis.

¿CÓMO DEFIENDEN LAS PLANTAS A LAS HOJAS TIERNAS?

Las hojas tiernas no pueden ser duras, porque la dureza impide el crecimiento. Las hojas tiernas pierden en promedio un 25% de su área al mes. Si se toma en cuenta que las hojas tardan en promedio 40 días para madurar, es evidente que el periodo de crecimiento hasta la madurez es una etapa muy peligrosa en la vida de una hoja. Las plantas, sin embargo, tienen muchas maneras de reducir el daño que ocasionan los herbívoros a sus hojas tiernas.

Estudiantes de posgrado en Costa Rica y Panamá encontraron que algunas plantas, como el *Croton* y la *Inga*, atraen hormigas que defienden sus hojas tiernas. El "señuelo" que ofrecen es néctar, un fluido azucarado que en los *Croton* brota de unas glándulas que están en la base de la hoja y en las *Inga* entre cada par de foliolos. Cuando las hojas son jóvenes, estas glándulas segregan su fluido y las hormigas acuden gustosas. Las hormigas que se acercan a las glándulas también comen orugas pequeñas y otras plagas.

Una estudiante de posgrado de Coley, Mitchell Aide, observó que otras plantas se esfuerzan por madurar las hojas a gran velocidad para que los herbívoros no tengan tiempo de comer mucho de ellas. Coley, por su parte, encontró que muchas plantas del sotobosque con hojas de maduración rápida retrasan el almacenamiento de proteínas fotosintéticas hasta que las hojas hayan crecido completamente. Si algo se come las hojas tiernas, por lo menos la planta no pierde esas proteínas. Por eso, algunas de las hojas tiernas del sotobosque son blancas, rosadas o azules, y no verdes (figs. 120-122).

Coley y Thomas Kursar, ahora de la Universidad de Utah, encontraron que las plantas que expanden sus hojas lentamente las cargan de una variedad de venenos contra herbívoros que son muy fuertes. En su búsqueda de plantas de utilidad medicinal o plaguicida, Coley y Kursar decidieron que lo mejor era enfocarse en las hojas

118

Las hojas jóvenes son devoradas más rápidamente
que las hojas maduras porque son más tiernas y nutritivas.
Esta plántula de *Calophyllum longifolium* es prueba de ello.

119

Para defenderse de los herbívoros, muchas plantas atraen hormigas a sus hojas por medio de unas estructuras que producen néctar (nectarios extraflorales). Las hormigas que acuden a los nectarios asustan o persiguen por lo menos a algunos depredadores. Este *Costus pulverulentus* atrajo a dos *Ectatomma ruidum*. Las hormigas impiden que una mosca parásita, cuyas larvas se comen las semillas en desarrollo de la planta, depositen sus huevecillos en la flor.

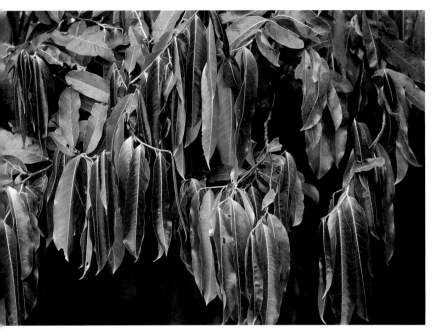

120

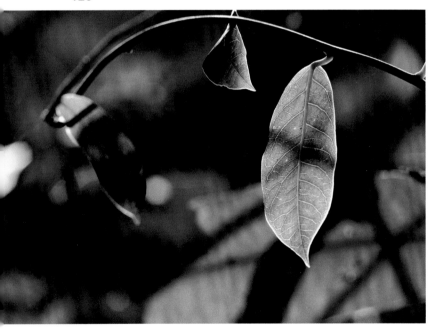

121

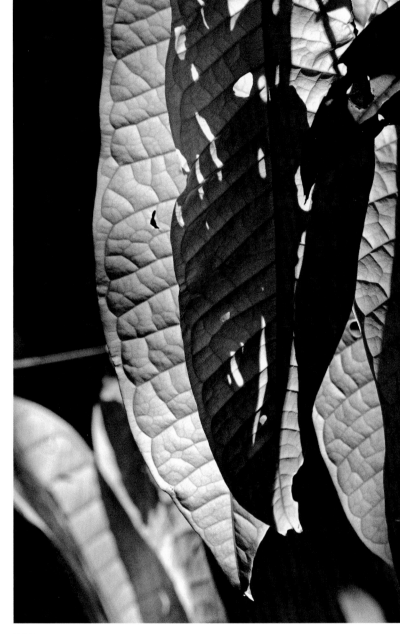

122

En Barro Colorado y otros bosques tropicales es frecuente que las hojas jóvenes, sobre todo las que crecen en el sotobosque, sean blancas, rojas o púrpura, porque todavía no han recibido la clorofila que les dará su color verde. Algunas plantas no les suministran clorofila o enzimas fotosintéticas a las hojas nuevas, que son las preferidas de los herbívoros, sino hasta que estén completamente desarrolladas y se hayan vuelto más duras. Si algo se come las hojas tiernas, por lo menos la planta no pierde esas proteínas fotosintéticas. **ARRIBA A LA IZQUIERDA:** Hojas jóvenes de color rojizo (fig. 120). **ABAJO A LA IZQUIERDA:** Hojas jóvenes de color rojizo (fig. 121). **DERECHA:** Hojas jóvenes de color blanquecino (fig. 122).

tiernas de crecimiento lento, ya que son las que contienen la mayor cantidad de venenos que pueden aplicarse en el control de plagas en cultivos o en el tratamiento de enfermedades humanas. Los venenos, sin embargo, tienen un alto costo para la planta, pues desvían recursos que de otra manera podrían usarse para expandir la hoja más rápidamente.

Aide encontró que las plantas pueden reducir las pérdidas que les ocasionan los herbívoros eligiendo el momento adecuado para producir hojas nuevas. Producir hojas nuevas en sincronía con muchas otras plantas garantiza que va a haber tantas hojas tiernas atrayendo la atención de los herbívoros que la mayoría de ellas sufrirá relativamente poco. En Barro Colorado, los dos picos principales de aparición de hojas son a comienzos de la estación lluviosa y a finales de año. Aide encontró que las hojas que brotaban en estos picos experimentaban menos daños que las que brotaban en otros momentos. Además, los insectos, sobre todo los más pequeños, que se secan fácilmente con el calor del sol, están menos activos en la época seca. Aide observó que las hojas del sotobosque que brotaban en la estación seca sufrían menos daño que las que brotaban a mediados o a finales de la época lluviosa. En el bosque seco caducifolio del sur de la India, que recibe la mitad de la precipitación anual que Barro Colorado y que tiene una estación seca que se prolonga por seis meses, la mayoría de los árboles produce hojas nuevas antes de la llegada de las lluvias, aparentemente para reducir las pérdidas que ocasionan los herbívoros.

EL COSTO DE DEFENDERSE DE LOS HERBÍVOROS

Así como la defensa militar tiene un peso significativo en los presupuestos nacionales, defenderse de los herbívoros también consume buena parte de los recursos de las plantas. Coley observó que las plantas con las hojas más duras y longevas mostraban el crecimiento más lento. En un claro, las especies con hojas que vivían 7 meses o menos crecían en altura un promedio de 81 centímetros al año, mientras que las especies con hojas que vivían 29 meses o más crecían en promedio 37 centímetros al año.

Cynthia Sagers, estudiante de Coley, midió el costo de las defensas de manera más precisa. Comparó el crecimiento de esquejes de arbustos de *Psychotria horizontalis*, cuyas hojas diferían en contenido de taninos protegiendo unos esquejes de los herbívoros y dejando los otros expuestos. Más específicamente, tomó dos esquejes de cada arbusto y los plantó en un claro del bosque, uno bajo una malla que lo protegía de los herbívoros y el otro, cerca, pero sin protección. Al cabo de veinte meses, los esquejes protegidos ganaron cinco veces más peso que sus contrapartes desprotegidas. El aumento de peso en los esquejes expuestos no se vio afectado por el contenido de taninos. Cierto, las plantas con hojas ricas en taninos perdieron menos follaje por causa de los herbívoros. Sin embargo, las plantas con hojas menos venenosas crecieron un tanto más rápido, lo justo para compensar por las pérdidas adicionales que les estaban causando los herbívoros. Como es de esperar, una defensa innecesaria es contraproducente. Las plantas con hojas más venenosas que estaban bajo la malla protectora crecieron más lentamente. Al estar protegidas de los herbívoros, las plantas ricas en taninos crecieron a un tercio de la velocidad que las plantas que tenían la séptima parte de su contenido de taninos.

Así pues, las plantas ofrecen un buen ejemplo de obsolescencia programada. Si una planta crece lo bastante rápido como para asegurar que una hoja que brote hoy va a quedar a la sombra de hojas más nuevas en un año, protegerá sus hojas justo lo necesario para asegurar que sean útiles durante ese año.

EL PROBLEMA DE COMER HOJAS

Hay muchos indicios de que las hojas se defienden para hacerles la vida imposible a los herbívoros. Los animales grandes que tienen que comer muchos tipos de hojas tienen que hacer grandes sacrificios para lograrlo. Los perezosos son los únicos mamíferos en Barro Colorado que viven casi exclusivamente de hojas (figs. 23, 112). Un perezoso tarda una semana en digerir su alimento, señal que de las hojas maduras que come no son fáciles de digerir. Los monos aulladores tardan 24 horas en digerir las frutas y hojas tiernas que comen, y los monos araña, que prácticamente sólo comen frutas maduras, 4 horas. El metabolismo de los perezosos es particularmente reptil y, al igual que en los reptiles, la temperatura de su cuerpo desciende durante la noche. Así no tienen que comer tantas de esas hojas indigeribles para satisfacer sus necesidades energéticas (tabla 3.1). Su metabolismo reptil, sin embargo, los hace lentos y aletargados. Permanecen tanto tiempo quietos, que a los ojos de un depredador pueden pasar por un nido de termitas o algún otro elemento fijo de los árboles. Cuesta tanto verlos que, a pesar de que en Barro Colorado hay miles (¡nos encantaría saber exactamente cuántos!), un visitante podrá considerarse afortunado si acaso logra ver uno.

Los otros vertebrados en Barro Colorado que se alimentan básicamente de hojas son las iguanas verdes (fig. 62), reptiles de sangre fría que comen relativamente poco (ver tabla 3.1). Para alcanzar 3 kilogramos de peso, una iguana salvaje tiene que comer el mismo peso total de comida que un pollo doméstico para alcanzar 2 kilogramos. Pero, a diferencia del pollo, que madura en 4 meses, la iguana necesita 3 años para alcanzar esos 3 kilogramos. Las iguanas, igual que los perezosos, pasan buena parte del tiempo quietas. Como son verdes, se escapan de los depredadores confundiéndose con el entorno. Las iguanas no tienen energía para cuidar a sus crías: ponen los huevos

en islas cercanas a las costas de Barro Colorado, donde los depredadores que merodean en la Isla, como los coatíes, no se las coman. Por eso, en Barro Colorado casi nunca se encuentran iguanas a más de cien metros de la orilla.

Las hormigas arrieras son el otro gran consumidor de hojas de la Isla. Son, además, los herbívoros que los visitantes seguramente verán en acción. Estas hormigas no pueden comer los trocitos de hojas que cortan, pero sí chupan el jugo. Lo que hacen es cultivar un "superhongo" capaz de digerir hojas de una gran variedad de árboles. El hongo digiere los trocitos de hojas que las hormigas le traen y las hormigas comen trocitos del hongo. Este superhongo es un recurso preciado: es lo que les permite a las hormigas vivir de la recolección de hojas. Cada nueva reina arriera que se separa para fundar su propio nido se lleva un bocado del hongo de su madre y un cultivo de una bacteria específica del género *Streptomyces*.

Cada tipo de planta defiende sus hojas tiernas con un tipo distinto de veneno. Un insecto que prospera comiendo hojas tiernas de un tipo generalmente no está equipado para resistir los venenos de otro tipo. Muchos insectos "chupadores de savia" se alimentan de la savia de una gran variedad de plantas, pero las hojas son más diferenciadas que la savia, y los "comedores de hojas" generalistas normalmente crecen más despacio que sus contrapartes especialistas. Si uno encuentra insectos defoliando plantas en Barro Colorado y presta atención verá que un tipo de planta está sufriendo todo o casi todo el daño. Otro de los estudiantes de posgrado de Coley, John Barone, quiso averiguar cuáles eran los agentes que dañaban las hojas de ocho especies de árboles jóvenes, algunas que crecían de sus progenitores, otras que crecían más lejos. Observó que la mayoría del daño lo causaban plagas especializadas.

En efecto, la mayoría de las plantas son atacadas por plagas especializadas que pueden vulnerar sus defensas. El látex blanco y pegajoso que rezuman las hojas del higuerón al ser cortadas, así como el látex que fluye de

los árboles de caucho cuando "se sangra" el tronco, les brinda protección contra la mayoría de los insectos pero nada puede contra las plagas especializadas. Los venenos que mantienen alejados a la mayoría de los insectos de la pasionaria, *Passiflora vitifolia*, cuyas flores, grandes, rojas y en forma de estrella han sido celebradas por tantos artistas, hacen de sus hojas el sitio ideal para *Heliconius cydno*, una mariposa azul oscuro, casi negra, con una banda blanca en las alas frontales, que acude allí a poner sus huevos. Los compuestos picantes presentes en las hojas del *Piper*, arbusto del que brotan delicadas espigas de flores y pequeños frutos blancos, apreciados por algunos murciélagos, alejan a la mayoría de los insectos, pero atraen a las orugas de la mariposa "cola de golondrina", *Papilio thoas* (fig. 123), una mariposa negra con bandas de color amarillo. ¿Cómo hacen las plantas tropicales para escaparse de las plagas que se especializan en ellas?

¿POR QUÉ HAY TANTOS TIPOS DE ÁRBOLES TROPICALES?

Barro Colorado tiene muchas clases de árboles. Veinticinco hectáreas de bosque presentan 210 especies entre 10 613 árboles de al menos 10 centímetros de diámetro; en el sur de Manchuria, 25 hectáreas de bosque primario presentan 31 especies entre 10 527 árboles. Es más, en Barro Colorado los distintos tipos de árboles se encuentran muy mezclados. Los vecinos más cercanos de un árbol adulto casi nunca son de su misma especie. La mezcla, sin embargo, dista de ser perfecta. Ciertos árboles son más comunes en unos lugares que en otros. El vecino adulto de la misma especie de un árbol se halla más cerca que si los árboles de esa especie se hubieran distribuido de manera uniforme por toda la Isla. Con todo, si se toma en cuenta la pequeña cantidad de semillas que son transportadas lejos de los árboles progenitores, el nivel de mezcla es sorprendentemente alto. Los análisis estadísticos muestran que los árboles adultos de Barro Colorado están tan bien mezclados porque las semillas, las plántulas y los árboles jóvenes que crecen más cerca de sus padres tienen mucho menos probabilidades de sobrevivir que los que crecen más alejados.

La causa más lógica de esta mezcla de especies es que las plagas tienen más posibilidades de acabar con las plantas jóvenes que crecen al pie del árbol progenitor o muy cerca de otras plantas de su misma especie. Si esto es así, los bosques tropicales contienen tanta variedad de árboles, al menos en parte, porque las plagas se encargan de mantener cada especie lo suficientemente escasa como para abrirle campo a otras especies. Una semilla o un retoño que crece lejos de sus padres o sus

TABLA 3.1

Consumo diario de alimentos de herbívoros seleccionados (gramos de peso seco por día)

Animal	Tasa de alimentación
Iguana verde de 3.0 kg	15 g de hojas
Perezoso de 4.0 kg	60 g de hojas
Mono aullador joven de 3.2 kg	50 g de hojas y 69 g de fruta (total =119 g)

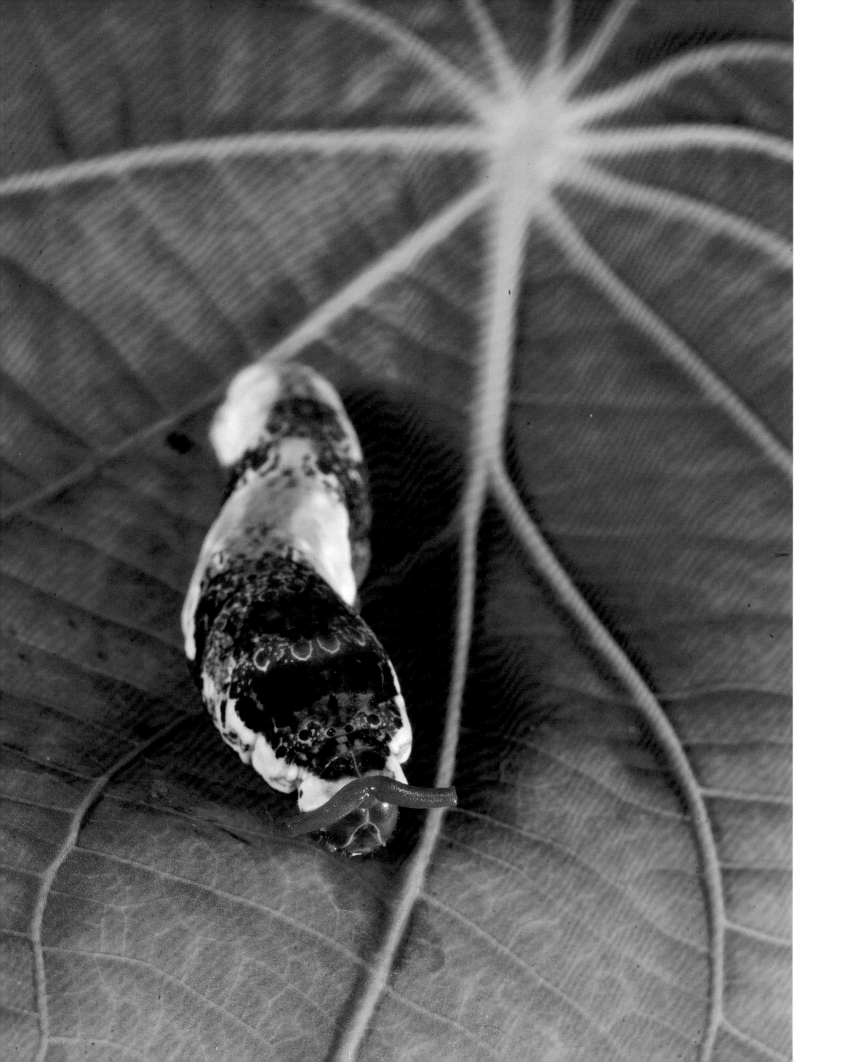

iguales tiene más probabilidades de alcanzar un tamaño seguro antes de que una plaga especializada en su tipo lo encuentre. El número de representantes de una especie se verá reducido a tal punto por las plagas que sólo sobrevivirán los jóvenes necesarios para reemplazar a los adultos que están muriendo. Es probable que los árboles mejor defendidos experimenten menos herbivorismo; en efecto, los árboles pueden escapar a la destrucción ya sea combatiendo a las plagas o escondiéndose de ellas hasta alcanzar un tamaño que les permita resistirlas. No obstante, cargarse de defensas implica crecer despacio: un árbol joven de crecimiento rápido de una especie poco común y poco defendida podría dejar atrás a un árbol de crecimiento lento e incluso suplantarlo.

Sin embargo, una especie de árbol que es lo suficientemente escasa como para que algunos de sus jóvenes escapen de las plagas se reproduce únicamente porque los animales polinizadores permiten el intercambio de polen entre árboles que se encuentran muy diseminados. Antes de que estos polinizadores evolucionaran, el bosque era mucho menos diverso y los árboles sobrevivían solo porque eran mucho más venenosos. En esa época, los grandes dinosaurios caminaban por la tierra porque tener un reservorio de grandes dimensiones era el medio más efectivo para digerir —¿o sería mejor decir para "compostar"?— una vegetación tan poco promisoria.

123

Un camuflaje ingenioso: la oruga de la mariposa "cola de golondrina" *(Papilio thoas)* se disfraza de excremento de pájaro. Aquí, sobre una hoja de *Piper.*

Pero, ¿por qué Panamá presenta una diversidad de árboles tan superior a la de Maryland? Con todo y ser mucho más venenosas, las hojas tiernas de Panamá son devoradas mucho más rápidamente que sus contrapartes de las zonas templadas. La presión de plagas es muchísimo más intensa en Panamá (y en el resto de los trópicos) que en un bosque templado del norte, porque Panamá no tiene un invierno que reduzca las poblaciones de plagas. A diferencia de las plagas de Barro Colorado, las plagas de los bosques lluviosos se libran de las dificultades inhibidoras de la estación seca. Por eso la presión de plagas es aún más intensa en los bosques lluviosos que en los bosques tropicales estacionales, como el de Barro Colorado, de modo que los bosques lluviosos presentan aún más tipos de árboles. Una hectárea de bosque lluvioso en Ecuador incluye 307 especies diferentes entre 693 árboles.

La diversidad de un bosque tropical juega un papel determinante en la defensa contra los herbívoros. ¿Pero bastará la diversidad química para defender al bosque? ¿O los bosques tropicales dependen de la ayuda de depredadores que controlen a los herbívoros que los asedian? Para responder a esta pregunta, necesitamos conocer un poco más sobre los depredadores de Barro Colorado.

¡DEPREDADORES!

Los bosques tropicales suelen ser descritos como lugares donde la belleza y el peligro se presentan en proporciones semejantes. La belleza puede ser peligrosa, como la de las águilas arpías, las serpientes venenosas —como la terciopelo y la cascabel— y la de los grandes felinos. Aunque muchos de estos especímenes habitan en la Isla o por lo menos aparecen de vez en cuando, los visitantes rara vez los ven. Pero una multitud de depredadores más pequeños y más

124

Las mantis religiosas tienen fama de ser cazadores voraces.

Aquí vemos a una de ellas engullendo a un esperanza.

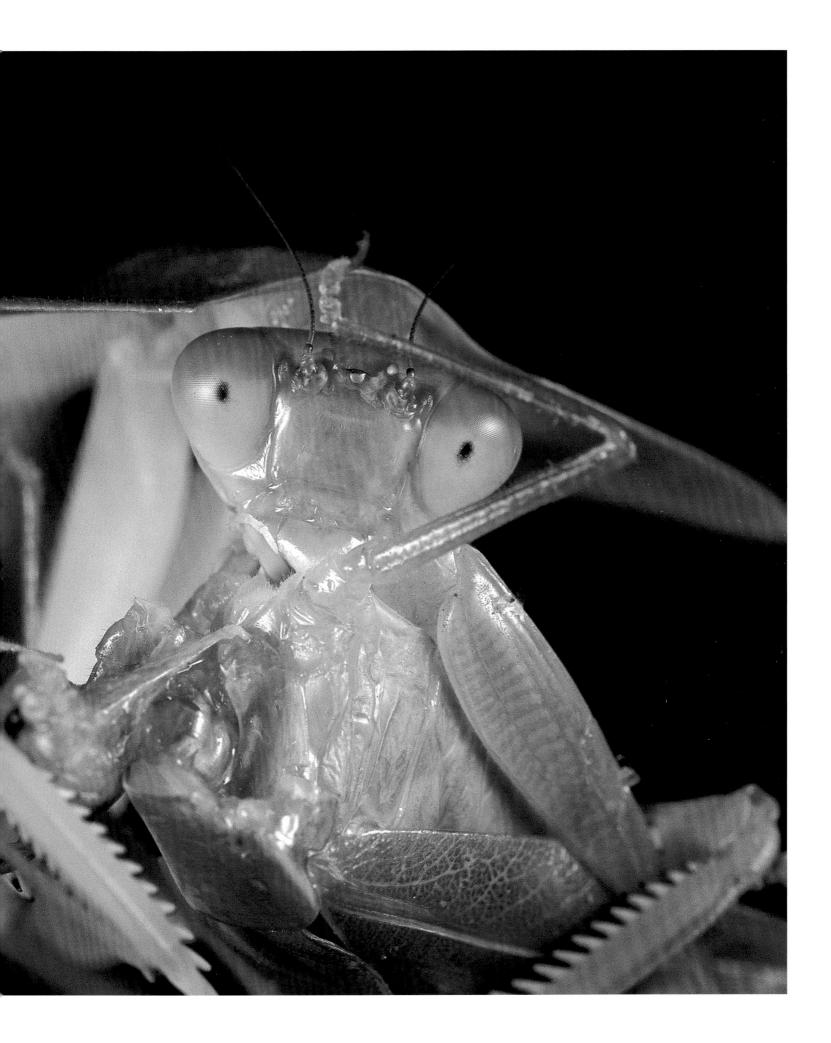

conspicuos son prueba irrefutable de que la naturaleza es en palabras de Tennyson, "roja en diente y garra", y revelan que, en efecto, ahí afuera impera la ley de la selva.

Es difícil caminar por Barro Colorado sin ver arañas y las telas que tejen para tender una trampa a su presa. Las mantis religiosas, con caras siniestras y antebrazos mortales, a menudo aparecen en las telas metálicas de las ventanas (fig. 124). Lagartijas pequeñas y sapos de tamaño variado se agazapan en el suelo o a unos pocos centímetros de altura a la espera de un insecto. Una caminata de un día puede revelar un ejército de hormigas guerreras pululando por el suelo despedazando insectos y entrando en hordas a los nidos de otras hormigas para robarles las larvas. Asimismo, uno podría toparse con uno o más coatíes olfateando la hojarasca buscando lagartijas o escarabajos, o escarbando frenéticamente el suelo para alcanzar una tarántula en su madriguera. Al cruzar un claro abierto por la caída de un árbol, acaso se observe una mosca depredadora o un chinche asesino (fig. 125) sobre una hoja o un tronco, recibiendo un baño de sol y esperando a la presa precisa. Una bandada de aves de especies diferentes podría atravesar el bosque sacudiendo el follaje a la caza de un insecto. En la época seca, sobre todo, es común escuchar a los cariblancos (figs. 169-170) haciendo crujir las hojas del dosel y ver como las examinan por si encuentran un insecto que merezca la pena ser comido.

Pero, por cada depredador que vemos, muchos otros escapan a nuestra vista: serpientes, avispas cazadoras y mirmeleóntidos, que esperan emboscados a su presa; hormigas depredadoras y libélulas, que las roban de las telarañas; y muchos más. Al caer la noche, otros depredadores salen a merodear: tarántulas, un grupo diferente de serpientes (fig. 163), zarigüeyas (fig. 158) y murciélagos que comen insectos (fig.150), ranas y sapos que comen hormigas (figs. 147, 162) y búhos, estos

últimos en busca de presas más grandes. Puede que no los veamos, pero la cantidad de defensas que suscitan son claramente perceptibles.

Aunque los visitantes prácticamente nunca ven a los depredadores más grandes, su impacto no guarda proporción con visibilidad. A principios del 2000, el Fondo Peregrino liberó en Barro Colorado un águila arpía hembra que pesaba ocho kilogramos (fig. 129). Con la ayuda de otras personas, Janeene Touchton, una pasante que trabajaba para el Fondo, se dedicó a observarla por 205 días el año siguiente. El águila capturaba un animal con un peso promedio de 3.6 kilogramos cada 4.4 días. A este ritmo, el águila tendría que comer 300 kilogramos de presa, es decir, casi 40 veces su propio peso en un año. Si extrapolamos los recuentos de esos 205 días, en un año esta águila comería 9 perezosos jóvenes de tres dedos, 34 perezosos adultos de tres dedos, 2 perezosos adultos de dos dedos, 4 monos aulladores jóvenes, 20 aulladores adultos, 5 monos cariblancos adultos, 4 iguanas verdes, 2 zarigüeyas comunes, 2 coatís y 1 cervatillo.

No es fácil calcular cuánto come un depredador grande: incluso los biólogos profesionales a veces tienen que pensarlo dos veces. Sabiendo que un par de águilas que está alimentando crías puede comer tres veces lo que comería un águila hembra sola —casi una tonelada de presa al año— algunos naturalistas se preguntaban si Barro Colorado podría darse el lujo de mantener una pareja de águilas arpías en reproducción. Los ocelotes (fig. 130), sin embargo les exigen a los mamíferos de Barro Colorado una cuota muchísimo mayor que lo que una pareja de águilas arpías podría exigirles jamás. Un ocelote de 10 kilogramos come aproximadamente 900 gramos de comida al día: 330 kilogramos (un tercio de tonelada) de presa, 33 veces su propio peso, al año. Ricardo Moreno, estudiante de la Universidad de Panamá, identificó el contenido de 40 deposiciones de ocelote halladas en Barro Colorado. A juzgar por el contenido, el consumo

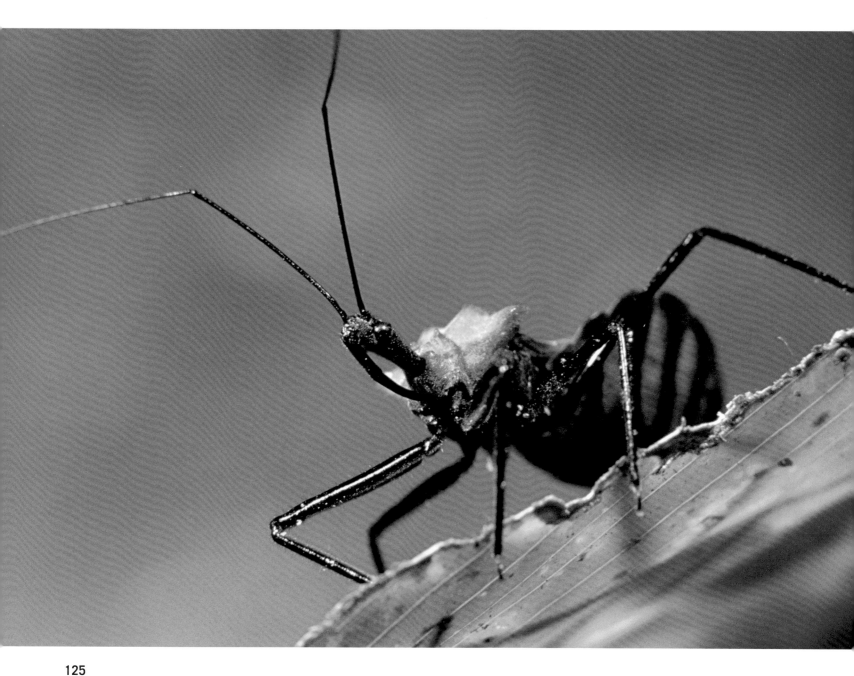

125

Muchos chinches asesinos (Reduviidae), como el que vemos aquí, se alimentan de insectos, sobre todo de orugas y escarabajos, con lo que ayudan a restringir el herbivorismo.

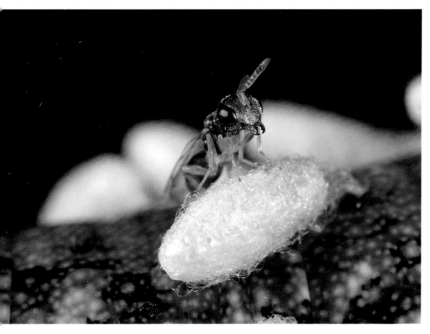

126

127

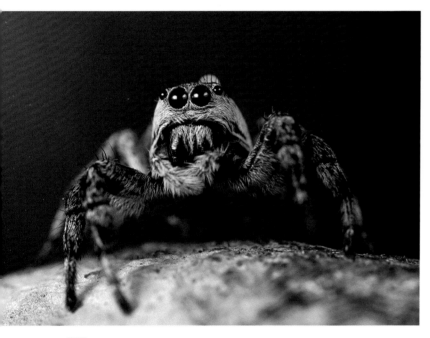

128

SIGUIENDO LAS MANECILLAS DEL RELOJ: Una avispa hiperparasitoide emerge de la crisálida de otra avispa (una avispa bracónida) cuyas larvas se desarrollan en la oruga de una polilla esfinge (el objeto café donde reposa la crisálida) (fig. 126). Otro "depredador" curioso es un hongo que infecta insectos y les ocasiona la muerte. En la imagen, una polilla infectada. El hongo ya desarrolló los cuerpos fructíferos que le permitirán propagar las esporas e infectar a otros insectos (fig. 127). Las arañas, como esta araña saltarina, son un grupo muy diverso de depredadores. Se alimentan de una gran variedad de insectos y hasta de vertebrados, para lo cual emplean distintos métodos de cacería (fig. 128).

¿Cómo logra el bosque mantenerse verde a pesar de la multitud de herbívoros que lo habitan? Las defensas químicas que posee el bosque no le bastan para controlar a los herbívoros: necesita la ayuda de los enemigos naturales de los herbívoros. Entre sus aliados más poderosos están las avispas parasitoides, llamadas así porque las larvas se desarrollan dentro o encima de otros insectos, sin matarlos inmediatamente. Muchas especies de parasitoides son muy especializadas y se alimentan de presas de una sola especie. También hay especies denominadas hiperparasitoides, que se especializan en depredar parasitoides.

anual de un ocelote incluye 21 perezosos de dos dedos, 18 perezosos de tres dedos, 15 monos cariblancos y 18 agutís. Durante mucho tiempo se pensó que en Barro Colorado había 10 ocelotes residentes. Cada ocelote tiene un patrón único en las manchas de su pelaje, así como cada uno de nosotros tiene una huella digital única. Jacalyn Giacalone, de la Universidad Estatal de Montclair, instaló cámaras automáticas alrededor de la Isla para fotografiar los animales que pasaban por ahí. Así descubrió que un perfume de Calvin Klein, *Obsession*, atraía a los ocelotes. Unos meses después de que el perfume fuera rociado cerca de las cámaras, al menos 30 ocelotes diferentes fueron fotografiados. Si todos estos ocelotes fueran residentes, estarían comiendo 10 toneladas de presa, mamíferos en su mayoría, al año (la Isla solo puede mantener unas 68 toneladas de mamíferos). Seguramente algunos son viajeros ocasionales de tierra firme, pero, aún así, el riesgo de convertirse en comida de felino es lo bastante alto como para que muchos mamíferos que viven en los árboles se muestren cautelosos ante la posibilidad de bajar al suelo.

CÓMO EVITAR A LOS DEPREDADORES

La amenaza constante que representan los depredadores en el bosque se manifiesta de muchas maneras. Los animales actúan con suma cautela. Muchos tienen colores que les permiten confundirse con el entorno. Las aves pequeñas del sotobosque, así como los monos grandes, tienden a moverse en grupo, pues así habrá más ojos vigilantes. Muchas avispas viven en colonias, porque una hembra solitaria no podría ir a buscar comida sin tener que abandonar el nido y dejarlo expuesto a los depredadores. En Europa, las abejas obreras tienen aguijones que les permiten defender el panal en caso de que un animal quiera acercarse a robarles la miel o a comerse sus larvas. En las regiones tropicales de

África, las abejas enfrentan un repertorio más diverso y peligroso de depredadores, así que las obreras se han ganado el sobrenombre de "abejas asesinas", porque salen del panal en hordas agresivas a picar a los posibles depredadores. Los nidos de las termitas son fortalezas de paredes gruesas protegidas por un implacable personal de "soldados" que no dudan en picar o desplegar sus defensas químicas ante la menor amenaza. Algunas orugas tropicales tienen el cuerpo recubierto de pelitos urticantes para protegerse de los depredadores. Las hormigas y muchos otros animales son de sabor desagradable o difíciles de comer.

Los animales pequeños que son peligrosos o tienen un sabor desagradable advierten su condición. Los colores encendidos de la serpiente de coral, el "uniforme" negro-amarillo de muchas abejas y avispas, el llamativo negro, azul o verde de otras, así como el zumbido amenazador de las abejas y avispas cuando alguien se acerca más de lo debido son, todos, señal de peligro. Los colores vistosos de muchas mariposas —y de las orugas que las preceden—, así como la tendencia de ciertas orugas conspicuas a congregarse en grupos más conspicuos todavía son señal de sabor desagradable (fig. 131). El negro y verde de la "rana venosa de dardo" de Barro Colorado y los colores aun más vivos de estas ranas en el resto de Panamá, lo mismo que el negro intenso de muchas hormigas advierten ambos: peligro y sabor desagradable.

Para ayudar a un depredador que ya aprendió a evitar a una especie de sabor desagradable a evitar a otra también, diferentes especies de mariposas de sabor desagradable se imitan (mimetismo) en el color y en la forma de las alas, y a veces incluso en la manera de volar (fig. 132). Un estudiante de posgrado, Peng Chai, se preguntó cuáles mariposas del bosque lluvioso del suroeste de Costa Rica se comería el jacamar, un ave depredadora de mariposas. Chai fue liberando mariposas,

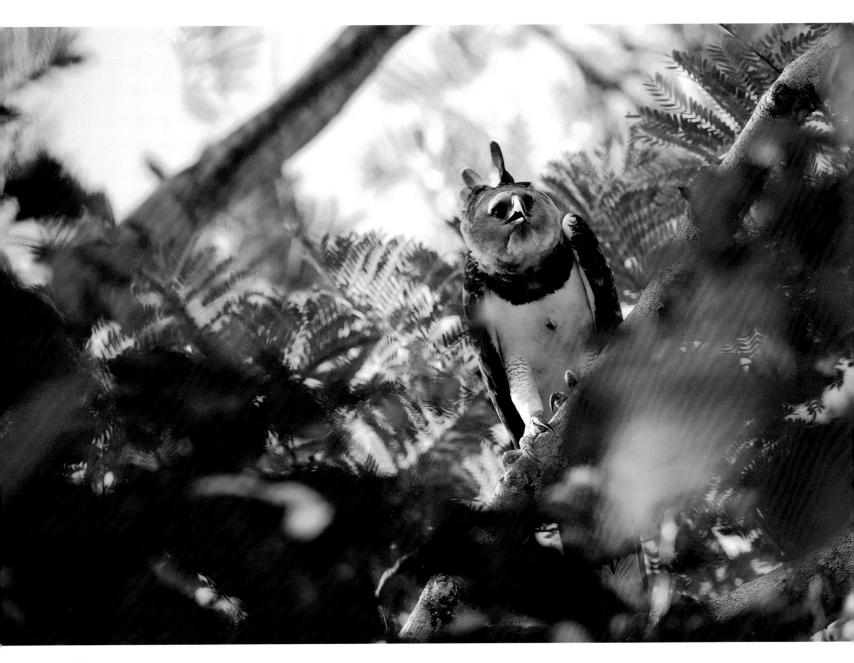

129

El águila arpía, *Harpia harpyja,* considerada el ave rapaz más poderosa del mundo, es el ave depredadora más grande de los bosques del neotrópico. La caza a la que ha estado sometida, así como la destrucción de su hábitat, han reducido considerablemente su ámbito de distribución. Las poblaciones que aún sobreviven se extienden desde Guatemala hasta Brasil. En Barro Colorado se introdujeron dos águilas arpías, pero ambas escaparon. Esta hembra, criada en cautiverio, fue la segunda que se introdujo en la Isla, a finales de 1999. Se marchó a finales del 2000.

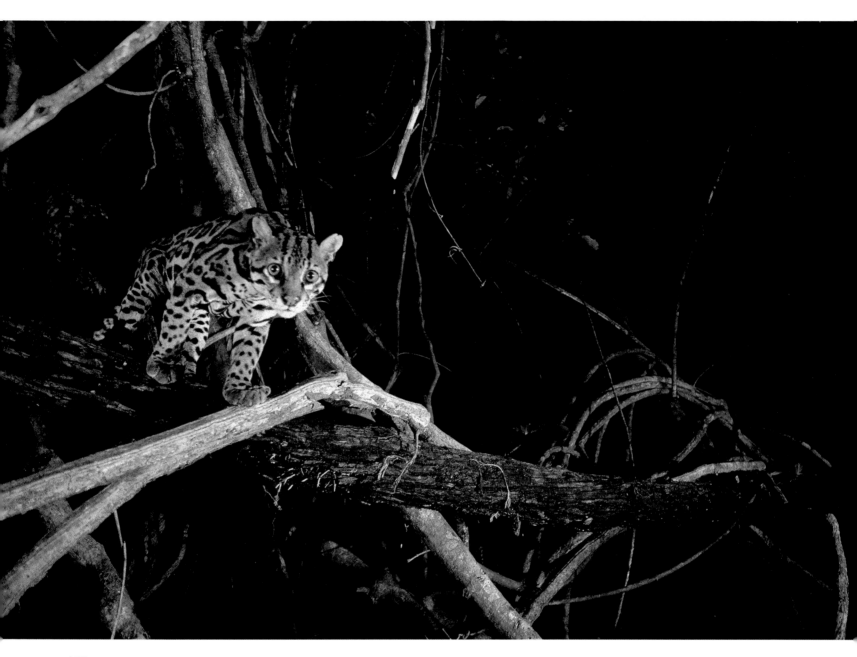

130

Sin contar a los pumas, que visitan la Isla con frecuencia, y a los jaguares, que muy de vez en cuando lo hacen, los ocelotes *(Felis pardalis)* son los depredadores más grandes (más pesados) de Barro Colorado. Una serie de fotografías tomada en 2005 con cámaras automáticas reveló la presencia de 30 ejemplares en la Isla. Como ha ocurrido con todos los felinos grandes, los ocelotes también han estado sometidos a una cacería intensa y su ámbito de distribución se ha reducido considerablemente. Es muy probable que los ocelotes, así como otros felinos grandes, cumplan un papel fundamental protegiendo al bosque de los herbívoros vertebrados, e indirectamente podrían influir en los patrones de dispersión de semillas. También son un componente esencial de la belleza y el carácter novelesco que se les atribuye a las selvas.

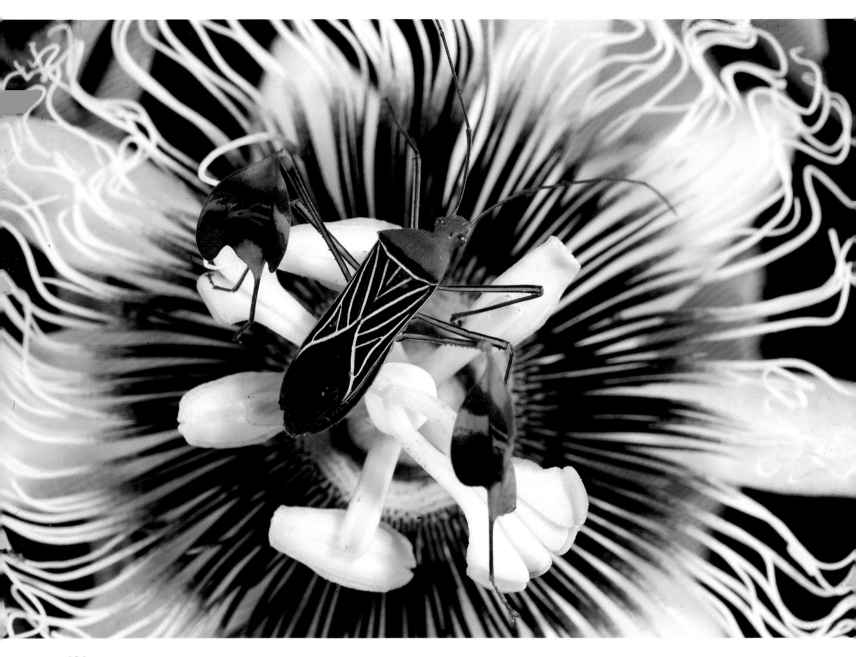

131

Muchos animales se defienden de un posible depredador porque son tóxicos, tienen mal sabor o son peligrosos, y lo anuncian exhibiendo "colores de advertencia" claramente visibles, como en el caso de este chinche, que parece portar banderillas rojas en las patas. Este chinche se alimenta de la flor de la pasión y acumula el veneno de la planta en su cuerpo. Aquí vemos a un ejemplar descansando sobre una de estas flores.

una a una, en la jaula del ave para ver cuáles se comía. El jacamar se negó a comerse las mariposas de la pasionaria, *Heliconius cydno, H. sapho, H. erato* y *H. Melpomene.* Estas cuatro especies son comunes en Barro Colorado. Allí, las dos primeras son de un negro azulado brillante, con una banda blanca y amplia en cada ala anterior. Las otras dos especies son negro azabache, con una banda roja brillante en las alas anteriores y un borde amarillo limón en la zona anterior de las alas traseras. Mientras hacía investigación en Panamá, el biólogo Robert Srygley encontró que aunque la *cydno* está más relacionada con la *melpomene*, y la *sapho* con la *erato*, la *cydno* no solo se parece a la *sapho*, sino que vuela como ella, mientras que la *melpomene* se parece a la *erato* y vuela como ella. Estas dos últimas especies coexisten en las tierras bajas tropicales de Suramérica. Tiempo atrás, al viajar río arriba por el Amazonas, el naturalista victoriano William Bate observó cambios repentinos en los patrones de coloración de este par de especies en tramos de apenas unos cuantos cientos de millas. Ambas especies cambiaban los patrones juntas, de modo que, cuando volaban juntas, las *erato* y las *melpomene* se veían parecidas.

Barro Colorado tiene muchos anillos miméticos como estos. En el claro del laboratorio a menudo se observan unas mariposas negras con una gran mancha roja en las alas traseras. Por lo general, las alas delanteras también presentan una mancha brillante de color blanco o verde. Estas mariposas podrían pertenecer a una de varias especies de *Parides*. Las *Parides* son venenosas porque cuando están en la fase de oruga se alimentan de plantas del género *Aristolochia* y así incorporan los venenos contra herbívoros que estas plantas contienen. Sin embargo, estas mariposas también podrían pertenecer a la especie *Papilio anchisiades*, una mariposa cola de golondrina "sin cola", que a pesar de no contener ningún veneno antiherbívoro, también fue rechazada por el jacamar de Peng Chai.

No toda advertencia de sabor desagradable o peligro inminente es verdadera. Algunas moscas inofensivas y crisópidos comestibles buscan protegerse adquiriendo una coloración semejante a la de las abejas y avispas agresivas e incluso zumbando como ellas. Muchas mantis tropicales y machacas (unos parientes de las chicharras de apariencia bastante curiosa, también llamados "víboras cuco"), cuando salen del nido, donde permanecen aisladas del mundo exterior gracias un material natural similar a una espuma de poliestireno, son negras, como hormigas pequeñas, y también corren de un lado a otro de una manera escalofriantemente similar a la de estos insectos (fig. 135). Si se les toca, las machacas adultas (fig. 133) y muchas polillas sacan a relucir las alas traseras mostrando lo que parecen ser un par de ojos de búho deslumbrantes. Esta imagen sorprende a algunas aves lo suficiente como para permitir que la presa se escape. Una mariposa del suelo del bosque, la sátira, tiene las alas diáfanas, recurso perfecto para pasar desapercibida, pero como además tiene una pizca de rojo en las alas traseras, un depredador que detecte movimiento centrará su atención en esa manchita, que se verá como un chinche nocivo flotando sobre el suelo (fig. 136).

Las mariposas comestibles intentan hacerse pasar por venenosas imitando a las venenosas. En Barro Colorado, tanto la mariposa plebeya, *Lycorea cleobaea,* pariente de la monarca, como la Ithomia o vitral, *Mechanitis polymnia* (fig. 132), anuncian su sabor desagradable con el anaranjado oscuro de sus alas y la barra negra perpendicular al cuerpo que las decora. Las puntas de las alas anteriores son negras con motas amarillas. La *Dismorphia amphiona*, mariposa apetecible, tiene una coloración similar a la de *Lycorea cleobaea*, a pesar de que las *Dismorphia* pertenecen a las mariposas "azufres y blancas", muy frecuentes en las zonas templadas. Otro anillo mimético compuesto principalmente por pequeñas mariposas de sabor desagradable con alas transparentes bordeadas de

132

Los depredadores no dudan en atacar una presa de colores brillantes si nunca antes la han probado. Cuando un animal que lleva aparejados la coloración llamativa y el sabor desagradable se ha vuelto tan común que los depredadores ya saben que hay que evitarlo, otras especies poco apetecibles podrían usarlo como modelo e imitar su color y su forma para beneficiarse del conocimiento aprendido del depredador. En este tipo de mimetismo, denominado "mülleriano", algunas especies adoptan colores de advertencia similares, con lo que inconscientemente contribuyen a simplificar la educación del posible depredador y a reducir el número de muertes que se necesitan para enseñarle que todas tienen mal sabor. Otras, especies comestibles, tratan de escapar de los depredadores imitando colores de advertencia. Así, en Estados Unidos, una variedad de moscas inofensivas imita el patrón negro-amarillo de las avispas "chaqueta amarilla". Las siete especies de mariposas y las dos especies de polillas que se observan en la imagen, todas de sabor desagradable, comparten el mismo patrón de coloración básico.

Arriba, de izquierda a derecha, están las mariposas *Mechanitis* sp., *Mechanitis polymnia isthmia* y *Heliconius ismenius clarescens*, que se imitan estrechamente. En la fila del medio, hay dos mariposas, *Mechanitis* sp. y *Heliconius hecale,* el supuesto modelo de este anillo mimético, que se imitan de cerca, y una mariposa nocturna de la familia Arctiidae, *Chetone kenara.* En la fila de abajo, está la mariposa nocturna, *Chetone angulosa,* y las mariposas *Melinaea menophilus,* así como *Mechanitis* sp., que imita de cerca a *Heliconius hecale.*

133

Los animales tienden a juzgan a su oponente por el tamaño de los ojos, de ahí que un par de ojos falsos en el lugar correcto

sirven para confundir al enemigo. Un animal que ha sido sorprendido por un depredador puede ganar segundos valiosos

desplegando un par de ojos aterradores. Aquí vemos las grandes manchas en forma de ojo que presenta la machaca, *Fulgora*

laternaria, en las alas traseras. Los colores crípticos de este insecto, un pariente de forma curiosa de las cigarras, le permiten

camuflarse con la corteza del árbol sobre el que reposa.

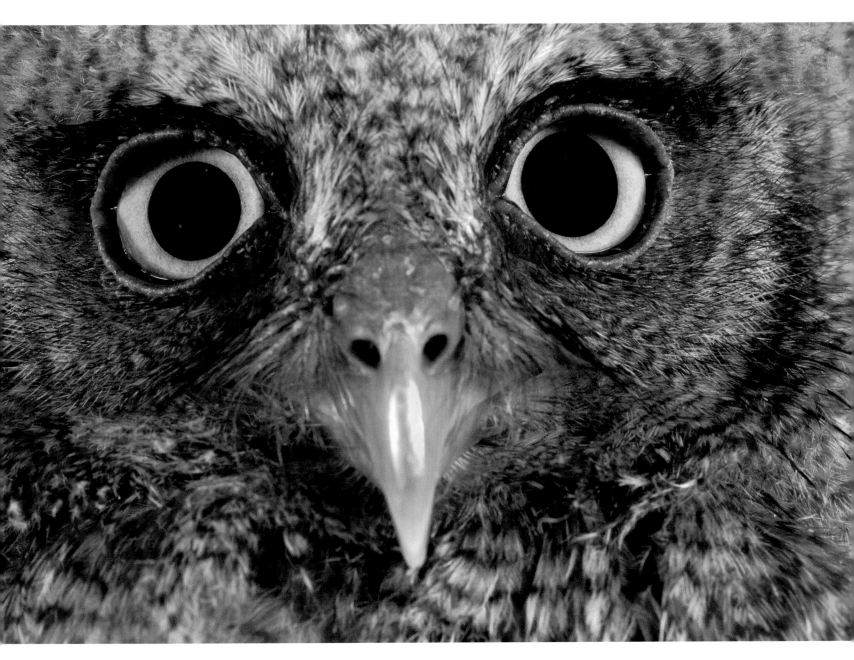

134

Una vista cercana a los ojos de un búho currucutú *(Otus choliba)*.

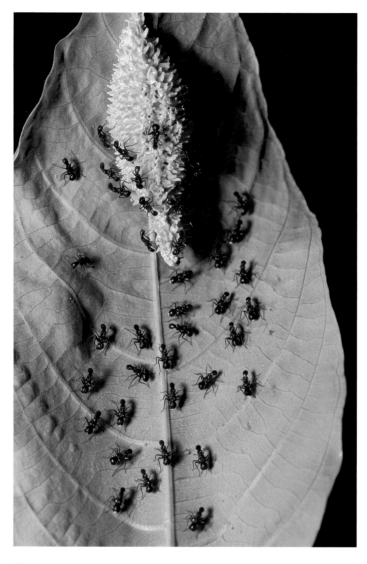

135

Muchas veces los animales apetecibles imitan el comportamiento, la forma y el color de los animales de mal sabor. Tras emerger de su nido de espuma, las machacas (*Fulgora laternaria*) suelen permanecer en grupo. A simple vista parecen hormigas y al ser molestadas también se mueven como hormigas, con lo que logran disuadir a muchos depredadores que prefieren mantenerse alejados de tales insectos.

negro y blanco, también incluye a una especie apetecible de *Dismorphia*, el único miembro de la familia de "azufres y blancas" en Panamá que tiene las alas transparentes. Los anuncios engañosos perjudican a los modelos realmente venenosos, pues le restan fiabilidad al mensaje. Si este tipo de mimetismo se vuelve demasiado común, el patrón de coloración del modelo deja de ser una protección.

Otro tipo de publicidad engañosa es parecerse a algo que un depredador jamás se comería, como un palo o una hoja muerta (figs. 137-41). En Barro Colorado, Michael Robinson estudió qué partes del cuerpo trataban de disfrazar o esconder distintos animales, con el fin de identificar qué era lo que más atraía a los depredadores. Los insectos palo son famosos porque se parecen a un palo (figs. 137, 138) y lo que más intentan disfrazar son las piernas, la cabeza y las antenas. Robinson encontró que estos apéndices atraían la atención inmediata de un mono enjaulado en busca de comida.

Los disfraces, sin embargo, pueden ser una carga. Un palo no puede caminar, pero los insectos palo de vez en cuando tienen que caminar. La mayoría resuelve el problema alimentándose de noche. Cuando se mueven de día adoptan un paso lento y con un ligero balanceo, un poco como una hoja balanceándose lentamente con la brisa. Además, los juanpalos de la misma especie no pueden estar muy cerca unos de otros, no vaya a ser que un depredador que haya probado uno decida probar todos los palos que están juntos y son del mismo tamaño. Para evitar que se los coman, los animales que son comunes deben diversificar sus disfraces. El sapito de hojarasca, *Rhinella alata*, común en el suelo de Barro Colorado, visto desde arriba parece una hoja seca (figs. 143-147). Sin embargo, cada hoja (cada imitación individual) difiere de la otra en el color, el diseño y el grado en que se destaca la nervadura central.

Otros animales intentan fundirse con el entorno para simular que ahí no hay nada. La machaca (fig. 133) tiene los

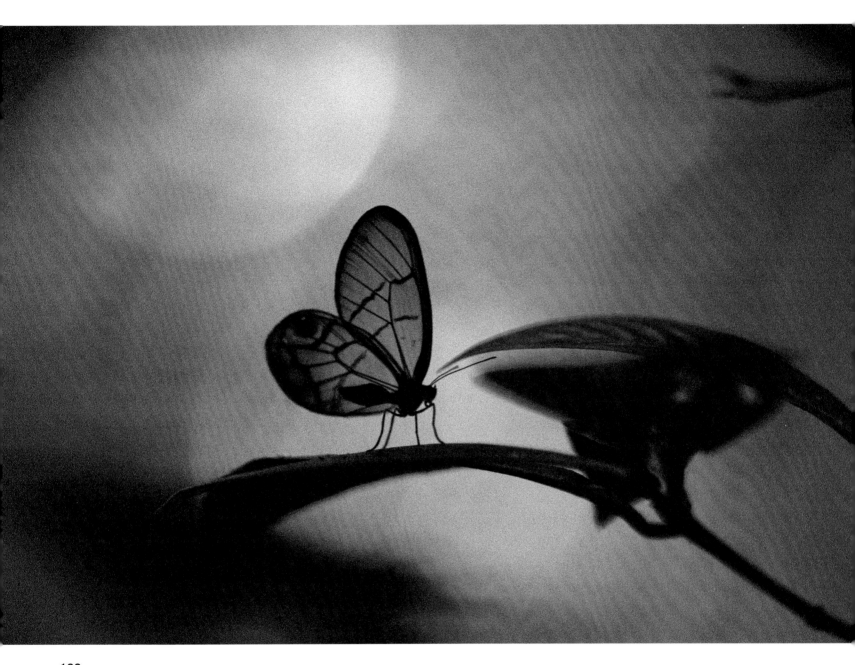

136

Muchas mariposas, y también otros insectos, recurren a trucos para engañar a los depredadores. Cuando vuelan, enseñan unas alas de colores brillantes que el depredador sigue con atención, pero cuando se posan, los colores encendidos se esconden y la mariposa se funde con el entorno. El depredador no tiene idea de qué pasó con la presa de colores que sus ojos seguían. La mariposa de alas de cristal, *Cithaerias menander,* tiene las alas transparentes, excepto por una pincelada de rojo en la punta del ala trasera. Cuando vuela es como si un chinche rojo estuviera volando, pero si se posa en la sombra, se esfuma.

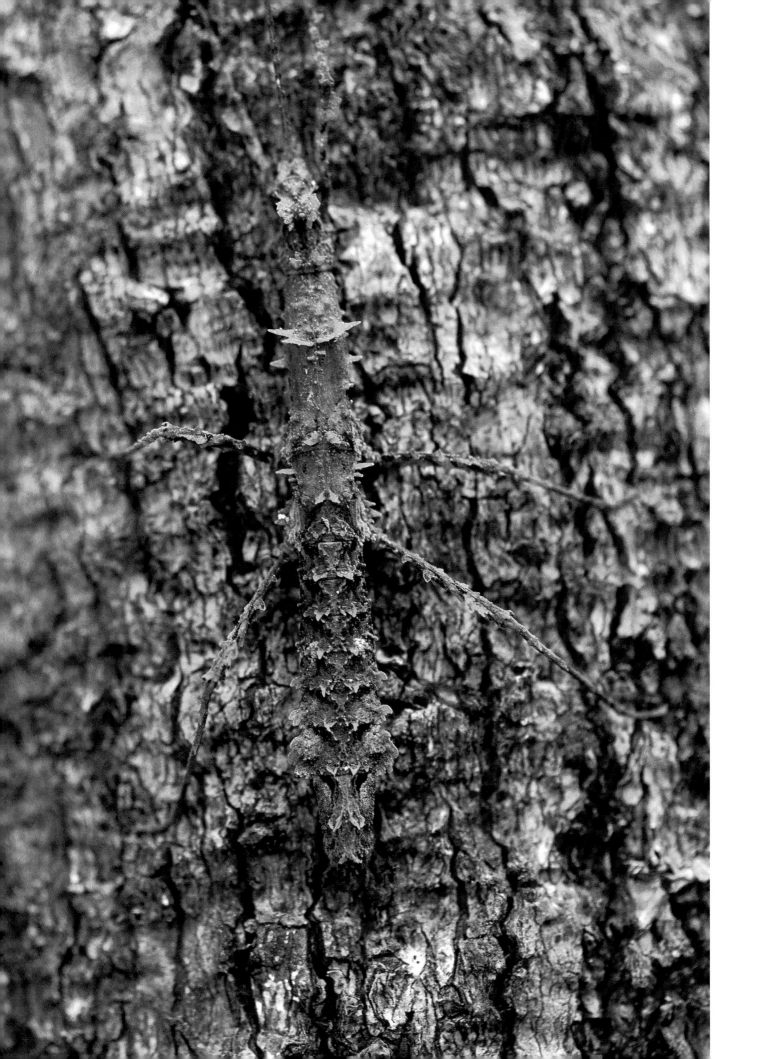

139

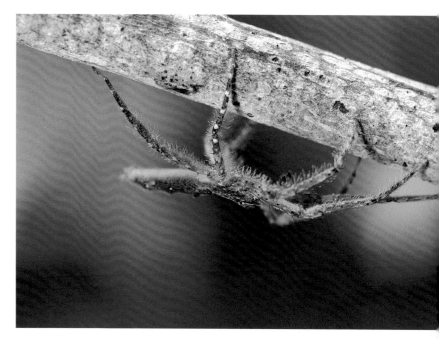

140

Los animales pueden evitar que se los coman disfrazándose
de objetos no comestibles, como una ramita seca,
o confundiéndose con el entorno. Los palos vivientes son
maestros del camuflaje (figs. 137, 138), al igual que
otros artrópodos, como las arañas (figs. 139, 140) y las
esperanzas (fig. 142).

137 Palo viviente (*Autolyca* sp.) camuflado de musgo.

138 Palo viviente *(Bacteria ploiaria)*.

139 Araña camuflada sobre una rama.

140 La misma araña echando a andar.

138

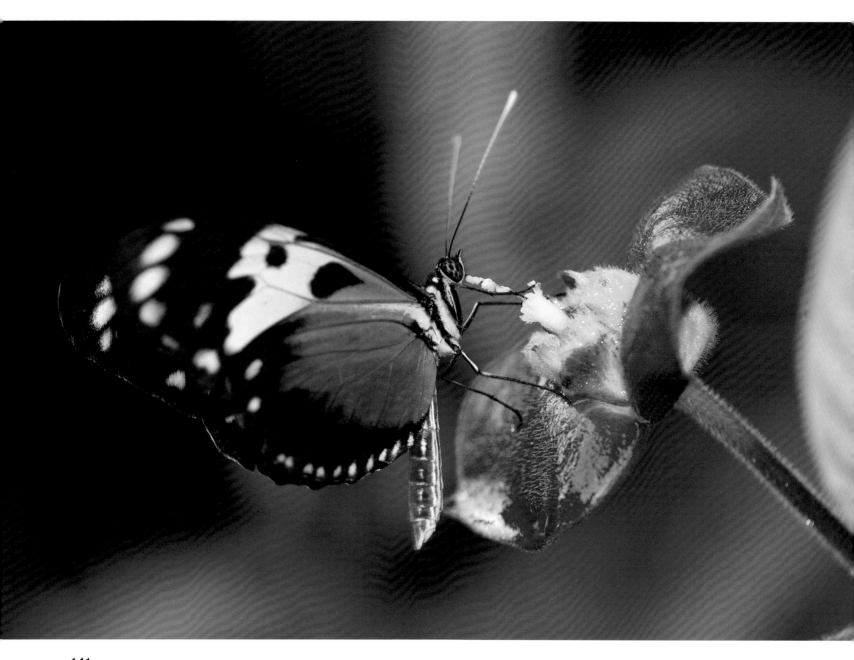

141

Una *Heliconius sara fulgidus*, mariposa de sabor desagradable, liba néctar en la selva.

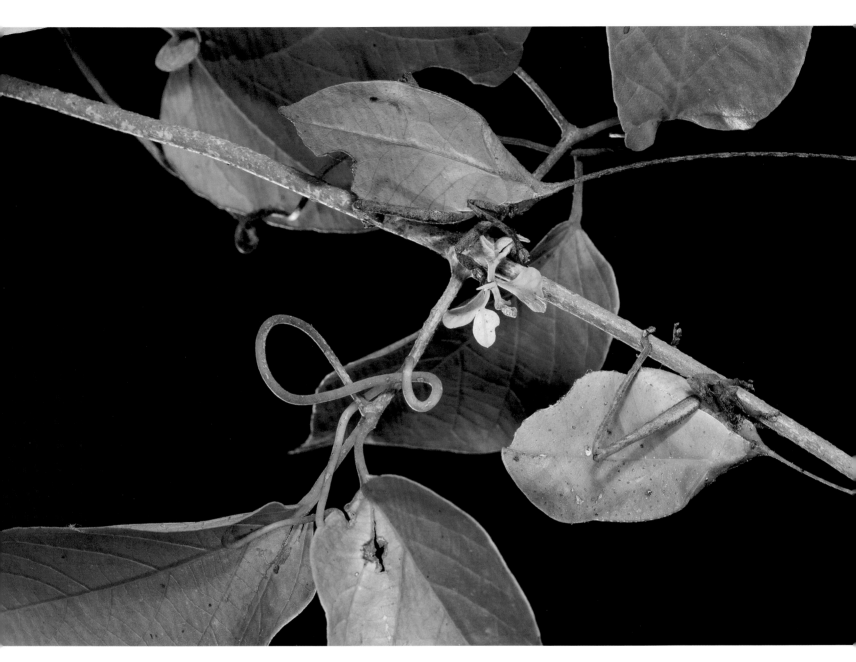

142

Las esperanzas del género *Mimetica* imitan hojas dañadas por hongos.

143 144

Los vertebrados también se camuflan para escapar de los depredadores. El sapito de hojarasca, *Rhinella alata,* lo hace con insuperable maestría. Cada uno de los ejemplares de esta especie presenta un patrón diferente y son casi imposibles de descubrir, a no ser que se muevan. Es más, ningún "buscador de imágenes" alcanza para detectar todos los ejemplares, por su infinidad de diseños.

145

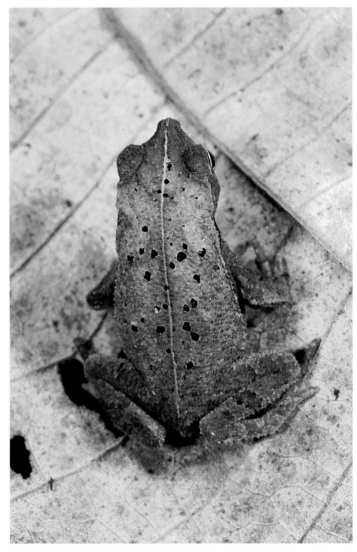

146

colores precisos para confundirse con la corteza del tronco del árbol de guapinol (algarrobo) de cuya savia se alimenta. Las mariposas morfo, que enseñan un deslumbrante azul iridiscente cuando vuelan, se confunden con el frondoso tapiz vegetal al plegar las alas. Los extremos a los que llegan algunos animales para camuflarse con el entorno son una de las maravillas de la historia natural de los trópicos. La variedad de medios que emplean para amedrentar a los depredadores o pasar inadvertidos pone de manifiesto la amenaza constante de ser devorados.

¿QUÉ DIFERENCIA HACEN LOS DEPREDADORES?

La depredación amenaza de forma constante a la mayoría de los animales del bosque. ¿Se podría sugerir que los bosques tropicales necesitan a los depredadores para que les ayuden a controlar a los herbívoros?

Los bosques del norte necesitan a los lobos y a los pumas para protegerse de los alces y los venados. Ahora que esta protección está ausente, la composición de

147

Tres ejemplares de *Rhinella alata*. ¿Dónde están las hojas y dónde los sapitos?

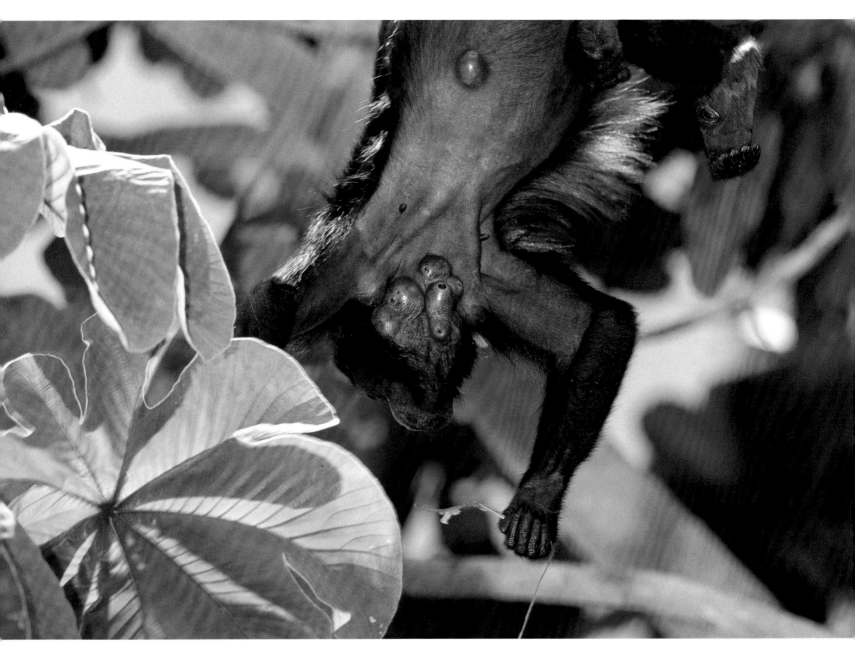

148

Las poblaciones de animales que tienen pocos depredadores se encuentran restringidas por la escasez estacional de alimentos. En la época de escasez, pueden ser más vulnerables a las enfermedades y a los parásitos. En Barro Colorado, los monos aulladores *(Alouatta palliatta),* que tienen pocos depredadores, son atacados inclementemente por un díptero especializado: *Alouattamyia baeri*. Aunque los tórsalos no les ocasionan la muerte, las heridas que dejan en la piel rápidamente se infectan de gusanos barrenadores y esto sí que resulta mortal. En la imagen se puede apreciar la cantidad de tumefacciones que presenta este mono en el cuello.

especies de árboles está cambiando inexorablemente. Una gran cantidad de estudiantes de doctorado han llegado a Barro Colorado a investigar los herbívoros vertebrados de la Isla —ardillas, monos cariblancos, agutíes, coatíes y monos aulladores; ratas espinosas que se alimentan de semillas, saltarines que se alimentan de fruta, murciélagos que se alimentan de higos; osos perezosos e iguanas que se alimentan de hojas— y han encontrado que todas estas poblaciones se encuentran limitadas por la escasez estacional de frutas y hojas nuevas. Cierto, los depredadores y los parásitos a menudo dan el golpe de gracia a los animales afectados por la escasez estacional de alimentos. Los ocelotes acaban con los agutíes jóvenes que tienen que arriesgarse más para encontrar comida cuando la fruta y las hojas nuevas escasean. Los tórsalos y los gusanos acaban con los monos aulladores desnutridos (fig. 148). Sin embargo, a diferencia de su contraparte del norte, parece que el bosque de Barro Colorado sí puede protegerse a sí mismo de los vertebrados sin ayuda de grandes felinos u otros superdepredadores (depredadores que no tienen depredadores naturales que los amenacen).

No obstante, el bosque tropical, necesita animales que lo protejan de las plagas de insectos que lo asedian. Phyllis Coley observó que algunas plantas de luz, poco defendidas, crecían justo lo necesario para dejar atrás a sus plagas. ¿Qué impide que estas plagas se vuelvan tan comunes que lleguen a detener el crecimiento de estas plantas? Coley encontró que muchos de los compuestos químicos con que las plantas se defienden no matan a las orugas, sino que desaceleran su ritmo de alimentación y alargan el tiempo de maduración. ¿Por qué habrían de hacer esto, si no es porque una maduración más lenta hace que la oruga sea más proclive a ser comida? Es más, los asistentes de Coley encontraron que la tasa de mortalidad de las orugas a causa de las avispas y otros depredadores era muy alta.

Que el bosque tropical no puede controlar a los insectos herbívoros sin ayuda lo demuestran de manera contundente las isletas de una hectárea recientemente aisladas de tierra firme en Venezuela por el aumento en el nivel del embalse del lago Guri. John Terborgh y sus colaboradores observaron que las hormigas arrieras habían proliferado desmesuradamente en esas isletas. Algunas isletas presentaban de cinco a seis colonias de hormigas por hectárea, y las hormigas drásticamente restringen el número y la diversidad de plantas que pueden germinar en las isletas. A pesar de que la tierra firme ofrece una fuente de comida más constante y abundante, ahí las poblaciones de hormigas arrieras son cien veces menos densas que en las isletas. Tiene que ser que algunos de los depredadores que no tardaron en desaparecer de las isletas están controlando a las poblaciones de hormigas arrieras en tierra firme. Los resultados de Terborgh causaron gran sorpresa, pues hasta ese momento se había pensado que las poblaciones de hormigas arrieras, así como las de monos aulladores estaban restringidas por la escasez estacional de hojas nuevas. Sin embargo, las pruebas de que los bosques tropicales necesitan la ayuda de aves, arañas y avispas para evitar ser devorados por los insectos continúan creciendo.

149

Un murciélago con hábitos
alimentarios muy especializados es
el *Noctilio leporinus*, el murciélago
pescador mayor. Esta especie vuela a
ras del agua recogiendo con sus patas
insectos suspendidos en la superficie
del lago que rodea la Isla.

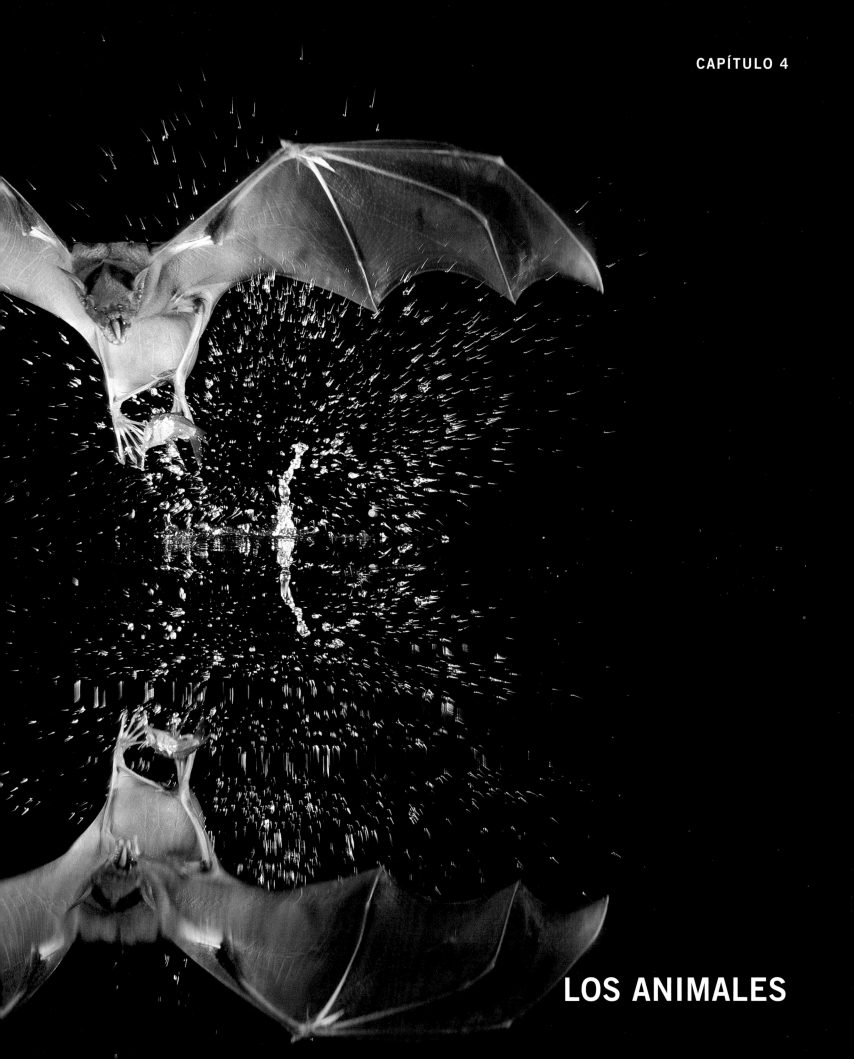

LOS ANIMALES

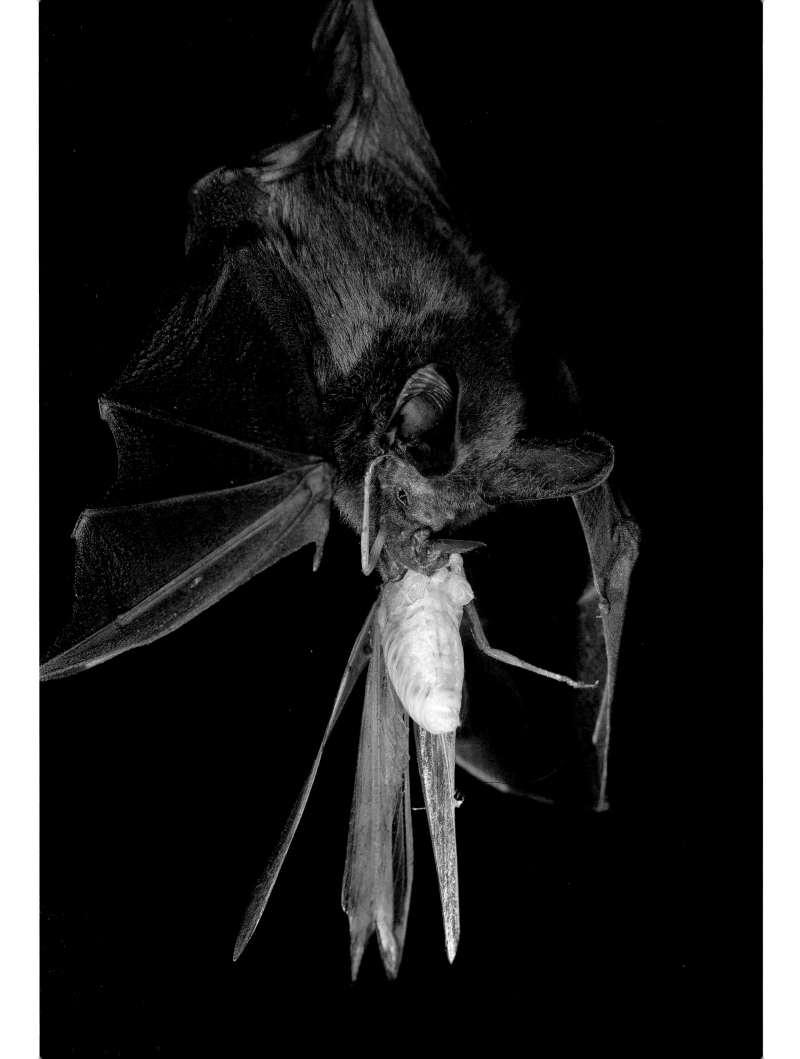

LOS ANIMALES

EL PORQUÉ DE LA DIVERSIFICACIÓN

¿Por qué en el mundo hay tantos animales distintos? Entre los seres humanos se observan tantos oficios y profesiones porque una persona con la experiencia y las herramientas para resolver una tarea específica puede hacerlo más rápido que una que debe resolver muchas tareas diferentes. Adam Smith comienza su *Investigación sobre la naturaleza y las causas de la riqueza de las naciones* señalando las razones por las que la división del trabajo aumenta la producción de riqueza. Su primer ejemplo muestra cómo un obrero poco preparado no puede confeccionar más de veinte alfileres por día, haciendo sólo eso, mientras que una fábrica equipada con diez obreros, cada uno especializado en un aspecto diferente de la producción, puede producir 4800 alfileres por día por trabajador.

150

Una variedad considerable de especies de murciélagos se alimenta de insectos. Una de ellas es el murciélago orejón común, *Micronycteris microtis*, que se observa aquí devorando un esperanza de grandes dimensiones. Esta especie vuela lentamente frente a la vegetación y usa su "sonar" para localizar presas comestibles.

Para poder hacer lo todo, un ser humano tendría que tener el conocimiento, el equipo y la experiencia que supone cada ocupación. Los seres humanos no se distinguen por la omnisciencia (mucho menos quienes afirman tenerla). Conforme aumenta el conocimiento humano, aumenta también el número de especialidades. Para ser lo bastante competitivos como para mantener un buen puesto, los académicos tienen que dominar su tema como nadie, circunstancia que a veces restringe peligrosamente su repertorio de conocimientos. Fuera de la academia, la destreza debe ir respaldada por la experiencia y puede ser que la capacidad de hacer bien un trabajo demande cierto tipo de equipo. La vida no es lo bastante larga para acumular la experiencia, o los recursos para adquirir el equipo, que permitirían resolverlo todo y de la mejor manera. Así, la división del trabajo surge como una necesidad en cada uno de los niveles que conforman una sociedad compleja.

De manera similar, hay tantos tipos de animales porque no hay uno solo que pueda hacerlo todo bien. Al igual que las plantas, los animales enfrentan compromisos *(trade-offs)*. Los animales que tienen una dieta basada en hojas maduras están mal equipados para cazar, o para digerir, presas animales, así que los bosques albergan ambos, herbívoros que comen hojas y depredadores. Un insecto que puede obtener nutrientes o protección de los venenos de una planta no puede esquivar, y mucho menos usar, los venenos de otra, así que los bosques

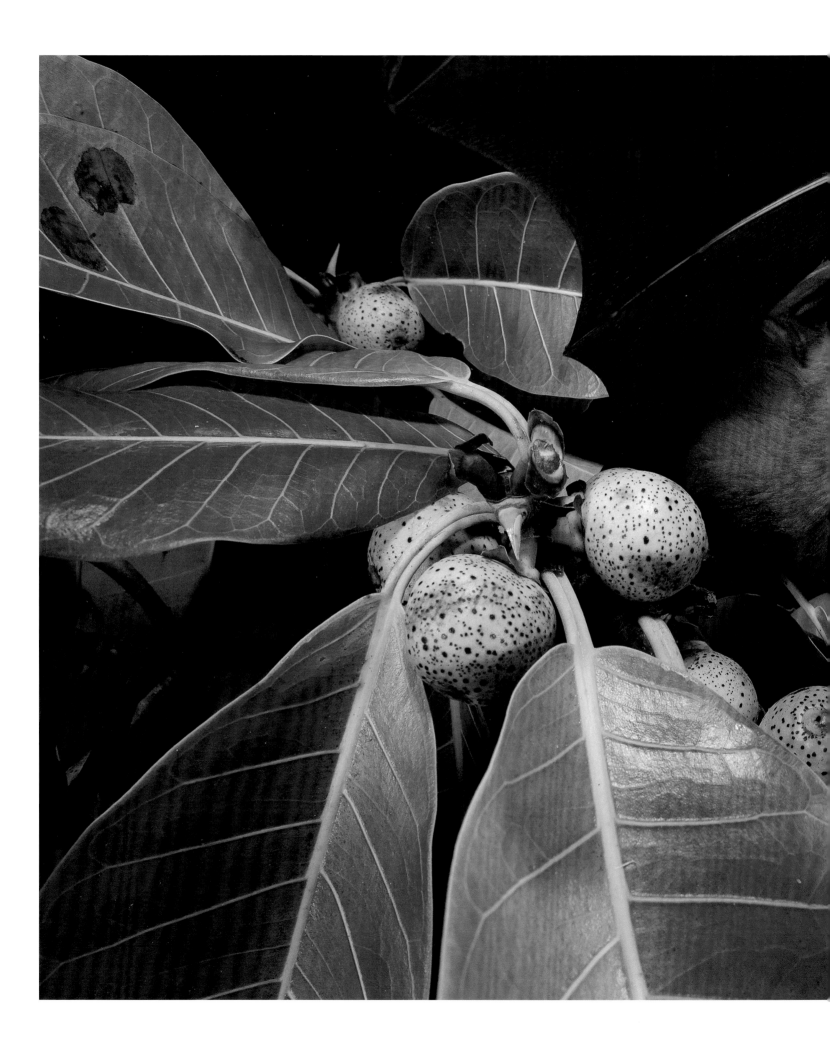

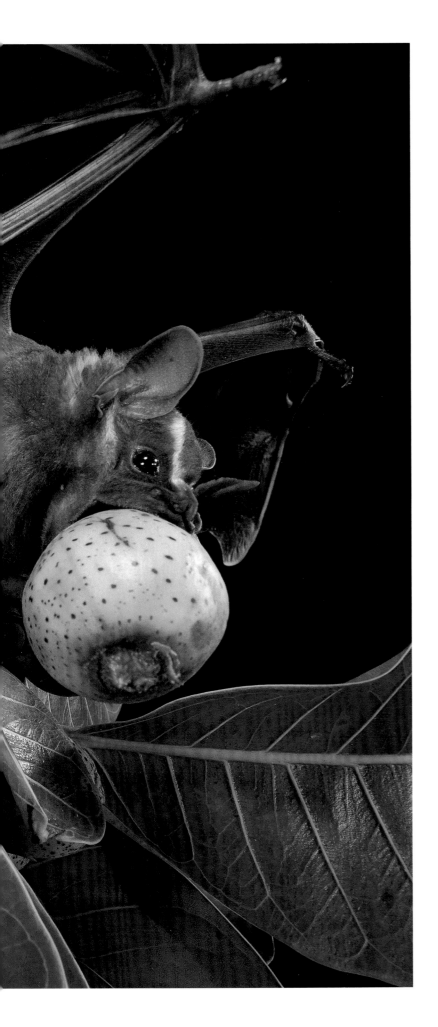

151

Un gremio importante de murciélagos es frugívoro.
El murciélago frutero grande, *Artibeus lituratus*, es
una especie común en Barro Colorado. Como todos
los murciélagos frugívoros, juega un papel clave en la
dispersión de semillas de muchas especies de plantas.

albergan una enorme diversidad de insectos herbívoros. Los buenos voladores son malos caminadores, y viceversa: los murciélagos, tal vez los mejores voladores del bosque, prácticamente no pueden caminar. Por tanto, un bosque alberga ambos, aves que vuelan y que caminan, murciélagos que vuelan y mamíferos que caminan. Los animales que se han adaptado a cazar venados no pueden vivir de mosquitos, mientras que una araña que vive de atrapar mosquitos en su tela difícilmente podrá atrapar a un venado. Por esta razón los depredadores vienen en una gran variedad de tamaños.

Otros compromisos son más sutiles. Un estudiante de posgrado de la Universidad de California en Los Ángeles, Todd Shelly encontró que la fisiología que hace que una mosca depredadora sea muy efectiva en los claros, al permitirle despegues rápidos, vuelos veloces, y gran capacidad de maniobra, una vez que ha calentado su cuerpo al sol, la sume en un estado letárgico a la sombra, donde apenas si logra calentarse. De esta forma, un tipo de moscas depredadoras caza en los claros, mientras que otro sobrevive a la sombra.

Otro estudiante de posgrado, Jan Sevenster, de la Universidad de Leyden (Holanda), observó un compromiso curioso en las moscas de la fruta, *Drosophila*, que viven de la fruta que se descompone en el suelo del bosque en Barro Colorado. Estas moscas necesitan encontrar fruta en el suelo para depositar sus huevecillos, porque solo ahí se pueden desarrollar las larvas. Cuando hay fruta y moscas de la fruta en abundancia, las moscas que salen mejor libradas son aquellas cuyas larvas se desarrollan más rápido y emergen antes de que sus competidoras puedan devorarse la fruta. Cuando la fruta es escasa, la "mamá mosca" que vive más tiempo tiene más probabilidades de encontrar fruta donde depositar sus huevecillos. Como las moscas más longevas tienen las larvas que se desarrollan más lento, y viceversa, las moscas de la fruta enfrentan un compromiso entre la competitividad de las larvas y la longevidad de los adultos: a las especies que les va mejor donde hay fruta en abundancia les va peor donde la fruta escasea. Como la abundancia de fruta varía significativamente de una estación a otra y de un lugar a otro, este compromiso, como el compromiso que enfrentan las plantas entre crecer rápido a plena luz o sobrevivir a la sombra, permite la coexistencia de varias especies.

Wibke Thies, estudiante de posgrado de la Universidad de Tübingen, encontró que los murciélagos que se alimentan de los frutos del sotobosque enfrentan un compromiso entre alimentarse de fruta que se encuentra uniformemente distribuida o ampliar su ámbito de exploración en busca de fuentes de alimento más generosas. Barro Colorado tiene dos tipos de murciélagos comunes que se alimentan sobre todo de los frutos del *Piper*, un arbusto del sotobosque. Thies observó que las poblaciones de estos murciélagos se encontraban reguladas por la escasez estacional de alimentos: en la estación de escasez de fruta, los murciélagos se comían prácticamente todos los frutos disponibles de *Piper* tan pronto como maduraban. Esta investigadora colocó pequeños radiotransmisores en los murciélagos a fin de rastrear sus movimientos. De ese modo, encontró que la especie más grande, *Carollia perspicillata*, que pesa

152

El murciélago de labios con flecos (*Trachops cirrhosus*) tiene una dieta insectívora y carnívora. Su afinado sentido del oído le permite localizar a las ranas túngaras por los llamados que emiten durante su ritual de apareamiento. Las protuberancias semejantes a verrugas que tiene alrededor de la boca podrían ser sensores que le permiten detectar si una presa es venenosa.

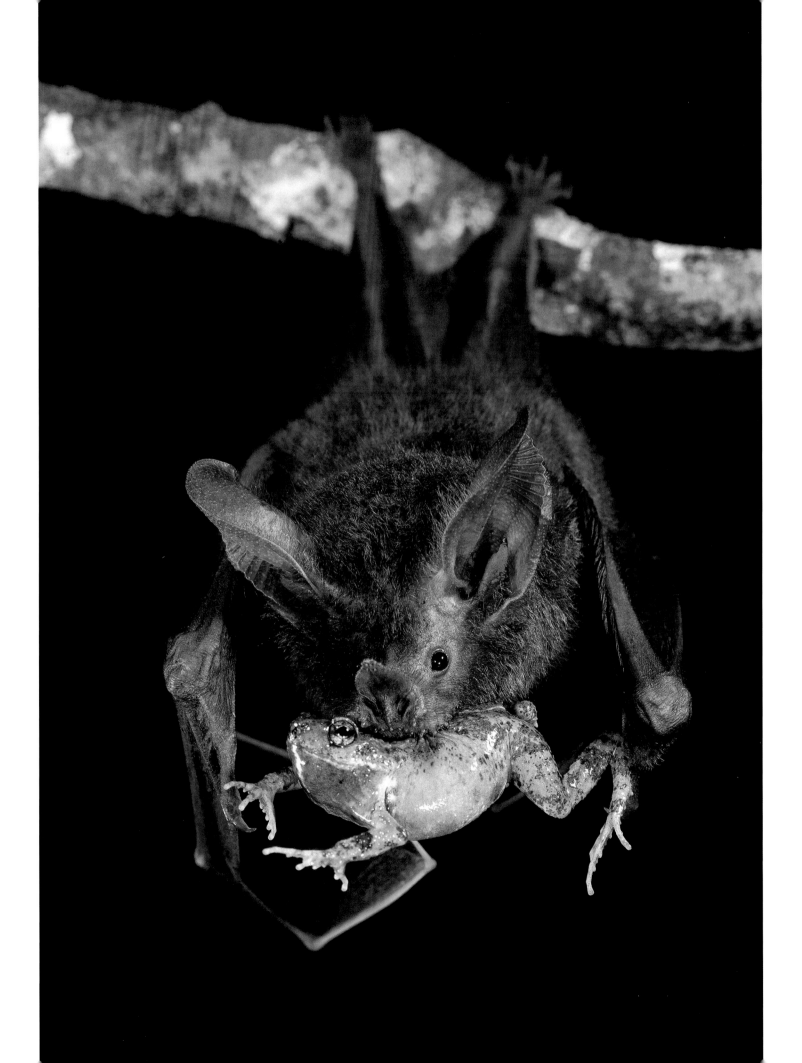

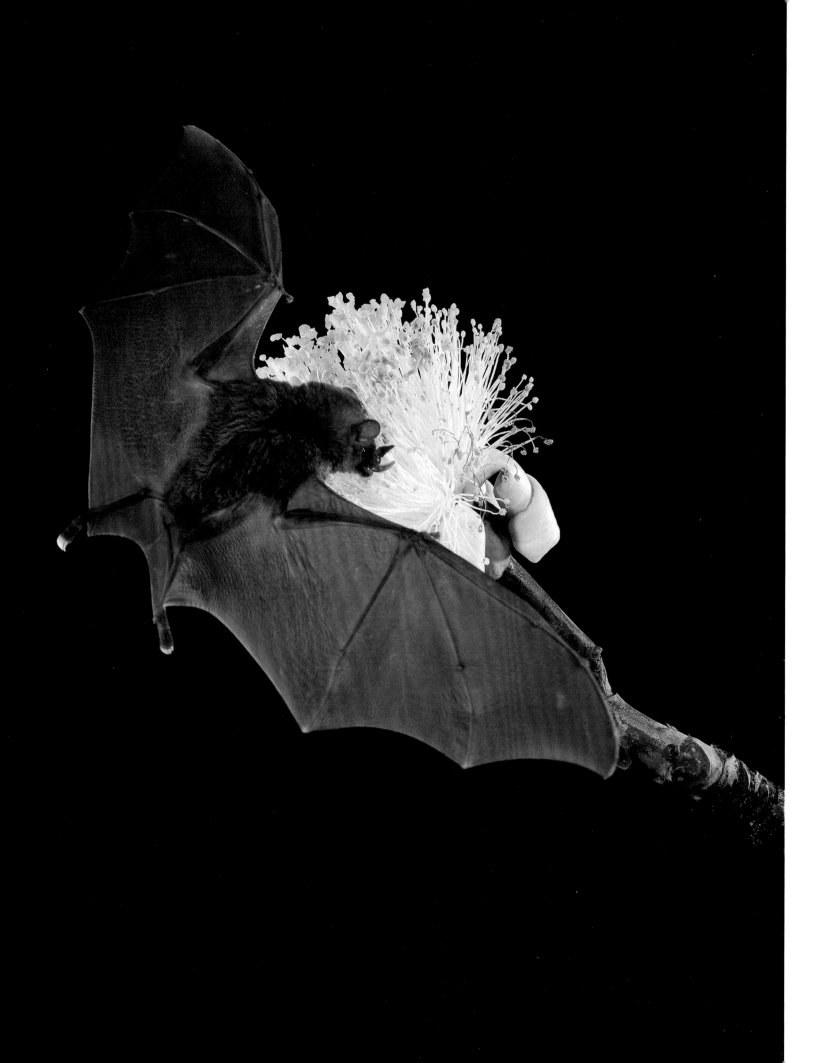

20 gramos, tenía un ámbito de exploración más amplio, y se alimentaba en varios lugares diferentes, como en los claros antiguos, donde había abundancia de frutos apropiados, mientras que la especie más pequeña, *Carollia castanea*, que pesa 13 gramos, se alimentaba sobre todo de frutos de *Piper* que se encuentran más esparcidos a lo largo de un único tramo del sotobosque. Una porción mayor de la fruta que la especie más grande consumía provenía de plantas distintas al Piper, pero esta especie se alimentaba de un menor número de especies de Piper. Los hábitos y destrezas de cada una de estas especies impiden que cualquiera de las dos reemplace a la otra.

Los murciélagos del neotrópico navegan por ecolocalización (localizan los obstáculos por el eco de sus propios llamados), lo mismo que los aviones de combate navegan de noche guiados por el eco de sus radares. Los murciélagos que cazan insectos en el aire también encuentran a su presa por ecolocalización. Elisabeth Kalko, de la Universidad de Tübingen, vino a Barro Colorado a explorar los compromisos *(trade-offs)* que enfrentaban los llamados de ecolocalización que funcionaban mejor en diferentes hábitats. Para entender cómo cazaban insectos en el aire, esta investigadora equipó un par de cámaras con flashes que se disparaban en secuencia mientras los obturadores permanecían abiertos. Para

153

En Barro Colorado hay un par de especies de murciélagos que tienen una dieta exclusivamente nectarívora y que juegan un papel clave en la polinización de ciertas especies de plantas. En la imagen vemos a un murciélago lengüetón *(Glossophaga soricina)* bebiendo néctar de la flor de un ceibo barrigón, *Pseudobombax.*

determinar qué llamados empleaban al buscar y atrapar a su presa, sincronizó los flashes con una grabadora que registraba los llamados de los murciélagos que estaban siendo fotografiados. Encontró que el eco de los llamados que usan los murciélagos que vuelan sobre el dosel para detectar insectos a larga distancia podía confundirse con el eco de la vegetación cercana al insecto; con la copa de un árbol, por ejemplo. Los murciélagos que buscan insectos que vuelan cerca de la vegetación necesitan usar otros llamados. La ecolocalización normalmente permite detectar insectos que se encuentran en el follaje únicamente si están aleteando, pero se necesitan diferentes llamados para sacar adelante esta tarea. Por esta razón, un gremio de murciélagos caza insectos sobre el dosel, otro gremio caza insectos que vuelan cerca de la vegetación; una especie más caza mariposas nocturnas en la vegetación, y otra, el murciélago pescador, vuela a ras del agua capturando a los insectos que se encuentran suspendidos en la superficie (fig. 149).

Los animales que están activos de noche necesitan un lugar seguro y cómodo para dormir durante el día. Muchos murciélagos duermen en cavernas, donde la temperatura es estable y nunca se pone demasiado caliente. Este hábito les permite mantener un nivel de respiración bajo; es decir, evitar el alto consumo de energía y la consiguiente liberación de dióxido de carbono asociada a las temperaturas diurnas. Algunos bosques, sin embargo, incluido el de Barro Colorado, carecen de grandes cavernas, y los murciélagos de cuevas son si acaso visitantes esporádicos de la Isla. En Barro Colorado, muchos murciélagos duermen en troncos huecos: un tronco hueco puede alojar hasta 500 individuos de varias especies (fig. 154). Algunos duermen escondidos donde el follaje es más denso, otros construyen su propia tienda de campaña (fig. 157) y también los hay que excavan "dormideros" en termiteros activos (fig. 155).

154

Muchas especies de murciélagos se cuelgan a dormir durante el día en árboles huecos —árboles vivos o árboles muertos que yacen derribados—. Aquí vemos a un pequeño grupo de *Micronycteris microtis* (murciélago orejón común) descansando en el amplio espacio que ofrece este tronco hueco.

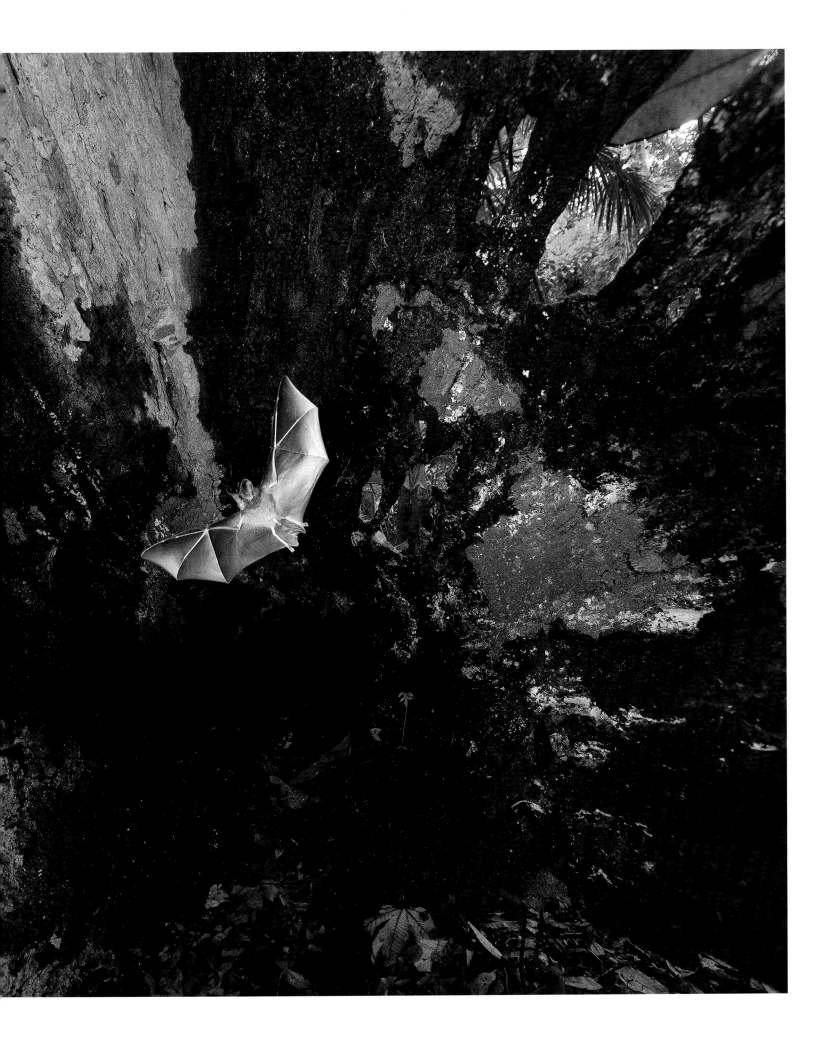

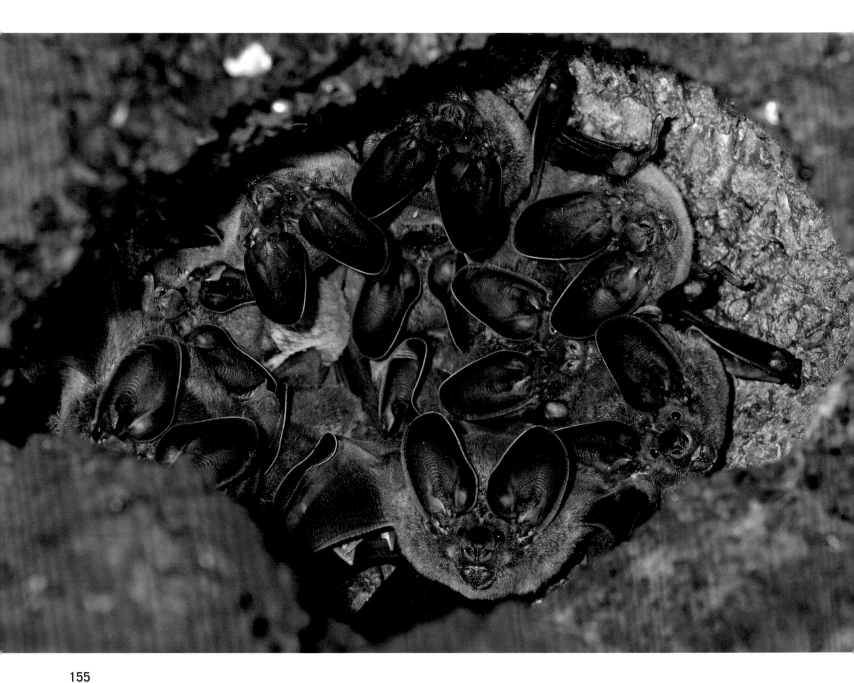

155

Los murciélagos de orejas redondas y garganta blanca, *Lophostoma silvicolum,* tienen hábitos de descanso poco comunes. Los machos excavan "dormideros" en los nidos de las termitas, e invitan a algunas hembras a dormir en el sitio. Estos murciélagos tallan los dormideros con sus propios dientes, sin destruir el nido, ni ser atacados por las termitas.

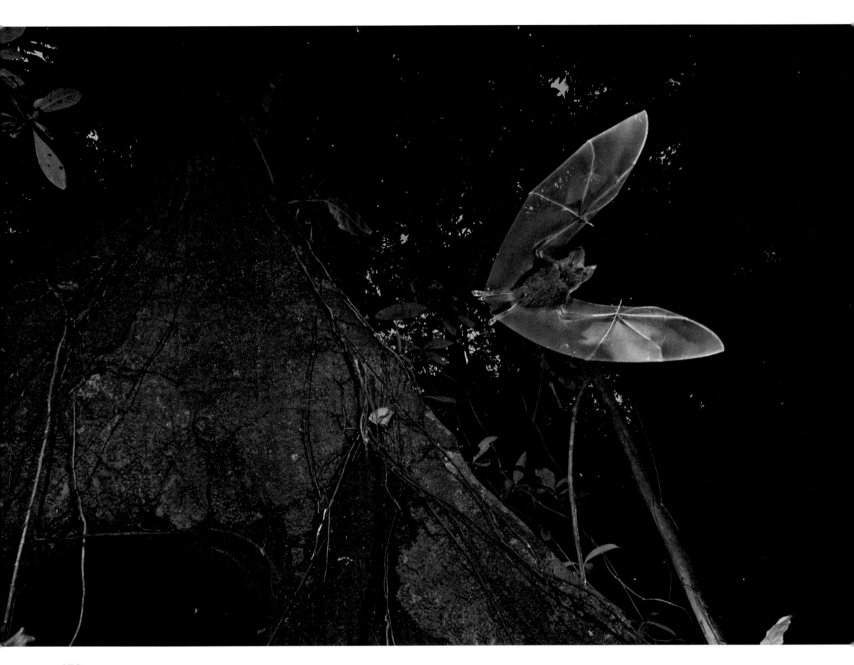

156

Los murciélagos de murciélago de labios con flecos,
Trachops cirrhosus, se cuelgan a dormir en troncos huecos,
en grupos de hasta veinte individuos. La imagen captura el
momento en que uno de ellos sale volando de una apertura
cercana al suelo.

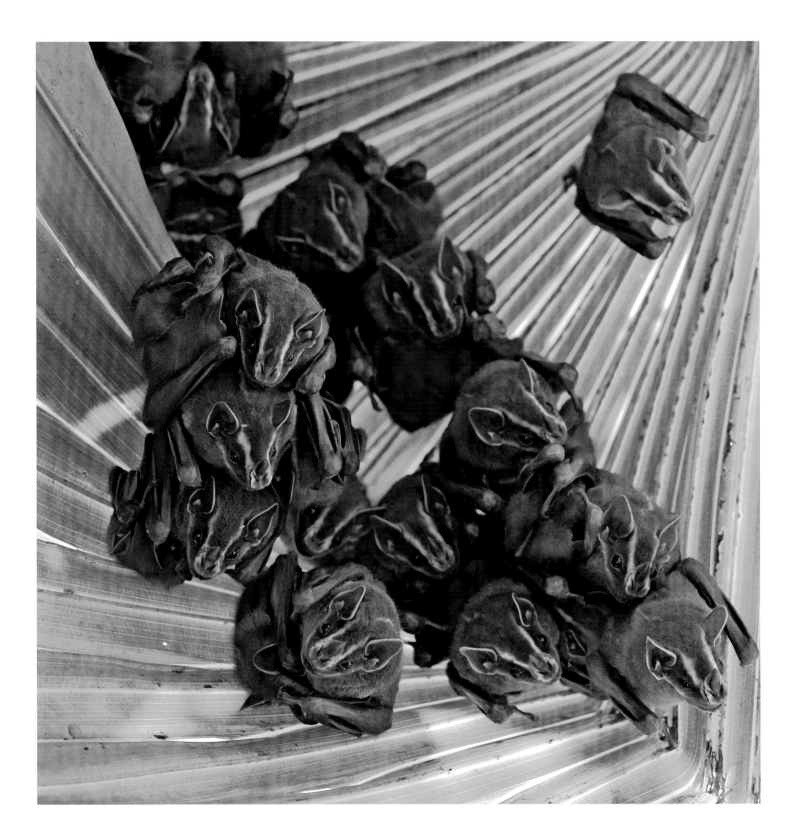

157

Un grupo de murciélagos frugívoros construye su propio refugio haciendo cortes en hojas de plantas como las heliconias, las palmeras o el banano. La hoja colapsa y se forma una "tienda de campaña". Esta enorme hoja de palmera se convirtió en el espacio de descanso ideal para este grupo de *Uroderma bilobatum*, murciélagos "constructores de tiendas".

Cuando en la Isla hay fruta en abundancia, muchos de los herbívoros terrestres de Barro Colorado —pecaríes, venados, pacas, agutíes, coatíes y ratas espinosas— viven de fruta. Aunque los pecaríes, los agutíes y las ratas espinosas pueden triturar nueces y semillas que para las otros resultan demasiado duras, todos prefieren comer mucho de los mismos tipos de fruta. ¿Cómo es que unas especies no reemplazan a las otras? Mientras hacía investigación de posgrado en Barro Colorado, N. Smythe observó que en la estación de escasez de frutas cada uno de estos animales recurría a una estrategia de forrajeo que resultaba poco práctica para los demás. Los pecaríes escarbaban el suelo con más frecuencia y a veces roían la corteza de unos pocos árboles. Los venados comían hojas de árboles jóvenes y de la hojarasca. Las pacas comían plántulas. Los agutíes vivían de las semillas que habían enterrado en la época de la abundancia, tras haberles quitado su aromática pulpa. Las ratas espinosas se alimentaban de las semillas que habían almacenado en su madriguera. Una vez que sabemos lo que hace cada uno en la época de escasez, entendemos cómo pueden coexistir.

Otros compromisos se relacionan más bien con la capacidad de defender, no solo de explotar, las fuentes de alimento. Animales que comen cosas similares a menudo enfrentan un compromiso entre ser lo bastante grandes y vigorosos como para defender una fuente generosa en alimentos o ser lo bastante pequeños como para sobrevivir donde la comida se encuentra muy desperdigada. Por eso los pecaríes, que pesan entre 20 y 30 kilogramos de peso, y que fácilmente pueden ahuyentar a un intruso, se alimentan de la fruta que se apila copiosamente al pie de los árboles, mientras que los agutíes, de 3 kilogramos de peso, viven de frutas o semillas que son demasiado pequeñas o se encuentran muy desperdigadas como para saciar el hambre de un pecarí. En 1960, Edwin Willis, entonces estudiante de posgrado de la Universidad de California, comenzó un estudio que se

prolongaría por once años sobre los pájaros hormigueros que se alimentan de los insectos que saltan al paso de las hormigas guerreras en Barro Colorado (figs. 32-37). Willis encontró que los hormigueros bicolores, de 33 gramos de peso (fig. 35), se alimentan en el centro del tropel, donde los insectos saltan en mayor abundancia. Estas aves desplazan a los hormigueros manchados de 18 gramos de peso (fig. 34) a los sitios marginales que son demasiado poco productivos para servir de sustento al hormiguero bicolor. No obstante, solo los hormigueros manchados sobreviven en islotes desprovistos de hormigas guerreras. Antes de 1970, en Barro Colorado era común observar hormigueros ocelados de 50 gramos de peso (fig. 36) cazando en los bordes más productivos del tropel y alejando a sus competidores más pequeños, algo que todavía se observa en tierra firme alrededor de la Isla. Los hormigueros ocelados, en cambio, no tienen cómo alimentarse lejos de las hormigas guerreras. Willis considera que la estación lluviosa particularmente corta y seca que se experimentó en 1968 diezmó el número de ejércitos de hormigas guerreras así como la abundancia de insectos de hojarasca, con lo cual se abrió la vía a la extinción de los hormigueros ocelados de Barro Colorado. El mundo animal es tan competitivo como el mundo de los humanos. Para evitar ser desplazado por un competidor superior, un animal tiene que hacer su trabajo mejor que cualquiera, lo que significa que tiene que especializarse al menos en algunos aspectos, pero no puede especializarse en un nicho que de vez en cuando desaparece.

En efecto, la especialización supone cierto grado de estabilidad ambiental. Los hormigueros ocelados resultaron ser demasiado especializados para Barro Colorado; la isla era demasiado pequeña para garantizarles un modo de vida confiable. Así como en las sociedades humanas, una economía grande, estable y productiva permite el ejercicio de una gran variedad de ocupaciones, también las condiciones de producción

relativamente estables que ofrece un bosque tropical de amplias dimensiones, donde todo el año hay frutas, hojas nuevas e insectos pueden servir de sustento a una mayor diversidad de animales.

EL BOSQUE DE NOCHE

De noche, el bosque se convierte en un hervidero de actividad, un espectáculo oculto a la mayoría de los visitantes. Cuando casi todos los actores diurnos se retiran a dormir, un grupo diferente de animales aparece en escena. De noche, un higuerón cargado de frutos maduros atraea cientos de murciélagos, kinkajús (fig. 160) y zarigüeyas lanudas (fig. 158), mientras las pacas, las ratas espinosas y quizá alguna zarigüeya forrajean la fruta del suelo. De día, ese mismo árbol convoca monos, sobre todo aulladores, pavas (aves pardas con la cola y el cuello muy largos y la papada roja y desnuda), tucanes, de pintoresco y desmesurado pico, y otras aves más, mientras los se disputan la fruta caída. De noche, un árbol cargado de hojas tiernas podría atraer a un perezoso de dos dedos (fig. 112) o a un puercoesín arborícola (fig. 161), que vendrán a darse un festín, mientras un hormiguero sedoso (fig. 159) inspecciona las ramitas en busca de nidos de hormigas. De día, ese mismo botín podría atraer a una tropa de monos

158

La zarigüeya lanuda, *Caluromys derbianus*, es una de seis especies de zarigüeyas presentes en Barro Colorado. Aquí, vemos a una de ellos benbiendo néctar de la copa de un balso al anochecer.

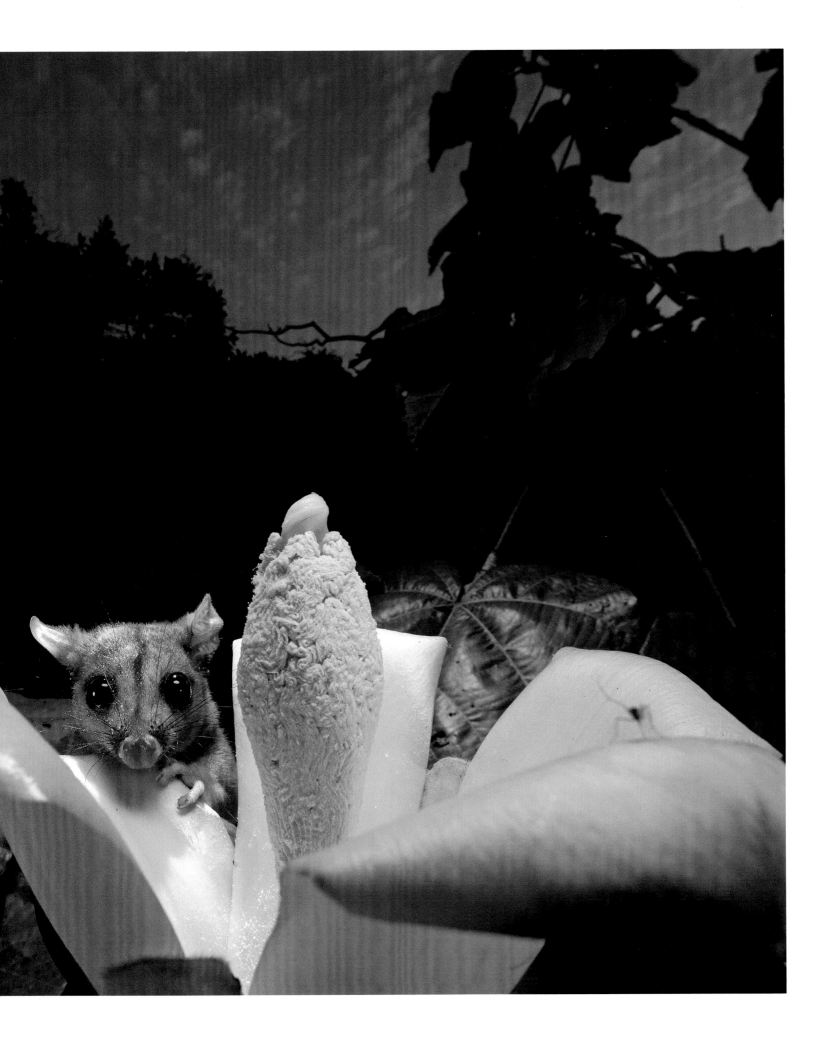

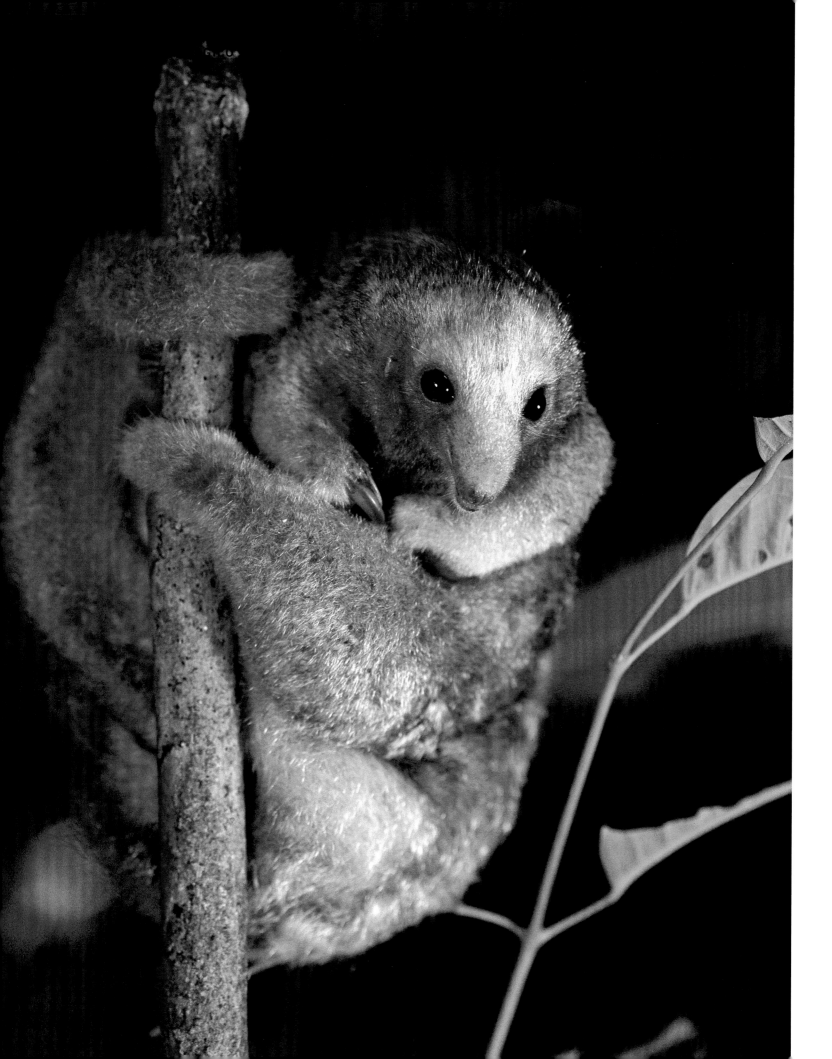

aulladores o a una columna de hormigas arrieras. Los perezosos de tres dedos (fig. 23) acudirán sin importar el horario. Los nidos de termitas —en Barro Colorado, uno de cada veinte árboles de más de diez centímetros de diámetro presenta uno en el tronco o en copa— pueden ser presa de los tamandúas de día, de noche, a cualquier hora (fig. 101).

Así pues, parece que muchos animales enfrentan un compromiso entre ser diurnos y ser nocturnos. Una faceta de este compromiso es que de día los animales pueden orientarse, y encontrar alimento, con la vista, mientras que los animales nocturnos tienen que tener los ojos muy grandes o, lo que es más común, depender casi por completo de otros sentidos, como el olfato y el oído. ¿Qué sabemos de los personajes nocturnos del bosque y qué enseñanzas nos ofrece su estudio?

LOS MURCIÉLAGOS

Los visitantes rara vez ven murciélagos. Durante el día, sin embargo, podrían observar grupos de *Saccopteryx leptura*, colgados entre las gambas de los árboles. También podrían ser sorprendidos por el revoloteo repentino de uno o varios murciélagos escapando por uno de los extremos de un tronco hueco. Quienes viven en la Isla tampoco ven murciélagos a menudo, a no ser que los busquen intencionalmente. Pero al caer el sol, de regreso en el bote que los conduce a la Isla, una multitud

159

El hormiguero sedoso o serafín de platanar *(Cyclopes didactylus)* tiene una dieta muy especializada, compuesta exclusivamente de hormigas que anidan en las ramitas de los árboles.

de murciélagos pescadores podría estar volando a ras del agua, atrapando intermitentemente insectos con sus patas. En el bosque o en el mismo claro del laboratorio, las últimas luces del día podrían dibujar el giro abrupto de un murciélago que en el último momento esquivó una colisión. Alguien que deje unos bananos en la terraza y salga de noche a recogerlos podría encontrarse con que un grupo de murciélagos los está mordisqueando. Al atardecer, largas hileras de *Molossus* abandonan los aleros de las casas para ir tras los insectos que vuelan sobre el dosel. No muy lejos, un lechuzón de anteojos espera el momento oportuno para resolver su cena con uno de ellos.

Los murciélagos, sin embargo, cumplen un papel más que destacado en la vida del bosque. Algunas plantas dependen de los murciélagos nectarívoros para que polinicen sus flores, otras, de los frugívoros para que dispersen sus semillas. Puede ser que los murciélagos que cazan insectos al vuelo ayuden a mantener la Isla libre de zancudos y otros molestos mosquitos, al matar como adultos a los que como larvas escaparon de las mandíbulas de las larvas de las libélulas gigantes. Los murciélagos ciertamente se han especializado en una amplia gama de ocupaciones: están los que comen fruta (fig. 151), los que beben néctar y comen polen, los que beben sangre, los que comen peces (fig. 149), los que atrapan insectos al vuelo, los que extraen del follaje insectos de todo tamaño, desde una cucaracha pequeña hasta un esperanza de dimensiones considerables (fig. 150) y están también los carnívoros, que comen ranas, murciélagos de menor tamaño y hasta ratas. No hay duda de que la capacidad de navegar por ecolocalización les ha permitido diversificarse para desempeñar una amplia gama de ocupaciones nocturnas.

Los murciélagos de Barro Colorado han sido especialmente bien estudiados. Frank Bonaccorso, estudiante de posgrado de la Universidad de Florida,

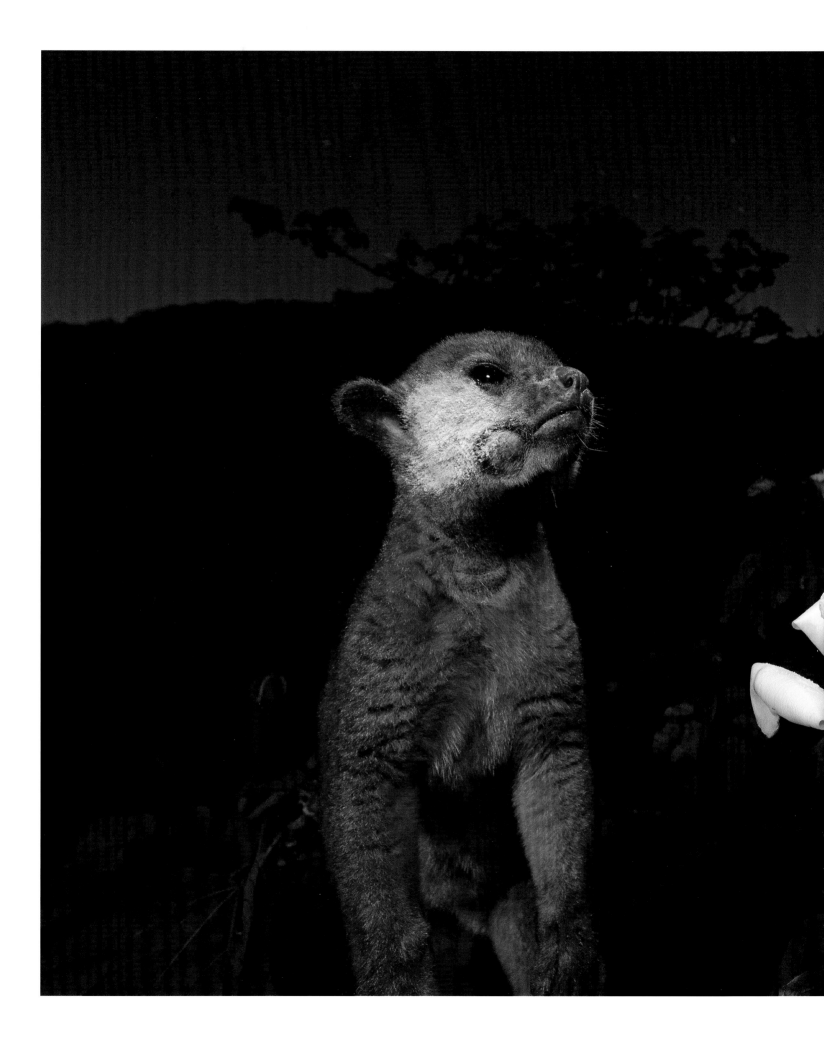

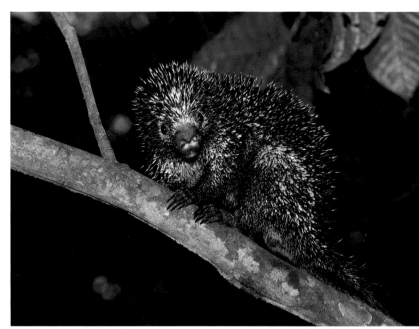

160 IZQUIERDA

La martilla o kinkajú, *Potos flavus*, es un interesante
animal nocturno que se ve poco. Aunque pertenece al
orden los carnívoros, generalmente se alimenta de frutas
y néctar. Aquí vemos a uno de ellos bebiendo el néctar
que las flores del balso ofrecen en abundancia.

161 ARRIBA

Otra especie que se ve poco es el puercoespín arborícola,
Coendou mexicanus, un mamífero nocturno que habita
en el dosel del bosque y se alimenta de semillas, frutas
y hojas.

dedicó parte de 1971 y 1974, y todo 1973, a capturar murciélagos en Barro Colorado. A cada murciélago capturado se le colocaba una banda en el ala con un número de identificación individual; se anotaba dónde y a qué distancia del suelo había sido capturado, de qué especie se trataba, qué comía (esto se deducía de las heces y de la fruta que traían a la red de captura) y si había hembras preñadas o en estado de lactancia. Las capturas se hicieron con redes de niebla de 2 metros de alto por 6 metros de largo, de un hilo negro y fino, difícil de distinguir en el sotobosque. Algunas redes se colocaron a nivel del suelo, otras, a alturas de entre 3 y 12 metros. También se colocaron trampas de arpa, que consisten en un marco de un metro cuadrado tendido de hilos verticales separados entre sí apenas para permitir el paso de un murciélago pequeño, detrás de otro tendido similar de hilos horizontales que guardan la misma separación. Las trampas de arpa permiten capturar murciélagos que cazan insectos al vuelo, como los murciélagos bigotudos del género *Pteronotus*, que generalmente esquivan las redes de niebla. Bonaccorso buscaba entender qué regulaba las poblaciones de murciélagos y cómo podía explicarse la coexistencia de tantas especies.

Bonaccorso capturó 2884 murciélagos de 33 especies distintas. Encontró que la mayor parte de las hembras de los murciélagos frugívoros tenían una cría cerca de abril y otra cerca de septiembre, cuando el bosque está particularmente repleto de fruta, mientras que las hembras de los murciélagos insectívoros tenían una cría al año, generalmente en mayo o en junio cuando las lluvias ya han llegado y hay mayor abundancia de insectos. Ambos programaban la reproducción para tener crías cuando abundaba el alimento apropiado. Por último, encontró que murciélagos que comían tipos de comida similares y en hábitats similares diferían en tamaño. Bonaccorso propuso que las múltiples especies de murciélagos que habitan en Barro Colorado coexisten porque cada una come algo diferente, busca comida en lugares diferentes o comen artículos de diferente tamaño.

El murciélago más notorio en Barro Colorado es el murciélago frutero común, *Artibeus jamaicensis*, un murciélago de 50 gramos de peso que se alimenta principalmente de higos silvestres. En 1972, otro estudiante de posgrado, Douglas Morrison, de la Universidad de Cornell, llegó a Barro Colorado con una beca predoctoral del Smithsonian a estudiar cómo localizaban la comida estos murciélagos, cuánto comían y cuánta comida había disponible. En 1973, Morrison se dedicó a capturar murciélagos fruteros con redes de niebla. En la primera captura, se les colocaba una banda en el ala con un número de identificación individual, y se anotaban el lugar y la fecha de captura y recaptura. Morrison encontró que las hembras adultas tenían una cría en marzo o en abril y otra en julio o en agosto cuando hay fruta en abundancia. De forma paralela, se mapeó la posición de los higuerones que crecen cerca del laboratorio y se les visitó cada quince días para observar cuándo y con cuánta frecuencia se cargaban de fruta. Morrison observó que los higuerones ofrecen fruta madura en abundancia durante unos pocos días a la vez. Cada árbol fructifica en un momento diferente y siguiendo un ritmo diferente. En Barro Colorado siempre hay algunos higuerones cargados de frutos, pero ¿cómo los encuentra el murciélago frutero común? Para averiguarlo, Morrison colocó un pequeño radiotransmisor en algunos de estos murciélagos a fin de rastrear sus movimientos. Así pudo determinar que a menudo volaban varios kilómetros por noche. Y después de haber comido solían volar siguiendo lo que parecía un patrón de búsqueda de árboles con frutos maduros. También encontró que para sortear a las serpientes y a las zarigüeyas lanudas que se esconden entre la fruta a la espera de que algo venga a comerla, los murciélagos vuelan de 25 a 400 metros, desde el árbol donde toman la fruta hasta un sitio donde puedan comerla en paz. Este comportamiento le permitió a Morrison

contar el número de "viajes al comedor". Resulta que un murciélago de 50 gramos de peso come 70 gramos de peso fresco (13 gramos de peso seco) de fruta por noche.

En 1976 Charles Handley, del Museo Smithsonian de Historia Natural, y varios colegas iniciaron un proyecto que se prolongaría por nueve años: "Murciélagos en Barro Colorado". Su objetivo: determinar cuántas especies de murciélagos vivían en la Isla, cuántos ejemplares había de cada especie, qué comían y qué distancias recorrían. En total, el proyecto capturó 35 000 murciélagos de 56 especies en redes de niebla. A cada murciélago se le colocó un collar con un número de identificación, y se registró el momento y el lugar de captura. El único murciélago que el proyecto verdaderamente pudo censar fue *Artibeus jamaicensis*. La red de mallas fue tan exhaustiva y estos murciélagos recorrían tan ampliamente la Isla que al cabo de unos pocos años prácticamente todos los adultos de esta especie habían sido marcados. La mortalidad anual de las hembras adultas se determinó por la caída anual en la proporción de hembras adultas que habían sido marcadas por Morrison o por Bonaccorso en 1973 entre la captura de hembras adultas de sus proyectos. La tasa de sobrevivencia de las hembras adultas de *Artibeus jamaicensis* fue de 58% al año (76% en medio año). Se calculó la probabilidad de que una hembra marcada x meses antes de enero de 1981 estuviera viva en esta fecha; luego se sumó la cantidad esperada de hembras vivas en esa fecha (enero de 1981), tomando todos los meses x antes de enero de 1981 en que se habían marcado hembras. A partir de esto, Handley pudo estimar que Barro Colorado puede mantener unas 1600 hembras adultas o 4000 *Artibeus jamaicensis*, incluyendo juveniles y machos adultos.

En 1991, Elisabeth Kalko trajo a la isla "detectores de murciélagos", equipos detectores de ultrasonidos que permiten grabar los llamados que emiten los murciélagos mientras vuelan. Con el fin de aprender a identificarlos por sus llamados, como los observadores de aves identifican a las especies por su canto, Kalko viajó a Venezuela junto a Charles Handley para grabar los llamados de los murciélagos en vuelo, los cuales fueron archivados por el profesor Jesús Molinari, de la Universidad de Mérida (Venezuela) e identificados por Handley. Este viaje le permitió a Kalko documentar la presencia en Barro Colorado de especies que nunca quedaban atrapadas en redes. El detector le permitió encontrar por lo menos 10 especies de murciélagos que no habían sido registradas antes en Barro Colorado. Actualmente la lista de murciélagos de Barro Colorado incluye 74 especies.

El compromiso fundamental de los murciélagos del neotrópico, y base primordial de su diversificación, es el compromiso entre cazar insectos que están volando o aleteando, o tomar el alimento —fruta, néctar, polen, insectos y vertebrados— de la vegetación. Las 32 especies de murciélagos que cazan insectos al vuelo en Barro Colorado se guían principalmente por ecolocalización para ubicar a su presa. Las 42 especies que forrajean en la vegetación usan el olfato, la temperatura o el ruido que hace la presa al moverse, además de la ecolocalización. En Barro Colorado, todas la especies que forrajean en la vegetación, excepto una, pertenecen a la gran familia suramericana de Phyllostomidae, murciélagos de nariz en forma de hoja, la cual incluye insectívoros, carnívoros, bebedores de sangre (vampiros), nectarívoros, frugívoros y omnívoros que comen insectos, frutas, y si son lo bastante grandes, también vertebrados. Los que cazan insectos al vuelo, en cambio, pertenecen a varias familias, ninguna de las cuales es la Phyllostomidae.

¿Cómo logran coexistir las distintas especies de murciélagos que conforman un gremio? Para empezar, los más grandes pueden comer presas más grandes. Como pasa con los *Carollia* que se alimentan de los frutos del *Piper*: los más grandes buscan sitios de forrajeo más generosos. También, dependiendo del tipo de murciélago, pueden dormir en lugares distintos durante el día. Wibke

Thies observó esto en sus *Carollia*: los *perspicillata*, que son más grandes, se cuelgan a descansar en troncos huecos, a menudo en compañía de murciélagos de otras especies, mientras que las *castanea*, que son más pequeñas, se retiran a descansar en agujeros subterráneos, bajo raíces medio expuestas, en la ribera del Lago Gatún, o en los márgenes de los arroyos del bosque. Dina Dechmann y Sabine Spehn, estudiantes de posgrado de Kalko, ahora en la Universidad de Ulm, Alemania, encontraron que tanto la *Tonatia sylvicola*, de 34 gr de peso (fig. 155) como la *Tonatia saurophila*, de 37 gramos de peso, forrajean insectos de tamaño considerable en el follaje, pero la *sylvicola* duerme en agujeros excavados en termiteros activos, mientras que la *saurophila* lo hace en árboles huecos. Kalko encontró que tanto el *Cormura brevirostris*, de 9 gramos de peso, como el *Saccopteryx bilineata*, de 7 gramos de peso, cazan insectos al vuelo, pero los *Cormura* cazan justo encima del dosel y los *Saccopteryx*, debajo. Además, los *Cormura* duermen debajo de los troncos o entre las gambas de los árboles caídos, mientras que los *Saccopteryx bilineata*, duermen su inquieto sueño colgados del cedazo de las ventanas o sobre el tronco de un árbol grande, entre los aletones, a la vista de todos.

La relación entre la estabilidad de una fuente de alimento y la diversidad del gremio que depende de ella la ilustran los higuerones y los murciélagos que se alimentan de sus frutos. En Barro Colorado, 14 especies de higuerón dan frutos que atraen murciélagos (fig. 151); estos frutos pesan entre 1 y 11 gramos. Los higuerones deben tener al menos unos cuantos árboles fructificando a lo largo del año, de lo contrario las avispas que los polinizan, que viven apenas unos días, se mueren. Esta fuente constante de frutos resuelve más de la mitad de la dieta de 10 especies de murciélagos comunes que pesan entre 9 y 70 gramos. En términos generales, los murciélagos más grandes comen los frutos más grandes. Está claro, sin embargo, que estos murciélagos

no coexisten solo porque comen higos de tamaños diferentes. También duermen en lugares diferentes. Douglas Morrison encontró que las hembras adultas de *Artibeus jamaicensis* duermen en grupo y que cada grupo comparte un tronco hueco con un macho adulto mientras que los machos solteros se cuelgan a dormir en el follaje, muy por encima del suelo, y van cambiando de "dormidero" (percha) para estar cerca de los higuerones en fruto. Otros murciélagos más grandes, también comen higos, se cuelgan a dormir en la espesura, a varios metros del suelo y diariamente alternan de dormidero como para confundir a los depredadores. Charles Handley y muchos estudiantes después de él, observaron que por lo menos algunos de los murciélagos fruteros más pequeños construyen su propio "dormidero" haciendo incisiones en las hojas de modo que estas colapsan y se forma una suerte de tienda de campaña (fig. 157). En resumen, las distintas especies de murciélagos que se alimentan de higos duermen en lugares completamente diferentes. Lo que todavía no se sabe es si estas diferencias ayudan a mantener su diversidad.

RUIDOS NOCTURNOS Y ESTANQUES ARTIFICIALES

Las ranas macho acostumbran llamar de noche por una compañera. El croar de la rana toro y las notas más altas de la ranita primavera, *Pseudacris crucifer*, son sonidos familiares en el este de Estados Unidos. Todavía recuerdo la sorpresa de un profesor de estudios clásicos recién llegado de Grecia que nos contaba que en un pantano de ese país había escuchado a las ranas cantando el mismo "brekekekex ko-ax, ko-ax" que cantaba el coro de ranas de *Las ranas* de Aristófanes, el máximo representante de la Comedia Antigua. Quienes hagan una caminata nocturna en un bosque montano en Puerto Rico seguramente escucharán el melodioso "co-quí, co-quí" de los sapitos

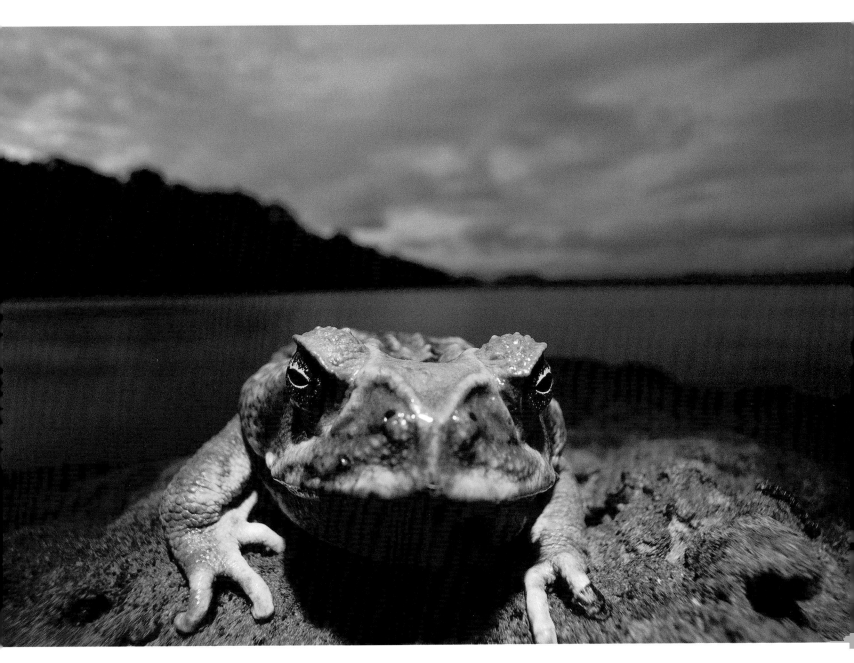

162

El *Rhinella marina*, el gran "sapo marino", es un personaje
habitual en Barro Colorado. En la estación seca, los machos
forman nutridos coros para atraer a las hembras. El macho
de la foto acaba de ocupar su lugar a orillas del lago Gatún.

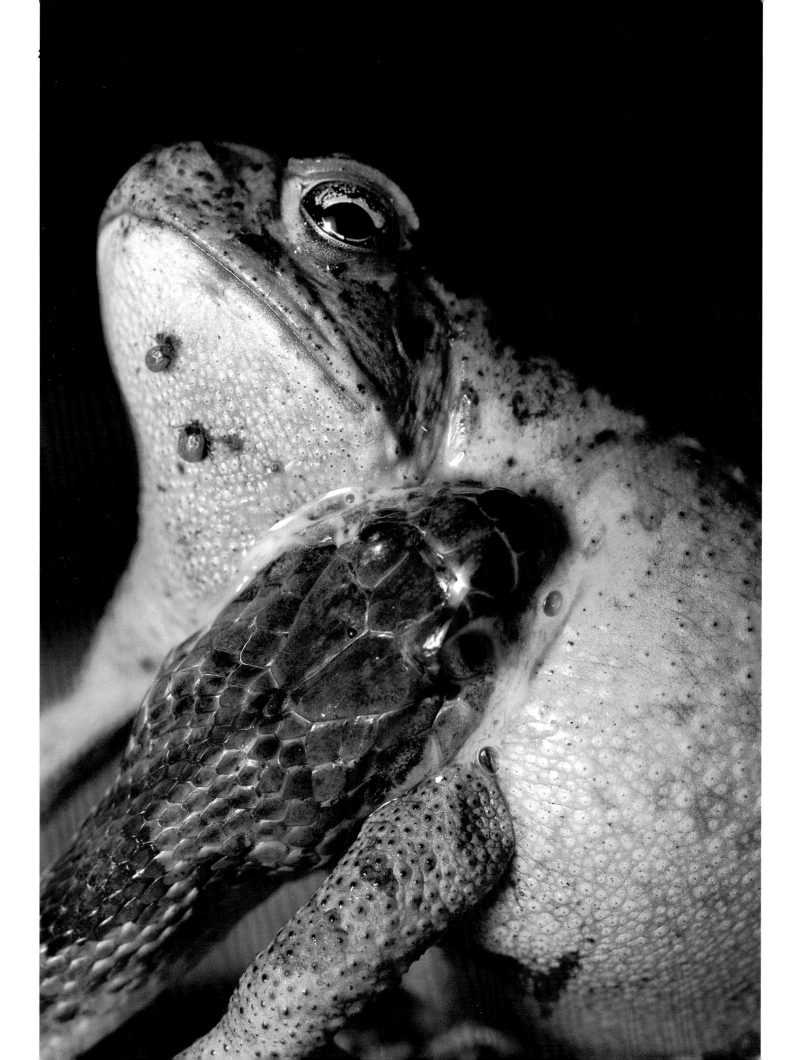

macho de *Eleutherodactylus coqui*, la segunda sílaba cantada en un tono más alto que la primera, aunque rara vez verán a estos cantores. En Panamá, los machos de las ranas túngaras se reúnen alrededor de las charcas o los estanques, cada uno repitiendo alrededor de cada dos segundos un llamado que suena como el gemido de un perrito, normalmente seguido de uno o más "golpes secos" en un tono más grave. Un coro de túngaras hace un escándalo que parece no tener fin, y es uno de los sonidos nocturnos característicos de la estación lluviosa en Panamá. Las ranitas de ojos rojos, verdes en su mayoría excepto por los ojos, se congregan en los árboles que cuelgan sobre los estanques, pero los machos son más callados: solo de vez en cuando se escucha un breve "chack". El llamado de una especie de rana difiere del llamado de otras y las hembras solo se muestran atraídas por el llamado de los de su propia especie. Por cierto, la guía de ranas y sapos de la región central de Panamá incluye un disco compacto con sus llamados para que también nosotros podamos identificarlas por sus cantos.

¿Qué factores influyen en el modo de cantar de una rana? A fin de responder a esta pregunta y estudiar la selección sexual en las ranas, Michael Ryan, en ese entonces estudiante de doctorado de la Universidad de Cornell, llegó a Barro Colorado en 1978 con una beca del Instituto Smithsonian. Su objeto de estudio eran las ranas túngaras, *Physalaemus pustulosus*, que se reúnen en el Kodak Pond, un pequeño estanque artificial en la parte alta del claro del laboratorio. Estas ranas, de unos tres centímetros de largo, pasan la mayor parte de las noches inspeccionando el piso del bosque en busca de insectos que no sean hormigas, pero acuden a las charcas y lagunas a reproducirse. Ryan marcó los machos y observó que dejaban a las hembras relativamente libres de elegir compañero. No obstante, los machos más grandes se apareaban con mayor frecuencia. En el laboratorio, Ryan enfrentó a un grupo de hembras túngaras a dos parlantes, uno que reproducía llamados sin "golpe seco" y otro que reproducía llamados con "golpe seco". Las hembras tendían a acercarse al parlante que reproducía llamados con "golpe seco". Luego dejó que las hembras eligieran entre parlantes que reproducían llamados con "gemidos" idénticos, pero unos llamados presentaban "golpes secos" más graves que los otros. Las hembras preferían los llamados con "golpes secos" más graves. Los machos más grandes, que tienen más probabilidades de fertilizar todos los huevos de la hembra, emiten llamados con "golpes secos" más graves: pareciera entonces que las hembras juzgan el tamaño de los machos por su llamado.

Los llamados de las túngaras también atraen depredadores. En el Kodak Pond, estos llamados atraen al sapo marino, *Rhinella marina* (fig. 162), el sapo más grande y más feo de Barro Colorado, asi como a la rana toro, *Leptodactylus pentadactylus*, y los dos comen túngaras. La serpiente "ojos de gato" (fig. 163) también acude al estanque a comer túngaras. Merlin Tuttle, un estudioso de los murciélagos que en ese entonces trabajaba en el Museo Público de Milwaukee, llegó a Barro Colorado a explorar, junto a Ryan, el efecto de los depredadores en el ritual de apareamiento de las ranas. Estos investigadores centraron sus observaciones en el "estanque de la represa", a unos 130 metros de la parte alta del claro del laboratorio, hacia el bosque.

Lo primero que mostraron fue que el apareamiento de las túngaras es extremadamente peligroso. En 14 horas de observación (con binoculares de visión nocturna) a lo largo de 7 noches encontraron que, en

163

En Barro Colorado, muchas serpientes se alimentan de ranas y sapos. Aquí vemos a una serpiente "ojos de gato", *Leptodeira annulata,* cenando *Rhinella marina.*

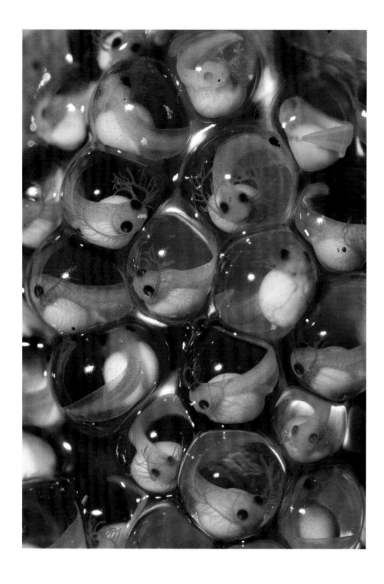

164 ARRIBA

Las ranitas de ojos rojos depositan sus huevos en racimos gelatinosas que adhieren al envés de las hojas que cuelgan sobre el agua. Cuando los renacuajos emergen, resbalan por la hoja hasta caer al agua.

165 DERECHA

Estudios llevados a cabo en Panamá muestran que una vez que los huevos han alcanzado cierta madurez, los renacuajos pueden eclosionar en cuestión de segundos en respuesta al ataque de una serpiente o una avispa. En la foto, una puesta de huevos es presa de una serpiente "ojos de gato". Algunos renacuajos logran resbalar en dirección al agua.

promedio, cada noche acudían al estanque 228 ranas túngaras a aparearse. De esas 228, los murciélagos de murciélago de labios con flecos, *Trachops cirrhosus*, se comieron 14, las ranas toro, 2, y las zarigüeyas de cuatro ojos, que también llegan al estanque atraídas por el canto de las ranas, otras 2. Es más, las ranas enfrentaban otro peligro. Como cantan flotando en el agua, los cangrejos del estanque pueden agarrarlas y comerlas (fig. 19). La depredación, sin embargo, tiene su lado positivo. Si más ranas acuden al estanque a aparearse, no por eso van a atraer más depredadores, más bien van a disminuir las probabilidades de cada rana de ser devorada. De igual forma, cuanto mayor sea el número de machos que se reúnan a cantar, mayor será, proporcionalmente, el número de hembras que se acerquen atraídas por sus cantos.

Por ser el principal depredador de ranas túngaras, el murciélago de murciélago de labios con flecos fue seleccionado para estudios posteriores. Experimentos realizados en jaulas de vuelo sugieren que estos murciélagos distinguen a las ranas por sus llamados y que evitan acercarse a presas que consideran indeseables. Tuttle y Ryan expusieron a un murciélago de murciélago de labios con flecos a pares de parlantes que reproducían simultáneamente llamados de diferentes tipos de ranas en una jaula de vuelo. Los murciélagos se acercaron con más frecuencia a los parlantes que reproducían el canto de las túngaras que a los que reproducían el canto del sapito de hojarasca, que es venenoso, o a los que reproducían el canto de la rana toro, que es demasiado grande como para que este murciélago se la coma. Para determinar el riesgo adicional de emitir llamados con "golpe seco", Tuttle y Ryan llevaron pares de parlantes al bosque: un parlante reproducía solo "gemidos", el otro, "gemidos" con "golpe seco". Los murciélagos verrugosos se acercaron al parlante que reproducían gemidos con golpe seco por lo menos dos veces más que al que solo

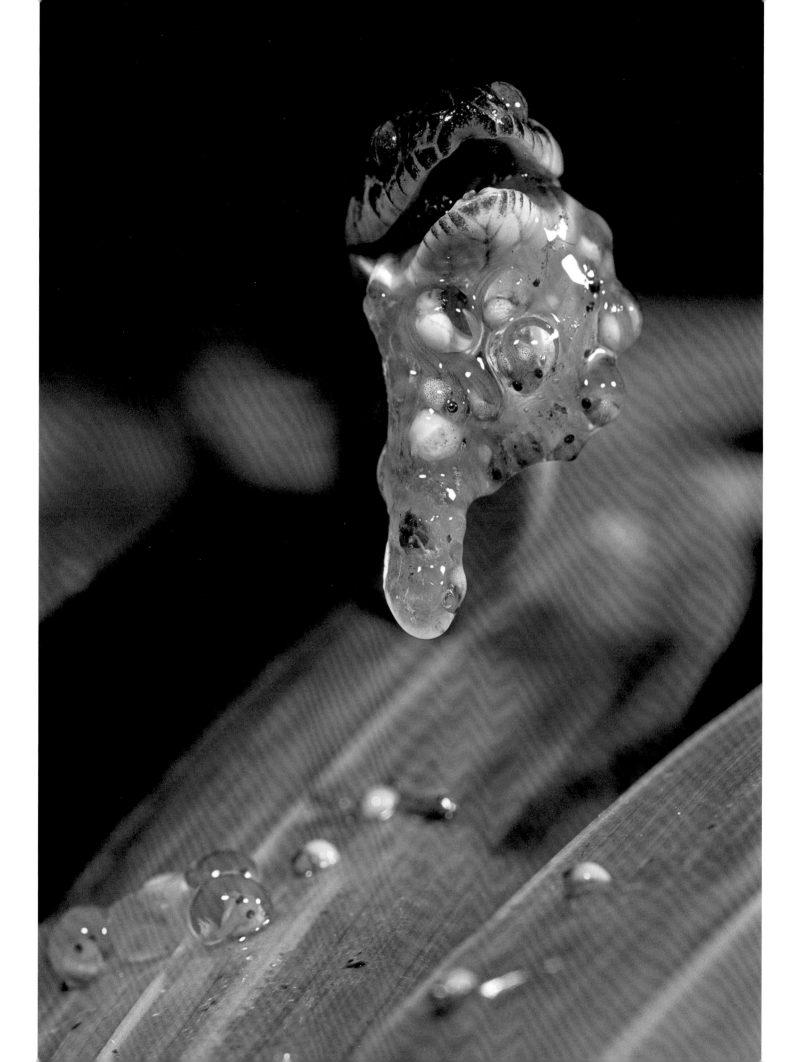

reproducía gemidos. Cuando el experimento se repitió en la jaula de vuelo, los murciélagos se acercaron ocho veces más al parlante que reproducía golpes secos.

Las túngaras les tienen miedo a los verrugosos. Los estudios de Tuttle y Ryan revelaron que si en el estanque hay suficiente luz y las túngaras pueden ver al murciélago acercándose dejan de cantar por 15 segundos. La aparición en escena de un murciélago insectívoro, que es más pequeño, causa menos conmoción. En todo caso, las ranas tienen que ver al murciélago para reaccionar: en noches nubladas o sin luna, cuando no se ve nada, las ranas cantan y cantan hasta que al final aparece el verrugoso.

Los depredadores se comen a las ranas que se están apareando y también a sus crías. ¿Cómo sortean las diferentes especies de ranas esta amenaza? Las túngaras recubren sus puestas con espuma con lo cual protegen los huevos de la desecación y la depredación. No obstante, los renacuajos de las ranas toro, que también se reproducen en el Kodak Pond, no lo piensan dos veces para comerse un renacuajo de túngara.

Los *Rhinella alata* (figs. 143-147), unos sapitos pequeños —de cuatro centímetros— que se camuflan como hojas secas y que pasan el día comiendo hormigas, también se reproducen en el Kodak Pond y en otros estanques cercanos, pero solo en la estación lluviosa. En 1977, como parte de un trabajo posdoctoral en el Smithsonian, Kentwood Wells estudió el comportamiento reproductivo de estos sapitos y su efecto en la seguridad de las crías. Estudió el ir y venir de los sapitos en distintas lagunas cerca del claro del laboratorio, por ejemplo, en el Kodak Pond y en el estanque de la represa, pero se centró sobre todo en el Animal House Pond, un estanque artificial a orillas del bosque, a 130 metros del estanque de la represa. Wells encontró que los machos acudían a aparearse a una laguna determinada solo una vez cada 3 a 6 semanas. Marcó los sapitos observados en cada estanque y encontró que, aunque un sapito podía

aparearse varias veces en un mismo estanque, rara vez cambiaba de estanque. También observó que en las noches de apareamiento los sapitos se congregaban en la tarde y empezaban a cantar a las nueve de la noche. Los machos compiten vigorosamente por una pareja, tanto que tratan de tumbar a sus rivales de la grupa de la hembra. En estos pleitos, los machos más grandes llevan las de ganar, así que tienen más probabilidades de aparearse. Al reunirse de manera poco frecuente y en grandes números, estos sapitos probablemente reducen el riesgo que corre cada uno de ser comido: aunque los murciélagos de murciélago de labios con flecos los consideran venenosos, los *Rhinella marina* se los comen sin problema. Es más, al reunirse en grandes cantidades, los machos atraen tantas hembras que estas ponen tantos huevos que las ranas toro no dan abasto comiéndoselos. Para los huevos de rana, así como para las ranas en apareamiento, a menudo la seguridad va ligada a la cantidad.

Las ranitas de ojos rojos, *Agalychnis callidryas*, se aparean en los árboles que cuelgan sobre el Kodak Pond y el Animal House Pond, lejos del alcance de los sapos marinos y las ranas toro. Los machos se instalan a cantar a unos diez o veinte metros del suelo, pero lo hacen muy esporádicamente. Cuando Michael Ryan llegó a Barro Colorado a hacer su investigación doctoral, tenía en mente estudiar la selección sexual y la elección de pareja en estas hermosas ranitas, pero cantaban tan poco, y la mayor parte de la acción tenía lugar tan alto en los árboles, que no tenía posibilidad de observarlas directamente, así que optó por las túngaras, que cantaban a sus pies. Lo que se sabe del comportamiento reproductivo de las ranitas de ojos rojos se debe a los estudios realizados en la década de 1960 por Frank Pyburn, de la Universidad de Texas en Arlington. Pyburn hizo sus observaciones en un bosque secundario cerca de Veracruz, en México, donde estas ranitas cantaban más cerca del suelo. Pyburn liberó una hembra cargada

de huevos, y observó que parecía dirigirse a un macho específico, sin detenerse en otros machos que encontraba en su camino. Una vez que un macho ha montado a una hembra receptiva, se queda unido a su grupo, mientras la hembra desciende al agua a llenar su vejiga. Luego la hembra vuelve a subir a alguna de las hojas que cuelgan sobre el agua, el macho todavía en su espalda, y deposita una masa gelatinosa de huevos en la hoja (fig. 164). El macho fertiliza la puesta y la hembra vacía su vejiga sobre esta masa gelatinosa para asegurarse de que los huevos se van a mantener húmedos. Una vez más, la hembra se dirige a la charca, con el macho siempre a cuestas, llena nuevamente la vejiga y vuelve a subir a otra hoja a depositar y humedecer una nueva masa de huevos. Por lo general cinco ciclos de estos son suficientes para que la hembra termine de depositar todos sus huevos. Ahora, en cualquier punto de estos viajes, un macho podría intentar reemplazar al macho que viaja sobre la hembra. Aunque estos ataques rara vez tienen éxito, a veces las hembras terminan depositando huevos con dos machos en la grupa dispuestos a fertilizarlos.

Si nada interpone en su desarrollo, los renacuajos eclosionan al cabo de unos ocho días y resbalan al agua. Muchas veces, sin embargo, una serpiente semiarbórea, la serpiente ojos de gato, llega a comerse las puestas de estas ranitas. Una estudiante de posgrado de la Universidad de Texas, Karen Warkentin, que estudió su comportamiento en el Parque Nacional de Corcovado, en Costa Rica, observó que si una serpiente ojos de gato se acerca a comerse los huevos cuando estos tienen al menos cinco días, la mayor parte de los renacuajos logra escapar eclosionando instantáneamente y dejándose caer al agua (fig. 165). Sin embargo, cuanto más pronto eclosionen, más vulnerables son a los depredares acuáticos. Solo el peligro inminente de ser atacados por una serpiente hambrienta los hace eclosionar más temprano de lo previsto. En definitiva, cada una de las tres especies mencionadas, tiene su propio modo de enfrentar la amenaza de los depredadores.

LAS ESPERANZAS Y SUS ENEMIGOS

Las esperanzas (fig. 12) también llaman a las hembras para aparearse. ¿Atraerán también a los murciélagos con sus llamados? En 1984, una estudiante de posgrado de la Universidad de Florida, Jacqueline Belwood, llegó a Barro Colorado con una beca predoctoral del Smithsonian a evaluar el efecto de los murciélagos insectívoros en el comportamiento reproductivo de las esperanzas. Con el fin de determinar si los llamados de las esperanzas atraían a los murciélagos, Belwood instaló pares de redes de niebla; una equipada con un señuelo, una grabadora que reproducía el llamado de las esperanzas; la otra, sin nada. En 13 sesiones de una hora, la red con señuelo atrapó 24 murciélagos insectívoros de cuatro especies que comen esperanzas, mientras que la red sin señuelo no atrapó ninguno. También encontró que algunas especies de murciélagos que comen esperanzas regresaban a dormideros fijos a comerse a su presa, donde dejaban caer las alas y otras partes no comestibles. Tras examinar estos "basureros", Belwood descubrió que los murciélagos atrapaban una gran cantidad de esperanzas hembra, que no cantan. Esta estudiante propuso que los murciélagos se quedan cerca de las esperanzas macho para comerse a las hembras que se acercan a ellos atraídas por su canto.

Belwood también notó que las esperanzas que están expuestos a la depredación de los murciélagos se comportan muy diferente que los que no lo están. Los murciélagos comedores de esperanzas nunca se acercan al claro del laboratorio y ahí las esperanzas cantan fuerte y seguido. De ese modo canta también una esperanza de bosque que vive entre las hojas serradas y puntiagudas de la piña, *Aechmea*, donde

166

Las colonias de hormigas guerreras, como estas en Panamá, están entre las más multitudinarias y sofisticadas del mundo. Despliegan una variedad de comportamientos complejos. Uno de ellos es la movilización diaria de toda la colonia, que puede estar compuesta hasta por un millón de individuos. Esta actividad ocurre durante la fase nómada, que se prolonga 14 de los 35 días que dura su ciclo reproductivo. Las hormigas nómadas no construyen nidos ni se instalan en cavidades, como la mayoría de las hormigas. Por el contrario, las obreras levantan vivacs (campamentos) tejiendo paredes con sus propios cuerpos para que las crías queden dentro. Aquí vemos el vivac de una colonia de por lo menos 300.000 individuos de *Eciton hamatum*, formado en su totalidad por hormigas que cuelgan asidas unas a otras por las extremidades. Se comienza creando una delgada cortina de hormigas, cuyas brechas se van cerrando rápidamente hasta formar una pared sólida de cuerpos vivos. Los miembros de las grandes colonias de insectos sociales tienen que vivir y trabajar de manera colectiva para poder sobrevivir. Sistemas de comunicación muy desarrollados transforman un conglomerado de individuos relativamente simples en una unidad compleja y muy efectiva.

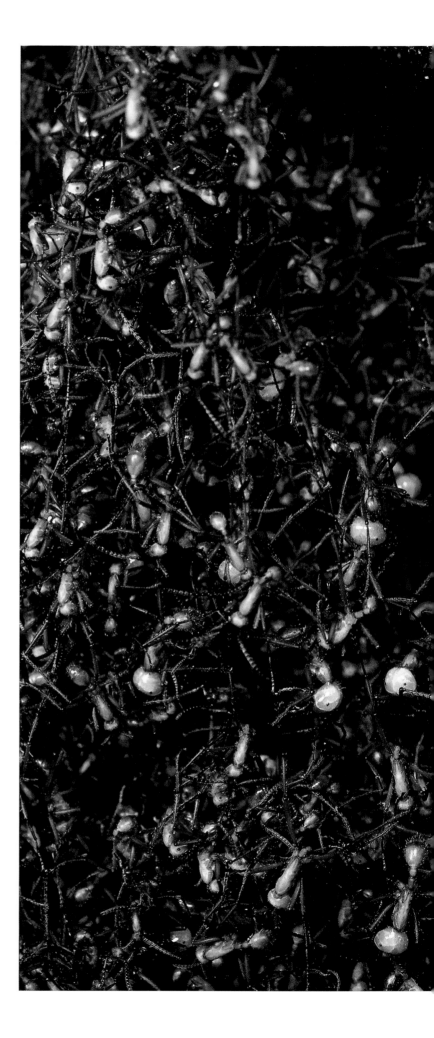

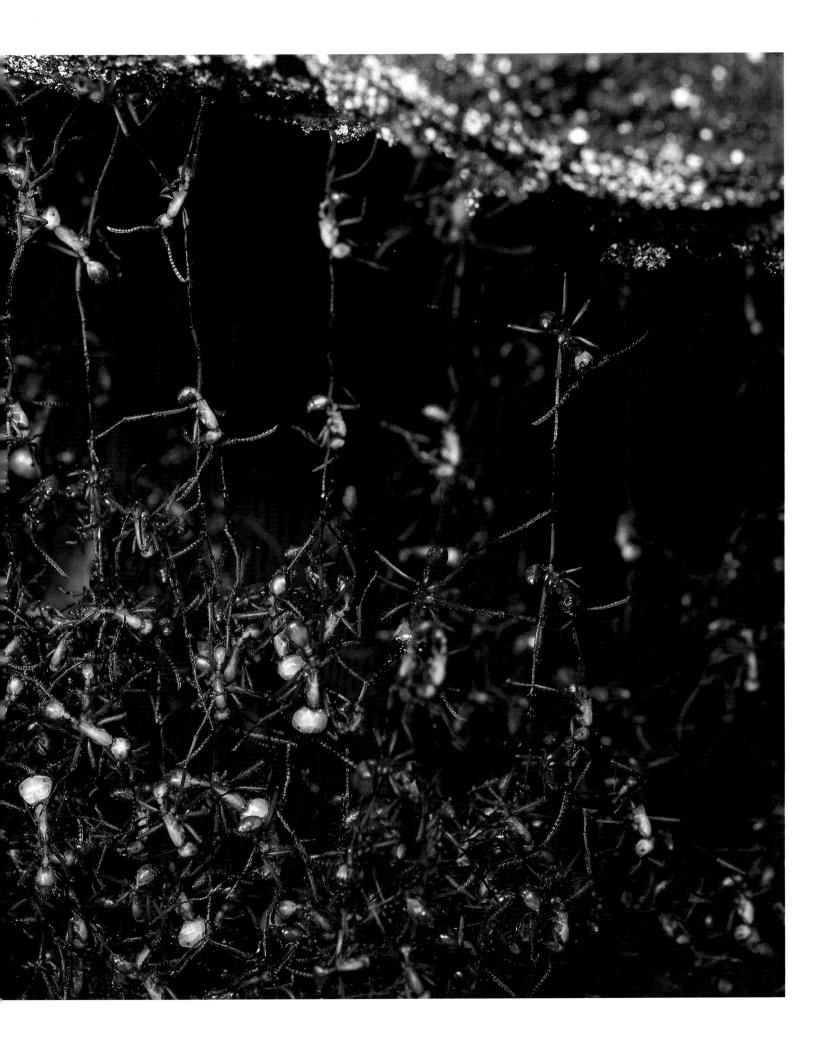

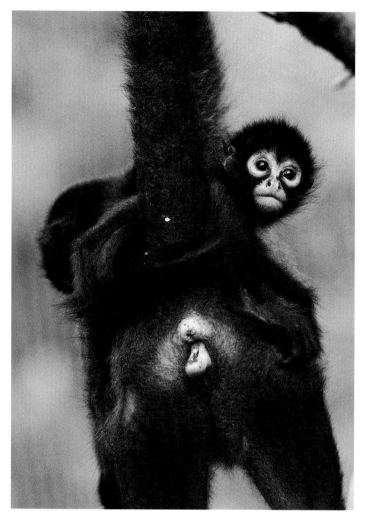

167

Los monos araña *(Ateles geoffroyi)*, la especie menos común de las cuatro especies de monos presentes en Barro Colorado, son primates sociales que muestran comportamientos complejos. Las hembras tienen crías cada tres años. Los lazos entre la madre y las crías son fuertes y duraderos. Los juveniles acostumbran mantenerse cerca de la madre, como vemos aquí.

ningún murciélago sensato se atrevería a entrar. En cambio, las esperanzas de bosque, que se posan donde los murciélagos podrían alcanzarlos, rara vez llaman, y si lo hacen, es en tonos claros, difíciles de localizar. Un esperanza que canta poco es más difícil de encontrar: en experimentos realizados en jaulas de vuelo, Belwood encontró que los murciélagos de orejas redondas, *Tonatia sylvicola* (fig. 155), necesitaban tantos segundos para ubicar a las esperanzas que llamaban 60 veces por minuto como minutos necesitaban para ubicar a aquellos que llamaban menos de una vez por minuto. En vez de llamar a la hembra, el esperanza de bosque hace vibrar el arbusto en que está posado de una manera compleja y específica de su especie, a fin de comunicar su presencia y su atractivo a las hembras de su especie que por casualidad estén en el mismo arbusto. La amenaza de ser devorados por un murciélago marca una diferencia profunda en la manera en que las esperanzas macho emiten señales para atraer una pareja.

¿POR QUÉ VIVIR EN GRUPO?

Las personas que visitan bosques tropicales como Barro Colorado a menudo ven animales en grupo —una tropa de monos, un ejército de hormigas, un nido de avispas, una banda de coatíes hembras con sus crías o una bandada de varias especies de aves que forrajean juntas.

¿Por qué los animales viven en grupo? Algunas veces, como en el caso de las hormigas arrieras, de las hormigas guerreras (fig. 166) y de las abejas, es evidente que los miembros del grupo trabajan en equipo: la división del trabajo entre los miembros del grupo hace que el grupo sea mucho más competitivo que lo que podrían ser los individuos si vivieran solos. Si alguien se acerca a un nido de abejas o a un nido de avispas al punto de ser atacado por estas podrá experimentar en carne propia y de manera brutal lo que es el trabajo en equipo.

En otros grupos, sin embargo, el trabajo en equipo solo se hace evidente cuando ocurren acontecimientos relativamente infrecuentes: dos tropas de monos aulladores compitiendo por la posesión de un árbol cargado de fruta, los miembros de una bandada de aves o de un grupo de monos cariblancos alertándose entre sí sobre la presencia de un depredador, o todavía más raro, un grupo de monos aulladores macho hostigando a un águila arpía para alejarla de la tropa. Estos ejemplos indican que muchos animales viven en grupo porque la cantidad trae seguridad: más ojos para detectar la presencia de depredadores, más aliados para alejar a los competidores.

EL PROBLEMA FUNDAMENTAL DEL COMPORTAMIENTO ANIMAL

A pesar de lo que se sabe hasta el momento, la razón por la que los animales viven en grupo sigue siendo un misterio. Ningún animal escapa a la prueba competitiva de la selección natural. Los miembros de un grupo son los competidores más inmediatos de cada cual, por comida, por una pareja, por un refugio y por todo lo demás que no es abundante. Entonces, ¿qué evita que la competencia entre los miembros destruya los beneficios de vivir en grupo y socave el interés común por el bienestar colectivo? En efecto, ¿por qué los animales habrían de cooperar, aun cuando fuera solo brevemente? Siempre que dos animales cooperen en la reproducción sexual para crear seres más variados que lo que cualquiera de los dos hubiera podido crear si se clonaba, es posible que uno de los dos esté engañando a su pareja. Algunas arañas y mantis religiosas hembra se comen al macho con el que acaban de copular. Las aves insectívoras y algunos peces buscan pareja para concebir y criar a sus retoños. En el nido de una pareja de aves, sin embargo, algunas de las crías que

el macho ayuda a alimentar puede ser que hayan sido engendradas por otro padre. De igual modo, es posible que los peces, tanto machos como hembras, abandonen el nido antes de que sus crías puedan sobrevivir de manera independiente. Por tanto, la razón por la que los animales cooperan en un mundo tan competitivo es realmente una pregunta fundamental en el estudio del comportamiento animal.

Si la competencia dentro de un grupo es destructiva, esto puede ser una verdadera amenaza. Una persona puede obtener una ventaja personal de muchas maneras que dañan a la sociedad en la que vive. Lo mismo aplica para otros animales. Un individuo puede aprovecharse de la situación y no cumplir con su parte en las obligaciones comunales de defensa, recolección de comida y cuidado de las crías, de las cuales se beneficia. Otro podría acaparar los beneficios del trabajo comunal, haciendo que sea perjudicial que el resto coopere.

Este problema fundamental del comportamiento animal tiene situaciones análogas en todos los niveles de la biología. Por ejemplo, las células del cuerpo de un animal normalmente cooperan por completo para formar un individuo funcional. Aun así, en ocasiones, un grupo de células se multiplica desaforadamente, sin contribuir al bienestar del individuo del que forman parte. Esta multiplicación descontrolada crea un cáncer que mata al individuo del que dependen las células cancerígenas. De hecho, este "problema fundamental" es un tema unificador de la biología que incluye también los asuntos humanos. Platón, Aristóteles y muchos de sus sucesores, desde esos tiempos y hasta la actualidad, se han preguntado qué tipo de organización en las sociedades humanas empata mejor la ventaja del individuo con el bienestar común; es decir, cómo estructurar la sociedad de manera que los individuos obtengan el mayor provecho trabajando por el bien común.

¿CÓMO MANTENER LA ARMONÍA EN LOS GRUPOS ANIMALES?

Las sociedades de avispas, hormigas y abejas comenzaron cuando las hermanas unieron fuerzas para fundar un nido, con lo cual evitaban el peligro de hacerlo solas. La competencia por celdas en el nido para poner los huevos tiene como resultado ganadores y perdedores. Los perdedores a menudo se benefician más ayudando a sus parientes a reproducirse que enfrentando los peligros de anidar en solitario. Después de todo, los hijos de los ganadores son sus sobrinos. Las sociedades primitivas de avispas ya mostraban una división del trabajo entre la que ponía huevos, las que defendían el nido y los parientes no reproductores que buscaban comida para las crías. Las obreras forrajeras, sin embargo, todavía son capaces de reproducirse y algunas veces luchan por cambiar roles con la ponedora de huevos. Algunas veces la ponedora de huevos o las que defienden el nido deben obligar a las obreras forrajeras a trabajar.

En una sociedad avanzada de hormigas arrieras (figs. 11, 41-45), una reina única se encarga en forma exclusiva de la reproducción. Al controlar cuánto come cada cría, la reina controla su destino. Unas cuantas se convierten en machos. Otras, en hembras reproductoras, destinadas a fundar nuevos nidos. La mayoría se convierten en obreras estériles. Ya que las obreras no pueden reproducirse, es un interés común ayudar a la reina a que se reproduzca. La reina arriera no obliga a nadie a trabajar. Aun así, la colonia de hormigas arrieras funciona de una manera maravillosamente coordinada y sin trabas: las exploradoras buscan árboles con hojas idóneas, las obreras cortan las hojas y traen los fragmentos de vuelta al nido, los soldados defienden el nido y las "autopistas" de las hormigas, las agricultoras cuidan el hongo y lo alimentan con los fragmentos de hojas que traen las arrieras, las nodrizas alimentan a las crías, los recolectores de deshechos llevan los fragmentos de hojas utilizados a vertederos de basura. A pesar de que el comportamiento de una hormiga arriera individual es simple y estereotipado, la colonia de hormigas arrieras es increíblemente versátil y se adapta rápidamente al ambiente gracias a su extraordinaria división del trabajo. Algunos biólogos pretenden usar las colonias de hormigas como modelo para explicar cómo una colección de neuronas simples puede combinarse para dar como resultado la inteligencia del cerebro humano.

Las sociedades de los monos (fig. 167) funcionan diferente. Carecen de la jerarquía rígidamente programada de las colonias de hormigas arrieras. Los grupos de monos funcionan porque cada mono depende de todos los otros en su grupo para ayudar a descubrir a los depredadores y ahuyentarlos junto con los otros competidores. Un mono se pone en peligro si causa la muerte de otro mono miembro de su grupo por no cumplir su papel en la defensa o en la huida coordinada. Aquí, la ventaja de cada mono coincide en gran parte con el bien común del grupo al que pertenece.

168

La formación de bandadas mixtas es un fenómeno común en los bosques tropicales de todo el mundo. Aves de diferentes especies se unen libremente para forrajear en grupo, lo que les da más ojos para vigilar la llegada de un posible depredador. Así tambien tienen más oportunidad de capturar insectos que se escapen a sus compañeros de vuelo. El *Momotus momota conexus*, "Momoto Coroniazulado" se une con frecuencia a estas bandadas en los bosques de tierra firme cerca de Barro Colorado, pero no necesita unirse a ellas para sobrevivir.

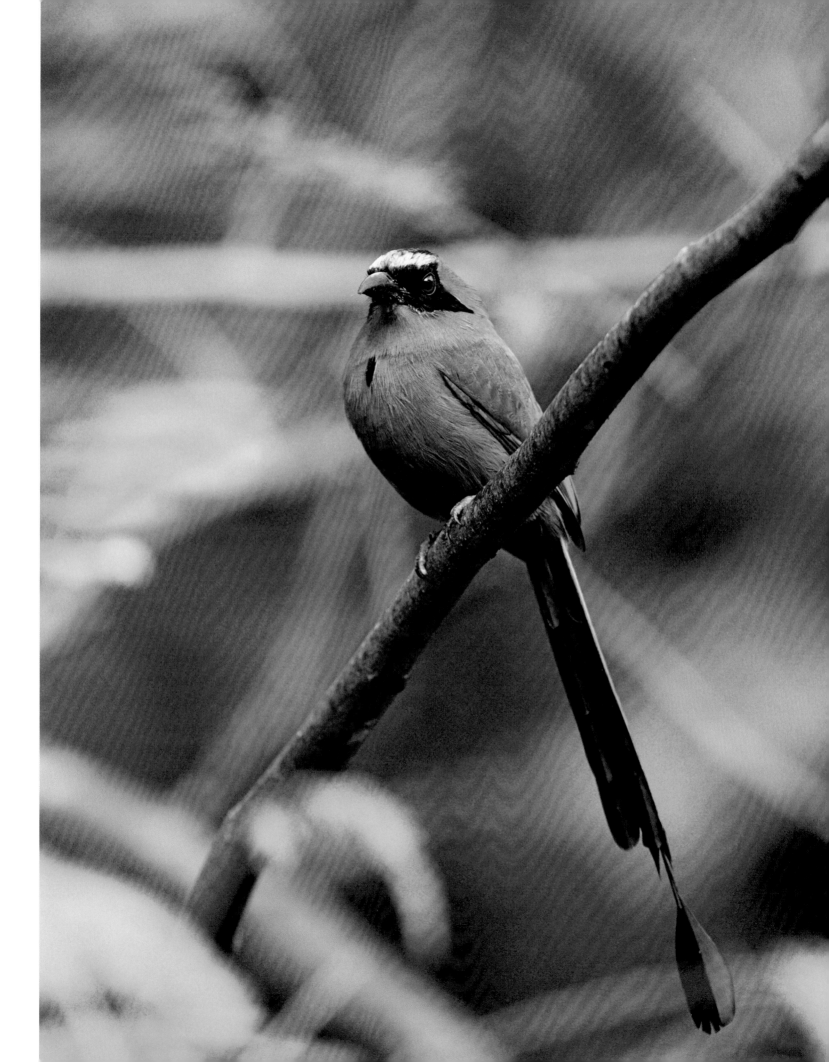

169

Los cariblancos (*Cebus capucinus*) son vivaces y activos, y viven en grupos de veinte o más individuos. Como son omnívoros, se alimentan de frutas, polen y animalitos pequeños. Cumplen un papel importante como dispersores de semillas, y quizá también como polinizadores. En Barro Colorado se les ha estudiado ampliamente.

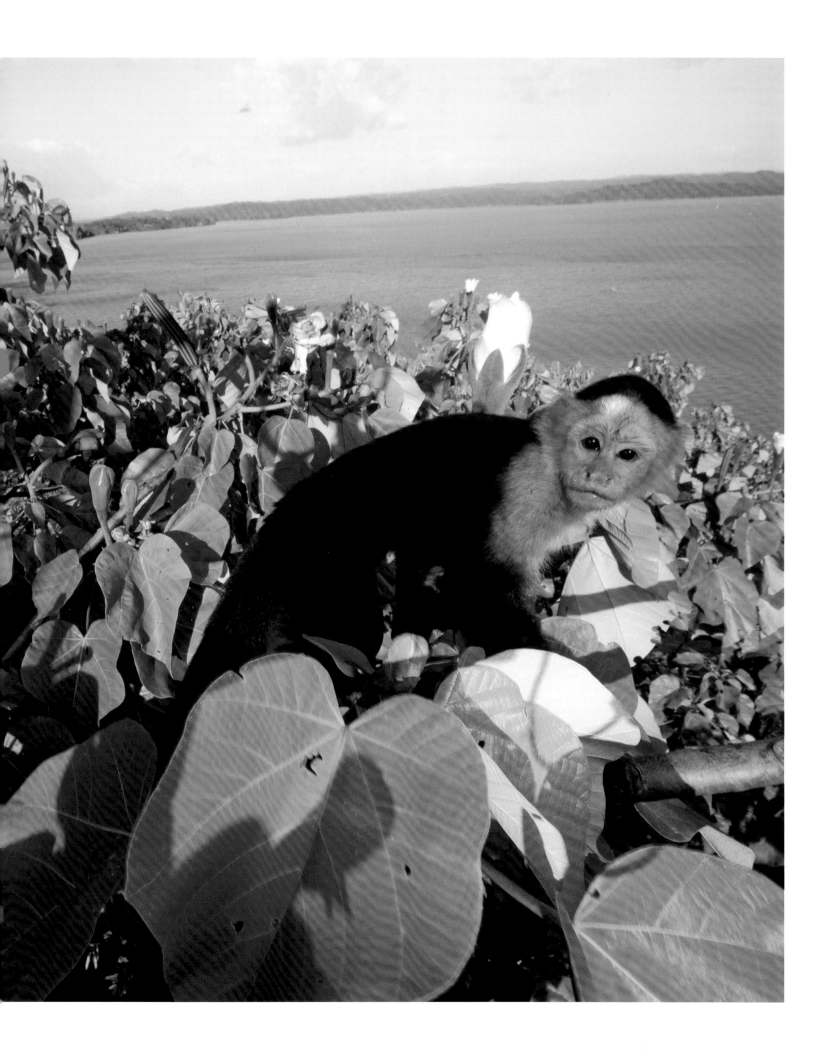

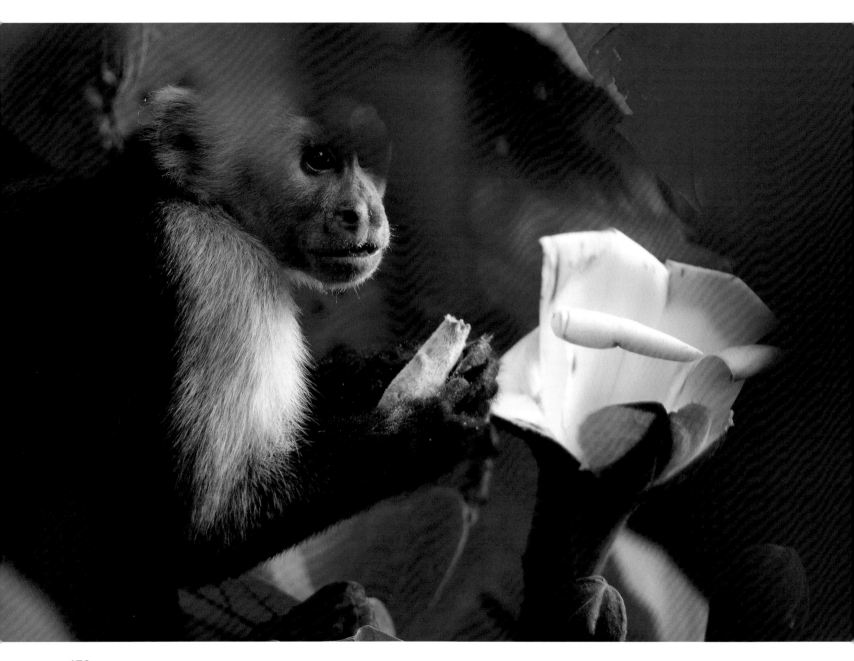

170

Los monos cariblancos (*Cebus capucinus*) son omnívoros. Su dieta incluye grandes cantidades de fruta, algo de hojas, animales pequeños y flores. Aquí vemos a uno de ellos forrajeando en la flor de un balso *(Ochroma pyrimidale)*. Los cariblancos tienden a destruir las flores de los balsos cuando beben su generosa carga de néctar, por lo que no son los mejores polinizadores de este árbol.

Las bandadas de aves mixtas son asociaciones que carecen de un "comandante" (figs. 34-37). Los primeros estudios en Barro Colorado mostraron que las aves de una bandada se alimentan de manera que se reduzca la competencia entre las diferentes especies presentes. No se unen en grupos para ayudarse mutuamente a encontrar alimento. Más bien, forrajean en bandada porque así son menos susceptibles de ser sorprendidos por un depredador que haya pasado inadvertido. Dar una llamada de alarma puede que no le cueste nada a un ave (a diferencia de lo que le podría costar a un mono). Si un ave divisa a un depredador a tiempo, fácilmente puede escapar y su llamado le informa al depredador que debería buscar alimento en otra parte porque no puede atrapar a quien emitió el llamado. A pesar de la naturaleza voluntaria de la asociación, las aves de una bandada se unen para hostigar a los depredadores. Además, las aves que se unen a este tipo de bandadas han desarrollado varios colores y hábitos que hacen que volar en grupo sea más beneficioso para los participantes.

LA COOPERACIÓN Y EL BIEN COMÚN

Aristóteles decía que las sociedades que mejor servían al bien común de sus miembros eran las menos vulnerables a las revoluciones, porque en estas sociedades si se revoca el orden social la mayoría sale perdiendo. Un animal se une a un grupo solo si esto le beneficia, de manera que los grupos de animales también deben servir al bien común de sus miembros. Una abeja reina o una hormiga reina manipula las circunstancias para crear un interés común entre las obreras por ayudarla. Pero, el interés que une a los monos de un grupo o a las aves de una bandada de especies mixtas no refleja tal manipulación.

La importancia de un interés común verdadero entre los colaboradores se revela en la historia de una pequeña avispa, la *Metapolybia aztecoides*. En una colonia de esta especie, algunas obreras pueden poner huevos, aunque normalmente se abstienen de hacerlo cuando la colonia tiene una reina saludable y totalmente desarrollada. Si la reina muere, ninguna obrera puede poner tantos huevos como para suministrarle a la colonia todas las obreras que necesita. Por esta razón, varias avispas colaboran para poner tantos huevos como sea necesario. No obstante, la puesta de huevos de una avispa mejora con la práctica. Cuando una de las avispas puede poner suficientes huevos como para mantener la colonia, las colaboradoras luchan por obtener el premio que habían creado de manera conjunta. El interés común en la cooperación termina cuando una avispa deja de necesitar la ayuda de las otras para mantener la colonia.

Siendo estudiante de grado en la Universidad de Harvard, Margaret Crofoot llevó a cabo un estudio sobre los monos cariblancos, *Cebus capucinus*, de Barro Colorado, que mostró cómo la fortaleza del vínculo de interés común entre los miembros afectaba el comportamiento del grupo. Crofoot se preguntó qué factores afectaban el resultado de un encuentro entre diferentes grupos de monos. Para responder a esta pregunta, utilizó el sistema automatizado de radio-telemetría que había en Barro Colorado. El sistema está compuesto por siete torres conectadas a una base central de datos a la cual se envían las señales de radio de los transmisores colocados al cuello de ciertos animales. Esta base permite rastrear su movimiento diario, siempre que estén dentro del alcance de las torres. Crofoot colocó este tipo de collares a animales de seis tropas distintas. El registro de sus movimientos mostró que el factor que más incidía en cuál grupo se batía en retirada luego de un encuentro no era el menor número de animales, sino la distancia a la que estaban del centro de su área de actividad. La ventaja de "jugar en casa" parece deberse a que los miembros del "grupo local" —el que está más cerca del centro de su área de actividad— corren un mayor riesgo común si el resultado es desfavorable.

Por esta razón, un mayor número de miembros del grupo se une a la pelea. Los miembros del grupo invasor, en cambio, no comparten un interés común tan fuerte en el resultado de la batalla; de ahí que menos de ellos se sumen al combate.

Vivir en grupo no es ventajoso para todo el mundo. Las águilas y los jaguares no son animales sociales. No tienen depredadores a los cuales temer, no necesitan ayuda para atrapar a sus presas y no están dispuestos a compartir con otros las presas que puedan conseguir. Al otro lado del espectro, los insectos que buscan escapar de los depredadores haciéndose pasar por un palito, una hoja o un excremento de ave, no quieren tener vecinos parecidos al lado, no vaya a ser que un depredador que se coma uno descubra cómo identificar a los compañeros que tiene cerca.

EL GRUPO MÁS GRANDE DE TODOS

Cada una de las plantas y animales que forman una comunidad ecológica —un ecosistema— dependen de los otros miembros de la comunidad, ya sea por que les proporcionan alimento o fertilizantes, un hábitat donde vivir, se deshacen de sus desechos y cadáveres, o incluso por el aire que respiran, o por el dióxido de carbono que necesitan, en el caso de las plantas.

La alteración irresponsable que ocasionan los humanos generalmente desmejora la diversidad de los ecosistemas naturales o su productividad (entendida como la tasa total de producción de materia vegetal y carne animal). Hasta las reservas ecológicas que intentamos conservar en estado natural se deterioran por efectos no intencionales de la actividad humana. En Norteamérica, las aves cantoras, que ayudan a controlar las plagas de insectos, están disminuyendo porque los bosques tropicales dónde pasaban el invierno están siendo reemplazados por granjas y terrenos baldíos. Como

los lobos desaparecieron y los pumas son tan escasos, los venados, que antes eran sus presas, se han vuelto tan abundantes que solo las plántulas de sabor más desagradable pueden sobrevivir, lo que está produciendo un cambio inexorable en la composición de especies de árboles de los parques nacionales de Norteamérica. La sobrepesca en el Pacífico norte deja a las ballenas asesinas con hambre, por lo que se acercan a la orilla a cazar nutrias marinas; en consecuencia, los erizos de mar que las nutrias se comían se han multiplicado y ahora se alimentan excesivamente de las algas que bordean estas costas, en perjuicio de los animales que vivían ahí, así como de las focas y de las águilas calvas, que vivían de la abundancia de esos animales.

Un cambio accidental en el mecanismo de un reloj, una máquina diseñada —organizada— para medir el tiempo, generalmente la deja inservible. Aristóteles consideraba que las cosas vivas estaban organizadas para sobrevivir y para reproducirse porque los mutantes, si en algo son diferentes, tienden a ser menos efectivos en estas funciones que sus contrapartes normales. Los cambios que se fraguan en un bosque tropical al talarlo, contaminarlo o fragmentarlo en parques y arboledas aisladas, disminuyen su diversidad, su productividad, o ambas. El argumento de Aristóteles implica, por tanto, que estos bosques, así como otros ecosistemas, son "mancomunidades" que se han organizado para mantener una gran diversidad de miembros y una elevada producción de alimentos que les sirva de sustento.

¿Qué tipo de organización es esa que permite a los ecosistemas alcanzar esos altos niveles de productividad y diversidad? Adam Smith sostenía que la competencia justa entre los seres humanos aumenta la producción de riqueza y la diversidad de ocupaciones, si la sociedad puede castigar la competencia desleal, que reduce la productividad. Los ecosistemas ilustran este punto mejor que la mayoría de las sociedades humanas.

La competencia implacable por un modo de vida y reproducción ha favorecido a organismos que han encontrado nuevas —o mejores— formas de generar "riqueza". Entre ellas, la fotosíntesis, que aprovecha la luz para crear azúcares a partir del dióxido de carbono y el agua; la respiración, que aprovecha el oxígeno liberado por la fotosíntesis para extraer más energía de los alimentos; el uso de energía para generar amoníaco para fabricar proteínas a partir del nitrógeno en la atmósfera; y la combinación de organismos con funciones complementarias para que cada uno sea más competitivo. Algunos corales, por ejemplo, incorporan algas fotosintéticas para obtener carbohidratos y, a cambio, fertilizan a las algas con sus deshechos. Las hormigas arrieras cultivan un superhongo que les ayuda a digerir los trozos de hoja que llevan al nido. La competencia despiadada por un modo de vida también ha favorecido a los organismos que se ganan la vida reciclando de forma novedosa los desechos o los cadáveres de otros. Tal es el caso de las bacterias desnitrificantes, que obtienen energía convirtiendo desechos nitrogenados en nitrógeno atmosférico; de los hongos y las termitas, que obtienen energía descomponiendo vegetación muerta; o de los animales excavadores, que explotan el carbón enterrado y lo convierten nuevamente en un recurso accesible.

La competencia por un modo de vida y reproducción también favorece a los especialistas, que realizan tan bien su trabajo que ninguna otra especie los puede reemplazar. La diversidad de especializaciones es, en efecto, una división del trabajo entre las diferentes especies de plantas y animales, que ahora dependen de las funciones de cada uno de ellos. Las plantas dependen de los descomponedores, los descomponedores de las plantas, los pastizales de los herbívoros que las libran de las plántulas, etcétera. En ecosistemas intactos, los herbívoros y los depredadores mejoran la productividad haciendo circular rápidamente los recursos en los cuerpos de otros. Algunos animales, como los polinizadores y los dispersores de semillas, han logrado desarrollar una buena forma de vida ofreciendo servicios que a las plantas les resultan de gran utilidad.

Adam Smith consideraba que los monopolios figuraban entre los mayores obstáculos para incrementar la riqueza de un país, porque protegían a quienes hacían un uso ineficiente de los recursos. La competencia despiadada que se observa en la naturaleza rápidamente erosiona los monopolios que reducen la productividad. En la naturaleza, las fuentes de energía que no han sido explotadas o que lo han sido solo escasamente, suelen atraer usuarios más eficientes. De hecho, en los climas tropicales los organismos aprovechan cualquier fuente de energía disponible, como bien lo saben los dueños de casas que han sido devoradas por termitas, o aquellos que un buen día encuentran sus libros y papeles carcomidos de cucarachas, o los lentes invadidos de hongos.

Está claro que muchos organismos se ganan la vida de una manera antieconómica y dañina, como el agente de la oncocercosis, que es capaz de arruinar una vida humana dada su predilección por los nervios ópticos. Este tipo de organismos también son parte de la naturaleza. Pero centrarse solo en ellos es dejar por fuera más de tres mil millones de años de evolución: es dejar por fuera a los ecosistemas, esas "mancomunidades" sorprendentemente funcionales que han evolucionado sin premeditación alguna, a partir de la implacable competencia entre plantas y animales por un modo de sobrevivir y reproducirse, proceso durante el cual ambos desarrollaron una extraordinaria red de mutualismos que hacen de los ecosistemas de los bosques tropicales un hogar productivo para una extraordinaria variedad de criaturas vivientes. Puede afirmarse, sin lugar a dudas, que la competencia entre los seres vivientes ha transformado la Tierra en un hogar más propicio aún para la vida, un hogar que ofrece una variedad aún mayor de modos de vivir. El bosque tropical es un ejemplo notable de este logro.

171

Los bosques gobiernan el clima,
tanto a nivel local como regional. Las
plantas, al transpirar vapor de agua
en abundancia, forman las nubes
que traerán las lluvias. En un área
deforestada, sale más agua de lluvia
de la cuenca como escorrentía, que
la que vuelve a la atmósfera como
transpiración. Aproximadamente
la mitad de la lluvia que cae sobre
la Amazonía es producto de la
transpiración de sus plantas.

LA IMPORTANCIA DE LOS BOSQUES TROPICALES

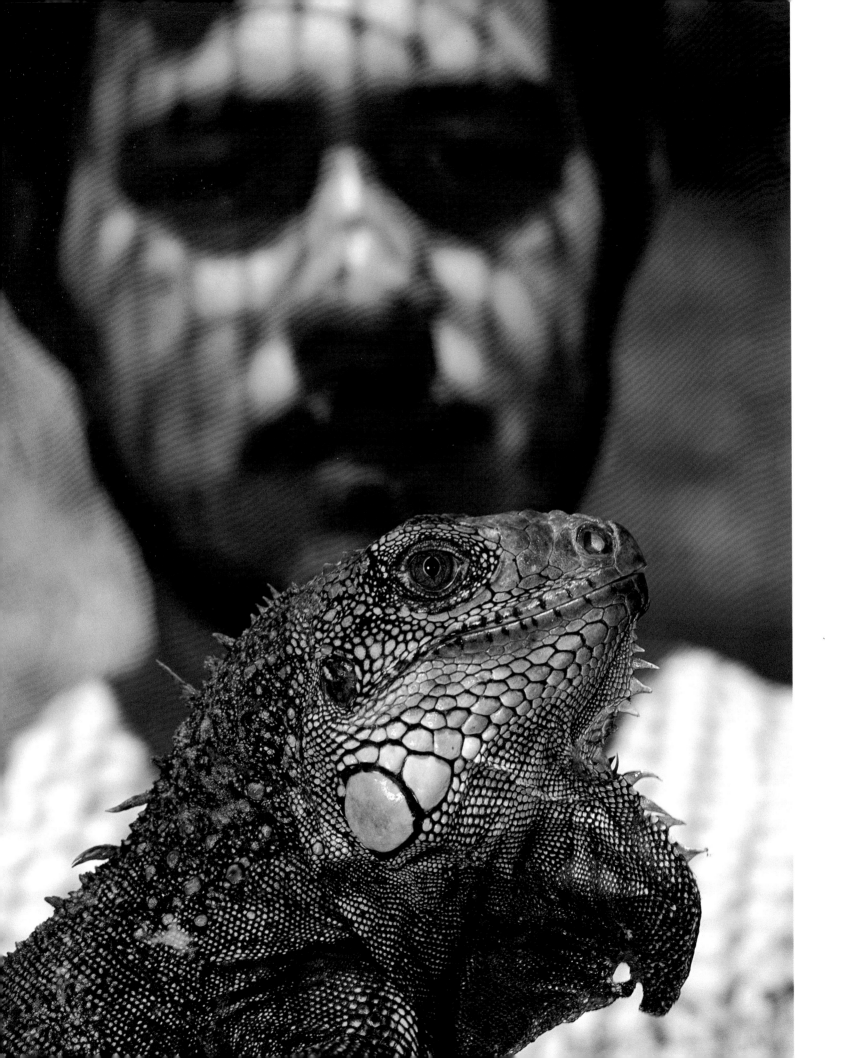

LA IMPORTANCIA DE LOS BOSQUES TROPICALES

LOS BOSQUES LLUVIOSOS BENEFICIAN A RICOS Y POBRES POR IGUAL

Cientos de millones de personas dependen de los bosques tropicales que les brindan materiales de construcción, madera para combustible, medicinas y alimentos. Cientos de millones los necesitan porque contribuyen a que en sus tierras el clima sea más tolerable, garantizan una fuente de agua relativamente confiable y ofrecen cierto grado de protección contra las inundaciones. Cada día aumenta el número de personas, dentro y fuera de los trópicos, que no duda en afirmar que los bosques tropicales son una de las maravillas de este planeta y que sin ellos el mundo se vería seriamente empobrecido.

172

Dondequiera que vivan, las iguanas verdes *(Iguana iguana)* son cazadas por su carne y por sus huevos. La Asociación Nacional para la Conservación de la Naturaleza (ANCON), una organización no gubernamental panameña, dirige una granja experimental que busca encontrar formas fáciles y económicas de criar estos animales, con el fin de brindarles a los agricultores una fuente accesible de proteína y al mismo tiempo reducir la presión de la caza sobre las poblaciones de iguanas silvestres. Aquí, el biólogo Augusto González sostiene una hembra de gran tamaño, criada en la granja.

LA RELACIÓN ENTRE LOS BOSQUES Y LAS POBLACIONES RURALES POBRES

Algunos pueblos del trópico —agricultores y cazadores-recolectores itinerantes— dependen enteramente del bosque para sobrevivir; de hecho, forman parte del ecosistema boscoso y lo manejan con habilidad asombrosa. Otras poblaciones rurales, en cambio, han reemplazado grandes tramos de bosque con granjas, campos de cultivo y poblados: han transformado el ecosistema. Aun así, siguen dependiendo del bosque, para obtener madera para hacer casas, muebles, herramientas, armas (para cazar y defenderse) y medios de transporte (canoas y carretas). También para obtener material de combustión para hacer el fuego con que cocinan y se calientan.

Los bosques, especialmente en los trópicos, también son fuente de medicinas, que se preparan con una gran variedad de hojas, flores, raíces, hongos y resinas (fig. 175): tan valiosa es esta fuente que hoy día etnobotánicos y naturistas de todo el mundo registran los bosques tropicales de extremo a extremo en busca de compuestos de uso medicinal (fig. 173). Muchos de los agricultores del trópico dependen de los bosques para sacar hojas de palma para techar casas y tejer canastas, así como para obtener alimentos difíciles de cultivar —algunas hojas, frutas, nueces y hongos— y cazar animales para suplementar su consumo de proteína (fig. 172). Muchos de los artículos que hacen no solo se usan a

nivel local, sino que se venden o intercambian para adquirir cosas que estos pueblos no pueden cultivar, recolectar o producir. Cuando los turistas o los habitantes de la ciudad constituyen un mercado apropiado, las poblaciones rurales también usan el bosque como fuente de maderas preciosas, fibra de palma, tagua o "marfil vegetal" (fig. 174), mimbre, tintes y otros materiales que les permiten hacer figuras talladas, muebles, canastas decorativas (fig. 176) y otras artesanías para vender.

De ese modo, la mayoría de los paisajes rurales son un mosaico de parcelas maderables, arboledas sagradas y otros fragmentos de bosque. Algunos están destinados a suministrar productos forestales que las poblaciones necesitan. Otros se resguardan por razones religiosas, aunque también satisfacen muchas de estas necesidades. En Java, Jamaica y muchas regiones que perdieron sus bosques naturales, los agricultores tradicionales mantienen huertos caseros que son bosques de muchas capas, pero compuestos en su totalidad por plantas de valor práctico pequeños paraísos vegetales diseñados para satisfacer necesidades y aspiraciones humanas.

173

Los compuestos químicos de valor medicinal son uno de los recursos más importantes de los bosques tropicales: muchos de los compuestos químicos que presentan las plantas para disuadir a los herbívoros sirven para tratar enfermedades. Actualmente se dedican grandes esfuerzos a la bioprospección, la búsqueda de este tipo de compuestos. De los cientos de miles de especies de plantas tropicales, solo una pequeña fracción se ha estudiado a fondo para verificar sus posibles beneficios medicinales. Aquí, el doctor John Teen, biólogo radicado en Florida, examina los resultados de sus análisis de extractos de muestras de plantas frescas para comprobar su efecto en la fibrosis cística.

EL BOSQUE COMO FUENTE DE INSPIRACIÓN Y BELLEZA

Los antiguos hebreos consideraban la naturaleza primitiva como algo digno de admiración, un trabajo maravilloso que revelaba el esplendor, la grandeza y la bondad de su Creador (Job 39-41; Salmo 104). No obstante, la mayoría de los asentamientos que se establecieron en el pasado, tanto en los trópicos como en las zonas templadas, solían percibir los "bosques vírgenes" como lugares temibles, guaridas de bestias salvajes y quizá también de bandidos y aborígenes: lugares que había que domesticar y explotar. Algo de este miedo se refleja en las descripciones de J. R. R. Tolkien del bosque de Mirkwood en *El hobbit*, o del Bosque Viejo y el bosque de Fangorn en *El señor de los anillos*. El aprecio por la belleza de los bosques tropicales y otros paisajes naturales rara vez se expresaba en Occidente, sino hasta hace relativamente poco. Cristóbal Colón se apartó del común de los conquistadores al manifestar abiertamente su admiración por los bosques tropicales que encontró en el Nuevo Mundo.

Biólogos como Alexander von Humboldt, Charles Darwin y Alfred Russel Wallace no pudieron evitar sentirse conmovidos ante la belleza de los bosques tropicales, donde la naturaleza indómita se revela más que asombrosa en su prodigalidad de plantas y animales, en la variedad de maneras en que esas plantas y esos animales logran sobrevivir, en lo intrincado de las relaciones que establecen entre ellos y en el frágil balance que sostiene esa interdependencia. Estos exploradores contemplaron maravillados cómo, en palabras de E. J. H. Corner, la "naturaleza, en su intransigencia, crea lo más bello, lo más artístico, lo más destructivo".

Los bosques tropicales también atraen, y cada vez en mayor número, a personas no científicas. Por años, los ingleses que vivían en la India, en la Península de Malasia y en otras regiones tropicales solían ir de excursión a las colinas de estos países a disfrutar del aire fresco y la belleza del bosque tropical montano. En 1915, y en atención a esos "ecoturistas", F. Fyson publicó una guía sobre la flora de las colinas de Nilgiri y Palni, en el sur de la India. Desde entonces han proliferado las guías sobre flores silvestres, mariposas, aves y mamíferos, primero en la India, Malasia y África, y, más recientemente, también en el neotrópico. Diariamente crece el número de turistas que visitan los bosques tropicales en Costa Rica. Aquí en Panamá, miles de estudiantes y turistas visitan la Isla Barro Colorado todos los años (fig. 177). Para quienes no tienen la posibilidad de viajar a los trópicos, muchos acuarios y parques zoológicos en Europa y Norteamérica intentan recrear el ambiente del bosque lluvioso, sus paisajes, sus sonidos, y a veces hasta sus olores, en grandes pabellones acondicionados para este propósito. Equipos de televisión visitan Barro Colorado y otros bosques tropicales para que todo el mundo pueda contemplar, desde la comodidad de sus casas, algunas de las escenas más impactantes de la naturaleza tropical. Hace un siglo, los jardines botánicos acostumbraban llenar invernaderos enormes con palmeras y otras plantas tropicales. El pintor Henri Rousseau extrajo su concepto de bosque tropical de uno de ellos.

¿A qué se debe esta fascinación tan extendida por los bosques tropicales? Hay quienes se sienten atraídos por su belleza y su extrañeza. Otros encuentran un significado espiritual en la naturaleza libre de ataduras. Un distinguido estudioso musulmán expresó su parecer de manera muy emotiva: "La naturaleza virgen posee orden y armonía. En este vasto dominio de realidad, que inmediatamente se percibe que no tiene un origen humano, existe un orden, una interrelación entre las partes, una complementariedad de funciones y roles y una interdependencia que, para la mente no paralizada por el reduccionismo inherente a la visión de mundo científica

174

175

176

EJEMPLOS DE USO SOSTENIBLE DE PRODUCTOS DEL BOSQUE

La palma *Phytelephas* tiene semillas cuya textura y color se asemejan a los del marfil. Aquí, una colección de figuras talladas en este "marfil vegetal" o tagua, que se venden como artesanías. Atrás, el fruto (infrutescencia), oscuro y espinoso de la planta, que contiene una gran cantidad de nueces (fig. 174). En Panamá, los pueblos del bosque extraen fibras de varios tipos de palma y tejen canastas y otros artículos que sobresalen por sus diseños únicos. En la imagen, una mujer emberá tejiendo una canasta (fig. 176). También se observa a un indígena emberá, vecino del río Chagres, organizando las plantas que recolectó del bosque y que se usan con fines medicinales en su aldea (fig. 175).

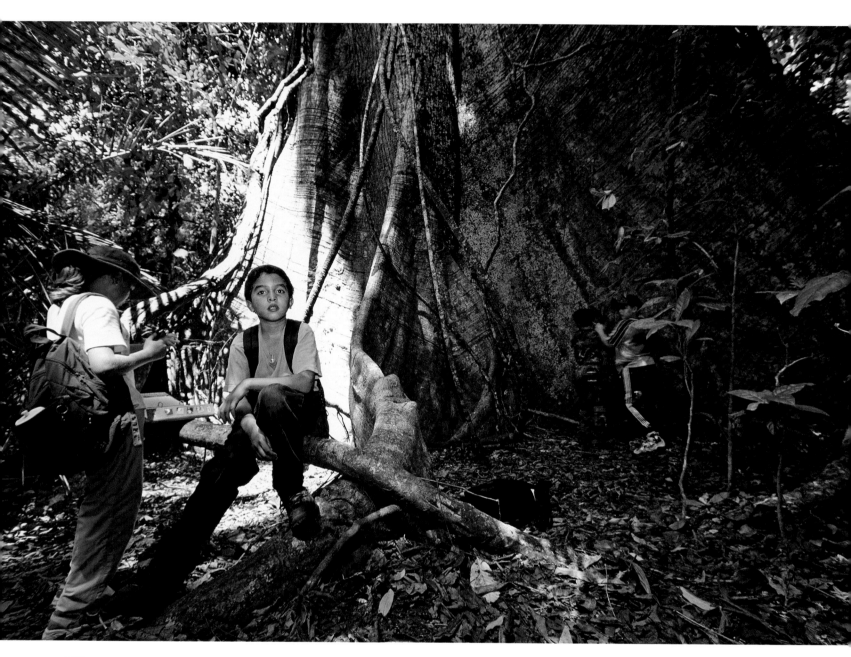

177

El ecoturismo es valioso no solo como industria, sino como un medio para educar. Les permite a los turistas apreciar la belleza y el valor del paisaje tropical y a los estudiantes aprender por qué hay que proteger las áreas que aún se conservan. También es una forma de obtener ingresos del bosque sin necesidad de destruirlo. Panamá tiene mucho potencial para el ecoturismo, pero esto significa proteger los recursos naturales que todavía quedan. En la imagen, estudiantes de Ciudad de Panamá, muchos de los cuales nunca habían visitado un bosque tropical, posan frente a "Bigtree", una ceiba enorme *(Ceiba pentandra)*. Quizás dentro de veinte años algunos de estos muchachos ocupen un puesto que les permita proteger los bosques tropicales. Quizás lo que aprendieron en Barro Colorado y el recuerdo este árbol legendario los motive a hacerlo.

moderna, no puede sino conducir a un sentimiento de asombro y de toma de conciencia del carácter espiritual de esa Luz que convirtió el caos en cosmos y que todavía se revela en el orden natural de las cosas".

CÓMO LOS BOSQUES TROPICALES NOS AYUDAN A ENTENDER LA NATURALEZA

La naturaleza de los trópicos no solo impresionó a los biólogos por su belleza; también planteó un reto intelectual que transformó radicalmente el campo de la biología. Los biólogos se vieron enfrentados a la necesidad de entender por qué las plantas y los animales tropicales encontraban tantas maneras diferentes de escapar de sus enemigos y de obtener lo que necesitaban para sobrevivir y para reproducirse. Darwin y Wallace encontraron respuestas a estas preguntas en su teoría de la evolución por selección natural. Esta teoría es el pilar de nuestro entendimiento de la biología.

Más recientemente, la naturaleza tropical ha impulsado a los biólogos a preguntarse cómo el proceso competitivo de selección natural podría favorecer la evolución del comportamiento social en los animales, por no mencionar las múltiples formas de cooperación entre plantas, animales, hongos y microorganismos de los cuales depende la diversidad y exuberancia del bosque tropical. ¿Cómo pueden los biólogos tropicales dar sentido a lo que E. J. H. Corner llamó "esta profusión de vida vegetal, que prospera sin premeditación alguna, que construye sin tener sangre en las venas, que siente y responde sin tener órganos sensoriales ni músculos, que convoca a los animales sin tener que ingeniárselas para ello y que satisface, con su sobreproducción, las necesidades alimentarias de sus miembros?".

La naturaleza de los trópicos también nos brinda la perspectiva necesaria para aprehender la "extrañeza" de las coníferas con hojas de aguja y la "normalidad"

de las palmeras, y de ver la naturaleza que nos rodea, dondequiera que estemos, en un contexto más amplio y más verdadero. Cada día son más los biólogos que vienen a los trópicos a "descubrir cómo los árboles modernos llegaron a ser lo que son hoy, cómo es realmente la vida de un árbol, lo que la vegetación puede hacer y, desde luego, lo que esto significó para los animales", como lo expresó Corner. Hemos escrito este libro para compartir con nuestros lectores la belleza que tanto nos atrae a nosotros, los biólogos, a los bosques tropicales, y para enseñarles a los lectores a ver los bosques tropicales de manera tal que puedan apreciar la cantidad de retos que enfrentan sus muchos y muy diversos habitantes, y cómo estos habitantes contribuyen, a su vez, a la exuberancia y a la belleza del bosque.

LA INTERACCIÓN ENTRE EL BOSQUE TROPICAL Y EL CLIMA

Alexander von Humboldt observó en 1799 que cerca de Cumaná, Venezuela, "los habitantes habían notado, con razón, que la aridez había aumentado en toda la provincia [en parte] porque estaba menos cubierta de bosques que antes de la conquista". Desde entonces, se ha observado que en las regiones tropicales la deforestación hace que el clima sea más caliente y que disminuya la precipitación, especialmente durante la época seca. Esta observación ha sido escasamente documentada y algunos estudiosos la consideran un mito; sin embargo, parece ser cierta. En la Amazonía, la mitad de la lluvia que cae regresa a la atmósfera. Los procesos de evaporación y transpiración consumen la mitad de la energía que recibe el bosque del sol y lo ayudan a mantenerse fresco (fig. 171). Además, tal y como se indicó en un capítulo anterior, el bosque tropical, "a través de su copiosa evaporación engendra sus propias tormentas". En las regiones que están lejos de los océanos, la precipitación declina cuando el bosque

es cortado. Las lluvias torrenciales, en efecto, regulan el clima tropical. El clima en África es más caliente tierra adentro que en la costa, especialmente durante el día, y el rango diario de temperatura es mucho mayor durante una estación seca muy larga que durante la época lluviosa.

Las cuencas arboladas normalmente se erosionan más lentamente y experimentan menos deslizamientos. Los ríos que drenan sus aguas en cuencas boscosas tienden a ser más claros y es menos probable que se ahoguen en sus propios sedimentos, en comparación con las corrientes que drenan sus aguas en áreas deforestadas (fig. 178). La sobrecarga de sedimentos que ahoga al río Amarillo es lo que causa tantos pesares a los habitantes de las llanuras del norte de China. Los suelos de los bosques absorben el agua más rápidamente, lo que no solo disminuye la frecuencia y extensión de las inundaciones, sino que aumenta la cantidad de agua que los suelos pueden almacenar, contribuyendo con ello a aumentar el caudal de los ríos en la época seca. Por esta razón, en los trópicos, los agricultores sabios, como los de Monteverde, en Costa Rica, cuidan los suelos y las fuentes de agua protegiendo las cumbres empinadas.

LOS BOSQUES TROPICALES Y EL EFECTO INVERNADERO GLOBAL PRODUCTO DEL DIÓXIDO DE CARBONO

El contenido de dióxido de carbono en la atmósfera de la Tierra está aumentando, lo que calienta el planeta al disminuir el porcentaje de radiación solar que regresa al espacio. La deforestación le inyecta dióxido de carbono a la atmósfera. ¿Hasta qué punto sirven los bosques tropicales como escudos protectores contra el calentamiento global?

En 1995, la atmósfera de la Tierra contenía 2.8 billones (2.8×10^{12}) de toneladas de dióxido de carbono. Esta cantidad estaba aumentando a una velocidad

de 13.9 mil millones de toneladas, o 0.5% al año. Para poner estos números en perspectiva, conviene pensar cuánto dióxido de carbono necesitan las plantas y los microbios para producir materia vegetal. Un grupo de investigadores considera que necesitan 400 mil millones de toneladas, otro, que más de 600 mil millones de toneladas al año —entre la séptima y la quinta parte del total de la atmósfera—. La respiración de los herbívoros y de los organismos que descomponen esa materia vegetal devuelve prácticamente todo este dióxido de carbono a la atmósfera.

Claramente, la Tierra se está calentando. En las montañas de Monteverde, en Costa Rica, las plantas y los animales de tierras bajas se están desplazando hacia tierras más altas; en los Estados Unidos, las plantas y las aves del sur se están desplazando hacia el norte. Los océanos se están calentando y expandiendo, lo que hace que se eleve el nivel del mar. El calentamiento global también está derritiendo los glaciares, provocando una elevación aún mayor del nivel del mar. Al examinar los registros del nivel del mar a los dos extremos del Canal de Panamá, John Cubit, biólogo marino que trabajó para el STRI, encontró que durante los últimos 80 años, éste había subido 1.3 milímetros al año en ambas costas, lo que se acerca bastante al aumento global promedio.

¿En qué medida contribuye el aumento en la cantidad de dióxido de carbono en la atmósfera al calentamiento de la Tierra? El aumento proporcional en el contenido de dióxido de carbono en la atmósfera determina el aumento en la temperatura. Entre 1910 y 1996, la temperatura global aumentó entre un 0.7 y un 0.8 °C, mientras que el contenido de dióxido de carbono de la atmósfera aumentó un 20%, al pasar de 300 a 360 partes por millón. Extrapolando estos datos, una duplicación en el nivel de dióxido de carbono en la atmósfera traería como resultado un aumento de 3 °C en la temperatura global. Como los humanos también afectan las propiedades de

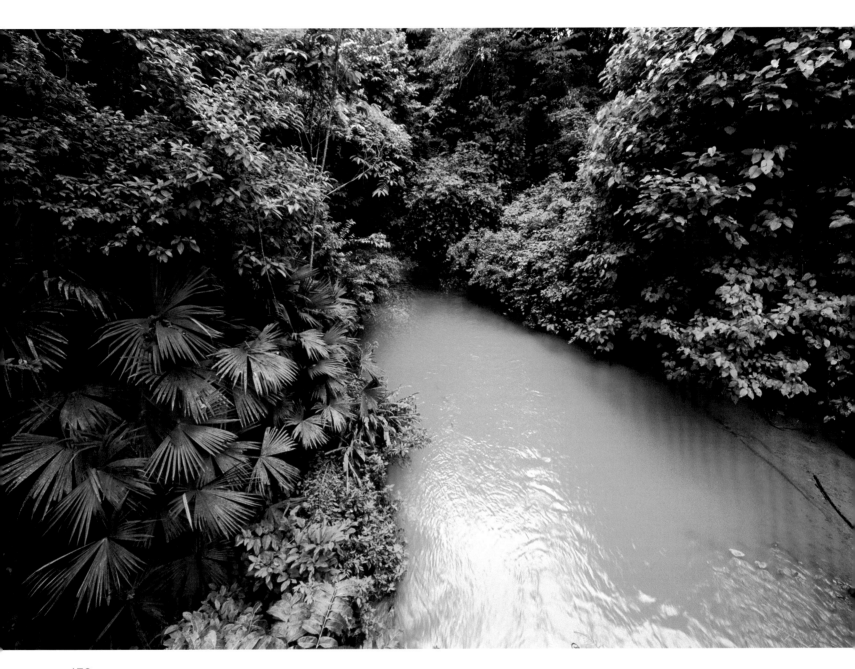

178

La cubierta de bosque reduce significativamente la erosión; despojada de sus árboles, la tierra se lava deprisa. Este arroyo cargado de sedimento discurre por un área deforestada en tierra continental.

invernadero de la atmósfera de otras formas, actualmente se estima que el aumento en temperatura que resultaría de una duplicación del contenido de dióxido de carbono en la atmósfera oscila entre 1.5 y 4.5 °C. Si la respuesta correcta es 3.0, en este momento el dióxido de carbono está calentando la Tierra a un ritmo de 0.02 °C por año. Este cambio no es perceptible en un periodo de gobierno, pero se vuelve desagradablemente evidente después de un siglo, especialmente si se derrite la suficiente cantidad de hielo como para producir una subida significativa en el nivel del mar. El calentamiento global exige una visión de largo plazo; se necesita la perspectiva geológica para evaluar el fenómeno, pero también la voluntad de pensar en las generaciones venideras para encontrar una solución.

El aumento del dióxido de carbono en la atmósfera ya causó calentamiento global en el pasado. El episodio mejor documentado ocurrió hace 56 millones de años, cuando el nivel de dióxido de carbono aumentó drásticamente en un lapso de 10 a 20 mil años, se mantuvo alto durante 100 mil años, y descendió a los niveles iniciales tras otros 90 mil años. Este cambio coincidió con un aumento en la temperatura planetaria de por lo menos 5 °C. Quizás la mejor explicación de este aumento es que el calentamiento inicial ocasionado por otros factores descompuso "el clatrato de metano" que se encuentra enterrado en las placas continentales. Los clatratos de metano son cristales: cada unidad de cristal es una molécula de metano atrapada en una retícula de moléculas de agua. El calentamiento desestabiliza los clatratos de metano. A una temperatura de –1.5 °C, son estables a profundidades de más de 250 metros; a 15 °C, son estables únicamente a profundidades mayores que 1460 metros. Datos de núcleos del fondo del mar alrededor del mundo indican que en este momento los clatratos de metano contienen más de diez veces la cantidad de carbono que existe en la atmósfera.

Al parecer, el carbono contenido en el metano liberado hace 56 millones de años aumentó el contenido de dióxido de carbono en la atmósfera en más de nueve billones de toneladas (recuadro 5.1), al pasar de 3.14 a 12.3 billones de toneladas. Este aumento, que equivale a más de 600 años de acumulación a la velocidad de aumento actual de 14 mil millones de toneladas de dióxido de carbono por año, produjo un aumento en la temperatura global promedio de más de 5 °C. Cuando el clima es más caliente y hay más dióxido de carbono disponible, las plantas producen más materia vegetal. Ahora bien, ¿cuánta de esta materia extra se entierra sin descomponerse? Santo Bains de la Universidad de Oxford, Richard Norris y dos colaboradores más encontraron que después del aumento en la temperatura generado por el metano, más materia orgánica parcialmente descompuesta cayó al suelo marino y luego fue enterrada. Sin embargo, tomó quizás 90 mil años para que el desbalance entre la producción y la descomposición de materia vegetal lograra extraer el excedente de nueve billones de toneladas de dióxido de carbono presentes en la atmósfera de la Tierra —una velocidad de extracción de 100 millones de toneladas de dióxido de carbono al año, menos que el 1% del ritmo de aumento que estamos presenciando actualmente.

¿Cuáles son los factores que determinan el aumento del dióxido de carbono a una velocidad de 14 mil millones de toneladas al año? Los seres humanos inyectan más de 23 mil millones de toneladas de dióxido de carbono a la atmósfera al año con la combustión de carbón y petróleo. La deforestación puede que agregue otros seis mil millones de toneladas al año. Buena parte de este dióxido de carbono no se queda en la atmósfera. Se piensa que el océano se "traga" seis mil millones de toneladas de dióxido de carbono al año. Los bosques del mundo en proceso de reforestación consumen varios miles de millones de toneladas de dióxido de carbono al

RECUADRO 5.1
¿Qué son los clatratos de metano y en qué cantidades están presentes en los océanos?

Los átomos de carbono presentan dos formas o isótopos: los átomos de carbono-12 (^{12}C) con 6 protones y 6 neutrones cada uno y, mucho menos comunes, los de carbono-13 (^{13}C) con 6 protones y 7 neutrones. Los clatratos de metano tienen un 6% menos de átomos de ^{13}C por cada átomo de ^{12}C que los océanos o la atmósfera. Hace 56 millones de años, la proporción de átomos de ^{13}C en el carbono de la biósfera disminuyó 0.3%, lo cual es un indicio de que se habían roto los clatratos de metano, probablemente por un calentamiento provocado por otras razones, y esto aumentó el almacenamiento de carbono en el mar y en el aire en una veinteava parte (un 5%). Casi todo este carbono excedente terminó pronto en la atmósfera como dióxido de carbono. Sin embargo, el intercambio metabólico pronto equiparó la relación ^{13}C/^{12}C en el mar y en el aire. Se piensa que el océano del Paleoceno contenía 50 billones de toneladas de carbono (en comparación con los 38 billones de toneladas que contiene actualmente). Si la ruptura de los clatratos de metano liberó una veinteava parte (un 5%) de esta cantidad de carbono a la atmósfera, el nivel de carbono de la atmósfera tiene que haber aumentado en 2.5 billones de toneladas, y el dióxido de carbono en 9.2 billones de toneladas, en un lapso de 10 mil o 20 mil años. Si duplicar el contenido de dióxido de carbono de la atmósfera aumenta la temperatura global en 3 grados Celsius (= 4.33 ln2, donde ln es el logaritmo natural, el logaritmo con base e = 2.718...) entonces multiplicar esta constante por R aumenta la temperatura en 4.33 ln R grados Celsius. Los investigadores no han llegado a un acuerdo sobre cuánto carbono contenía la atmósfera antes de que comenzara este calentamiento: las propuestas varían entre 300 y 640 partes por millón. Un buen cálculo, adoptado aquí, es el de 400 partes por millón, lo que representa un contenido atmosférico de 857 mil millones de toneladas de carbono. Si esto es así, la adición de 2.5 billones de toneladas de carbono provocaría un aumento de 4.33 ln [2.5 + 0.857)/0.857], o casi 6 grados Celsius en la temperatura global.

179

El café se cultiva en las tierras altas del oeste de Panamá. Cuando se cultiva "café de sombra", los agricultores suelen conservar algunos árboles nativos. Si bien la diversidad biológica en estas áreas es mucho menor que en los bosques nubosos intactos, no es tan baja como en las áreas que han sido totalmente deforestadas.

180

Contraste entre áreas vecinas: el Parque Nacional Barú
en la provincia de Chiriquí protege un bosque nuboso de
gran diversidad que contrasta con la agricultura intensiva
que se practica fuera del Parque. La tierra se erosiona
aceleradamente en estas laderas empinadas, que reciben
más de 3000 mm de lluvia al año.

181

Esta plantación de cebollas sustituyó lo que hasta hace
apenas unos años era un bosque nuboso, hermoso y diverso.
Las lluvias rápidamente lavan la tierra de las laderas
empinadas.

182

183

184

185

Grandes áreas del Pacífico Central de Panamá han sido deforestadas por décadas o incluso por siglos y ahora solo sirven para pastizales de baja calidad (fig. 182). La zona central de Panamá presenta patrones de erosión sorprendentes. El crecimiento secundario en áreas que todos los años se queman no logra sostener el suelo. Al final, no quedan más que suelos rocosos depauperados y tierras lavadas (fig. 183). Los parajes deforestados son particularmente susceptibles de ser invadidos por animales y plantas que han perdido a sus enemigos naturales. El pasto del sudeste asiático, *Saccharum spontaneum,* invadió el área del Canal de Panamá cerca de 1970 y ahora se apodera de las tierras deforestadas. En las áreas silvestres de su hábitat nativo, los elefantes y los rinocerontes se alimentan de este pasto, pero en Panamá nada se lo come y cada estación seca se quema, impidiendo que los árboles lo reemplacen. Paisajes casi desérticos, producto de las quemas frecuentes y la erosión severa se observan en la zona central de Panamá (fig. 184). Un pastizal de *Saccharum* crece en torno a una *Cecropia* muerta, cerca de la ciudad de Gamboa (fig. 185).

año. Robert Stallard ha calculado que, a nivel mundial, los deslizamientos y otros sedimentos erosionados entierran entre 0.6 y 1.5 mil millones de toneladas de carbón vegetal al año, dejándolo fuera del alcance de los organismos que descomponen material vegetal. Al enterrar este carbono se impide que entre dos y cinco mil millones de toneladas de dióxido de carbono regresen a la atmósfera. Ahora pues, cabe preguntarse si el mayor contenido de dióxido de carbono en la atmósfera que está incrementando el exceso de productividad de las plantas sobre el consumo y la descomposición es tan alto como para explicar el excedente. A juzgar por el evento de calentamiento global ocurrido hace 56 millones de años, es poco probable que el exceso de producción por encima del consumo y la descomposición sea el responsable de más de 100 millones de toneladas de dióxido de carbono al año, y no alcanzaría para contener el aumento que se observa actualmente en el dióxido de carbono en la atmósfera.

¿Cuánto se limitaría el calentamiento global con la protección de los bosques tropicales? La Amazonía tiene 5 millones de kilómetros cuadrados (500 millones de hectáreas) de bosque tropical —más de la mitad del total mundial—. Si este bosque contiene 120 toneladas de carbón combustible por hectárea, quemarlo produciría 440 toneladas de dióxido de carbono por hectárea. Si toda la Amazonía se quemara o fuera consumida de un solo golpe por las termitas y los hongos, 220 mil millones de toneladas de dióxido de carbono entrarían a la atmósfera —cifra que supera ligeramente la cantidad de dióxido de carbono que todas las plantas terrestres del mundo usan para la producción de materia vegetal en un año—. Si duplicar el dióxido de carbono de la atmósfera aumenta la temperatura global en 3 grados Celsius, agregar esos 220 mil millones de toneladas haría que ésta aumentara en 0.3 grados Celsius, que es menos que el aumento que han ocasionado el carbón y el petróleo que hemos usado para combustión.

Además, los registros fósiles nos han mostrado que la mayor producción vegetal de los bosques, que resulta del calentamiento del clima y de la mayor presencia de dióxido de carbono en la atmósfera, puede hacer poco para mitigar la velocidad actual de calentamiento global. Los bosques tropicales benefician a la humanidad, pero no son la cura contra el calentamiento global.

LA FRAGMENTACIÓN Y LA DESTRUCCIÓN DE LOS BOSQUES TROPICALES

Los bosques tropicales se están degradando y destruyendo de muchas maneras. Entre 1981 y 1990, cada año se cortó en promedio un 0.8% del total de bosques de tierras bajas (fig. 180). Un 0.3% adicional se talaba anualmente por primera vez para extraer madera, en general de forma innecesariamente destructiva y despilfarradora. Ya hace algún tiempo que la mayoría de los terrenos que están junto a la frontera sur del Monumento Natural de Barro Colorado perdieron el bosque original que antes los cubría. Grandes extensiones de bosque cayeron presa del fuego en Brasil e Indonesia en los años de sequías de El Niño, lo cual produjo tanto humo que llegó a considerarse una amenaza para la salud humana y obligó al cierre de los aeropuertos de las principales ciudades. En Brasil, los mineros de oro están cazando a los animales que los árboles necesitan para dispersar sus semillas y están contaminando los ríos de los bosques con el mercurio que usan para extraer el oro de la roca. Por otra parte, la subdivisión progresiva del bosque tropical en fragmentos está alterando los ecosistemas boscosos de muchas maneras.

LA DEFORESTACIÓN Y EL DESPERDICIO DE RECURSOS

La característica más impactante de la destrucción de los bosques tropicales es la escala del desperdicio. Por lo

general, el bosque tropical se destruye, no para instaurar un sistema estable y productivo de agricultura o agroforestería, sino para llevar a cabo actividades que no pueden sostenerse por mucho tiempo y que suelen dejar una estela de tierras baldías e improductivas (figs. 182, 183, 184).

La "limpieza" de los bosques tropicales con fines agrícolas no necesariamente tendría que aumentar la tasa de erosión o la frecuencia de las inundaciones, ni reducir el caudal de los ríos durante la época seca o dejar la tierra inservible. Los agricultores indígenas itinerantes han vivido durante largo tiempo en equilibrio con los bosques tropicales de África y Sudamérica. La agricultura itinerante solamente amenaza la integridad de los bosques tropicales cuando una cantidad demasiado alta de agricultores se congrega en un área demasiado pequeña. La tribu Kofyar de Nigeria ha practicado la agricultura sostenible durante años en explotaciones pequeñas y permanentes, sin ocasionar apenas erosión y sin recibir ninguna guía por parte de los servicios de extensión agrícola. Los agricultores tradicionales de arroz del sur y del este de Asia proporcionan, desde hace muchísimo tiempo, un modelo de uso sostenible de la tierra. En todo caso, la deforestación generalmente no perjudica únicamente al bosque. En la ribera del Canal de Panamá, frente a Barro Colorado, Robert Stallard comparó dos cuencas aledañas, con topografía y lechos rocosos similares. La tercera parte de una de las cuencas está compuesta por pastizales que se queman todos los años, otro 13%, por pastizales abandonados. La otra cuenca está totalmente cubierta de bosque. La cuenca que ha sido parcialmente talada tiene un suelo más compacto y menos permeable a la lluvia, sufre de inundaciones más intensas y repentinas, y presenta un menor caudal durante la época seca en comparación con su contraparte boscosa. Los pastizales y los campos de cultivo abandonados cerca de un pueblo aledaño al Monumento Natural de Barro Colorado han caído presa

de un pasto estéril compuesto por una sola especie, *Saccharum spontaneum* (fig. 185), cuya erradicación con fines productivos solo sería posible haciendo un esfuerzo significativo. Casos como estos se observan no solo en Panamá, sino en otros países tropicales, desde Puerto Rico hasta Brasil, desde Java hasta Madagascar.

La tala tiende, asimismo, a ser irresponsablemente antieconómica: normalmente destruye el 60% del bosque para obtener el 10% de la madera. Si se planea previamente dónde van a caer los árboles, si se cortan las lianas para evitar que los árboles que se cortan se traigan abajo otros árboles y si se tiene cuidado al sacar los árboles cortados, se aumentaría la cantidad de madera útil que se saca, al tiempo que se dejaría el 65% del bosque intacto, en lugar de solo el 40%. Estas técnicas de "tala de impacto reducido" se conocen desde hace más de un siglo. La mayoría de los madereros, sin embargo, las consideran costosas y difíciles de aplicar, aunque bien podrían estar equivocados al creer que la tala de impacto reducido afecta las ganancias inmediatas.

Además de esto, la forma en que se extraen los maderos también causa mucho daño. La maquinaria pesada que se usa para sacar la madera compacta el suelo. Cuando se desata una tormenta, la mayor parte de la lluvia que cae no puede penetrar el suelo, así que discurre por la superficie, agravando la erosión y aumentando las probabilidades de que se produzca una inundación. Los caminos, que se abren de manera apresurada y descuidada, y que se cubren apenas con el lodo que dejan expuesto las excavadoras, se convierten en canales de erosión que rápidamente se van haciendo más y más profundos. Estos efectos de la extracción de madera también se pueden mitigar, si se toman medidas apropiadas, pero la desidia tiende a prevalecer.

En resumen, la mayoría de las actividades de limpieza y tala de bosques tropicales privilegian prácticas que sacrifican los intereses de los vecinos que viven río abajo,

186

Plantación de teca cerca del Monumento Natural de Barro Colorado.

así como los de las futuras generaciones, a cambio de una ganancia o una comodidad inmediatas.

¿A QUÉ SE DEBE ESTE DESPERDICIO IRRESPONSABLE?

Las maneras de mitigar los efectos perjudiciales de la deforestación y de lograr un uso prolongado más beneficioso de los terrenos despejados se conocen desde hace mucho tiempo. Debido a que el desperdicio de terrenos deforestados engendra más deforestación para despejar más terrenos que desperdiciar, estamos en la obligación de preguntarnos por qué la tierra recién despejada no se usa con más cuidado.

Muchos consideran que las escrituras hebreas tratan la naturaleza con hostilidad porque su énfasis primordial está en el ser humano y, sobre todo, en que debemos mostrar nuestro amor a Dios y al prójimo, conservando la armonía social y haciendo un uso responsable de la tierra que Dios nos ha dado. Sin embargo, estas escrituras proclaman que la injusticia social lastima la naturaleza. El profeta Isaías culpó

187

Una isla de bosque en un mar de monotonía. Esta fotografía aérea muestra la frontera entre el Monumento Natural de Barro Colorado y las uniformes plantaciones de teca con las que colinda. La diversidad biológica se reduce drásticamente con los monocultivos.

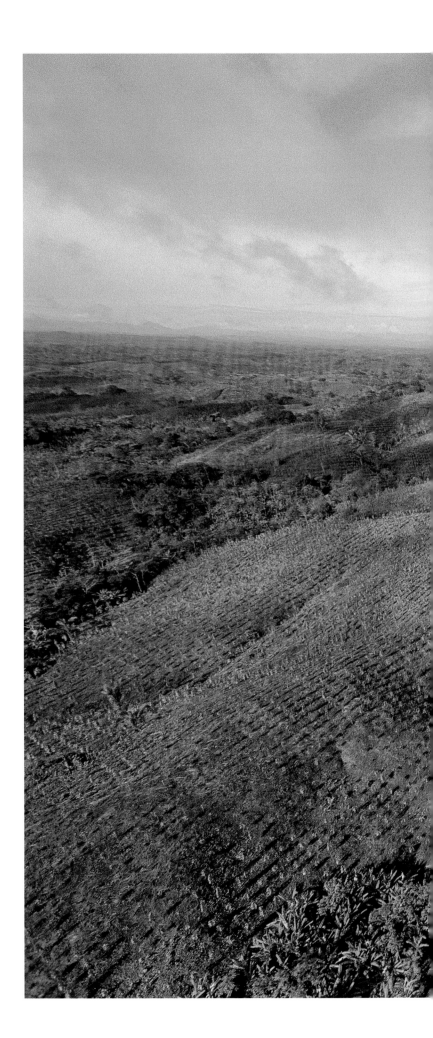

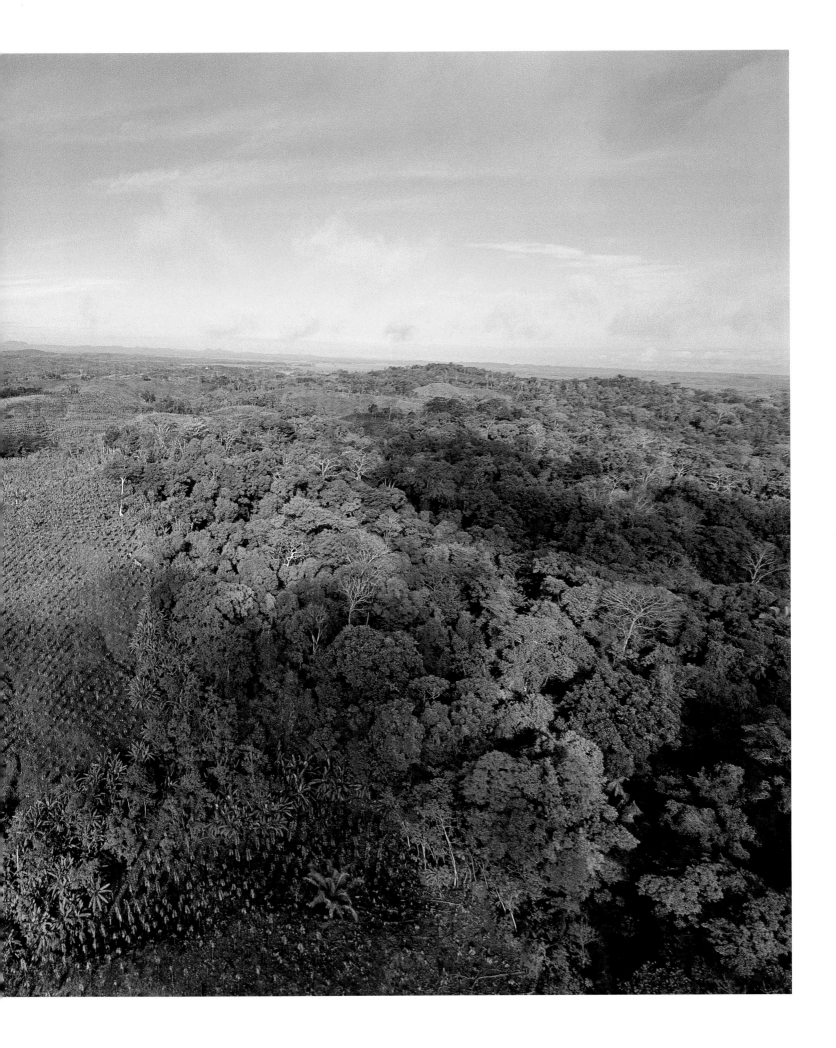

a la injusticia social por las malas cosechas, al lanzar la siguiente advertencia: "¡Ay, los que juntáis casa con casa, y campo a campo anexionáis, hasta ocuparlo todo y quedaros solos en medio del país! Así ha jurado a mis oídos Yahveh Sebaot: ¡Han de quedar desiertas muchas casas grandes y hermosas, pero sin moradores! Porque diez yugadas de viña producirán sólo una medida, y una carga de simiente producirá una medida" (*Isaías 5:8-10, Biblia de Jerusalén*). El profeta Oseas también advierte que la injusticia humana perjudica la naturaleza: "Escuchad la palabra de Yahveh, hijos de Israel, que tiene pleito Yahveh con los habitantes de esta tierra, pues no hay ya fidelidad ni amor, ni conocimiento de Dios en esta tierra, sino perjuicio y mentira, asesinato y robo, adulterio y violencia, sangre que sucede a sangre. Por eso, la tierra está en duelo, y se marchita cuanto en ella habita, con las bestias del campo y las aves del cielo; y hasta los peces del mar desaparecen." (*Oseas 4:1-3, Biblia de Jerusalén*). Este mensaje llega al corazón de la crisis ambiental. La mayor amenaza que enfrentan los bosques tropicales no es la ignorancia biológica sino la injusticia social, dentro de las naciones y entre las naciones.

188

¿El efecto isla? Como la extensión de la Isla no sobrepasa las 1600 hectáreas, las poblaciones de algunas de las especies más grandes parecen fluctuar más que las de tierra firme. En ciertas épocas, Barro Colorado tiene más coatís (*Nasua narica*) por hectárea que otros bosques similares con mayor cantidad de felinos grandes. A los coatís se les ha culpado de la desaparición de varias especies de aves que antes anidaban en el sotobosque de Barro Colorado; sin embargo, es más probable que los cambios que experimentó el bosque al hacerse más viejo sean los responsables de la mayoría de estas extinciones. Aquí vemos a un coatí comiéndose un huevo de cocodrilo al que le faltaba poco para eclosionar.

El despilfarro de la deforestación de los bosques tropicales no refleja otra cosa que indiferencia social y conflicto social. Los modernos mercaderes de madera, ajenos a las comunidades que viven en los lugares que deforestan, no muestran más comprensión o preocupación por las consecuencias que sus actividades podrían traer a los pueblos del bosque lluvioso que la que mostraron los colonos de las Grandes Llanuras de los Estados Unidos hacia las necesidades o los miedos de sus predecesores nómadas. Mientras tanto, la desconfianza hacia las compañías madereras extranjeras conduce a los gobiernos de los países tropicales a firmar concesiones por periodos demasiado cortos como para incentivar a los madereros a pensar más allá de la primera cosecha, lo cual no hace sino reforzar el círculo vicioso de la desconfianza y el desperdicio.

Los bosques tropicales también sufren porque los gobiernos de los países tropicales son mucho más propensos a ser derrocados por motines urbanos que por disturbios rurales. Estos gobiernos, entonces, buscan mantener los precios de los alimentos lo más bajo posible para prevenir los motines urbanos. Por tanto, hasta los políticos honestos están más interesados en el ingreso que generan los "bienes forestales nacionales" que en las repercusiones que puedan tener las prácticas madereras en la gente del campo. Los precios de los alimentos subsidiados de esta manera son a menudo demasiado bajos como para permitir que los agricultores movilicen los recursos que se necesitan para practicar una agricultura sedentaria. Asimismo, los gobiernos de los países tropicales frecuentemente promueven la adquisición, y el consiguiente desplazamiento, de fincas pequeñas por parte de grandes negocios agrícolas que cultivan, no siempre de manera sostenible, productos de exportación gravables. Especialmente en los países donde los agronegocios se han apropiado de las mejores tierras, el crecimiento de la población a menudo obliga a la gente a cultivar tierras que deberían conservarse, lo que no hace sino empeorar la

erosión y las inundaciones. La urgencia de saldar la deuda extranjera aumenta la presión sobre los gobiernos de los países tropicales por generar exportaciones donde puedan, frecuentemente a expensas del bosque lluvioso y en formas que empeoran la injusticia social.

Para complicar más las cosas, los intentos de los gobiernos de los países tropicales por contrarrestar la crisis ambiental a menudo resultan contraproducentes. Iniciativas pobremente expresadas que abogan por la reforestación motivan a los propietarios de tierras a despejar bosques naturales para "reforestar" la tierra con teca o algún otro árbol exótico. La propaganda acerca de las virtudes de las familias pequeñas también se convierte con frecuencia en otro motor de conflicto social inútil. Los niños son la única "seguridad social" que tienen las familias pobres. Además, un buen número de sociedades ve a los niños, no enteramente sin razón, como regalos de Dios, que deben valorarse como tales. La tasa de natalidad solo disminuye cuando la educación de las mujeres les abre nuevas oportunidades o cuando las condiciones económicas mejoran lo suficiente como para disminuir la mortalidad infantil y hacer que valga la pena preparar bien para la vida a unos pocos niños, en lugar de a muchos, pero más pobremente.

El prejuicio arraigado que dicta que cuanto más grande mejor, compartido tanto por los políticos como por los organismos que otorgan financiamiento, dificulta el desarrollo del tipo de agricultura sedentaria que reduce la presión sobre los bosques. Robert Netting, antropólogo de la Universidad de Arizona, encontró que la agricultura sostenible tiene más probabilidades de ser practicada por los pequeños productores tradicionales que heredan la tierra y según normas que aseguren que los agricultores van a obtener la mayor parte de los beneficios que se deriven de las mejoras que hagan a sus fincas o de las nuevas maneras que encuentren de cultivarlas. Para estos agricultores, la finca de la familia y las técnicas para cultivarla son el principal legado de los padres a los hijos.

Donde la finca es el futuro de la familia, la tierra estará bien cuidada, si la familia sabe cómo hacerlo.

La agricultura minifundista, sin embargo, enfrenta muchos obstáculos. Hay países que no tienen la tradición de la agricultura sostenible. En Panamá, los colonos se asentaron en un territorio que en gran parte había sido vaciado de los pobladores anteriores por las enfermedades y la esclavitud. Por lo menos los colonos más pobres practicaban la agricultura itinerante porque requiere menos trabajo y demanda menos dinero que la variedad sostenible. Los campos abandonados por los agricultores itinerantes se destinaron a la ganadería en vez de dejar que el bosque los reclamara. Hoy, el crecimiento de la población, y una preocupación cada vez mayor por lo que queda del bosque, trae consigo una reutilización demasiado seguida de la tierra; la agricultura itinerante ya no es sostenible. Aun así, gran parte de la sociedad rural panameña todavía está orientada a la limpieza de nuevos terrenos. En las tierras bajas de Panamá, el desarrollo de una agricultura minifundista tradicional es tan traumático que, mientras algo se define, la agroindustria está adquiriendo los derechos de buena parte de la tierra utilizable (fig. 186).

Las expectativas, siempre en ascenso, llevan a algunos pequeños agricultores a menospreciar sus tierras y su ocupación, al considerarlas incapaces de darles la vida que desean. Si la tierra se convierte en un simple vehículo, en un medio para vivir mejor en otra parte, se trata con menos cuidado. Las tierras agrícolas corren los mayores riesgos cuando el cambio social sucede rápidamente; cuando el cambio es lento, las personas van emigrando poco a poco y las fincas que dejan atrás se van expandiendo hasta llegar a ser económicamente viables.

En conclusión, los pequeños agricultores cultivan sus tierras de forma sostenible, si la agricultura satisface sus aspiraciones, si conocen y aman la tierra y entienden sus cultivos, si conocen a sus vecinos y confían en ellos, si la tenencia de la tierra es segura y si pueden

obtener beneficios de las innovaciones que hagan. La escasez de tierras, el desorden civil y la tentación de lograr mejores oportunidades económicas, sin embargo, está desarraigando a más y más gente de sus redes de relaciones sociales, lanzándola a tierras y a sociedades que no conocen o que no entienden, a vivir entre gente por la que no sienten ninguna responsabilidad. Muchos gobiernos promueven la colonización de terrenos "baldíos" por parte de agricultores cuya experiencia previa no tiene nada que ver con la tierra que se les entrega. Debido la brecha social entre ricos y pobres en las áreas rurales, algunos empresarios no se dan cuenta o no prestan atención a las consecuencias que deben sufrir sus vecinos más pobres por causa del agua o el aire contaminados. Lo mismo ocurre con algunos latifundistas, que están más que dispuestos a buscar la nulidad de los títulos de propiedad de los pequeños propietarios que tienen cerca para crear así una reserva de mano de obra barata para sus propias fincas.

LA FRAGMENTACIÓN DEL BOSQUE

La deforestación con fines agrícolas, aun si se hace con mucho cuidado, termina dejando parches de bosque: parcelas de árboles de dominio comunal o privado, o, a veces, extensiones considerables que se guardan en recuerdo de esplendores pasados. El represamiento de los ríos para crear embalses de agua también crea un mosaico de bosques en forma de cumbres aisladas de lo que otrora fueran cerros en tierra firme. Barro Colorado es uno de esos fragmentos.

Las consecuencias de la fragmentación por embalsamiento son las más fáciles de explicar porque el agua simplemente aísla. Los pastizales, en cambio, engendran amenazas que afectan de manera activa los fragmentos de bosque, tales como incendios, vacas, especies de árboles que se extienden como mala hierba y otras similares. La fragmentación que ocasiona un

embalse cambia un bosque de muchas maneras. Pero la fragmentación también nos brinda la oportunidad de aprender. Al entender por qué desaparecen especies de fragmentos de bosque que ahora son islas; cuáles de las poblaciones que antes regulaban ahora se multiplican —y con qué consecuencias—, aprendemos mucho acerca de los factores que mantienen el balance natural en los bosques intactos de tierra firme.

La construcción de una represa sobre el río Chagres para crear el Lago Gatún, sede de la sección central del Canal de Panamá, dejó muchos fragmentos de bosque aislados. El más grande de ellos, con 1500 hectáreas de extensión, es Barro Colorado. Pero incluso esta Isla sintió pronto los efectos del aislamiento. Los pecarís de labios blancos, que tienen un gran efecto en el suelo del bosque, desaparecieron tras una hambruna provocada por una escasez de fruta en 1930. Estos pecarís viven en rebaños compuestos por cientos de animales, y Barro Colorado es demasiado pequeña para mantener un rebaño. Además, parece que a los pecarís de labios blancos se les disparaba mientras nadaban entre la Isla y tierra firme. En 1920, Barro Colorado tenía 200 especies de aves que anidaban en tierra; en 1996 solo quedaban 135. Treinta de las especies que se extinguieron vivían en bosques jóvenes que se habían vuelto demasiado maduros para ellas. Las otras 35 eran aves que se alimentaban de insectos del sotobosque en bosques maduros, cuya extinción se atribuyó, injustamente, al exceso de coatíes (fig. 188). Muchas de ellas no pueden o no intentan volar sobre aguas abiertas, así que no podrán recolonizar las poblaciones de la Isla, si estas llegan a desaparecer. Por ejemplo, el hormiguero ocelado (fig. 36), el ave hormiguera más grande, más especializada y más competitiva de las que se alimentan de los insectos que saltan al paso de los ejércitos de hormigas guerreras, se extinguió luego de que una sequía particularmente severa redujera significativamente la abundancia de hormigas

189

Las isletas, como los pequeños fragmentos de bosque,
presentan poca diversidad vegetal. Esta fotografía tomada
en Barro Colorado muestra docenas de especies de
plántulas . . .

190

. . . mientras que esta otra, tomada en un área de suelo
equivalente, en una isleta en el Lago Gatún, presenta
una sola especie.

guerreras en la Isla en 1968. El hormiguero ocelado sobrevive en la tierra firme circundante.

Los pecaríes de labios blancos y muchas aves del sotobosque desaparecieron de Barro Colorado porque se les hacía imposible cruzar a nado el agua que rodea la Isla aunque fuera de vez en cuando. El ecosistema de Barro Colorado, sin embargo, ilustra muy bien el bosque de tierra firme porque muchos otros animales sí pueden, al menos de vez en cuando, movilizarse entre la Isla y tierra firme. Los pumas y el esporádico jaguar, visitan la Isla por periodos de tiempo variados, con lo que acostumbran a los animales de la Isla a una depredación intensa. La Isla tiene treinta ocelotes residentes, pero los inmigrantes ocasionales le inyectan la indispensable variación genética a esta población.

Muchas de las especies de la Isla necesitan salir por lo menos ocasionalmente a buscar comida. Los murciélagos que se alimentan de higos silvestres visitan tierra firme de vez en cuando para encontrar higuerones con frutos. Los colibríes se trasladan a tierra firme cuando allí abundan las flores que necesitan y en la Isla escasean. Algunos murciélagos que se alimentan de higos silvestres abandonan e la Isla en las épocas en que estos escasean ahí. Durante la hambruna que se suscitó por escasez de fruta entre agosto y diciembre de 1970, los tucanes y los loros abandonaron la Isla con rumbo desconocido pero regresaron cuando la hambruna había terminado.

Los desplazamientos de los animales también cumplen otras funciones. Algunas de las poblaciones de mariposas se renuevan desde tierra firme cuando en la Isla se han acabado. Las aves que migran desde Norteamérica dispersan las semillas de algunos de los árboles de Barro Colorado. Las diminutas avispas que polinizan los higos, y que pueden volar decenas de kilómetros, acarrean polen de tierra firme para los higuerones de la Isla, y los murciélagos que comen higos, que vuelan largas distancias, traen a la Isla semillas de especies de higuerones poco comunes.

En resumen, los desplazamientos de los animales, que tienen frecuencias variadas, que cubren distancias variadas y que tienen, también, motivaciones variadas, mantienen la diversidad y la integridad del ecosistema de Barro Colorado, tal y como lo hacen en los bosques de tierra firme. De igual modo, estos desplazamientos mantienen la intensidad de la depredación y el herbivorismo en la Isla, su ritmo de vida y la diversidad genética de las especies. En los ecosistemas naturales, la autosuficiencia es enemiga de la productividad y la diversidad, como lo es también en las economías humanas.

El lago Gatún dejó aislados otros fragmentos más pequeños, con consecuencias aún más dramáticas. Las islitas de menos de una hectárea no podían mantener mamíferos residentes. La diversidad de árboles declinó no pocas veces de manera abrupta: la mitad de los árboles que había en algunas de las isletas pertenecían a las especies mas comunes (figs. 189, 190), algo poco frecuente en parcelas de tamaño similar en tierra firme. Las semillas de muchas especies de árboles únicamente sobreviven si los agutís las entierran y las ponen a salvo de los insectos. De este modo, solo las especies que no necesitan que los agutís entierren sus semillas podían reproducirse y propagarse. Las isletas de dos hectáreas, por su parte, mantenían poblaciones de ratas espinosas, *Proechimys semispinosus*, que prácticamente no tenían depredadores, por lo que comenzaron a hacerse más grandes y a reproducirse más tardíamente y con menor frecuencia que las ratas espinosas de tierra firme. La fragmentación bajó su ritmo de vida. En las islas de menos de 20 hectáreas, las lagartijas, cuyo metabolismo les permite sobrevivir a la escasez local de alimentos, son más comunes, y las aves insectívoras y los murciélagos, que tienen un metabolismo mucho más rápido, menos comunes, que en tierra firme. El daño que ocasionaban los insectos a las hojas de cuatro

especies de árboles comunes tanto en las islas como en tierra firme era menos frecuente y menos intenso en las islas, sobre todo en las más pequeñas, a pesar de que aquí estas especies se presentaban en mayor abundancia. Resumiendo, al trastocar relaciones de interdependencia que resultan esenciales, la fragmentación redujo de manera tajante la diversidad de vertebrados y árboles, disminuyó la intensidad del herbivorismo y la depredación, y bajó el ritmo de vida, lo que en ocasiones llegó incluso a favorecer a los animales con las tasas metabólicas más bajas.

Para entender de qué manera la fragmentación desencadena esos cambios, John Terborgh y algunos colegas, comenzaron a estudiar fragmentos de reciente aparición en Venezuela en 1990. Los fragmentos que estudiaban se crearon en 1986 al producirse una elevación de 50 metros en el nivel del agua del embalse Guri.

El primer efecto de la fragmentación fue que los animales menos móviles desaparecieron de fragmentos que eran demasiado pequeños para mantener sus especialidades. Las poblaciones que antes estaban bajo su control se multiplicaron desaforadamente. La desaparición de los armadillos y las hormigas guerreras probablemente favoreció la explosión de las poblaciones de hormigas arrieras. En algunas isletas se han contabilizado seis colonias de hormigas arrieras por hectárea, una densidad que supera con creces la densidad que se observa en tierra firme y que basta para comerse una cuarta parte de la producción de hojas de las isletas. Estas arrieras han reducido significativamente el número y la diversidad de plántulas nuevas.

La fragmentación también atrapó monos aulladores en isletas desde las que no se veía la tierra firme. Algunas isletas de una hectárea mantenían seis monos, y había tantos porque los monos más jóvenes no tenían donde marcharse, con lo cual se estaba obstruyendo el mecanismo normal de control de población. Los monos perduraron porque lo único que tenían que hacer era sobrevivir,

mientras que, sobre todo cuando la comida escaseaba, los monos de tierra firme tenían que comer suficiente para poder rechazar a otros grupos de competidores. Pese al consumo de hojas por parte de los monos, los árboles crecían más rápido en las isletas con mayor densidad de monos, como si el reciclamiento de nutrientes por parte de los monos pagara con creces las hojas que se comían.

A juzgar por lo que ha ocurrido en el Lago Gatún, ni los aulladores ni las hormigas arrieras de las isletas de Guri van a durar indefinidamente. Con el tiempo, la diversidad de plantas, la presión de los herbívoros y la presión de los depredadores, alcanzarán un punto muy bajo. La historia de las economías humanas es la historia del incremento en la productividad y en la diversidad de ocupaciones sobre la base de una interdependencia cada vez más intensa, más compleja y a mayor escala. Lo mismo aplica a los ecosistemas naturales. Al trastornar relaciones de interdependencia, la fragmentación está revirtiendo eras de evolución natural y reemplazando bosques lluviosos, diversos y exuberantes, por una vegetación depauperada que ofrece mucho menos medios de subsistencia para los animales.

La injusticia social que nace de la indiferencia hacia otros seres humanos está degradando el elaborado mutualismo de la civilización humana. La degradación de la civilización, a su vez, está acabando con otro mutualismo igualmente elaborado, aquel por medio del cual los polinizadores, los dispersores de semillas, los carnívoros y los insectívoros de los bosques tropicales mantienen la diversidad y hacen posible la productividad de los árboles y otras plantas. La manera en que se malbarata la tierra, que no es sino una manera implícita de negar toda responsabilidad y conexión con otros seres humanos, muchas veces termina creando pastizales de una sola especie, tanto en Panamá como en Indonesia. Pastizales que son la negación misma de toda relación con cualquier otro animal o planta, ya que usan el viento

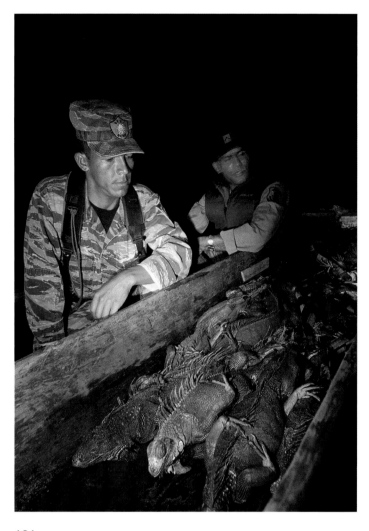

191

Guardabosques junto a un bote confiscado con iguanas cazadas furtivamente. El objetivo: venderlas como "carne de monte".

para transportar el polen y para dispersar las semillas, y se apoyan en el fuego para eliminar a sus competidores y ampliar sus dominios. Estos pastizales son la expresión última de un monopolio asfixiante que contrasta de manera sombría con la belleza y la diversidad del bosque tropical lluvioso, y son, también, un claro reflejo de la falta de conexión entre los seres humanos.

LA PRESERVACIÓN DE LOS BOSQUES TROPICALES

Los parques y reservas de bosques tropicales deben hacer frente a un sinnúmero de amenazas. Particularmente donde la tierra escasea, la gente quiere que se les permita cultivar estos terrenos o que sus animales puedan pastar ahí. Algunos quieren la madera. Otros, el oro o el petróleo que yace bajo algunos bosques tropicales, pero la extracción de cualquiera de los dos traería daños serios, incluso catastróficos, a los ecosistemas y a los moradores de estos lugares. En algunas reservas de bosques lluviosos, la colecta excesiva de plantas medicinales por parte de las poblaciones vecinas representa una verdadera amenaza. Más que nada, las reservas de bosques lluviosos atraen cazadores, que buscan carne para comer y a menudo para vender (fig. 191).

LA PROTECCIÓN DE BARRO COLORADO

Barro Colorado puede considerarse afortunado. No está en la mira de ningún minero. Nadie ha tratado de sacar madera ilegalmente o despejar áreas para cultivo, ni en la Isla ni en las penínsulas que rodean la Isla, después de que fueran declaradas reservas.

Los cazadores, sin embargo, asediaban la Isla hasta que el Instituto Smithsonian de Investigaciones Tropicales estuvo en condiciones de contratar los guardabosques que se necesitaban para mantenerlos a raya. En1932,

un aumento repentino en la caza furtiva diezmó las poblaciones de tapires y felinos de la Isla. En 1969, los cazadores visitaban Barro Colorado a su antojo, tanto, que las trampas de hojarasca y residuos vegetales —unos recipientes verdes de unos 30 cm de ancho que Robin Foster había colocado en el bosque para medir la caída de hojas, flores y fruta— tuvieron que ser reemplazados una y otra vez hasta que los pobladores de las aldeas vecinas pudieron hacerse con todos los recipientes que quisieron. Ya en 1985 la caza furtiva en Barro Colorado había llegado a su fin. El STRI designó a uno de sus científicos, S. Joseph Wright, para que estuviera a cargo de los guardabosques (fig. 192); se interesó por ellos, escuchó sus consejos, cambió los horarios de los patrullajes para que fueran más seguidos y sin previo aviso, y organizó emboscadas en los lugares en los que la caza furtiva era más frecuente. Sus medidas dieron resultados.

Barro Colorado es demasiado pequeña para mantener su diversidad completa. Para contar con un hábitat que fuera lo suficientemente grande como para mantener animales que quieren volar o nadar a tierra continental, el STRI adquirió cinco penínsulas cercanas cubiertas de bosque, con lo cual se formó el Monumento Natural de Barro Colorado (MNBC), que protege 5500 hectáreas de bosque. A la vez, este Monumento colinda con el Parque Nacional Soberanía, de Panamá, que tiene 22 000 hectáreas. Juntos, protegen más de 27 000 hectáreas de bosque.

La protección de las penínsulas, no obstante, causó resentimiento entre los pobladores aledaños que ahora quedaban excluidos de los bosques donde antes solían cazar. El resentimiento crecía porque los lugares para cazar escaseaban. Así, no tenían escrúpulos para seguir cazando en las penínsulas y hasta ayudaban a otros a hacerlo. Un cazador furtivo molesto le disparó a un policía panameño que estaba patrullando con los guardabosques del STRI (el cazador fue atrapado y castigado debidamente). No hay duda de que los guardabosques del STRI han trabajado duro para reducir la cacería en las penínsulas. Los resultados están a la vista: mamíferos de todo tipo son ahora más frecuentes que en 1979 y no menos comunes que en Barro Colorado. Sin embargo, los esfuerzos del STRI por hacer las paces con estos pobladores han sido menos exitosos. La mayoría de los representantes del STRI en estos pueblos, incluidos los guardabosques son personas con estudios universitarios, que no siempre se relacionan de la mejor manera con la gente del campo. En general, el solo hecho de mantener a la gente fuera de una reserva no garantiza un futuro estable para la conservación.

LAS AMENAZAS QUE ESTÁN FUERA DEL ALCANCE DE LOS GUARDABOSQUES

Actualmente, el Monumento Natural de Barro Colorado enfrenta amenazas más siniestras que la de un grupo de pobladores molestos. Aunque el monumento es parte de unas 30 000 hectáreas de bosque protegido, esa extensión no basta para preservar intacto el ecosistema del bosque. Algunos tipos de aves que solían migrar estacionalmente del Parque Soberanía a las laderas cubiertas de bosque de la parte alta del Río Chagres desaparecieron cuando se taló la parte del bosque que conectaba el Parque con las montañas. Barro Colorado es "posada de invierno" o ruta de paso para muchas aves migratorias que se reproducen en Norteamérica. Algunas plantas de Barro Colorado programan la fructificación para emplear estas aves como dispersores de semillas. El desarrollo adverso en Norteamérica o a lo largo de las rutas de vuelo podría impedir que estos pájaros siguieran visitando Barro Colorado.

Hay especies de murciélagos que viven en Barro Colorado solo en ciertas estaciones. También hay poblaciones de insectos que mueren anualmente o se mudan cada año a otros sitios para ser reemplazadas luego

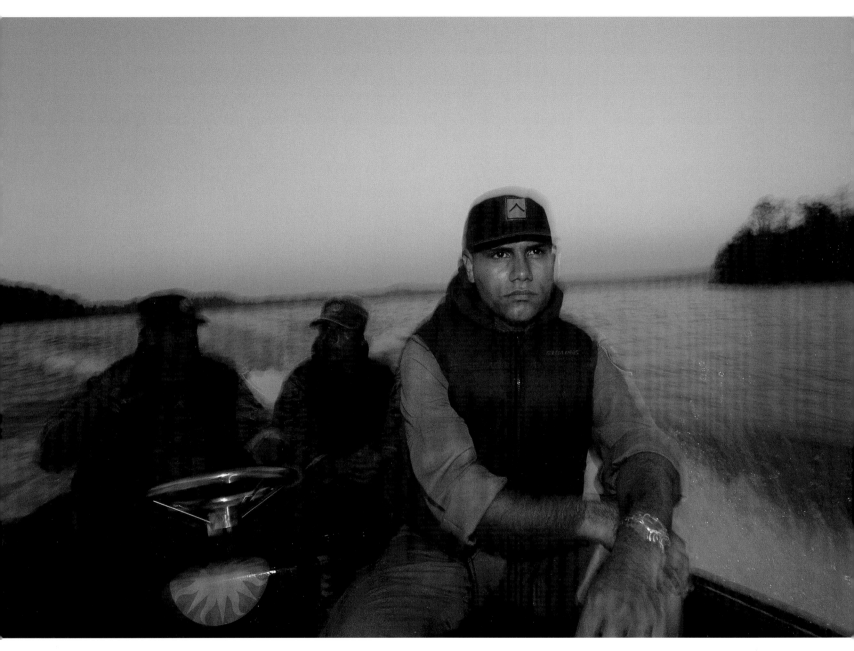

192

Momento en que los guardabosques salen de la Ensenada
del Laboratorio a realizar su patrullaje nocturno.

por migrantes de tierra firme. Muchas mariposas de Barro Colorado migran en masa con los cambios de estación. No se sabe adónde van estos animales cuando dejan la Isla o qué tan seguras serán sus rutas de vuelo y sus otros hogares.

Igualmente, los guardabosques no pueden proteger a Barro Colorado del cambio climático ocasionado por el constante aumento de la carga de dióxido de carbono en la atmósfera, ni por los nitratos y nitritos que transporta el aire contaminado. Los vientos traen a Centroamérica polvo del Sahara y contaminantes producto de la quema de vegetación que tiene lugar al sur del Sahara. Con ellos viajan esporas de patógenos que matan a los corales. Tal vez porque la lluvia está cayendo en tormentas más escasas pero más fuertes, las lianas de Barro Colorado han aumentado considerablemente. La proporción de árboles con troncos de más de 20 centímetros de diámetro con al menos una liana en su copa pasó de 45% a 74% entre 1980 y 2007. La contribución de las lianas a la producción de hojas de la Isla aumentó de 13% a17% entre 1987 y 2002. Las lianas matan a los árboles y obstaculizan su crecimiento. El agua no puede aislar la Isla de lo que acontece en otros lugares.

¿CÓMO CONSTRUIR UN CONSENSO NACIONAL POR LA CONSERVACIÓN?

El Instituto Smithsonian de Investigaciones Tropicales ha tenido la suerte de contar con el favor de varios gobiernos sucesivos en Panamá y, en general, de la opinión del pueblo panameño. A diferencia de lo que se escucha muchas veces en Brasil, los panameños no ven la conservación como una maniobra de los países del primer mundo para bloquear el desarrollo nacional. Del mismo modo, la mayoría de los panameños no ven la conservación como una acción encubierta para reservar grandes extensiones de selva virgen para el aprovechamiento exclusivo de turistas extranjeros o el enriquecimiento de unos cuantos citadinos acaudalados, locales o extranjeros.

En efecto, los panameños han cobrado cada vez más conciencia de que al conservar el bosque que aún queda en las áreas que desaguan en el Canal de Panamá se puede reducir la velocidad a la que el canal se llena de sedimento. También están mostrando un mayor aprecio por la naturaleza tropical. Panamá tiene varias organizaciones de conservación que trabajan activamente. Cuando se construyó una autopista a través de un bosque que bordeaba Ciudad de Panamá, hubo grandes manifestaciones, que, si bien no bastaron para detener la construcción de la carretera, sí demostraron que en Panamá la naturaleza tropical tiene muchos defensores.

El STRI ha sido más exitoso fomentando la conservación entre la población panameña en general que entre sus vecinos inmediatos. Muchos estudiantes panameños ganaron experiencia en investigación en el STRI, lo que permitió a algunos completar estudios de posgrado en Estados Unidos y en otros lugares, y a otros, encontrar un trabajo más satisfactorio en Panamá. Muchos trabajan ahora en pro de la conservación.

Un programa cada vez más popular, de visitas diarias a Barro Colorado con guías hispanohablantes, está haciendo correr la voz acerca de las bellezas del bosque tropical. Los esfuerzos del STRI por divulgar los resultados de sus investigaciones —en libros dirigidos al público en general, en artículos de periódicos y en programas de televisión— también están ayudando en este sentido.

Sin embargo, en Panamá, lo mismo que en Estados Unidos, todavía se está lejos de alcanzar un verdadero consenso por la conservación. Las organizaciones de conservación más poderosas de Panamá quizás no han sabido convencer a las poblaciones rurales de los beneficios de la conservación. El crecimiento urbano avanza velozmente con la consiguiente contaminación del aire. La cuenca del Canal de Panamá alberga a 150 000

personas: 90 000 viven a 2.6 kilómetros de distancia de la carretera que atraviesa el Istmo. Pese a eso, Barro Colorado, con sus cincuenta residentes, tiene una de las únicas dos plantas de tratamiento de aguas de toda la cuenca (un hotel tiene la otra). Las aguas negras que van a dar a los ríos que desaguan en la cuenca fertilizan grandes extensiones de lechuga de agua en la parte baja del Río Chagres, el cual, si ha llovido mucho, a veces se descarga en el Canal.

MONTEVERDE: UN MODELO DE CONSERVACIÓN

Pocos esfuerzos de conservación surgen por iniciativa local en los trópicos, y sin embargo, los programas de conservación iniciados y controlados por comunidades locales son los que tienen más probabilidades de ser exitosos. No muy lejos de Barro Colorado se encuentra el logro de conservación más famoso gestado por iniciativa local. Nos referimos a Monteverde, una comunidad montañosa situada en Costa Rica, donde, en 1951, se asentó un grupo de cuáqueros que se dedicaron a la lechería. Para proteger la cuenca que los abastecía de agua, estos colonos decidieron guardar como reserva 554 hectáreas de bosque, en la cresta de la montaña, de las más de 1400 hectáreas que habían comprado originalmente. A partir de entonces, la reserva original se fue multiplicando en una serie de reservas contiguas que protegen decenas de miles de hectáreas de bosque montano. ¿Cómo se llegó a eso?

Un sistema económico justo ayudó. Cuando los cuáqueros llegaron a Monteverde, 175 personas vivían de lo que producían las fincas del lugar. Las grandes desigualdades sociales todavía no se habían desarrollado. Los cuáqueros decidieron que el producto lácteo más fácil de transportar por los difíciles caminos de la zona era el queso, así que comenzaron una fábrica de queso.

En apego a su hábito de comerciar de manera justa, los cuáqueros ofrecieron precios justos por la leche que se les entregaba. De ese modo, la posición económica de la mayoría de las personas del lugar mejoró y pronto se sintieron seguros para hacer planes para el futuro.

Es más, las creencias éticas y religiosas de los cuáqueros favorecieron la conservación en muchos sentidos. En palabras de Wolf Guindon, uno de los primeros colonos cuáqueros que llegó a Monteverde, este lugar debía convertirse en "una comunidad que buscara el bienestar de todos sus miembros, y que probara modos de vida que condujeran de manera natural a la paz en el mundo. Buscar soluciones conjuntas, sacar tiempo para que cada quien tuviera la oportunidad de expresarse y tomar en cuenta el punto de vista de cada quien fue un reto enorme. La creencia inquebrantable en el poder visible e invisible de la creación y en la interrelación de todas las cosas vivas, así como el deseo de vivir de modo sencillo y en estrecha unión con la naturaleza eran los valores compartidos que fortalecían a la comunidad. Siempre hubo un interés por usar los recursos naturales de manera prudente y por proteger la cuenca hidrográfica".

De acuerdo a estas aspiraciones, los cuáqueros cuidaron la tierra y la cuenca, como correspondía a una comunidad que quería quedarse a vivir allí indefinidamente: la tierra no era un vehículo desechable que conduce a una vida mejor en otra parte. Es más, los cuáqueros buscaron el consenso de la comunidad entera, no solo de la comunidad cuáquera. El hecho de que cualquier preocupación expresada por alguno de los miembros de la comunidad fuera sometida a consulta, y la proliferación de organizaciones de asistencia mutua fortalecieron sin duda el sentido de comunidad de Monteverde.

Originalmente, los cuáqueros cuidaban más la tierra que los animales silvestres, pero su creencia en la bondad

de la creación los hizo receptivos a la perspectiva de los biólogos a lo que daban albergue sobre las virtudes de la naturaleza silvestre como un todo, incluidos los animales. De este modo, cuando los biólogos buscaron extender los límites de la reserva para proteger quetzales, tapires y otros animales que ocupan espacios más amplios, los cuáqueros ofrecieron un apoyo total y efectivo.

Los cuáqueros, que valoran la educación, fundaron una buena escuela. Sus graduados estaban intelectualmente preparados para entender asuntos relacionados con la responsabilidad comunal, el uso sostenible de la tierra y las maneras correctas de alcanzar la conservación. Cuando algunos biólogos, y los cuáqueros que los apoyaban, solicitaron la ayuda económica de organizaciones internacionales para comprar más tierras para sus reservas y para contratar personal que las protegiera y manejara, las organizaciones estaban encantadas de brindar apoyo a este caso insólito: una comunidad rural en los trópicos que tenía bosques que valía la pena conservar, donde todos compartían el deseo de custodiarlos y encima tenían el conocimiento para hacerlo.

Los cuáqueros encomendaron el manejo de su reserva original de 554 hectáreas al Centro Científico Tropical de San José. El Centro decidió invitar a turistas que quisieran pagar por ver la reserva para financiar así su mantenimiento y protección. A los turistas les gustó lo que vieron y se lo contaron a sus amigos. Con el tiempo, los habitantes de Monteverde construyeron hoteles y restaurantes para atender a estos turistas. Los biólogos que hacían investigación en Monteverde escribieron manuales y capacitaron guías naturalistas para que enseñaran el bosque nuboso a los visitantes. Gracias a la iniciativa local, se inició el *boom* del ecoturismo y como el *boom* involucraba empresas locales, su desarrollo se hizo de acuerdo a las normas de la comunidad. Conforme creció la afluencia de turistas, se crearon nuevas reservas comerciales de bosque nuboso para satisfacer el auge repentino. Como toda la comunidad se benefició, se suscitó en todos un interés personal por conservar la integridad de los bosques nubosos, lo que constituía una buena base para su conservación.

Anteriormente vimos cómo la forma en que los bosques tropicales son destruidos refleja la falta de interés que demuestran los seres humanos hacia sus semejantes. Por el contrario, el milagro de conservación que tuvo lugar en Monteverde fue posible gracias a la propensión cuáquera a la buena vecindad y la justicia social, lo que restableció cierto grado de interés mutuo y de armonía social entre los pobladores del área. ¿Podrá un sentido de comunidad extenderse sin tardanza entre los seres humanos para poder darle una vida duradera y satisfactoria a la gente, y un hogar apropiado a las plantas y a otros animales, a lo largo y ancho de los trópicos?

DÓNDE ENCONTRAR MÁS INFORMACIÓN

INTRODUCCIÓN

Existen varios libros de agradable lectura para quienes deseen saber más sobre los bosques tropicales. E. J. H. Corner ofrece un recuento cautivador sobre bosques tropicales en su libro *The Life of Plants [La vida de las plantas]* (World Press, 1964). Este libro hace una recapitulación de la evolución de las plantas que abarca desde las algas microscópicas de mar abierto hasta los árboles más impresionantes, y celebra los bosques tropicales como la cúspide de la evolución de las plantas. Otra breve introducción a los bosques tropicales son los textos de T. C. Whitmore, *An Introduction to Tropical Rain Forests [Introducción a los bosques tropicales lluviosos]*, 2da. ed. (Oxford University Press, 1998), y de John Terborgh, *Diversity and the Tropical Rain Forest [La diversidad y el bosque tropical lluvioso]* (Scientific American Library, 1992). La mayoría de los biólogos de mi generación aprendieron sobre los bosques lluviosos gracias al libro de P. W. Richards, *The Tropical Rain Forest [El bosque tropical lluvioso]* (Cambridge University Press, 1952); una edición ampliada considerablemente apareció en 1996, publicada por la misma editorial. E. G. Leigh, Jr., A. S. Rand, y D. M. Windsor, eds., presentan un informe más detallado del bosque de Barro Colorado y de algunos de sus animales en *The Ecology of a Tropical Forest [Ecología de un bosque tropical]* (Smithsonian Institution Press, 1996). E. G. Leigh, Jr. examina el bosque de Barro Colorado desde una perspectiva global en *Tropical Forest Ecology [Ecología de los bosques tropicales]* (Oxford University Press, 1999). Esta obra, mencionada de ahora en adelante únicamente por su título en inglés, es la principal fuente de información del presente libro. También se extrajo información de muchas otras fuentes, tal y como se detalla a continuación. Cuando se cita un artículo únicamente por cifras que se toman de determinadas páginas, el título no se indicará.

CAPÍTULO 1

La inmensa variedad de organismos tropicales

Las razones por las que existen tantos tipos de árboles tropicales y por qué hay tanta diversidad de plantas y animales tropicales se discuten en el capítulo 8 del libro *Tropical Forest Ecology*. Las razones que explican por qué los trópicos albergan tantos tipos más de animales que las zonas templadas se discuten en el libro de Robert MacArthur, *Geographical Ecology [Ecología geográfica]* (Harper y Row, 1972).

La cantidad de árboles y de especies de árboles que se encuentran en un rectángulo de bosque de 120 × 80 metros en Brunei se especifica en el artículo de S. J. Davies y P. Becker, *Journal of Tropical Forest Science*, vol. 8 (1996), p. 544. La información de otros sitios se toma de la tabla 8.5 de *Tropical Forest Ecology*.

La información sobre Indiana que aparece en la tabla 1.1 (diversidad por parcela) se tomó del libro *Tropical Forest Ecology*, p. 203; los datos acerca de los sitios tropicales vienen del Centro de Ciencias Forestales del Trópico, un órgano del Instituto Smithsonian de Investigaciones Tropicales, que coordina los inventarios y censos de árboles y plántulas que se llevan a cabo en parcelas de monitoreo situadas en distintos bosques tropicales alrededor del mundo. Ver, por ejemplo, Elizabeth Losos y E. G. Leigh, Jr., eds. *Tropical Forest Diversity and Dynamism: Findings from a Large-Scale Plot Network [La diversidad y el dinamismo de los bosques tropicales: Resultados de una red de parcelas a gran escala]* (University

of Chicago Press, 2004). En la tabla 1.1 (diversidad por región), la información sobre Europa y el este de Estados Unidos se tomó del libro *Species Diversity in Ecological Communities [Diversidad de especies en las comunidades ecológicas]* de R. E. Latham y R. E. Ricklefs, editado por R. E. Ricklefs y D. Schluter (University of Chicago Press, 1993), p. 296; la información sobre Panamá y Malasia se encuentra en R. Condit et al., *Journal of Ecology*, vol. 84 (1996), p. 559.

Los datos sobre la diversidad de murciélagos presentados en la tabla 1.2 para Indiana y el este de Alemania provienen de las tablas 4.1 y 4.2 del libro de James Findlay, *Bats [Murciélagos]* (Cambridge University Press, 1993). La información acerca de Panamá se tomó de E. K. V. Kalko, en H. Ulrich, ed., *Tropical Biodiversity and Systematics [Biodiversidad y Sistemática Tropical]* (Zoologisches Forschungsinstitut y Museum Alexander Koenig, Bonn, 1997), pp. 24-27, y se complementó con una comunicación personal de Elizabeth Kalko (2000).

H. Jactel y E. G. Brockerhoff muestran que los árboles sufren más a causa de los insectos herbívoros en parcelas de una única especie en "Tree Diversity Reduces Herbivory by Forest Insects" ["La diversidad forestal reduce el herbivorismo de los insectos del bosque"], en *Ecology Letters*, vol. 10 (2007), pp. 835-48. Liza Comita y colegas observan que en Barro Colorado las plántulas sobreviven mejor cuando tienen menos vecinos de su misma especie, y que las plántulas de especies menos frecuentes sufren más por la presencia de cada vecino adicional de la misma especie en "Asymmetrical Density Dependence Shapes Species Abundances in a Tropical Tree Community" ["La dependencia asimétrica de la densidad moldea la abundancia de las especies en la comunidad de árboles tropicales"], *Science*, vol. 329 (2010), pp. 330-2. Scott Mangan y colegas ofrecen evidencia de que la mortalidad relacionada con la vecindad es causada, al menos en parte, por hongos patógenos del suelo, en "Negative Plant-Soil Feedback Predicts Tree Species Relative Abundance in a Tropical Forest" ["La retroalimentación negativa planta-suelo predice la abundancia relativa de las especies de árboles"], *Nature*, vol. 466 (2010), pp. 752-5.

El impacto que tuvo un calentamiento global brusco en el herbivorismo de los insectos en el sur de Wyoming hace 56 millones de años es descrito por P. Wilf y C. C. Labandeira, en "Response of Plant-Insect Associations to Paleocene-Eocene Warming" ["Respuesta de las asociaciones plantas-insectos al calentamiento del Paleoceno-Eoceno"], *Science,* vol. 284 (1999), pp. 2153-6, y por Ellen Currano y colegas en "Sharply Increased Insect Herbivory during the Paleocene-Eocene Thermal Maximum*" ["Drástico aumento en el herbivorismo de los insectos durante la máxima térmica del Paleoceno-Eoceno"]*, *Proceedings of the National Academy of Sciences, USA*, vol. 105 (2008), pp. 1960-4.

La información que aparece en la tabla 1.3 sobre Santa Rosa, Costa Rica, proviene de R. J. Burnham, *Biotropica*, vol. 29 (1997), p. 388; el resto de los datos fueron tomados de la tabla 8.6 de *Tropical Forest Ecology*.

La tabla 1.4 se basa en la tabla VIII de A. H. Gentry publicada en *Evolutionary Biology*, vol. 15 (1982), p. 38.

La selección sexual y su rol en la especiación son descritos por William Eberhard en dos libros, *Sexual Selection and Animal Genitalia [La selección sexual y los genitales de animales]* (Harvard University Press, 1985), y *Female Control [El control femenino]* (Princeton University Press, 1996). Ola Fincke describe la selección sexual en las libélulas/caballitos del diablo gigantes en dos artículos, "Consequences of Larval Ecology for Territoriality and Reproductive Success of a Neotropical Damselfly" ["Consecuencias de la ecología de larvas en el comportamiento territorial y el éxito reproductivo de una libélula neotropical"], *Ecology*, vol. 73 (1992), pp. 449-62 y "Interspecific Competition for Tree Holes: Consequences for Mating Systems and Coexistence in Neotropical damselflies" [La competencia entre especies por los agujeros en los árboles: consecuencias en los sistemas de reproducción y en la coexistencia de las libélulas neotropicales"], *American Naturalist*, vol. 139 (1992), pp. 80-101.

La cita de Martin Moynihan se encuentra en el *Journal of Theoretical Biology*, vol. 29 (1970), p. 103.

Christopher Jiggins y colegas explican el rol de la selección sexual en la coloración de las alas en la rápida división de una especie de mariposa en dos, en "Reproductive Isolation Caused by Color Pattern Mimicry" ["El aislamiento reproductivo causado por la imitación

de un patrón de color", *Nature*, vol. 411 (2001), pp. 302-5. Maria Servedio y colegas ofrecen otros ejemplos en los cuales la selección sexual asociada a rasgos relacionados con la divergencia ecológica promueve la especiación, en "Magic Traits in Speciation: Magic but not Rare?" ["Los rasgos mágicos en la especiación: ¿mágicos pero no escasos?"], *Trends in Ecology and Evolution*, vol. 26 (2011).

La interdependencia: las múltiples formas en que las especies dependen unas de otras

El rol del mutualismo en el bosque tropical se examina en el capítulo 9 de *Tropical Forest Ecology*, y en Egbert Leigh, Jr., "The Evolution of Mutualism" ["La evolución del mutualismo"], *Journal of Evolutionary Biology*, vol. 23 (2010), pp. 2507-2528. Egbert Leigh, Jr. *et al.* describen el rol fundamental que cumple la interdependencia en el funcionamiento de los ecosistemas en el artículo "What do Human Economies, Large Islands and Forest Fragments Reveal About the Factors Limiting Ecosystem Evolution" ["¿Qué revelan las economías humanas, las islas de gran tamaño y los fragmentos de bosque sobre los factores que limitan la evolución de los ecosistemas?"], *Journal of Evolutionary Biology*, vol. 22 (2009), pp. 1-12. El último libro de Darwin es *The Formation of Vegetable Mould through the Action of Worms [La formación del manto vegetal por la acción de las lombrices]* (John Murray, 1881, reimpresión, University of Chicago Press, 1985).

Philip DeVries describe la subversión de los mutualismos hormiga-planta en "Singing Caterpillars, Ants and Symbiosis" ["Orugas cantoras, hormigas y simbiosis"], aparecido en *Scientific American*, en octubre de 1992, pp. 76-82.

Las hormigas arrieras más comunes de Barro Colorado, las *Atta colombica*, acumulan desechos en el exterior. Otras especies de hormigas arrieras entierran la basura; sus nidos se pueden identificar por un área de varios metros de ancho donde las hormigas han limpiado toda la vegetación baja. Las medidas que toman las hormigas arrieras para preservar su hongo digestor de hojas de la contaminación se describen en C. R. Currie *et al.*, "Fungus-Growing Ants Use Antibiotic-Producing Bacteria to Control Garden Parasites" ["Las hormigas cultivadoras de hongos usan bacterias productoras de antibióticos para controlar

los parásitos de los cultivos"], *Nature*, vol. 398 (1999), pp. 701-4, y en Hermógenes Fernández-Marín *et al.*, "Reduced Biological and Enhanced Chemical Pest Management in the Evolution of Fungus Farming in Ants" ["Reducción biológica y química mejorada para manejo de pestes en evolución del cultivo de hongos por arrieras"], *Proceedings of the Royal Society of London,* series B, vol. 276 (2009), pp. 2263-9.

R. S. Seymour, G. A. Bartholomew y M. C. Barnhart describen la manera en que las inflorescencias de una especie de arácea se calientan para esparcir su olor y atraer polinizadores sin cocinarlos en "Respiration and Heat Production by the Inflorescence of *Philodendron selloum* Koch" ["Respiración y producción de calor de la inflorescencia de *Philodendron selloum* Koch"], *Planta*, vol. 157, pp. 336-43.

La forma en que la "domesticación" de animales como los polinizadores estableció las condiciones propicias para la dispersión de las plantas con flor, aunque las cicas y otras gimnospermas que "domesticaron" animales polinizadores se beneficiaron mucho menos de esta innovación, se explican en Conrad Labandeira *et al.*, "Pollination Drops, Pollen, and Insect Pollination of Mesozoic Gymnosperms" ["Gotas de polinización, polen y polinización por insectos en las gimnospermas mesozoicas"], *Taxon*, vol. 86 (2007), pp. 663-95 y en Egbert Leigh, en las pp. 2517-8 de "The Evolution of Mutualism" ["La evolución del mutualismo"]*, Journal of Evolutionary Biology*, vol. 23 (2010), pp. 2507-28.

Las relaciones entre los higuerones y las avispas que los polinizan se describen en E. Allen Herre, "An Overview of Studies on a Community of Panamanian Figs" ["Resumen de los estudios sobre una comunidad de higuerones panameños"], *Journal of Biogeography*, vol. 23 (1996), pp. 593-607 y en E. A. Herre *et al.*, "Evolutionary Ecology of Figs and their Associates: Ongoing Studies and Outstanding Puzzles" [La ecología evolutiva de los higuerones y sus asociados: estudios en proceso y enigmas por resolver"], *Annual Review of Ecology, Evolution and Systematics*, vol. 39 (2008), pp. 439-58. K. C. Jandér y E. A. Herre describen la manera en que los higuerones castigan a las avispas que no cumplen su función en "Host Sanctions and Pollinator Cheating in the Fig Tree-Fig Wasp Mutualism" ["Las

sanciones del hospedero y los polinizadores tramposos en el mutualismo entre el higuerón y su avispa", *Proceedings of the Royal Society*, serie B, vol. 277 (2010), pp. 1481-8.

En la tabla 1.5 sobre el área dentro de la cual el higuerón puede atraer a las avispas polinizadoras, los datos del *Ficus obtusifolia* se tomaron de la figura 2A, en J. D. Nason, E. A. Herre y J. L. Hamrick, *Journal of Biogeography*, vol. 23 (1996), p. 506. La información del *Ficus dugandii*, así como la explicación del proyecto, se describen en J. D. Nason, E. A. Herre y J. L. Hamrick, "The Breeding Structure of a Tropical Keystone Plant Resource" ["La estructura reproductiva de un recurso vegetal tropical clave"], *Nature*, vol. 391 (1998), pp. 685-687.

S. A. Zimov *et al.* relatan la historia de cómo la caza humana excesiva hizo que los alrededores del Estrecho de Bering pasaran de pastizales a tundra en "Steppe-Tundra Transition: A Herbivore-Driven Biome Shift at the End of the Pleistocene" ["Transición de estepa a tundra: Un cambio de bioma provocado por herbívoros al final del Pleistoceno"], *American Naturalist*, vol. 146 (1995), pp. 765-94.

La forma en que la silvicultura se puede mejorar imitando a la naturaleza se describe en el capítulo 6 de E. F. Bruenig, *Conservation and Management of Tropical Rainforests [La conservación y el manejo del bosque tropical lluvioso]* (CAB International, 1996) y en Jerry Franklin *et al.*, "Alternative Sylvicultural Approaches to Timber Harvesting: Variable Retention Harvest Systems" ["Enfoques alternativos a la silvicultura para la cosecha de madera"], pp. 111-139 en *Creating a Forestry for the 21st Century [La creación de una silvicultura para el siglo XXI]*, editado por Kathryn Kohm y Jerry Franklin (Island Press, 1997).

CAPÍTULO 2

Klaus Winter, un fisiólogo de plantas, inició su clase de prueba para aspirar a un puesto en el Instituto Smithsonian de Investigaciones Tropicales diciendo que nosotros, y todos los otros organismos en este planeta, somos huéspedes de las plantas verdes que lo habitan. Fue contratado.

El área foliar de un bosque, la interceptación de la luz y la fotosíntesis se describen en el capítulo 6 de *Tropical Forest Ecology*. En el capítulo 3 del mismo libro, se indica cuánta

agua usan los bosques y cómo el bosque funciona como un sistema de aire acondicionado gigante. La manera en que la evolución de los bosques causó un enfriamiento global se describe en J. Robinson, "The Burial of Organic Carbon as Affected by the Evolution of Land Plants" ["El impacto de la evolución de las plantas terrestres en el entierro del carbono orgánico"], *Historical Biogeography*, vol. 3 (1990), pp. 189-201, y en Gregory Retallack, "Ecology and Evolution of Devonian Trees in New York, USA" [Ecología y evolución de los árboles del Devónico en Nueva York, EUA"], *Palaeogeography, Palaeoclimatology, Palaeoecology*, vol. 299 (2011), pp. 110-28.

La tabla 2.1 se basa en la tabla 3.10 de *Tropical Forest Ecology*.

La cita sobre la evapotranspiración es de Corner, *Life of Plants*, p. 107.

En busca de la luz

Egbert Leigh explica cómo el bosque ilustra una "tragedia de los comunes" en la p. 124 de "Tropical Forest Ecology, Sterile or Virgin for Theoreticians" ["La ecología de los bosques tropicales, estéril o virgen para los teóricos"], en *Tropical Forest Community Ecology [Ecología de las comunidades de los bosques tropicales]*, ed. Walter Carson y Stefan Schnitzer (Wiley-Blackwell, 2008), pp. 121-42. La cantidad de madera que producen los bosques para soportar el peso de las hojas y la velocidad a la que el bosque renueva su madera se describen en el capítulo 6 de *Tropical Forest Ecology*. La tasa de mortalidad de los árboles de distintos tamaños en la parcela experimental de 50 hectáreas de Barro Colorado se presenta en la tabla A.1.

José Luis Andrade y Park Nobel describen las distintas maneras de ser una epífita en "Microhabitats and Water Relations of Epiphytic Cacti and Ferns in a Lowland Neotropical Forest" ["Los microhábitats y la relación con el agua de los cactus epífitos y los helechos en un bosque neotropical de tierras bajas"], *Biotropica*, vol. 29 (1997), pp. 261-70. La carga de epífitas en un bosque lluvioso de Borneo aparece en la Tabla 2 de T. Yamakura *et al.*, *Southeast Asian Studies*, vol. 23 (1986), p. 464.

Las costumbres de los higuerones estranguladores, otras hemiepífitas y las lianas son examinadas en N. M. Holbrook y F. E. Putz, "Physiology of Tropical Vines

and Hemiepiphytes: Plants That Climb Up and Plants That Climb Down" [Fisiología de las enredaderas y las hemiepífitas tropicales: plantas que escalan hacia arriba y plantas que escalan hacia abajo", en *Tropical Forest Plant Ecophysiology [Ecofisiología de las plantas de los bosques tropicales]*, editado por S. S. Mulkey, R. L. Chazdon y A. P. Smith (Chapman and Hall, 1996), pp. 363-94.

La lianas se analizan en *Tropical Forest Ecology*, pp. 134-35. F. E. Putz describe las distintas variedades de lianas en "The Natural History of Lianas on Barro Colorado Island, Panama" ["La historia natural de las lianas en la Isla de Barro Colorado, Panamá"], *Ecology*, vol. 68 (1984), pp. 1713-24. La cantidad de lianas y las especies de lianas presentes en la parcela de monitoreo de 50 hectáreas en Barro Colorado provienen de un censo realizado por Stefan Schnitzer: ver S. A. Schnitzer *et al.* "Liana Abundance, Diversity and Distribution on Barro Colorado Island, Panamá" [Abundancia, diversidad y distribución de las lianas en la Isla de Barro Colorado, Panamá] , en la revista en línea PLoS ONE, 7(2): e52114 (2012). La cantidad de árboles y de especies de árboles en dicha parcela provienen de la tabla 24.2, p. 455, de E. Losos y E. G. Leigh, Jr., eds. *Tropical Forest Diversity and Dynamism [La diversidad y el dinamismo de los bosques tropicales]* (University of Chicago Press, 2004). La proporción con que contribuyen las lianas a la producción de hojas de Barro Colorado se tomó de la fig. 1 de S. Joseph Wright *et al.*, "Are Lianas Increasing in Importance in Tropical Forest? A 17-Year Record from Panama" ["¿Está aumentando la importancia de las lianas en el bosque tropical? Un registro de 17 años de Panamá"], *Ecology*, vol. 85 (2004), pp. 484-9.

La tabla A.2 compara el contenido de hojas y madera de las lianas de diferentes bosques con el de los árboles de estos bosques. Los datos de Pasoh, Malasia, se tomaron de la tabla 24.1, de T. Kira en *Tropical Trees as Living Systems [Los árboles tropicales como sistemas vivientes]*, ed. P. B. Tomlinson y M. H. Zimmermann (Cambridge University Press, 1978), p. 569. Las cifras de Sebulu, Borneo, provienen de la tabla 2 en T. Yamakura *et al.*, *Southeast Asian Studies*, vol. 23 (1986), p. 464. Las cifras de San Carlos de Río Negro, Venezuela, se tomaron de F. E. Putz, *Biotropica*, vol. 15 (1983), tabla 2, p. 187.

El contraste entre la disposición de las hojas en el dosel y en el sotobosque y otros aspectos relacionados con la forma de las plantas se presentan en el capítulo 5 de *Tropical Forest Ecology*, pp. 94-98.

El contraste fisiológico entre plántulas de especies del dosel y plántulas del sotobosque del mismo tamaño que crecen en iguales condiciones, se describe en S. C. Thomas y F. A. Bazzaz, "Asymptotic Height as a Predictor of Photosynthetic Characteristics in Malaysian Forest Trees" ["Altura asintótica como indicador de las características fotosintéticas de los árboles del bosque malayo"], *Ecology*, vol. 80 (1999), pp. 1607-22. Las

TABLA A.1

Árboles de diferentes tamaños (N), en diferentes años, y tasa de mortalidad (m) en el intervalo entre un censo y otro

Diámetro a la altura del pecho	N, 1985	m, 1985-90	N, 1990	m, 1990-95	N, 1995
5 - <10 cm	24 490	1.97	29 024	1.98	28 906
10 - < 20 cm	12 745	1.97	13 154	1.92	13 307
20 - < 40 cm	5277	1.96	5333	1.83	5415
40 - < 80 cm	2012	2.12	1971	2.08	1968
> 80 cm	323	1.45	368	1.19	370

diferentes maneras de sobrevivir como especie tolerante a la sombra se exponen en T. A. Kursar y P. D. Coley, "Contrasting Modes of Light Acclimation in Two Species of the Rainforest Understory" [Formas contrastantes de aclimatación a la luz en dos especies del sotobosque del bosque lluvioso"], *Oecologia*, vol. 121 (1999), pp. 489-98.

El compromiso (*trade-off*) entre el crecimiento rápido con abundancia de luz y la supervivencia en la sombra se describe en el capítulo 8 de *Tropical Forest Ecology*, p. 188. Alguna información adicional sobre este tema en encuentra en David King, "Influence of Light Level on the Growth and Mortality of Saplings in a Panamanian Forest" [Influencia de la cantidad de luz en el crecimiento y la mortalidad de las plántulas en un bosque panameño]", *American Journal of Botany*, vol. 81 (1994), pp. 948-57, y en K. Kitajima, "Relative Importance of Photosynthetic Traits and Allocation Patterns as Correlates of Seedling Shade Tolerance of 13 Tropical Trees" [Importancia relativa de las características fotosintéticas y patrones de distribución de recursos en relación con la tolerancia de las plántulas a la sombra"], *Oecologia*, vol. 98 (1994), pp. 419-28. La información para la tabla 2.2 se extrajo de N. V. L. Brokaw, *Journal of Ecology*, vol. 75 (1987), p. 9.

La búsqueda de nutrientes y agua

Alguna evidencia visible de la competencia por nutrientes se presenta en Nalini Nadkarni, "Canopy Roots: Convergent Evolution in Rainforest Nutrient Cycles" [Las raíces del dosel: evolución convergente en los ciclos de nutrientes del bosque lluvioso"], *Science*, vol. 214, pp. 1023-24.

El capítulo 6 de *Tropical Forest Ecology* presenta los factores que influyen en la repartición de la energía de las plantas para la construcción de raíces y de hojas, y para el crecimiento del tallo, y cómo evaluar esta repartición. Las tablas 2.3 y 2.4 se basan en las tablas 6.6 y 6.17, respectivamente, de este mismo libro.

La profundidad del suelo de la cual los diferentes árboles extraen el agua es descrita por Paula C. Jackson *et al.*, en "Partitioning of Water Resources among Plants of a Lowland Tropical Forest" ["Distribución de las fuentes de agua entre las plantas de un bosque tropical de tierras bajas "], *Oecologia*, vol. 101 (1995), pp. 197-203; y por Frederick Meinzer *et al.*, en "Partitioning of Soil Water among Canopy Trees in a Seasonally Dry Tropical Forest" ["Distribución del agua del suelo entre los árboles del dosel en un bosque tropical con estación seca"], *Oecologia*, vol. 121 (1999), pp. 293-301.

La descomposición y el reciclaje de nutrientes se describen en Corner, *Life of Plants* [*La vida de las plantas*]. M. J. Swift, O. W. Heal y J. M. Anderson examinan la comunidad de los descomponedores en *Decomposition in Terrestrial Ecosystems [La descomposición en los ecosistemas terrestres]* (Blackwell Scientific, 1979). Los descomponedores de los bosques tropicales son descritos más brevemente en T. C. Whitmore, *An Introduction to Tropical Rain Forests [Introducción a los bosque tropicales*

TABLA A.2

Área foliar de árboles y lianas, y cantidad de madera requerida para soportar un metro cuadrado de cada uno de ellos, en bosques seleccionados

Sitio	Tamaño de la parcela	Área foliar árboles por hectárea	Kg de madera por m² de hojas de árbol	Área foliar lianas por hectárea	Kg de madera por m² de hojas de liana
Pasoh, Malasia	1/5 hectárea	71 000 m²	6.45 kg/m²	6600 m²	1.38 kg/m²
Sebulu, Borneo	1/8 hectárea	68 640 m²	12.47 kg/m²	8400 m²	1.30 kg/m²
San Carlos, Venezuela	No disponible	52 000 m²	6.44 kg/m²	12 000 m²	1.31 kg/m²

lluviosos], 2d. ed. (Oxford University Press, 1998), pp. 162-64; y en Whitmore, *Tropical Rain Forests of the Far East [Bosques tropicales lluviosos del Lejano Oriente]* (Oxford University Press, 1984), pp. 131-34. Conrad Labandeira *et al.* describen a los primeros descomponedores en "Oribatid Mites and the Decomposition of Plant Tissues in Paleozoic Coal-Swamp Forests" ["Ácaros oribátidos y la descomposición de los tejidos de las plantas en los bosques de pantanos de carbón del Paleozoico"], *Palaios*, vol. 12 (1997), pp. 319-53. Las hormigas guerreras de Barro Colorado son descritas por Nigel Franks, "Ecology and Population Regulation in the Army Ant *Eciton burchelli*" [Ecología y control de las poblaciones de la hormiga guerrera *Eciton burchelli*"], en *Ecology of a Tropical Forest [Ecología de un bosque tropical]*, ed. E. G. Leigh *et al.* (Smithsonian Institution Press, 1996), pp. 389-95.

El ciclo de los nutrientes y la formación del suelo se analizan en los capítulos de I. C. Baillie, C. P. Burnham, P. Sollins y L. A. Bruijnzeel en *Mineral Nutrients in Forest and Savanna Ecosystems [Nutrientes minerales en los ecosistemas del bosque y de la sabana]*, ed. J. Proctor (Blackwell Scientific, 1989), y en los capítulos de P. Sollins *et al.* y G. G. Parker en *La Selva: Ecology and Natural History of a Neotropical Rain Forest [La Selva: Ecología e historia natural de un bosque neotropical lluvioso]*, ed. Lucinda McDade *et al.* (University of Chicago Press, 1994). La cita de Bruenig sobre la materia orgánica del suelo se tomó de su libro *Conservation and Management of Tropical Rainforests [Conservación y manejo del bosque tropical lluvioso]* (CAB International, 1996), pp. 17-19. La erosión y la formación del suelo se estudian en el capítulo 4 de *Tropical Forest Ecology*. La información sobre los deslizamientos de la tabla 2.5 se tomó del capítulo de Matthew Larsen y Abigail Santiago Roman en *Geomorphic Processes and Riverine Habitat [Procesos geomórficos y hábitat fluvial]*, ed. J. M. Dorava *et al.* (American Geophysical Monographs, 2001); los datos sobre la exportación de sedimentos son de Matthew Larsen y Robert Stallard, *United States Geological Survey Fact Sheet [Fichas del Servicio Geológico de los Estados Unidos]* no. 163-99 (June 2000). Robert Stallard suministró los datos para las tablas 2.6-2.8.

Eberhard Bruenig describe los árboles que arruinan el suelo en *Conservation and Management of Tropical*

Rainforests [Conservación y manejo del bosque tropical lluvioso] (CAB International, 1996), p. 23; la pregunta de si la selección natural alguna vez favorece a los árboles que matan a sus vecinos se discute en William Bond y Jeremy Midgley, "Kill Thy Neighbor: an Individualistic Argument for the Evolution of Flammability" ["Mata a tu prójimo: un argumento individualista por la evolución de la inflamabilidad"], *Oikos*, vol. 73 (1995), pp. 79-85.

Ritmos estacionales, estación seca y estación lluviosa

La rigurosidad de la estación seca de Barro Colorado se discute al principio del capítulo 3 de *Tropical Forest Ecology*.

La manera en que diferentes plantas hacen frente y responden a la época seca y por qué lo hacen se discute en *Tropical Forest Ecology*, pp. 152-154. Frederick Meinzer *et al.* señalan diferentes formas en que los árboles afrontan las sequías, en "Xylem Hydraulic Safety Margins in Woody Plants: Coordination of Stomatal Control of Xylem Tension with Hydraulic Capacitance" ["Márgenes de seguridad hidráulica del xilema en las plantas leñosas: coordinación del control estomatal de la tensión del xilema con la capacitancia hidráulica"], *Functional Ecology*, vol. 23 (2009), pp. 922-30. S. J. Wright y otros muestran cómo las sequías severas producidas por El Niño afectan el bosque de Barro Colorado en "The El Niño Southern Oscillation, Variable Fruit Production, and Famine in a Tropical Forest" ["El Niño – Oscilación del Sur, producción variable de frutos y hambruna en el bosque tropical"], *Ecology*, vol. 80 (1994), pp. 1632-47.

En el capítulo 7 de *Tropical Forest Ecology* se describe el rol que la escasez estacional de frutos y hojas nuevas tiene en el control de las poblaciones animales, y cómo las diferentes plantas saben cuándo florecer o cuándo retoñar. De acuerdo con K. A. Nagy, "Field Metabolic Rate and Food Requirement Scaling in Mammals and Birds" ["Tasa metabólica del suelo y escala de requerimientos alimenticios en mamíferos y pájaros"], *Ecological Monographs*, vol. 57 (1997), pp. 111-128, un mamífero "típico" que pesa x gramos come $0.235x^{0.822}$ gramos de peso seco de comida por día. Los conteos de mamíferos y de pesos que se ofrecen en *Tropical Forest Ecology*, p.

172, nos permitieron, por tanto, calcular cuánta comida necesitan estos animales.

G. Rivera y R. Borchert presentan evidencia de que, en Costa Rica, *Cochlospermum vitifolium* y otras plantas florecen en respuesta al acortamiento de los días durante septiembre, octubre y noviembre en "Induction of Flowering in Tropical Trees by a 30-Min Reduction in Photoperiod: Evidence from Field Observations and Herbarium Specimens" ["Inducción de la floración de árboles tropicales por una reducción de 30 minutos en el fotoperiodo: evidencia de observaciones de campo y de especímenes de herbario"], *Tree Physiology*, vol. 21 (2001), pp. 201-12.

CAPÍTULO 3

El herbivorismo

Phyllis Coley compara el herbivorismo y las defensas contra los herbívoros presentes en las hojas nuevas y maduras de diferentes especies de plantas en "Herbivory and Defensive Characteristics of Tree Species in a Lowland Tropical Forest" ["Herbivorismo y características defensivas de distintas especies de árboles en un bosque tropical de tierras bajas "], *Ecological Monographs*, vol. 53 (1983), pp. 209-33.

T. Mitchell Aide plantea la posibilidad de que las plantas ajusten el momento de producción de hojas nuevas con el fin de reducir el herbivorismo en "Patterns of Leaf Development and Herbivory in a Tropical Understory Community" ["Patrones de desarrollo de las hojas y herbivorismo en una comunidad del sotobosque tropical"], *Ecology*, vol. 74 (1993), pp. 455-66.

Phyllis Coley y sus colegas argumentan que las hojas de crecimiento lento son las que tienen más probabilidades de tener compuestos relevantes desde un punto de vista medicinal en "Using Ecological Criteria to Design Plant Collection Strategies for Drug Discovery" [Aplicación de criterios ecológicos para diseñar estrategias de recolección de plantas para el descubrimiento de medicamentos"], *Frontiers in Ecology and the Environment*, vol. 1 (2003), pp. 421-8.

La información para calcular las tasas de crecimiento promedio de las plantas con hojas de larga y de corta

vida se tomó de P. Coley, *Ecological Monographs*, vol. 53 (1983), pp. 230-31.

El costo que implica defender las hojas de *Psychotria horizontalis* se analiza en Cynthia Sagers y Phyllis Coley, "Benefits and Costs of Defense in a Neotropical Shrub" [Beneficios y costos de defensa en un arbusto neotropical"], *Ecology*, vol. 76 (1995), pp. 1835-43.

En la tabla 3.1, la tasa de alimentación de las iguanas se calcula con base en la ecuación 24 de K. A. Nagy en *Iguanas of the World* [*Iguanas del mundo*], editado por G. M. Burghardt y A. S. Rand (Noyes Publications, 1982), p. 57. De acuerdo con esta ecuación, un iguánido típico que pesa x gramos come $0.024x0.80$ gramos de comida en peso seco por día. La tasa de alimentación de los perezosos proviene de K. A. Nagy y G. G. Montgomery, "Field Metabolic Rate, Water Flux, and Food Consumption in Three-Toed Sloths (*Bradypus variegatus*)" ["Tasa metabólica, flujo de agua y consumo de alimentos en el campo de tres perezosos de tres dedos (*Bradypus variegatus*)"], *Journal of Mammalogy*, vol. 61 (1980), pp. 465-72; y la tasa de alimentación de los monos aulladores se tomó de K. A. Nagy y K. Milton, "Energy Metabolism and Food Consumption by Wild Howler Monkeys (*Alouatta palliatta*)" ["Metabolismo y consumo de alimentos de los monos aulladores salvajes"], *Ecology*, vol. 60 (1979), pp. 475-80.

Las hormigas arrieras se describen en *Tropical Forest Ecology*, pp. 36-37.

La razón por la cual los insectos comedores de plantas se especializan, y cómo su especialización promueve la diversidad de plantas tropicales, se trata en *Tropical Forest Ecology*, pp. 190-94.

Las razones de la existencia de tantos tipos de árboles tropicales se discuten en E. G. Leigh, Jr. *et al.*, "Why Do Some Tropical Forests Have So Many Species of Trees" ["Por qué algunos bosques tropicales tienen tantas especies de árboles"], *Biotropica*, vol. 36 (2004), pp. 447-473. Los datos de una parcela de 25 hectáreas de bosque primario del sur de Manchuria provienen de Hao Zhanqing *et al.*, *Changbaishan Temperate Forest Dynamics Plots: Broad-Leaved Korean Pine Mixed Forest and Secondary Poplar-Birch Forest. Species Composition and their Spatial Patterns [Parcelas de monitoreo en bosques templados en Changbaishan: un bosque mixto de pinos coreanos y árboles*

caducifolio, y un bosque secundario de álamos y abedules. Composición de especies y patrones espaciales] (China Forestry Publishing House, 2009). Los datos de Barro Colorado se tomaron del censo que se realizara en el 2005 sobre la mitad este de la parcela de monitoreo de 50 hectáreas que hay en la isla y fueron proporcionados por el Centro de Ciencias Forestales del Trópico.

¡Depredadores!

La información sobre lo que comió un águila harpía durante su estadía en Barro Colorado fue recopilada por Janeene Touchton y algunos asistentes temporales, con recursos del Fondo Peregrino.

Louise Emmons discute cuánto comen los felinos en "Comparative Feeding Ecology of Felids in a Neotropical Rainforest" ["Ecología alimentaria comparada de los felinos en un bosque lluvioso neotropical"], *Behavioral Ecology and Sociobiology*, vol. 20 (1987), pp. 276-77. Para calcular cuántos perezosos y otros animales se come un ocelote al año, partí de las observaciones de Ricardo Moreno, quien, en 25 de 40 excrementos examinados, encontró evidencia de presas con un peso igual o superior a los 2.5 kilogramos, de lo cual deduje que las presas de este peso representaban cinco octavos del total de consumo de presas. Supuse, también, que cada ocelote produce un excremento al día y que un animal que pesa 2.5 kilogramos o más (monos cariblancos, agutíes y perezosos) estaría evidenciado en tres excrementos, de manera que la aparición de una de estas especies en un excremento representaría un tercio del animal. Ocho de estos excrementos tenían restos de perezosos de dos dedos. Estos restos representaban 2.7 perezosos de dos dedos. Un ocelote excreta una vez al día, o 365 veces al año, por lo se desprende que un ocelote debe comer 9 x 2.7, o 24, perezosos de dos dedos al año.

Lincoln Brower examina la evolución del sabor desagradable y de la coloración de advertencia en "Chemical Defenses in Butterflies" ["La defensas químicas en las mariposas"], en *The Biology of Butterflies* [La biología de las mariposas], ed. R. I. Vane-Wright y P. R. Ackerly (Academic Press, 1984), pp. 109-134, y J. R. G. Turner analiza la coloración de advertencia en

"Mimicry: the Palatability Spectrum and Its Consequences" ["Mimetismo: el espectro de sabor y sus consecuencias"], en la pp. 141-61 del mismo volumen.

Peng Chai compara la reacción de un jacamar cautivo a diferentes mariposas en "Field Observations and Feeding Experiments on the Response of Rufous-Tailed Jacamars (*Galbula ruficauda*) to Free-Flying Butterflies in a Tropical Rainforest" ["Observaciones de campo y experimentos de alimentación relacionados con la respuesta del jacamar colirrufo (*Galbula ruficauda*) a mariposas que vuelan libres en un bosque tropical lluvioso"] , *Biological Journal of the Linnean Society*, vol. 29 (1986), pp. 161-89. Robert Srygley y C. P. Ellington muestran cómo las mariposas con sabor desagradable se imitan unas a otras tanto en la manera en que vuelan como en el color de las alas, en "Discrimination of Flying Mimetic, Passion-Vine Butterflies, *Heliconius*" [Discriminación de las mariposas miméticas de la *Passiflora*, *Heliconius*"], *Proceedings of the Royal Society of London*, series B, vol. 266 (1999), pp. 2137-40.

M. H. Robinson describe las diferentes maneras en que los insectos se disfrazan o se presentan engañosamente para evitar ser comidos en "Defenses against Visually Hunting Predators" ["Defensas ante los depredadores que cazan guiados por la vista"], *Evolutionary Biology*, vol. 3 (1969), pp. 225-59.

El papel de los depredadores en la protección del bosque de Barro Colorado contra los herbívoros se examina en *Tropical Forest Ecology*, pp. 158-59 y pp. 167-68. Margareta Kalka y colegas evalúan el impacto de los murciélagos en el herbivorismo de los insectos en "Bats Limit Arthropods and Herbivory in a Tropical Forest" ["Los murciélagos restringen la acción de los artrópodos y el herbivorismo en un bosque tropical"], *Science*, vol. 320 (2008), p. 71.

La explosión de hormigas arrieras y otros herbívoros en isletas de reciente aparición y el impacto de estos herbívoros en la vegetación de las isletas se describe en John Terborgh *et al.*, "Ecological Meltdown in Predator-Free Forest Fragments" ["Colapso ecológico en fragmentos de bosque libres de depredadores"], *Science*, vol. 294 (2001), pp. 1923-26.

CAPÍTULO 4

El porqué de la diversificación

Las ventajas de especializarse en una ocupación o en un estilo de vida particular se esbozan en *Tropical Forest Ecology*, pp. 187-89.

Los compromisos que enfrentan las moscas depredadoras entre buscar comida en áreas soleadas y buscarla a la sombra se describen en Todd Shelly, "Comparative Foraging Behavior of Neotropical Robber Flies (Diptera: Asilidae)" ["Comportamiento alimentario comparado en las moscas depredadoras del neotrópico (Diptera: Asilidae)", *Oecologia*, vol. 62, pp. 188-95.

El dilema que enfrentan las moscas de la fruta entre la competitividad de sus larvas y la longevidad de sus adultos se examina en Jan Sevenster y Jacques J. M. van Alphen, "A Life History Trade-off in *Drosophila* Species and Community Structure in Variable Environments" ["Relaciones de compromiso en las estrategias vitales de las especies de *Drosophila* y estructura de la comunidad en ambientes variables"], *Journal of Animal Ecology*, vol. 62 (1993), pp. 720-36.

Hans-Ulrich Schnitzler y Elisabeth Kalko describen los compromisos (*trade-offs*) que entran en juego en distintas maneras de ecolocalización en "Echolocation by Insect-Eating Bats" ["Ecolocalización de los murciélagos insectívoros"], *BioScience*, vol. 51 (2001), pp. 557-69.

Las relaciones entre mamíferos frugívoros de distintas especies durante la estación de escasez de fruta se presentan en *Tropical Forest Ecology*, pp. 160-61.

Edwin Willis muestra que las aves hormigueras más pequeñas son las menos competitivas de las aves que siguen a los ejércitos de hormigas, pero las que mejor sobreviven lejos de estos ejércitos, en *The Behavior of Spotted Antbirds [El comportamiento del hormiguero moteado]*, Ornithological Monographs no. 10, American Ornithological Union (1993), particularmente pp. 109-23. Willis analiza la extinción del hormiguero ocelado en Barro Colorado, en "Populations and Local Extinctions of Birds on Barro Colorado Island, Panamá" ["Poblaciones y extinción local de aves en la Isla de Barro Colorado, Panamá"], *Ecological Monographs*, vol. 44 (1974), pp. 153-69.

El bosque de noche

La manera en que tantas especies distintas de murciélagos logran coexistir en Barro Colorado y los compromisos (*trade-offs*) que enfrentan se describen en Frank Bonaccorso, "Foraging and Reproductive Ecology in a Panamanian Bat Community" ["Ecología alimentaria y de reproducción en una comunidad de murciélagos en Panamá"], *Bulletin of the Florida State Museum, Biological Sciences*, vol. 24 (1979), pp. 359-408, y en Elisabeth Kalko, Charles Handley y Darelyn Handley, "Organization, Diversity and Long-Term Dynamics of a Neotropical Bat Community" ["Organización, diversidad y dinámicas a largo plazo de una comunidad neotropical de murciélagos"], en *Long-Term Studies of Vertebrate Communities [Estudios a largo plazo de comunidades de vertebrados]*, ed. M. L. Cody y J. A. Smallwood (Academic Press, 1996), pp. 503-53. Charles Handley, Don Wilson y Alfred Gardner presentan un resumen de nuestro conocimiento sobre los murciélagos frugívoros comunes en "Demography and Natural History of the Common Fruit Bat, *Artibeus jamaicensis*, on Barro Colorado Island, Panamá" ["Demografía e historia natural del murciélago frugívoro común, *Artibeus jamaicensis*, en la Isla de Barro Colorado, Panamá"], *Smithsonian Contributions to Zoology*, no. 511 (1991), pp. 1-173. Elisabeth Kalko, E. Allen Herre y Charles Handley describen el gremio de los murciélagos comedores de higos y sus fuentes de alimento, en "Relation of Fig Fruit Characteristics to Fruit-Eating Bats in the New and Old World Tropics" ["Relación entre las características de los frutos de higo y los murciélagos que comen higos en los trópicos del Nuevo y el Viejo Mundo"], *Journal of Biogeography*, vol. 23 (1996), pp. 565-76.

Roberto Ibáñez, A. Stanley Rand y César Jaramillo escribieron una guía bilingüe sobre ranas, sapos y otros anfibios del centro de Panamá, la cual complementaron con grabaciones de sus llamados de apareamiento: *The Amphibians of Barro Colorado Nature Monument, Soberanía National Park, and Adjacent Areas [Los anfibios del Monumento Natural de Barro Colorado, del Parque Nacional Soberanía y de otras áreas adyacentes]* (Smithsonian Tropical Research Institute, 1999).

Michael Ryan escribió su trabajo sobre las ranas túngaras —cómo las hembras escogen a sus parejas,

cómo los machos atraen a las hembras y el riesgo que corren al hacerlo— en el libro *The Tungara Frog [La rana túngara]* (University of Chicago Press, 1985).

Kentwood Wells describe los hábitos de apareamiento de *Bufo typhonius* en "Reproductive Behavior and Male Mating Success in a Neotropical Toad, *Bufo typhonius*" ["Comportamiento reproductivo y éxito de apareamiento de los machos en un sapo neotropical, *Bufo typhonius*"], *Biotropica*, vol. 11 (1979), pp. 301-7. William Pyburn describe los hábitos de apareamiento de la rana verde de ojos rojos de México, en "Breeding Behavior of the Leaf-Frogs *Phyllomedusa callidryas* and *Phyllomedusa dacnicolor* in Mexico" ["Hábitos de apareamiento de las ranas verdes *Phyllomedusa callidryas* y *Phyllomedusa dacnicolor* en México"], *Copeia 1970* (1970), pp. 209-18.

Karen Warkentin describe el comportamiento extraordinario de los huevos de la rana verde de ojos rojos cuando son atacados por depredadores, en "Adaptive Plasticity in Hatching Age: A Response to Predation Risk Trade-offs" ["Plasticidad adaptativa en el tiempo de incubación: una respuesta al riesgo de depredación"], *Proceedings of the National Academy of Sciences, USA*, vol. 92 (1995), pp. 3507-10.

Jacqueline Belwood y Glenn Morris describen el riesgo que representan los murciélagos para las esperanzas que viven en el bosque, en "Bat Predation and Its Influence on Calling Behavior in Neotropical Katydids" ["La depredación de los murciélagos y su influencia en el comportamiento de llamado de las esperanzas neotropicales"], *Science*, vol. 238 (1987), pp. 64-67. Otros trabajos sobre la influencia de los murciélagos en el comportamiento de las esperanzas se resumen en Alexander Lang y Heinrich Römer, "Roost Site Selection and Site Fidelity in the Neotropical Katydid *Docidodercus gigliotosi* (Tettigoniidae)" ["Selección de los sitios de descanso y fidelidad al sitio del esperanzas neotropical *Docidodercus gigliotosi* (Tettigoniidae)"], *Biotropica*, vol. 40 (2008), pp. 183-9 y en H. Römer *et al.*, "The Signaller's Dilemma: A Cost-Benefit Analysis of Public and Private Communication" ["El dilema del emisor de señales: un análisis de costo-beneficio de la comunicación pública y privada"], *PLoS One* vol. 5(10) (2010), e13325.

¿Por qué vivir en grupo?

Las ventajas de vivir en grupo se discuten en el capítulo 9 de *Tropical Forest Ecology*. Egbert Leigh explora el problema fundamental del comportamiento animal en "Levels of Selection, Potential Conflicts, and Their Resolution: The Role of the 'Common Good'" ["Niveles de selección, conflictos potenciales y su resolución: el rol del 'bien común'"], en *Levels of Selection in Evolution* [*Niveles de selección en la evolución*], ed. Laurent Keller (Princeton University Press, 1999), pp. 15-30.

Nigel Franks describe las hormigas guerreras como un modelo de la mente humana en "Army Ants: A Collective Intelligence" ["Las hormigas guerreras: una inteligencia colectiva"], *American Scientist*, vol. 77 (1989), pp. 138-45.

Mary Jane West Eberhard cuenta la historia de *Metapolybia aztecoides* en "Temporary Queens in *Metapolybia* Wasps: Nonreproductive Helpers without Altruism?" ["Las reinas temporales en las avispas *Metapolybia*: ¿ayudantes no reproductivas carentes de altruismo?"], *Science*, vol. 200 (1978), pp. 441-43.

Margaret Crofoot *et al.* documentan la influencia que tiene "jugar en casa" en el resultado de los enfrentamientos entre grupos de *Cebus capucinus* en "Interaction Location Outweighs the Competitive Advantage of Numerical Superiority in *Cebus capucinus* Intergroup Contests" ["La ubicación compensa con creces la superioridad numérica en los enfrentamientos intergrupales de *Cebus capucinus*"], *Proceedings of the National Academy of Sciences, USA,* vol. 105 (2008), pp. 577-81.

Egbert Leigh y Geerat Vermeij examinan cómo la lucha por sobrevivir de plantas y animales ha creado comunidades ecológicas productivas y diversas en "Does Natural Selection Organize Ecosystems for the Maintenance of High Productivity and Diversity?" ["¿Organiza la selección natural los ecosistemas para el mantenimiento de una alta productividad y diversidad?"], *Philosophical Transactions of the Royal Society of London*, series B, vol. 357 (2000), pp. 709-18.

CAPÍTULO 5

Los beneficios de los bosques lluviosos para ricos y para pobres

Las relaciones entre los pueblos y el bosque tropical en el que viven estos pueblos se describen en Serge Bahuchet *et al.*, *Tropical Forest Peoples Today [Habitantes de los bosques tropicales en la actualidad]*, vol. 1, *Tropical Forests, Human Forests: an Overview [Bosques tropicales, bosques humanos: un panorama general]* (Avenir des Peuples des Forêts Tropicales, 2001). Las diversas maneras en que los bosques tropicales son importantes para los pueblos de escasos recursos de las zonas rurales se analizan en un voluminoso texto, *Tropical Forests, People and Food [Bosques tropicales, sus habitantes y sus alimentos]*, ed. C. M. Hladik *et al.* (UNESCO and Parthenon, 1993).

La cita sobre la intransigencia de la naturaleza se tomó de Corner, *Life of Plants [La vida de las plantas]*, p. 113.

La forma en que los bosques tropicales y otras manifestaciones de la naturaleza indómita sirven como fuente de belleza e inspiración se describe en S. H. Nasr en las pp. 119-120 del capítulo 8 de su libro, *The Need for a Sacred Science [La necesidad de una ciencia sagrada]* (State University of New York Press, 1993).

La cita sobre "esta profusión de vida vegetal" viene de Corner, *The Life of Plants*, p. 1, y la cita sobre cómo surgieron los árboles modernos se tomó de la p. 141 del mismo libro.

La cita de Alexander von Humboldt se extrajo de *Personal Narrative of a Journey to the Equinoctial Regions of the New Continent [Narración personal de un viaje a las regiones equinocciales del Nuevo Continente]* (reimpresión, Penguin, 1995), p. 82.

El efecto de los bosques tropicales sobre el clima se describe en *Tropical Forest Ecology [Ecología de los bosques tropicales]*, pp. 56-59. El efecto de la precipitación en el clima del África tropical se ilustra en la tabla A.3, la cual brinda información sobre Yangambi, Zaire; Bria, República Centroafricana, y Birao, también en la República Centroafricana. Esta se tomó de M. J. Muller, *Selected Climatic Data for a Global Set of Standard Stations for Vegetation Science [Información climática de un grupo global de estaciones estándar de la ciencia de la vegetación]* (W. Junk, 1982).

David Montgomery y otros muestran en un estudio excepcionalmente cuidadoso que despojar de vegetación las laderas empinadas de los bosques lluviosos de la zona templada de Oregón aumenta considerablemente los deslizamientos, en "Forest Clearing and Regional Landsliding" ["La tala de los bosques y los deslizamientos regionales"], *Geology*, vol. 28, pp. 311-14, del mismo modo que la deforestación promueve la frecuencia de deslizamientos en Puerto Rico.

La cantidad de dióxido de carbono que contiene la atmósfera, la cantidad de carbono que se libera a la atmósfera por la deforestación y la quema de madera, carbón y petróleo, y dónde va este carbono se calculan en la fig. 7.3 de *Climate Change 2007: The Physical Science Basis. Contribution of Working Group I to the Fourth Assessment Report of the Intergovernmental Panel on Climate Change [Cambio climático 2007: Fundamentos de las ciencias físicas. Contribución del grupo de trabajo I al Cuarto Informe de Evaluación del Panel Intergubernamental sobre Cambio Climático]* (IPCC, Washington, DC, 2007).

La fig. 7.3 del reporte de IPCC mencionado ofrece un estimado de cuánta materia orgánica produce la tierra. Christopher Field y otros evalúan la cantidad de materia orgánica que produce la tierra en "Primary Production of the Biosphere: Integrating Terrestrial and Oceanic Components" ["Producción primaria de la biósfera: integración de componentes terrestres y oceánicos"], *Science*, vol. 281 (1998), pp. 237-240.

J. A. Pounds, M. P. L. Fogden, y J. H. Campbell registran la expansión montaña arriba de varias plantas y animales en Monteverde, Costa Rica, en respuesta al calentamiento global, en "Biological Response to Climate Change on a Tropical Mountain" ["Respuesta biológica al cambio climático en una montaña tropical"], *Nature*, vol. 398 (1999), pp. 611-15. John Cubit calcula la velocidad de aumento del nivel del mar en "Possible Effects of Recent Changes in Sea Level on the Biota of a Caribbean Reef Flat and Predicted Effects of Rising Sea Levels" ["Posibles efectos de los cambios recientes en el nivel del mar en la biota de un arrecife del Caribe y efectos predichos

en relación con el incremento en el nivel del mar"], *Proceedings of the Fifth International Coral Reef Congress, Tahiti,* vol. 3 (1985), pp. 111-18.

Los datos sobre cuánto han cambiado la temperatura y la concentración de dióxido de carbono en la atmósfera entre 1910 y 1996 se tomaron de las fig. 3.14 (p. 79), fig. 11.5 (p. 371) y p. 360 de W. H. Schlesinger, *Biogeochemistry: An Analysis of Global Change [Biogeoquímica: un análisis del cambio global]*, 2da. edición (Academic Press, 1997). Los diferentes estimados de cuánto aumentaría el cambio global, si el contenido de dióxido de carbono en la atmósfera se duplicara, fueron extraídos del reporte del 2007 del IPCC sobre el cambio climático citado tres párrafos antes. Gregory Retallack propone una manera para medir la temperatura de tiempos pasados y el contenido de dióxido de carbono en la atmósfera, en "A Three-Hundred-Million-Year Record of Atmospheric Carbon Dioxide Content for Fossil Plant Cuticles" ["Registro de trescientos millones de años del contenido de dióxido de carbono en la atmósfera, en las cutículas de plantas fósiles"], *Nature,* vol. 411 (2001),

pp. 287-90 y "Greenhouse Crises of the Past 300 Million Years" ["Crisis de invernadero de los últimos 300 millones de años"], *GSA Bulletin*, vol. 121 (2009), pp. 1441-55

El aumento considerable de dióxido de carbono que se experimentara hace 56 millones de años, su impacto en el clima global, y el tiempo que se necesitó para que el contenido de dióxido de carbono de la atmósfera regresara a un nivel normal se discuten en Francesca Inerny y Scott Wing, "The Paleocene-Eocene Thermal Maximum: A Perturbation of Carbon Cycle, Climate and Biosphere, with Implications for the Future" ["El máximo térmico del Paleoceno-Eoceno: una perturbación en el ciclo del carbono, el clima y la biósfera, con implicaciones para el futuro"], *Annual Review of Earth and Planetary Sciences*, vol. 39 (2011), pp. 489-516; Gerald Dickens, "Methane Release from Gas Hydrate Systems during the Paleocene-Eocene Thermal Maximum and Other Past Hyperthermal Events: Setting Appropriate Parameters for Discussion" ["Liberación de metano de los sistemas de gas de hidrato durante el máximo térmico del Paleoceno-Eoceno y

TABLA A.3

Precipitación promedio (mm), temperatura máxima diaria promedio (T) y temperatura mínima diaria promedio (t) en grados Celsius, en tres sitios del continente africano

Sitio y latitud		Ene	Feb	Mar	Abr	May	Junio	Julio	Ago	Sept	Oct	Nov	Dec
Yangambi, Zaire	P	85	99	148	150	177	126	146	170	180	241	180	126
0.8°N	T	30	31	31	31	30	29	27	27	28	29	29	30
	t	17	18	20	20	19	19	19	19	19	19	18	17
Bria, República Centro-africana	P	10	10	104	117	206	173	251	277	208	211	66	<3
6.5°N	T	35	36	35	33	32	30	29	29	30	31	32	33
	t	15	17	20	20	21	19	19	19	19	19	17	14
Birao, República Centro-africana	P	0	0	2	19	97	112	217	204	171	37	1	0
10.3°N	T	35	37	39	39	37	34	31	30	32	34	35	35
	t	12	15	19	21	23	22	21	21	21	20	14	12

otros eventos hipertermales anteriores: definición de parámetros de discusión apropiados"], *Climate of the Past Discussions*, vol. 7 (2011), pp. 1139-73; Richard Norris y Ursula Röhl, "Carbon Cycling and Chronology of Climate Warming during the Paleocene/Eocene Transition" ["Ciclo del carbono y cronología del calentamiento del clima durante la transición del Paleoceno/Eoceno"], *Nature*, vol. 401 (1999), pp. 775-78; y Santo Bains *et al.*, "Termination of Global Warmth at the Paleocene/Eocene Boundary through Productivity Feedback" ["Fin del calentamiento global en la frontera del Paleoceno/Eoceno debido a la retroalimentación de la productividad"], *Nature*, vol. 407 (2000), pp. 171-74. Gerald Dickens *et al.* calculan la cantidad de metano que tendría que ser liberado a la atmósfera para reducir la proporción de ^{13}C en relación con ^{12}C en 0.3%, en "Dissociation of Oceanic Methane Hydrate as a Cause of the Carbon Isotope Excursion at the End of the Paleocene" ["Disociación del hidrato de metano oceánico como causa de la excursión del isótopo de carbono al final del Paleoceno"], *Paleoceanography*, vol. 10, pp. 965-71. John Casperson *et al.* presentan más evidencia sobre lo poco que el dióxido de carbono adicional puede ayudar a que los bosques ralenticen el aumento en el contenido de dióxido de carbono de nuestra atmósfera, en "Contributions of Land-Use History to Carbon Accumulation in U. S. Forests" ["Contribuciones de la historia del uso de la tierra a la acumulación de carbono en los bosques de EUA"], *Science*, vol. 290 (2000), pp. 1148-51. Los autores muestran que los bosques de la misma edad producían tanta madera en la década de 1930 como lo hacían en la década de 1980.

Robert Stallard calcula cuánto carbón está enterrado alrededor del mundo en los sedimentos erosionados, en "Terrestrial Sedimentation and the Carbon Cycle: Coupling Weathering and Erosion to Carbon Burial" ["La sedimentación terrestre y el ciclo del carbono: la relación entre la erosión y la meteorización y el carbono enterrado"], *Global Biogeochemical Cycles*, vol. 12 (1998), pp. 231-57.

La fragmentación y la destrucción de los bosques tropicales

T. C. Whitmore calcula el área de bosque tropical húmedo en diferentes continentes en 1990 y la velocidad a la que está siendo "limpiado" o talado para extraer madera, en *An Introduction to Tropical Rain Forests [Introducción a los bosques tropicales lluviosos]*, 2d. ed. (Oxford University Press, 1998), pp. 207-9. William Laurance describe las diversas maneras en que el bosque tropical de la Amazonía se está degradando, así como el despilfarro que se da en el uso de la tierra, en "A Crisis in the Making: Responses of Amazonian Forests to Land Use and Climate Change" ["Una crisis en ciernes: respuestas de los bosques de la Amazonía al uso de la tierra y al cambio climático"], *Trends in Ecology and Evolution*, vol. 13 (1998), pp. 411-15.

El suelo tropical puede ser cultivado de una manera sostenible. Adam Smith en *The Wealth of Nations [La riqueza de las naciones]* (Modern Library, 1937), libro 3, capítulo 2, describe, a partir de la experiencia europea, las razones por las cuales los pequeños productores con tenencia de la tierra heredable, ya sean dueños o inquilinos que pagan un alquiler fijo, cultivan de manera más productiva. Robert Netting en *Smallholders, Householders [Pequeños productores, grandes cuidadores]* (Stanford University Press, 1993) examina por qué estos pequeños productores, ya sea en los trópicos o en las zonas templadas, son más propensos a cultivar de manera sostenible, y las amenazas que enfrenta la pequeña agricultura.

Las cifras sobre el daño típico que ocasiona la extracción de madera provienen de la fig. 19.6 de T. C. Whitmore, *Tropical Rain Forests of the Far East [Bosques tropicales lluviosos del Lejano Oriente]*, 2d. ed. (Oxford University Press, 1984), p. 271. El daño causado por la extracción de madera, la forma de reducir este daño y cuánto se puede reducir se discuten en T. C. Whitmore, *An Introduction to Tropical Rain Forests*, 2d. ed, pp. 132-39, y en E. F. Bruenig, *Conservation and Management of Tropical Rainforests [Conservación y manejo de los bosques tropicales lluviosos]* (CAB International, 1996), pp. 105-24. En este mismo libro, E. F. Bruenig describe algunas de las causas del descuido y el desperdicio que normalmente caracteriza la extracción de madera en los países tropicales.

En "How Wide is a Road? The Association of Roads and Mass-Wasting in a Forested Montane Environment" ["¿Qué tan ancha es una carretera? La asociación entre las carreteras y la erosión masiva de un ambiente montano

boscoso"], *Earth Surface Processes and Landforms*, vol. 22 (1997), pp. 835-48, Matthew Larsen y John Parks muestran que, en los bosques lluviosos en áreas montañosas, los deslizamiento son cinco veces más frecuentes a una distancia de hasta 85 metros de una carretera que en cualquier otro lugar del bosque.

Las consecuencias sociales y ecológicas que por lo general trae consigo el desplazamiento de los pequeños productores tropicales por causa de los agronegocios se examinan en William Durham, *Scarcity and Survival in Central America [Escasez y supervivencia en Centroamérica]* (Stanford University Press, 1979). El daño causado por el trasplante de agricultores a regiones que no se habían cultivado anteriormente debido a la pobreza de los suelos se esboza en T. C. Whitmore, *Tropical Rain Forests of the Far East*, 2d. ed. (Oxford University Press, 1984), pp. 171-72.

La fragmentación del bosque tropical y sus consecuencias se analizan en *Tropical Forest Remnants [Restos del bosque tropical]*, ed. William Laurance y Richard Bierregaard, Jr. (University of Chicago Press, 1997).

William Glanz hace una lista de los mamíferos que se han extinguido en Barro Colorado en la tabla 16.1 de *Four Neotropical Rainforests [Cuatro bosques lluviosos neotropicales]*, editado por A. H. Gentry (Yale University Press, 1990), p. 289. Excluí los tres mamíferos más grandes de la lista porque los tapires quizá nunca desaparecieron de la isla y los dos felinos más grandes, simplemente la visitan. Además, es casi seguro que los monos araña desaparecieron antes de que Barro Colorado se convirtiera en una isla. La disminución de la diversidad de aves desde que Barro Colorado se convirtió en isla es descrita por Edwin Willis (quien ahonda en las causas de la extinción del hormiguero ocelado) en "Populations and Local Extinctions of Birds on Barro Colorado Island, Panamá" ["Poblaciones y extinción local de aves en la Isla de Barro Colorado, Panamá"], *Ecological Monographs*, vol. 44 (1974), pp. 153-69, y por W. D. Robinson en "Long-Term Changes in the Avifauna of Barro Colorado Island, Panama, a Tropical Forest Isolate" ["Cambios a largo plazo en la avifauna de la Isla de Barro Colorado, Panamá, un bosque tropical aislado"], *Conservation Biology*, vol. 13, pp. 85-97. El tema de si la ausencia de felinos de gran tamaño ha causado un desbalance ecológico serio en Barro Colorado se discute en *Tropical Forest Ecology*, pp. 158-59.

Las relaciones de interdependencia que hacen posible la existencia de un bosque tropical exuberante y diverso, y lo que sucede cuando un embalse fragmenta un bosque tropical continuo en islas desperdigadas, se describen en el Capítulo 9 de *Tropical Forest Ecology*; E. G. Leigh, Jr., "The Evolution of Mutualism*" ["La evolución del mutualismo"], *Journal of Evolutionary Biology*, vol. 23 (2010), pp. 2507-28; G. J. Vermeij y E. G. Leigh, Jr., "Natural and Human Economies Compared" ["Comparación de las economías naturales y humanas"], *Ecosphere*, vol. 2 (2011), artículo 39; E. G. Leigh *et al.*, "What Do Human Economies, Large Islands and Forest Fragments Reveal about the Factors Limiting Ecosystem Evolution?" ["¿Qué revelan las economías humanas, las islas grandes y los fragmentos de bosque sobre los factores que limitan la evolución de los ecosistemas?"], *Journal of Evolutionary Biology*, vol. 22 (2009), pp. 1-12; J. Terborgh *et al.*, "Ecological Meltdown in Predator-Free Forest Fragments" ["Colapso ecológico en fragmentos de bosque libres de depredadores"], *Science*, vol. 294 (2001), pp. 1923-6; J. Terborgh *et al.*, "Vegetation Dynamics of Predator-Free Land-Bridge Islands" ["Dinámica de la vegetación en islas que antes estaban conectadas a tierra firme y que ahora están libres de depredadores"], *Journal of Ecology*, vol. 94, pp. 253-63, y K. Feeley y J. Terborgh, "The Effects of Herbivore Density on Soil Nutrients and Tree Growth in Tropical Forest" ["El efecto de la densidad de herbívoros en los nutrientes del suelo y en el crecimiento de los árboles en los bosques tropicales"], *Ecology*, vol. 86 (2005), pp. 116-24. El efecto en poblaciones de monos aulladores se discute en G. Orihuela *et al.*, "When top-down becomes bottom-up: Behavior of hyperdense howler monkeys (*Alouatta seniculus*) trapped on an 0.6-ha island" [Cuando las regulaciones 'de arriba hacia abajo' se convierten en 'de abajo hacia arriba': comportamiento de poblaciones hiperdensas de monos aulladores (*Alouatta seniculus*) atrapados en una isla de 0.6 hectáreas"], *PLoS ONE* 9(4) e82917 (2014). Las características de los ecosistemas de fragmentos de bosque se ilustran de manera aún más evidente en islas

que llevan mucho tiempo aisladas: ver E. G. Leigh, Jr. *et al.*, "The Biogeography of Large Islands, or How Does the Size of the Ecological Theater Affect the Evolutionary Play?" ["La biogeografía de las islas grandes, o cómo el tamaño del teatro ecológico afecta la obra evolutiva que se representa"], *Revue d'Écologie (La Terre et la Vie)*, vol. 62 (2007), pp. 105-168.

La preservación de los bosques tropicales

R. K. Enders describe el incremento de la caza furtiva que tuvo lugar en Barro Colorado en 1932 y su impacto en las poblaciones de los felinos depredadores y de los grandes herbívoros, en "Changes Observed in the Mammal Fauna of Barro Colorado Island, 1929-1937" ["Cambios observados en la fauna mamífera de la Isla de Barro Colorado, 1929-1937"], *Ecology*, vol. 20 (1939), pp. 104-6.

La forma en que el daño ecológico en una parte del mundo causa problemas en otras partes se detalla en Robert Stallard, "Possible Environmental Factors Underlying Amphibian Decline in Eastern Puerto Rico: Analysis of U. S. Government Data Archives" ["Posibles factores ambientales responsables de la disminución de los anfibios en el este de Puerto Rico: análisis de los Archivos de datos del Gobierno de EUA"], *Conservation Biology*, vol. 15 (2001), pp. 943-53: el polvo que se levanta en las áreas deforestadas de África y que es empujado por el viento puede estar causando epizootias y otros daños en el neotrópico. La creciente abundancia de lianas en Barro Colorado y su impacto en los árboles se registra en S. J. Wright *et al.*, "Are Lianas Increasing in Importance in Tropical Forests? A 17-Year Record from Panama" ["¿Está aumentando la importancia de las lianas en el bosque tropical? Un registro de 17 años de Panamá"], *Ecology*, vol. 85 (2004), pp. 484-9, y en Laura Ingwell *et al.*, "The Impact of Lianas on 10 Years of Tree Growth and Mortality on Barro Colorado Island, Panama" ["El impacto de las lianas en diez años de crecimiento y mortalidad de los árboles de la Isla de Barro Colorado, Panamá"], *Journal of Ecology*, vol. 98 (2010), pp. 879-87.

Los éxitos y los retos en relación con la conservación de la naturaleza en las cercanías del Canal de Panamá se resumen en Richard Condit *et al.*, "The Status of the Panama Canal Watershed and Its Biodiversity at the Beginning of the 21st Century" ["El estado de la cuenca del Canal de Panamá y su biodiversidad en los inicios del siglo XXI"], *BioScience*, vol. 51 (2001), pp. 389-98, y se describen con más detalle en *La cuenca del Canal: deforestación, urbanización, y contaminación*, ed. Stanley Heckadon-Moreno, Roberto Ibáñez y Richard Condit (Smithsonian Tropical Research Institute, 1999).

La conservación exitosa de Monteverde, Costa Rica, se describe en *Monteverde*, un voluminoso texto editado por Nalini Nadkarni y Nathaniel Wheelwright (Oxford University Press, 1999). Egbert Leigh resume esta historia en una reseña del libro en *Environmental Practice [Prácticas ambientales]*, vol. 3 (2001), pp. 65-67.

NOTAS SOBRE LA FOTOGRAFÍA

Planificación

Gran parte de mi trabajo fotográfico —mucho antes de siquiera tocar una cámara— es la planificación. Lo primero que hicimos Egbert y yo fue sentarnos a hacer un bosquejo de una tabla de contenidos que incluyera procesos y fenómenos que nos parecieron importantes. Luego comencé a pensar en las fotografías que representarían los diferentes grupos de organismos y los conceptos ecológicos que queríamos presentar.

El colibrí no solo es un bonito ejemplo de un polinizador nada común, sino que relata la historia de todo un gremio alimentario que existe solo en los trópicos y que, de esa forma, contribuye a la mayor diversidad que se observa en los bosques tropicales. Los brúquidos, o escarabajos de las semillas, representan a miles de otras plagas especializadas en semillas que ayudan a mantener la diversidad de los árboles. La mayoría de los animales y las plantas de este libro son símbolos y "embajadores" de muchos, a veces de miles de otros organismos que cumplen papeles similares.

Los bosques lluviosos y la fotografía

Los bosques lluviosos son lugares fantásticos. La vida está por todos lados —una composición abrumadora de colores, formas, sonidos, olores y humedad. Los bosques lluviosos también son lugares sutiles; los animales son silenciosos y se esconden de los visitantes. Durante un largo rato, uno no se da cuenta de cuántas criaturas lo rodean. Si uno cierra los ojos, se puede sentir la presencia de abundante vida en derredor.

Desde el punto de vista de un fotógrafo, los bosques lluviosos pueden ser un ambiente desafiante por muchas razones. Una es el clima extremo: el calor y la humedad pueden hacer que el equipo falle o que el fotógrafo se rinda. Algunos de mis lentes fueron víctimas de la humedad y del moho; muchas cámaras dejaron de funcionar; una cámara con flash fue mordida por un cocodrilo.

Dos hechos biológicos tuvieron serias consecuencias para la fotografía. Uno es que solo aproximadamente el uno por ciento de la luz que cae sobre el dosel logra alcanzar el suelo del bosque. Esto tiene como resultado una permanente carencia de luz allí donde el fotógrafo la necesita. Lo segundo es que, debido a la enorme cantidad de especies, prácticamente cualquier animal que uno está buscando va a ser escaso y difícil de encontrar.

El bosque esconde bien sus secretos. Aun cuando uno ve algo, la mayoría de las veces cuesta capturar una fotografía decente. Pero también hay momentos en que se produce la magia. De pronto pasa un ave; de pronto el sol brilla justo en el lugar que queremos y nos ofrece la oportunidad de tomar una o dos imágenes antes de que todo se desvanezca nuevamente. De eso se trata la fotografía: de esas pequeñas ventanas en el tiempo y en el espacio en que el bosque está dispuesto a compartir sus secretos.

Métodos de trabajo: conocimiento biológico, paciencia y suerte

Solo unas cuantas imágenes de este libro son el resultado de encuentros fortuitos y tomas espontáneas. La mayoría de ellas llevó tiempo prepararlas; en primer lugar tuve que averiguar cómo y dónde encontrar al organismo, y luego buscar la forma de lograr la situación y la perspectiva en las cuales quería mostrarlo. Me tomó cerca de dos semanas (con la ayuda de un ornitólogo)

encontrar el nido de un momoto. Durante otras dos semanas, escondido detrás de una carpa cerca del nido, gradualmente fui moviendo el equipo donde estaba montada la cámara con un control remoto, más cerca cada día, sin molestar a las aves. Finalmente pude posicionar la cámara cómodamente enfrente de la entrada del nido, donde pude capturar el momento íntimo en que un ave regresaba a alimentar a su cría.

Para capturar imágenes de los ocelotes, utilicé una trampa fotográfica. Diseñé y mejoré mi sistema (luego de aprender una dolorosa lección mientras intentaba impermeabilizar mi equipo: perdí tres flashes en el proceso) y seguí las huellas que encontraba para instalar la cámara en lugares prometedores. Once semanas y más de cuarenta rollos de película después, que produjeron imágenes geniales de la lluvia, de zarigüeyas (hay muchas, muchas zarigüeyas ahí), de murciélagos y de otras curiosidades, finalmente conseguí mi primera toma de un ocelote.

Escogí estos dos ejemplos para ilustrar que la fotografía de la naturaleza comprende mucho más elementos que solamente ver el animal y presionar un botón. El conocimiento de los organismos, el desarrollo de una sensibilidad sobre el comportamiento de los animales y lo que pueden tolerar, mucha paciencia y otro tanto de suerte son tan cruciales como el conocimiento de la técnica —quizá incluso más importantes—.

Todas las imágenes de este libro son de animales salvajes, la mayoría tomadas en la Isla Barro Colorado, algunas en los alrededores, y unas cuantas del último capítulo en el oeste de Panamá.

Equipo

Para la mayor parte usé el Sistema EOS de Canon con lentes de 14 a 500 milímetros. Para algunas situaciones trabajé con una cámara Canon manual (una T 90) y para los paisajes algunas veces con una Pentax 67. Utilicé flash en la mayoría de las imágenes. El material de la película fue principalmente Fuji Velvia, Fuji Astia y Kodak E 200, forzado a ISO 800. Se necesitó un trípode para muchas imágenes. En algunos casos, se utilizaron algunos dispositivos especiales, como un control remoto o disparadores infrarrojos de alta velocidad para capturar las imágenes sin molestar demasiado a los animales. En muchos casos, trabajé detrás de carpas o escondites. Para las tomas macro fotografié el animal en un estudio o, más frecuentemente, construí un estudio de campo con múltiples flashes para balancear la luz natural con la luz artificial.

Notas sobre la fotografía de la segunda edición

El bosque lluvioso no ha cambiado mucho en los últimos diez años, los niveles de luz son tan bajos como siempre y muchos animales continúan siendo tan reservados como siempre en su manera de vivir. El mundo de la tecnología fotográfica, por otro lado, parece de otro planeta: las cámaras han cambiado en aspectos que nunca creímos posibles. La película prácticamente ha desaparecido y los sensores digitales han hecho que las cámaras sean mucho más parecidas al ojo humano, especialmente en términos de adaptación a la poca luz. Por esta razón, casi un tercio de las imágenes fueron sustituidas en esta segunda edición, sobre todo con versiones más nuevas y, yo considero, mejores, de imágenes muy similares, que fueron posibles gracias a la tecnología digital (la cámara que usé fue, principalmente, una Canon EOS 5 D II). Esperemos que las cámaras sigan evolucionando para ofrecer a los fotógrafos herramientas todavía mejores para poder compartir con todos la fascinación de las maravillas naturales.

CHRISTIAN ZIEGLER

AGRADECIMIENTOS

Para la primera edición, 2002

Este proyecto ha sido largo y emocionante, y muchas personas han contribuido de diversas maneras, por lo cual estoy muy agradecido. Mis padres, Christa-Anita Ziegler y Hans-Walter Ziegler, siempre confiaron en mí y apoyaron mi trabajo. Sin su ayuda nada de esto hubiera sido posible, y les estoy enormemente agradecido. También quiero agradecer a mi hermano, Johannes Ziegler, por su apoyo.

Quiero agradecer al Dr. Ira Rubinoff, director del Instituto Smithsonian de Investigaciones Tropicales (STRI, por sus siglas en inglés), por su confianza en este proyecto, y al Dr. Cristian Samper por su apoyo.

Mucho de lo que sé sobre ecología tropical lo aprendí en la Universidad de Wuerzburg en Alemania, con el profesor Karl-Eduard Linsenmair y con el Dr. Gerhard Zotz. Ellos me ayudaron a sentar las bases científicas de mi fascinación por los trópicos.

Le estoy agradecido a Janeene Touchton, con quien he estado compartiendo felizmente mi vida y quien me ha apoyado con su ternura, su amor y su entusiasmo.

Debo también agradecer a mis amigos y colegas en la Isla Barro Colorado por un tiempo maravilloso y por nuestras conversaciones sobre ciencia y sobre la vida. Otras personas vinieron a visitarme a "mi isla" y me recordaron que no me habían olvidado en casa. Todos fueron muy generosos al compartir conmigo su conocimiento sobre los organismos que estudiaban, lo cual mejoró las fotografías considerablemente. Vivir en una isla cubierta de bosque durante 15 meses genera la necesidad de hacer buenos amigos. La siguiente es una lista que está lejos de ser completa (espero que la gente que haya olvidado mencionar entienda que esto puede suceder, y que sepa que aun así les estoy agradecido): Dora Álvarez, Jennie Bee, Juergen Berger, Christiane Broeker, Chrissy Campbell, Stelios Chatzimanolis, Ellie Clark, Sandra Correa, Cameron Currie, Dina Dechmann, Dr. Robert Dudley, Dr. Bettina Engelbrecht, Amy Faivre, David Gálvez, Jacalyn Giacalone, Rachel Goeriz, Víctor González, Denise Hardesty, Dr. Michaela Hau, Dr. Hubert Herz, Margaretta Kalka, Dr. Elisabeth Kalko, Dr. Roland Kays, Andreas Kompa, Alexander Lang, Stefan Laube, Johanna Marxer, Ricardo Moreno, Jay Nelson, Timothy Pearson, Matthias Pestel, Scott Powell, Dr. Carl Rettenmayer, Ghislain Rompre, Tara Sackett, Lauren Schachner, Gerold Schmidt, Stefan Schnitzer, Steffen Schultz, Kirsten Silvius, Sabine Spehn, Annie St. Amand, Sabine Stuntz, Jens-Christian Svenning, Dr. Edmund Tanner, Dr. John Teen, Ingeborg Teppner, Katja Ueberschaer, Julia von Puttkamer, Martina Wagner, Elan Wang, Paige Wickner, Dr. Martin Wikelski y Dr. Rainer Wirth.

El personal del STRI en Isla Barro Colorado se aseguró de que todo fluyera sin problemas; Oris Acevedo, en particular, logró lo que parecía imposible. El mecánico de botes, especialmente Ricardo Cajar, arregló mi pobre bote muchas veces. Los cocineros Juan Dutari, Gary Oses y Edward Robinson me dieron buenas comidas. Los guardabosques cumplieron con su difícil trabajo todo el tiempo, protegiendo el monumento. También me ayudaron a localizar a los animales. Otras personas que necesito mencionar aquí son Rafael Batista, Víctor Pérez y José Sánchez.

Les agradezco a las siguientes personas de la administración del STRI y del laboratorio de fotografía del STRI, quienes me ayudaron a revelar la ridícula cantidad de película que utilicé: Laura Flores, Nelly Flores, Marcos

Guerra, Beth King, Maria Leone, Gloria Maggiori, Raineldo Urriola y Jorge Ventocilla. Entre los investigadores del STRI que compartieron su conocimiento conmigo, debo mencionar a la Dra. Annette Aiello, quien me ayudó a identificar insectos; al Dr. George Angehr, quien me proporcionó información sobre aves; al Dr. Phyllis Coley al y Dr. Thomas Kursar, quienes compartieron historias interesantes sobre plantas y orugas; al Dr. Allen Herre y Adalberto Gómez, quienes me ayudaron a encontrar y a entender los higuerones y sus polinizadores; al Dr. William Laurence, quien me instruyó sobre la fragmentación de los bosques; al Dr. Stanley Rand y a la Dra. Karen Warkentin, quienes compartieron conmigo su conocimiento sobre ranas; al Dr. William Wcislo y al Dr. Donald Windsor, quienes me brindaron información sobre abejas y escarabajos; y al Dr. Joseph Wright, quien contestó mis múltiples preguntas sobre plantas.

Quiero agradecer a Augusto González de la Asociación Nacional para la Conservación de la Naturaleza (ANCON), quien me mostró la granja experimental de iguanas. En Alemania, Matthias Pestel me ayudó con temas relativos al laboratorio y a su organización.

Le estoy agradecido a las siguientes personas por sus críticas constructivas y por la confianza que depositaron en mi trabajo fotográfico: Ruth Eichhorn, Annette Hasselmann, Venita Kaleps, Frans Lanting y Rosamund Kidman-Cox.

Por último, pero no por eso menos importante, quiero agradecer a Frans Lanting en general por su ayuda tanto en mi carrera fotográfica como en este proyecto en particular. Él me brindó inspiración y motivación en un momento crucial y me ha apoyado enormemente desde ese entonces. Él me permitió convertirme en un fotógrafo profesional de la naturaleza, y sin él este libro nunca hubiera comenzado.

Para la segunda edición, 2012
Por promocionar la segunda edición de *Un tejido mágico*, al ex director, Eldredge Bermingham, y al actual director Matthew Larsen. También, deseo agradecer a Sharon Ryan por su entusiamo y compromiso para llevar a cabo la publicación de *Un tejido mágico* en español. Sin su apoyo este proyecto no habría sido posible. También quiero agradecer a Oxford University Press, que generosamente devolvió los derechos al STRI para garantizar la publicación de esta segunda edición a tiempo.

El STRI continúa siendo mi hogar académico, y me gustaría agradecer a la comunidad del STRI por hacer de Panamá un lugar fantástico para vivir y para trabajar. Panamá se ha convertido en mi hogar, con muchos buenos amigos que agradezco haber conocido. Sobre todo, he disfrutado explorar BCI con Daisy, y espero ver muchos otros lugares junto a ella y nuestra creciente familia.

Muchas de las imágenes nuevas que se incluyeron en esta segunda edición fueron fotografiadas en proyectos para la *Revista National Geographic*. Agradezco a la revista por su apoyo continuo de mi visión fotográfica, y quiero agradecer especialmente a Kathy Moran, editora principal para la sección de historia natural.

Lisa Lytton hizo maravillas para sacar adelante esta segunda edición: rediseñó el libro, le dio una imagen renovada y logró que se imprimiera a tiempo. ¡Muchas gracias!

CHRISTIAN ZIEGLER

ÍNDICE

Nota: las palabras en cursiva indican ilustraciones, en redonda indican referencias en el texto

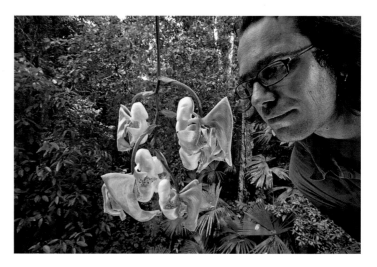

EGBERT GILES LEIGH, JR. es científico de planta del Instituto Smithsonian de Investigaciones Tropicales en Panamá desde 1969. Le interesan sobremanera los procesos ecológicos y evolutivos que dan forma a la ecología de los bosques tropicales. Leigh ha publicado docenas de artículos evaluados por expertos, artículos científicos, y varios libros cuyos temas van desde el mantenimiento de la diversidad de los árboles tropicales a la evolución de los mutualismos y la cooperación social y el paralelismo entre los ecosistemas y las economías humanas. Cuando no se encuentra de viaje impartiendo charlas y conferencias, Egbert Leigh trabaja desde su oficina en Isla Barro Colorado.

CHRISTIAN ZIEGLER es un biólogo que se convirtió en fotógrafo, especialmente de la naturaleza de los trópicos. Asiduo contribuyente de National Geographic, ha cubierto temas que van desde las ranitas arbóreas a los ocelotes, desde los murciélagos tropicales a los primates africanos. Le gusta pensar que su trabajo consiste en traducir el contenido de ciencias como la Ecología y la Historia Natural en imágenes, de manera que esos estos temas sean más accesibles al gran público.

Ziegler llegó a Panamá a hacer trabajo de campo en Isla Barro Colorado y ahora es asociado de comunicación en el Instituto Smithsonian de Investigaciones Tropicales. Es miembro fundador de la Liga Internacional de Fotógrafos para la Conservación, y ha recibido reconocimientos internacionales en la categoría de fotografía de la naturaleza como Fotógrafo del Año, Fotógrafo Europeo del Año y Mejor Fotografía del Año. Para más información sobre el trabajo de Ziegler, visitar: www.naturphoto.de.

Esta es la traducción al español de la segunda edición de *A Magic Web: The Tropical Forest of Barro Colorado Island*, publicado en 2012 por el Instituto Smithsonian de Investigaciones Tropicales.

Publicado por
SMITHSONIAN INSTITUTION SCHOLARLY PRESS
P.O. Box 37012, MRC 957
Washington, DC 20013-7012, USA
scholarlypress.si.edu

El diseño original del libro de Lisa Lytton, Paraculture Books, www.paraculture.com.

Impreso en Canadá